Encyclopaedia
of
Oil Painting

Encyclopaedia of Oil Painting

materials and techniques

Frederick Palmer

NORTH LIGHT CINCINNATI, OHIO

For Eunice

Jacket photographs
Front: Venice by Arnold Keefe
Back: Villas in Provence (detail) by Adrian Ryan

Published in Great Britain by
B T Batsford Ltd
4 Fitzhardinge Street
London W1H 0AH

Published in North America by
North Light, an imprint of Writer's Digest Books
9933 Alliance Road
Cincinnati, Ohio 45242

Library of Congress Cataloging in Publication Data
Palmer, Frederick, 1936–
 Encyclopaedia of oil painting.

 Includes indexes.
 1. Painting—Technique. 2. Artists' materials.
I. Title.
ND1500.P27 1984 751.45 83-25400
ISBN 0-89134-078-5

Printed in Great Britain

Contents

Acknowledgment 6
Introduction 7

Equipment and Materials
General points 9
Easels 9
Palettes 11
 Cleaning palettes 12
Palette knives 13
Painting knives 13
Dippers 14
The mahl stick 14
Rags 14
General studio equipment 16
Supports 16
 Stretching a canvas 23
 Marouflage 24
Brushes 25
 Cleaning brushes 28
 Airbrushes 32
Grounds 33
Binding media (mediums) 37
Oil percentages in pigment 39
Drying times of some oil colours 40
Drying oils 42
Solvents 44
Painting media (mediums) 44
Driers 46
Varnishes and varnishing 47
Guide to drying times of oils and
 varnishes 48
Pigments 48
 Permanence of pigments 57
 Poisonous pigments 60
Colour 60
 Tone and black and white 63
 Warm and cool colours 68
 Complementary colours 70

Colour contrasts and harmony 73
Local and light colour 74
Greys 74
Colour and space 77
Limited palettes 77
Responses to colour 80
Captions to colour plates 81

Techniques
General 87
Glazes 88
Underpainting 88
Alla prima 92
Wet into wet 94
Impasto 94
Scumbling 95
Encaustic 99
Painting with a knife 102
Staining 103
Spraying 104
Stencilling 104
Airbrushing 107
Collage 108
Additions to the paint 110
Serigraphy 116
Painting from photographs 118
Photography 128
Tonking 125
Scraping 129
Sinking 129
The application of colour 130
Three basic techniques 133
 Glazing 133
 Painting with additional layers 136
 Alla prima 137
Van Eyck and the development of oil
 painting 140
The technique of Titian 142

The technique of Rubens 144
The technique of Rembrandt 148
The Impressionist technique 153
Painting with flat colour 160
Painting with impasto 164
Painting with modulated colour 167
Painting with optical mixtures of colour 169
Procedures 173
Composition 188
The structure of a painting 188
 The golden section 191
Lines and shapes 194
Pattern and texture 201
Space and the third dimension 210

Position on the picture plane 213
Scale 214
Overlapping 216
Colour 220
Aerial perspective 220
Linear perspective 220
Multiple viewpoints 223
Projection systems 225
Squaring up 229
The subject 230
Points worth considering 280

Index to artists 282
General index 285

Acknowledgment

In writing a book of this kind there are not only those people to be thanked for making research material available or granting permission to reproduce works in their collection, but there are also those without whose support and encouragement it would have been impossible to complete.

In the former category I should like to thank all those museums, galleries and private collectors who have been so kind as to permit the reproduction of works in their possession or of which they hold the copyright.

Of those colour manufacturers who have been helpful it is particularly appropriate to thank Winsor and Newton and especially their Technical Director, Peter Staples who made archive material available to me.

In the latter category I should like to extend my gratitude to those painters who have not simply allowed me to reproduce their pictures, but who have been so kind as to write a short piece about their working method. Stephen Gardiner and Mel Gooding are included here for writing about their father and father-in-law respectively. I am also extremely grateful to Fanny Baldwin for reading the manuscript and offering constructive comment and advice. My son, Jake Palmer, should be thanked for many of the photographs on this his first photographic commission.

Finally, my warmest thanks to my editor Thelma M Nye whose hard work, encouragement and patience have seen the production of the book through from her first idea to its publication.

London 1984 FP

Unnumbered illustrations are reproduced by kind permission of Winsor and Newton from their 1891 catalogue.

Introduction

There are two things in the painter, the eye and the mind; each of them should aid the other. It is necessary to work at their mutual development; in the eye by looking at nature, in the mind by the logic of organised sensations which provides the meaning of expression.

Paul Cézanne

I meet many people who wish to paint with oil colours, but who have little experience or knowledge of materials and techniques and it is for them that this book is written. It explains in simple terms the purposes of the equipment and materials along with some of the basic concepts of painting which are the concern of the intelligent amateur as well as the student and professional painter. Descriptions of techniques are also given and the emphasis throughout the book is on practical advice which will allow the reader to begin painting in oil colour with the minimum of cost and with an understanding of the medium which will present the least number of practical difficulties whilst still ensuring a degree of permanence to the work. Discussion of technique is aimed at the amateur who is not concerned with the facile tricks so often presented to the beginner, but who is interested in learning from the works of professional painters

1 **Jan van der Straet:** *Painting in oil, c* 1600. Engraving from *Nova Reperta.*
British Museum, London
The painter in his studio surrounded by apprentices painting a portrait, drawing from the cast, preparing the master's palette and grinding colour

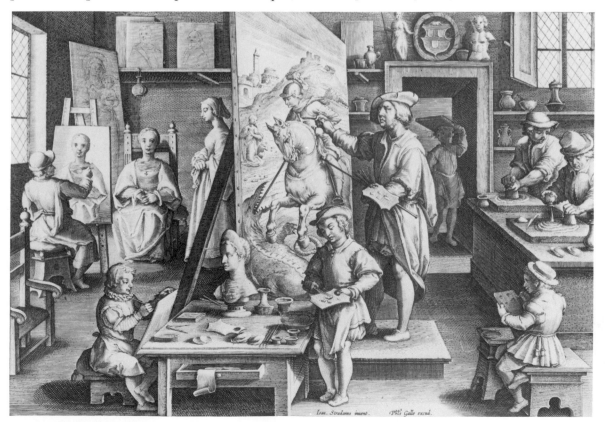

Ioan. Stradanus invent . Phls Galle excud.

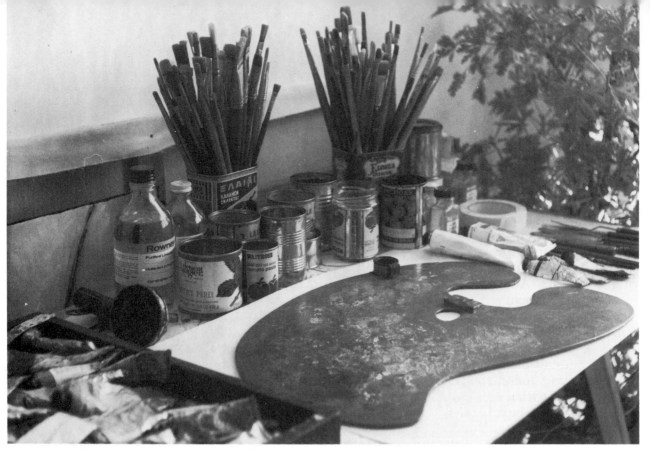

and having begun with this book will, I hope, go on to further study.

2 Studio table

The descriptions of the techniques of some of the great painters of the past are included as practical advice rather than for aesthetic or historical content, and are chosen to encourage the person who wishes to paint just because he feels a desire to express himself in visual terms. Nothing in the book is based on the somewhat erroneous assumption that in order to do this one must have a certain basic 'talent', but simply on the notion that most people, given the opportunity and confidence, are able to make visual statements. Certain preconceived ideas about what constitutes 'art' may have to be overcome, for the book is not about the mystique of the 'artist', nor the teaching of superficial techniques. Its main concern is with information and advice which will help the beginner to interpret what he sees and thinks. It is a book about materials, equipment and simple concepts for those who wish to learn through practical involvement, through experience and their own discovery.

Equipment and Materials

GENERAL POINTS

For the beginner the colourman's catalogue can look both enticing and daunting: the price list frightening. Although there is an exciting wealth of equipment and materials from which to select it should not be assumed that to begin painting with oil colour is an expensive enterprise. With reasonably priced materials and a limited amount of equipment it is possible to begin painting. Indeed this is probably the best way. To start with a wide range of costly items is foolish and can be confusing.

Everyone is tempted by the beautiful artist's colour boxes with their polished wood and rows of neatly laid out items, but delightful presents though they make do they really contain what each individual requires in the quantity needed with room for expansion? It is better to save the money for the really useful items, the paints and the brushes, and either make a simple wooden box or use an old suitcase, toolbox, army surplus container or haversack. The British painter Wilson Steer carried his painting gear around in an old cricket bag, Stanley Spencer wheeled his about in an old pram. Such eccentricities may not appeal to everyone, but there are few professional painters who use the expensive Studio Chests and Oil Colour Sets. That which is the cheapest and most suitable for the individual requirements is the best paint 'box'.

An easel, although not absolutely essential, is really the only major piece of equipment that the beginner needs to think of buying. It is possible to paint with the canvas or board propped in some less stable manner, or laid horizontally, but neither is really satisfactory in the long term. An easel with its stability and the means of tilting the work to take advantage of the light or alternatively avoid reflection and glare, is a sensible investment.

A wide range of colours and brushes may well be built up over a period of time but there is no reason when starting to spend a lot of money. A few carefully selected brushes and only those colours which may form the basis of a larger palette, or one of the range of pigments given in the *Limited Palette* section, are sufficient. Five or six colours are adequate. To these may be added those which are required from time to time, but the beginner should not be tempted to purchase colours for which there is no apparent need, just because they appeal. Such colours may remain hardly used. It is, however, a false economy to purchase small tubes of oil colour except in the case of the very expensive pigments such as Vermilion. The tube usually known as 'Studio' with the British size number 14 is for many painters the most economical and convenient. It holds either 37 ml or 38 ml depending upon the manufacturer. White may be bought in the larger number 20 or number 40 tubes holding 56 ml/57 ml and 115 ml/122 ml respectively. For a palette almost any non-porous surface will suffice and suggestions are given later, as they are for inexpensive supports on which to paint.

EASELS

Numerous easels are on the market and range from heavy adjustable ones which are designed to take large canvases to small sketching easels which are useful both indoors and out. These are the cheapest and the type of easel with which most people begin.

STUDIO EASEL

This is a stable construction for permanent use in the studio. It will take large canvases, usually up to 1·5 m (5 ft) in height but is heavy and often has not been designed to fold away. Some have a built in shelf or pigeon-hole.

RADIAL EASEL

A good substitute for the studio easel, this is a most useful type and is found in the studios of many professional painters and in schools of art. It is sturdy and adjustable, allowing the canvas to be tilted both forwards and back. It will also fold away fairly compactly. There is a more complex version of the standard one which will also set up as a table for watercolour painting or holding the canvas in a horizontal position.

SKETCHING EASEL

This is a lightweight folding easel obtainable in numerous forms which take different size canvases and boards. Some will also adjust to the horizontal and have various degrees of incline.

BOX EASEL

A compact box and easel combination which is useful for outdoor sketching and has the advantage of the box forming a table or palette rest.

There are variations on these such as combination studio easel and table or the simple table top or desk easel which is not very suitable for oil painting. Although a sturdy stable easel is advantageous it is not absolutely essential. A canvas can be propped against the wall or the back of a chair if necessary or may be laid flat on the floor. Jackson Pollock did the latter and Bonnard pinned canvas to the wall. Jaime Sabartés tells how Picasso painted in Royan in 1939 '... when he needed an easel he remembered one which he had seen in this shop, and eventually, after I finally persuaded him to give up the habit of using a chair, we went to get it. However, instead of buying an easel which was

3 Studio easel

4 Radial easel

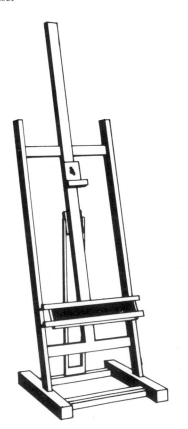

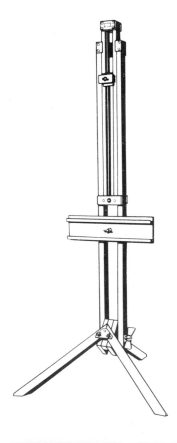

more or less the size he needed, if rather fancy – one which was doubtlessly used to support a family portrait in the corner of some parlour – he took with him a very small one, which was probably intended to hold a photograph and could be used only if one placed it on top of a table or piano. Picasso tied its hind leg to the back of a chair, and thus did not gain the least extra comfort for his work, for he had to continue to paint as before, in a squatting position, his stomach tight against his thighs.'
Picasso, An Intimate Portrait by Jaime Sabartés.

PALETTES

Commercially produced palettes are usually made from wood, mahogany being a favourite choice, although in the past few years white palettes in plastic or melamine faced have been introduced. One of the reasons why the traditional wooden palette was used is that its colour was similar to that of the red bole grounds popular in the sixteenth and seventeenth centuries and so it was possible to see on the palette the colour as it would appear on the canvas. If painting on a white ground it would seem logical to have a white palette but this is obviously not essential as the canvas only remains white for a limited period of time and colours placed upon it as the work progresses are done so in relationship to each other or over the top of other colours.

A wooden palette may be made quite simply from plywood sanded smooth and rubbed with linseed oil to make it less porous. If this is done, not only is it possible to save money but also to get the size and shape of palette most suited to individual needs. It is important that a palette be comfortable to hold for long periods of time and that it is sufficiently large for colour to be mixed without overcrowding. A small palette is seldom much use. Oblong shapes are quite adequate but not always well balanced. Probably the best are the large kidney shaped palettes sometimes called Studio palettes, the

5 Folding sketching easel

6 Box easel

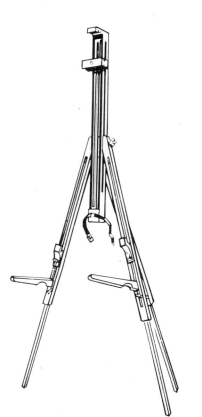

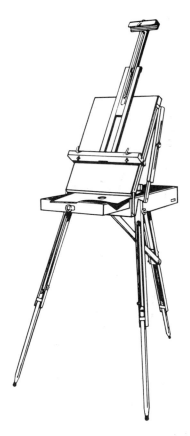

hook shaped ones although associated in the popular imagination with 'artists' are not as comfortable as the larger studio type. An oblong one which fits into the painting box is useful when painting out of doors. It is not necessary to buy an expensive palette or even to make one. Many painters prefer to use a non absorbent surface which they do not hold but have on a table or chair beside them. A piece of glass with a neutral toned paper underneath is very good, as is a metal sheet, an old dinner plate, hardboard or linoleum. There are tear-off paper palettes on the market which save the trouble of cleaning but these are uneconomical and seldom sufficiently large.

Cleaning palettes is essential; not only because of the deterioriation of the surface which will occur if this is not done, but also because a dirty palette will affect subsequent colour mixtures. Anecdote has it that Turner, when teaching at the Royal Academy Schools, would look first, not at the student's painting, but at his palette and on the basis of that inspection make comment about the work in progress. A dirty, ill-kept palette will say a lot about the painter and his work. This does not mean that the palette is always in an immaculate condition, only that the painter is conscious of the arrangement of his colours and the way in which they are organised in relationship to the picture he is painting. By the end of the working session the palette may well be in a messy condition but to begin a day's work with it in a disorderly and even dirty state makes difficulties. Consequently it is necessary to clean the palette *after each working session*. Small portions of colour may be left around the outer rim for use the next day but quantities of mixed pigment smeared across the palette or mounds of half-dried colour

7 Selection of palettes, with palette and painting knives

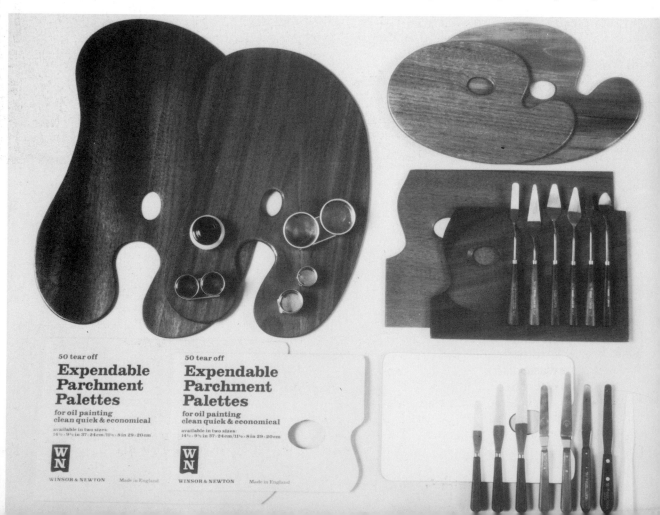

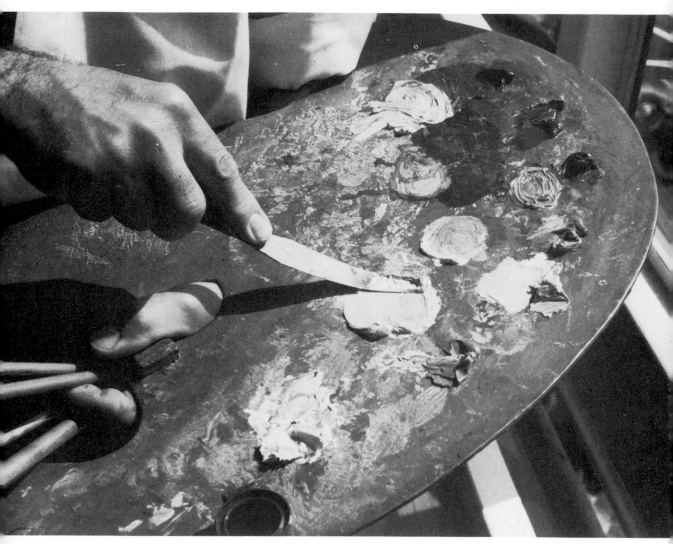

8 Paint being mixed on the palette

should not be left to harden and subsequently mix with fresh paint. The palette should be scraped with a palette knife or spatula, the excess paint wiped onto newspaper or old rag and then the surface wiped with cloth until all traces of pigment are removed. Rag dipped in white spirit should be used and if the palette is made of wood a final wiping over with linseed oil is desirable to both seal and preserve the surface. It is a waste of time, effort and money to leave the palette after each session so that ultimately an application of commercial paint remover or even the use of a blow lamp is required to remove the crusts of hardened pigment.

PALETTE KNIVES

A palette knife is needed for mixing the paint, scraping excess off the canvas and cleaning the palette after use. It should be straight and have a flexible steel blade. The length is a matter of choice but the shorter ones are often easier to manage. Plastic knives although cheaper are not as useful. A palette knife with a cranked shank can double as a painting knife.

PAINTING KNIVES

Painting knives come in a range of sizes and shapes – trowel, pear, diamond – and are suitable only for applying paint to the picture.

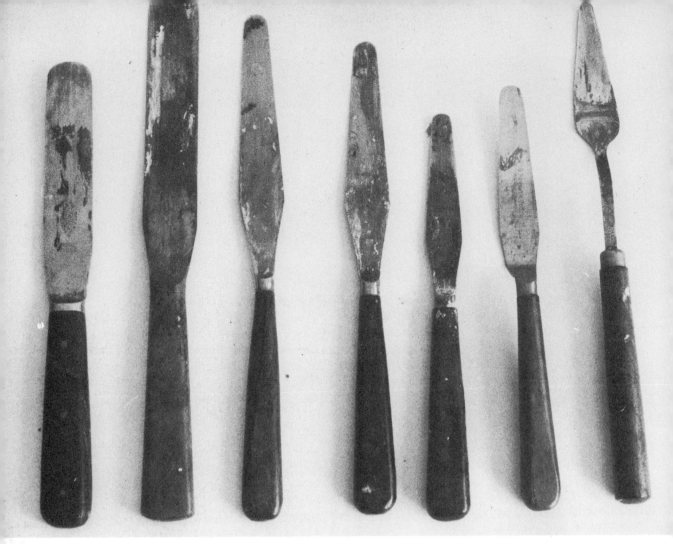

DIPPERS

These are metal containers which clip onto the edge of a palette and hold solvent and medium. There are single and double dippers of different sizes and although of use if holding a palette, especially out of doors, they can easily be replaced by tins or jars. Should a dipper be bought, however, it is best to buy the type with a removable lip as this will allow for thorough cleaning.

MAHL STICK

A mahl stick is used to rest the arm on to steady it when painting fine detail. The conventional mahl stick is bamboo with a chamois covered

9 A selection of spatulas, palette knives and a painting knife

pad at one end; today there are aluminium and rubber sticks available, but it is easy enough to make one from a length of cane or dowel rod and a pad of cloth.

RAGS

A collection of rags should always be available in the studio for general cleaning purposes and for wiping the brush occasionally when painting. Also newspaper for tonking and for wrapping up the scrapings from the palette; sheets from old telephone directories are a useful substitute.

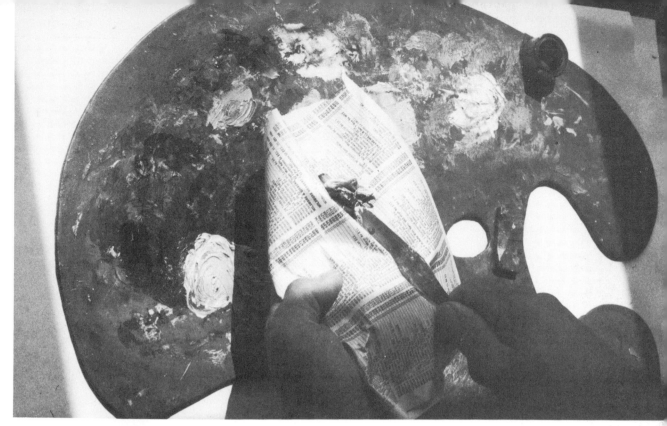

10 Cleaning the palette

a Paint is scraped off the palette with a palette knife and wiped on newspaper or rag

b The palette is wiped with a cloth dipped in turpentine substitute (white spirit)

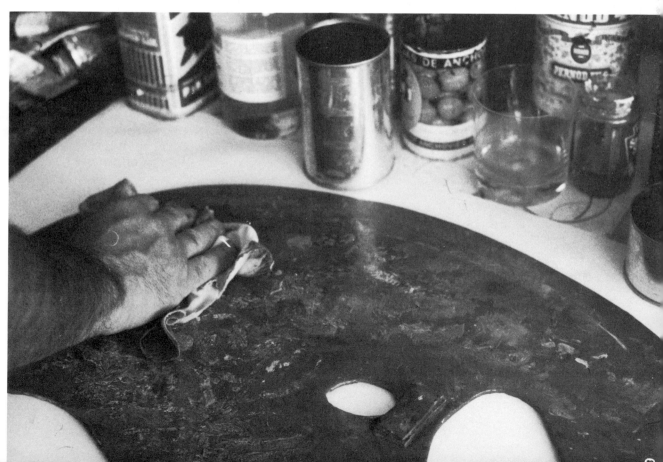

GENERAL STUDIO EQUIPMENT

Other pieces of equipment will be found necessary from time to time in the studio for example:

charcoal	Scotch tape
drawing pins	Stanley knife
hammer	staple gun and staples
house painter's brush	steel rule
masking tape	string
old toothbrush	tacks
pliers	tins and jam jars
razor blades	T-square
scissors	

SUPPORTS

WOOD

Wood panels are one of the oldest supports for transportable oil or easel paintings as they are sometimes called. Hard woods, such as mahogany, have the advantage of being more stable and less likely to warp than soft woods but

11 The maximum amount of paint may be obtained from a tube by pressing it with the edge of a glass bottle and forcing the pigment towards the nozzle

whatever wood is selected it should be well-seasoned and carefully prepared for the application of the paint and protection against moisture. The expansion of wood in dampness and its contraction when drying may adversely affect the painting upon it and panels should be battened or cradled to prevent warping. *Cradling* is the name for screwing reinforcing strips of wood across the grain on the back of a panel in such a manner that warping is avoided but slight movement of the wood is allowed. It is also a good idea to prime both sides of the panel as protection against distortion, and the addition of a coat of paint on the back is advantageous.

The main disadvantage of wood as a support is that large panels are heavy and difficult to transport. Wood's response to moisture and heat is also a problem, as is the present day cost.

HARDBOARD

Hardboard is a popular contemporary substitute for wood panels, it has much to recommend it in that it is strong, except at the corners, and does not decay. If carefully battened around the edges it is sturdy, and larger panels may be cross battened. Most panels, particularly unbattened ones, should be sized on both sides, before priming, to counteract warping. Although the rough side of hardboard has a grain rather like canvas it is not a very satisfactory surface. The regular, mechanical looking 'tooth' is difficult to paint on and tends to dominate the finished picture, the majority of professional painters who use hardboard work on the smooth side.

PLYWOOD

Plywood may warp unless cradled but plywood is a good support with a pleasant surface. It is inadvisable to use a board less than five ply.

CHIPBOARD

Chipboard does not warp as easily as plywood and is sturdier than hardboard, but it is very heavy and has an absorbency which takes a great deal of priming.

CANVAS

Canvas is the support normally associated with oil painting and since the Renaissance has been used by most painters. The popularity of canvas coincided with the advent of oil painting and its growing ascendency over tempera and fresco as the major painting medium. This does not mean that pictures had not been painted on fabric before the middle of the fifteenth century. There is evidence that it was used by the Romans and even, some authorities claim, by the Egyptians, and one has only to consider the countless wallhangings, flags and banners which were painted on cloth of various sorts, to appreciate this fact.

During the fifteenth century, the *Quattrocento*, oil painting began gradually to supplant tempera as the main medium for easel pictures. Tempera needs a firm support if it is not to crack

BRITISH CANVAS of the finest quality, and made of PURE FLAX, is used by WINSOR & NEWTON, Limited, in the production of their Best Artists' Prepared Canvas.

The space afforded by their large Factory, the extensive plant contained therein, and their staff of trained and skilled workmen, enable them to execute all orders with despatch.

The superior method in the preparation adopted by WINSOR & NEWTON, Limited, materially enhances the quality of their Artists' Canvas.—*It is dried slowly and without the aid of artificial means*, thus the adhesion of the surface of preparation to the ground of raw Canvas is so intimate and thorough as to preclude the possibility of its peeling up or becoming detached in any way.

and wood panels had been used for centuries, they were easily obtainable, durable in most conditions, and could be incorporated into both secular and religious furniture and architecture. Furthermore wood could be carved and was an excellent support for gilding, but with the increased use of oil paint artists found that canvas had certain advantages. Light in weight, it could be easily transported and therefore used for large paintings which previously would have had to be painted on heavy wooden panels. This facility to produce large pictures in the studio and then move them either on their stretchers, or by rolling them up, was also a great benefit to painters whose larger works had usually been done on walls and ceilings in the more restricting medium of fresco.

It has not been definitely established whether in fact oil painting and the use of canvas originated in the north of Europe; Vasari claims

that the medium was the discovery of the Flemish painter van Eyck, but it must surely have been a lengthy more evolutionary process which reached a similar stage of development at the same time in many parts of Europe. The claim that the Venetians were the first to use canvas as a support for oil painting, because the damp atmosphere of their city affected wooden panels, is likewise only partly to be believed. Some truth there may be in these stories but they are certainly not the complete reasons.

When canvas is stretched over a frame and given a ground of primer it is a most sympathetic surface on which to paint, the flexibility of the cloth responding to the pressure of the brushstroke and its weave holding the paint. Although not as sturdy as a wood panel and more liable to tearing and denting, it is nonetheless a reasonably robust support. One has only to look at the great masterpieces in the galleries and museums to appreciate this fact. This does not mean that with time a canvas does not deteriorate and, in certain instances, rot thus needing professional restoration, but that for most artists, if not restorers, its benefits outweigh its disadvantages.

Linen canvas The best canvas for the artist is linen made from flax. Its regular and closely woven threads provide a support which may be obtained in a number of different weights and with smooth or rough weaves.

Canvas which has a pronounced grain or 'tooth' as it is called is best suited to paint applied in a broad manner whilst the small 'tooth' of a smoother canvas should be used if the picture is to have much detail.

12 Detail of unfinished painting on cardboard in which the tone and texture of the support show through the loosely brushed pigment

13 **Peter Paul Rubens:** *The Miraculous Draught of Fishes,*
1618–19 (detail), Pencil, pen and oil on paper stuck on
canvas. See also figure 106
National Gallery, London

Cotton canvas is economical, but often its softness and thin consistency make it stretch badly and loosen, although a professionally primed and stretched canvas of good quality cotton is adequate and much cheaper than a linen one. Unbleached calico is also inexpensive, but has the same problems to a greater degree and, whilst it may be acceptable for small experiments by the beginner, it cannot really be recommended.

Linen and cotton mixtures have the disadvantages of both. The two cloths absorb oil and pigment at differing rates and so may distort the weave.

Hessian provides a rough surface on which to paint but it requires a lot of priming and can become brittle with age.

Jute-based cloths are not long lasting and although it is interesting to use all manner of supports as a means of experiment and discovery, serious work should be done on more permanent bases. It may be noted though that some of Gauguin's Tahitian pictures were painted on rough sacking.

The major manufacturers of artists' materials produce ready-primed canvas of differing qualities but this is an expensive way of buying them, and the priming is not always suited to individual needs. Furthermore, with the increasing cost of timber the stretchers of ready stretched canvas are not as free from warp as they once were, but this is also a problem when stretchers are bought separately. Many professional painters prefer to buy unprepared canvas and stretch and prime it themselves. To purchase canvas and stretchers from specialist firms, other than the major colourmen (manufacturers), is often more economical.

A cheaper substitute for canvas is the wooden panel or sheet of cardboard with muslin or cotton stuck on to it with glue size and then primed. It is best to prepare such boards onself. The manufactured boards with canvas-like surfaces are usually unsatisfactory having too regular a tooth and a slimy or glossy priming on which it is difficult and unpleasant to paint.

OIL SKETCHING PAPER
Much the same may be said for this commercially produced primer coated paper with a canvas-like grain which is usually sold in blocks of ten or twelve sheets.

CARDBOARD

A support which is often underrated, cardboard has been used in the past by many artists, for example, Degas, Toulouse Lautrec and Vuillard. Heavy pasteboard should be sized on both sides and preferably battened as it warps easily. Unsized and unprimed cardboard may be used if preferred but this does soak up a large amount of oil and the paint sinks. Fungus and mildew are the main enemies.

ESSEX BOARD

A heavy form of building cardboard, Essex board is a sound support and should be sized and primed for the best results. Cotton or muslin may also be stuck on to it for a rougher surface.

14 Detail of unfinished painting showing pigment thinned with turpentine on brown wrapping paper

PAPER

A better support than is often thought, paper has been used for works in oil paint by many artists, for example Holbein the Younger, Rubens, Rembrandt, Delacroix, Constable, Degas and Cézanne. Usually the paper is stuck to a board for strength and permanence. This is not always done by the artist but by later owners and restorers. Good quality water-colour paper is the best to use, the heavier weight and rough tooth being more suited to oil paint than a flimsier cartridge. Sometimes it might be found advantageous to give the paper a coat of shellac or glue size to counteract its

absorbent character but this is a matter of taste rather than necessity.

'When stuck onto a canvas or a panel with casein, paper offers an excellent support. Roualt has never painted in any other way. The paint must be spread very vigorously in very thin layers diluted in refined mineral spirits, as oil burns the paper.

'In the *Gazette des beaux-Arts* of September 1933, M Van den Bergh, painter and restorer, explains that the marvellous state of Ruben's *Virgin with Cherubim* in the Louvre is the result of its being painted on paper (the traces of backing are apparent in the corners of the picture). Van Dyck's *Charles I* is painted on six widths of paper which overlap each other.'

Treatise on Landscape Painting
Andre Lhote, page 47

METALS
Copper, zinc, iron and aluminium have been used by artists as supports, the Dutch at one time favouring copper for small detailed work; but the expense, weight and dangers of deterioration, particularly through oxidization, makes it little used today.

GLASS
The fragility and slipperiness of glass are definate disadvantages but on occasion the transparency has been exploited, noticeably in some folk art. Paul Klee and Gainsborough used it for small works.

15 Painting on cartridge paper clipped to a board on the easel

18 Marcel Duchamp: *The Bride Stripped Bare by Her Bachelors, Even (The Large Glass),* 1915–23. Oil, lead wire, foil, dust and varnish on glass, 277·5 cm × 175·9 cm Reconstruction by Richard Hamilton *Tate Gallery, London*

STRETCHING A CANVAS

Stretching a canvas is not absolutely essential but it is best to fix the canvas over a wooden frame called a stretcher. If this is not done the canvas will have to be attached in some manner to a rigid surface, such as a board or a wall, which will not have the 'give' to the brush which is so pleasant a feature of painting on canvas.

A stretcher is made from four pieces of seasoned timber and it is essential that the wood be seasoned for, if green, it will warp either from pressure or atmospheric conditions. Each end of the stretcher pieces are cut in such a way as to allow the corners to be slotted together so that the joins may be expanded by the insertion of flat triangular pieces of wood called wedges or keys. The width of the stretcher pieces may vary according to the size of rectangle they make but it should be sufficient to provide a rigid frame which will hold the canvas taut and withstand warp. Obviously the four stretcher pieces used should be the same width. Sometimes for large canvases it is advisable to have a strengthening cross bar. One wide side of each stretcher piece should be bevelled so that the assembled stretcher will slope backwards towards the inside edge and so avoid contact with the canvas except where it comes over the outside edge of the frame. Such a bevel is necessary if the canvas is to avoid being marked by the width of the stretcher behind it which could result in permanent damage to the finished picture.

Care must be taken when assembling the stretcher to make sure that it is absolutely square at the corners. Failure to ensure this will produce a lopsided canvas which is difficult to paint on, unpleasant to look at and almost impossible to frame. A T- or set square should be used or alternatively a piece of string stretched across the diagonal. The assembled stretcher should be placed, bevel edge downwards, onto a piece of canvas which is 50 mm ($1\frac{1}{2}$–2 in.) larger all round so that the edges may be folded over onto the back of the stretcher. The warp and weft, the vertical and horizontal

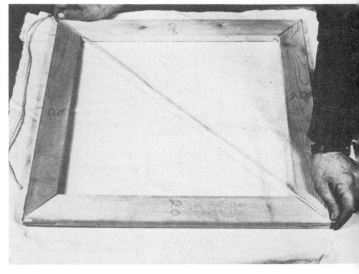

16 Stretching a canvas
a Squaring up the stretcher

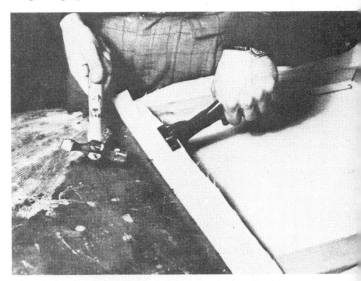

b Pulling canvas tight with canvas pliers

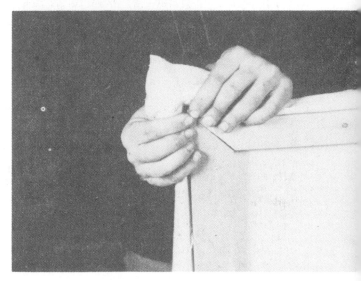

c Folding the corner

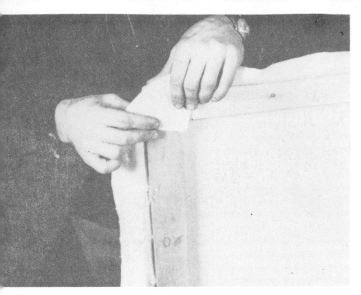

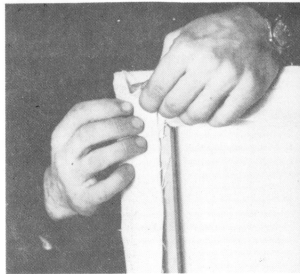

d Folding the corner

e Folding the corner

weave, should be parallel to the sides of the stretcher. Drawing pins, thumbtacks, tacks or staples can be used to pin the canvas to the wood but if tacks are used it is a good idea not to hammer them in completely at first so that they may be removed easily should alterations need to be made. The canvas is attached to the narrow edge of the stretcher beginning in the centre of each side. Next, moving outwards and pulling firmly with the hand or with a pair of canvas pliers, further tacks are driven in opposite to each other. Each of the four sides should progress together and it is best to work from one side to the opposite and to left and right of each centre tack.

The flaps of canvas which are left at the corners are folded over along the stretcher joint and secured neatly with tacks or staples. The overlap of canvas along the back of the stretcher may be fixed down in two or three places. Two wooden wedges are inserted into the slots at each corner so that at a later time they may be tapped in with a hammer should the canvas become loose during painting or storage. It is important not to hammer these wedges in at this stage or they will be useless later on. The tautness of the canvas should be due to the stretching and not to the wedges.

MAROUFLAGE
The disadvantages of canvas as a support for oil painting may be in some measure lessened by

g Tacking the corner

17 Corner of a commercially stretched canvas

24

marouflage which is a method of sticking canvas to a wooden panel. This protects the fabric from deterioration by atmospheric conditions and helps to stop the fibres becoming brittle. An added advantage is that there is less risk of damage when handling. In his *Notes on the Technique of Painting* Hilaire Hiler suggests a mixture of Venice Turpentine and Oil Copal Varnish (commercial) in equal parts, to which White Lead powder is added until a putty is formed. This should be too thick to spread with a brush and is applied with a palette knife to the wooden support. Ready prepared canvas is spread out over this with the primed side uppermost and pressed from the centre outwards to remove air bubbles. Application is somewhat easier if the canvas is larger than the board, and overlapping margins may be trimmed off when the panel is dry.

White lead is extremely poisonous, so a possible alternative is to buy it ready mixed with Oil Copal Varnish or to use Titanium or Zinc Oxide powder.

A sturdy wooden panel is the best to use if warping is to be avoided. Plywood and chipboard are suitable but, should hardboard be used, it will require priming on the reverse side, Ideally it should be marouflaged, but a coat of primer will be, in most cases, sufficient to counteract the tension.

BRUSHES

Brushes made from hog bristle or sable hair are the two main types used for oil painting although nowadays brushes made with nylon are becoming increasingly popular.

Hog hair brushes made from pig's bristle which has been bleached are the commonest type of oil painting brush and the most versatile. The bristle, unlike hair, has a split end which helps to retain a quantity of paint. The four main shapes of hog hair brushes are: Rounds, Flats, Brights and Filberts.

Rounds are used for applying thinned paint to large areas and for painting lines.

SKETCHING STOOLS AND SEATS.

No. 1A. — Nos. 3 and 4. — No. 11. — Nos. 7 and 8. — No. 9. — No. 10. — No. 13.

Flats have long bristles and broad, bold applications of colour can be made with them as can lines and short marks with the sides.

Nos. 1 to 6 Each **8d.**

EQUIPMENT AND MATERIALS

Brights are like flats, but have shorter bristles. *Filbert* shaped brushes are similar to flats, but curve inwards at the end. These are most useful and can produce tapering strokes and dabs of colour.

Sable hair brushes The best are made from the tail hair of the Siberian Kolminsky Sable which is a type of mink and consequently they are expensive.

Rounds are the most common shape but brights are also available. They will apply paint in a smooth layer, will help to fuse brushstrokes (which is not always desirable), and are excellent for detail. Round sables should have a point when moistened and all sables will have a spring which brushes made from other hair, such as squirrel or ringcat, will not have. More economical hair brushes are made from mixtures of sable and ox ear hair and are suitable if of good quality. These blends are also available in larger flat shapes.

Fan blenders in both hog and sable are produced for the purpose of blending colours together and smoothing the surface of the paint.

19 Selecting and grading hair from the tail of a Kolminsky sable

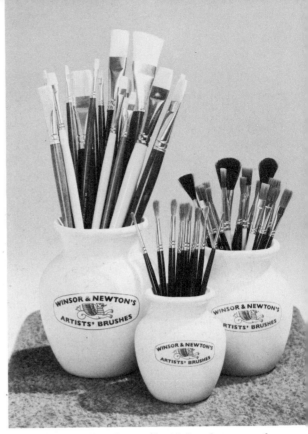

20 Selection of hog hair and sable brushes correctly stored

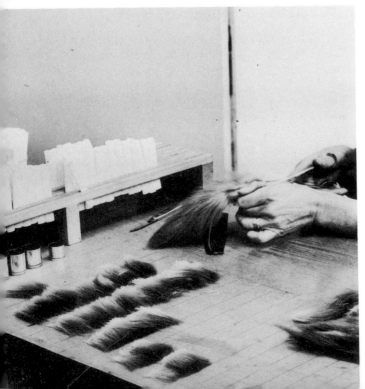

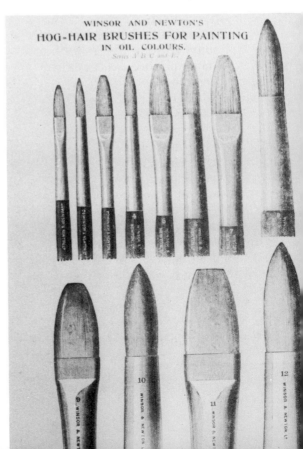

WINSOR AND NEWTON'S
HOG-HAIR BRUSHES FOR PAINTING
IN OIL COLOURS.

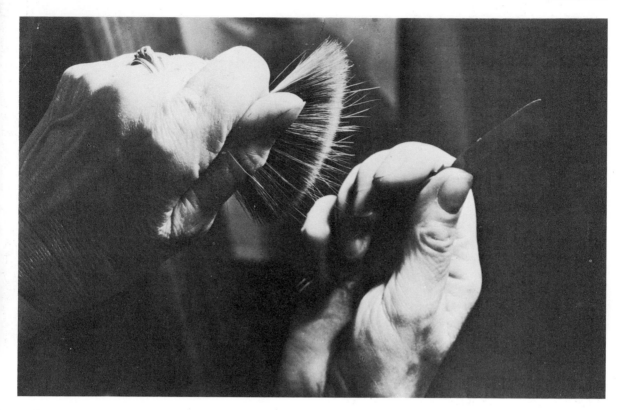

21 Trimming the hair

Nylon brushes come in the same shapes as hog hair and sable and are extremely hard wearing. Their flexibility is somewhere between the hardness of hog and the softness of hair. They are a sound economical substitute and have the advantage that they may also be used for watercolour and gouache painting.

There is a wide selection of brush sizes on the market and it is a matter of personal choice which are used. Hog hair brushes are usually listed in increasing sizes from 1 to 12, sables start very small at 000 and go up to 12 or 14, but a number 14 sable is not the size of a large hog hair.

A variety of types and sizes may be collected over a period of time, but to begin with a limited number is all that is necessary, for example:

Hog hair rounds: 2 No. 8
 2 No. 4

Hog hair flats or filberts: 1 No. 12 2 No. 8
 2 No. 10 1 No. 2

Sable or sable and ox (optional): 1 No. 7.

Even this small selection may be too expensive and it is perfectly possible to start painting with fewer, but it is a mistake to economise by buying only small size brushes, Similarly, it is a false economy to purchase cheap brushes. They will not last and will adversely affect the painting. A few good quality brushes are a more sensible investment than a large number of cheaper ones; they will also prove to be less frustrating.

The shape of a good brush is due to careful selection, grading and arranging of the hair by the brush maker. If made well and looked after by the painter it will not splay at the ends, but retain its form and flexibility. The ends of brushes are shaped by selection and should not be trimmed by the artist.

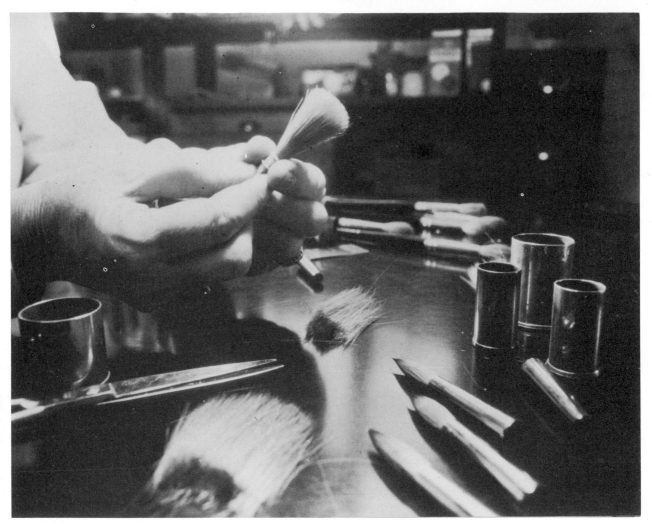

Studio Brush Cleanser, with Steel Clips, Washer and Cleaner, &c., complete.

22 Metal containers and rings are used to obtain the correct amount of hair for each size of brush

CLEANING BRUSHES

All brushes should be thoroughly cleaned at the end of a painting session. They should not be left to dry, however slightly, when holding paint, nor should they stand soaking in a jar of white spirit as the pressure on the hair will distort them. Immediately after use brushes should be washed in white spirit and rubbed on a rag until the paint has been removed. It is a good idea to have two tins or jars containing a little solvent so that when a brush has been washed in one jar and rubbed on a rag, it may then be washed again in the cleaner fluid. Next the brush should be held under the cold water tap and then rubbed softly on a bar of soap. Warm water may be used but never hot. The

bristles need to be rubbed on the palm of the hand so that the lather will cleanse them, after which the brush should be carefully rinsed in clean water and the excess squeezed out. Brushes must be stored with their bristles uppermost in a jar so that nothing is in contact with the hair or bristle. Should they be left so that the paint dries on them they may be cleaned with a commercial brush cleaner, but such a practice will, if repeated too often, cause irreparable damage.

Brushes for priming and varnishing are usually thicker and wider than normal hog hairs; similar to those for house painting and decorating; although it should be stated that those used for varnishing are better if not so dense with bristle. A house painter's brush is admirable for sizing and priming a board or canvas, it holds sufficient paint to allow for good, broad applications of primer to be laid on the surface. For varnishing a specially manu-factured brush, about 50 mm (2 in), but with less bristle than a decorator's brush is re-commended so that the liquid may be applied without danger of flooding the surface of the painting and so causing pools and dribbles of varnish. Alternatively, a broad hog hair paint-ing brush will provide a perfectly adequate substitute, enabling varnish to be brushed in a multi-directional manner across the surface of the painting and into any crevices created by impasto.

23 Different brush shapes and sizes. Hog hair flat, round and filbert to the left of the picture, varnishing brush and sable to the right

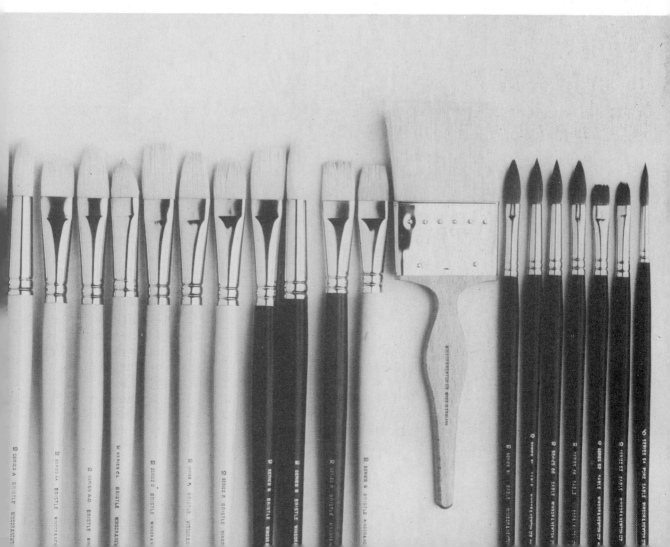

24 Cleaning brushes
a Washing in white spirit. After wiping off the excess pigment the bristles are immersed in white spirit and the handles rolled between the palms of the hands. This removes most of the paint from the brushes. They should then be washed individually in clean white spirit

b The brush is rubbed on a piece of clean cloth

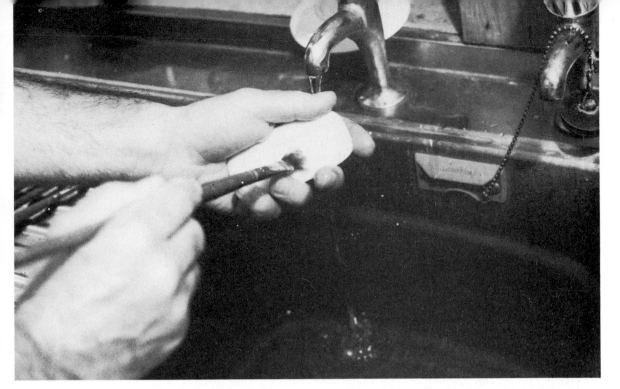

c The bristles are rubbed with soft soap and running
water until all trace of colour has gone

d Finally, the brush is rinsed in clean water
Brushes should be stored with their bristles uppermost so
that their shape is not distorted

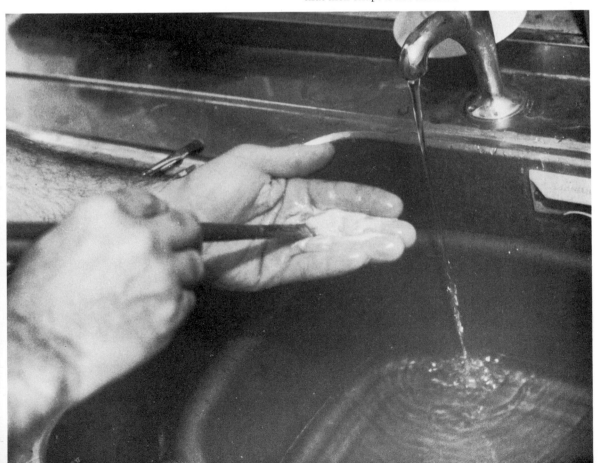

AIRBRUSHES

The airbrush is similar in shape to a fountain pen but has a flexible pipe which connects it to a supply of compressed air. Although there are different types of airbrushes designed for different purposes, the component parts are much the same and the principle identical. Liquid colour is blown from a reservoir attached to the brush through a nozzle the size of which determines the rate at which the colour is expelled. Manufacturers produce airbrushes and nozzles for differing purposes; fine sprays for photo-retouching and delicate gradations of tone, fast coverage of large areas, precise and detailed line work. General purpose airbrushes are available as well as ones to spray types of abrasive which act as erasers of paint and ink, or can be used to etch onto glass. For large-scale work a spray gun is better than an airbrush. The reservoir contains a greater quantity of paint and the nozzle is such that coverage is greater and faster.

The supply of air may be obtained in a number of forms ranging from the small aerosol type can, which is in the long term an extravagant way of buying air, through the medium priced refillable and portable cylinders to the expensive piston or diaphragm compressors which are used in design studios.

Cleaning is essential whenever the airbrush has been used. It should be washed immediately and never left for however short a period or time. Dried pigment will harm the precision made parts of the equipment and may result in not just ruining the next piece of work but in permanent damage.

Few painters in oil colour use airbrushes. The slow drying nature of the medium is a disadvantage with this type of work. Furthermore the quality of most airbrush technique is one which is allied more to those aspects of photo-realism, technical illustration and photo-retouching associated with commercial design studios rather than the painter.

25 Airbrush. An external mix gun in which paint flow can be adjusted by turning the paint tip at the front. Available with heavy duty needle assembly. Shown here with aerosol propellant
Badger 350 – Morris and Ingram (London) Ltd

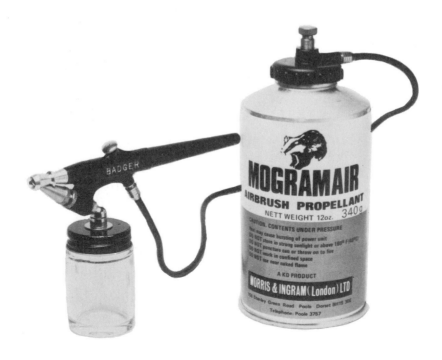

GROUNDS

Some painters paint directly onto raw un-primed canvas preferring the rough texture, colour and absorbency to a sized and primed surface. Francis Bacon is such an artist, but it is customary for a surface to be treated prior to painting. A thin coat of shellac varnish is sufficient for paper should the artist dislike the absorbency but for most other supports something a little more robust is required.

Today the introduction of acrylic grounds has made life much easier for the painter wishing to prepare his own canvas or board. Although their life has been comparatively short such grounds have so far shown no signs of deterioration nor do they appear to have adverse effects on the pigments. It may be that at a later date discoloration or cracking may occur but, so far, acrylic grounds seem to have more advantages than problems. They can be bought from most reputable colourmen and may be applied to canvas or board without prior sizing, two or three coats thinly applied will usually suffice.

Commercial manufacturers also produce primers which are variants on the traditional oil based grounds and need to be applied onto surfaces already treated with a glue size. The prepared canvas supplied by artists' colourmen is an expensive way of buying a support and the surface does not suit everyone.

To paint on a porous surface is to encounter difficulties. The oil from the pigment will be rapidly absorbed so making hard work of the application and in the case of unprimed canvas there will be the added danger of deterioration with the oil attacking the fibres and eventually causing rot. Furthermore it is expensive on both paint and medium. The surface should be sealed if these difficulties are to be avoided and a greater facility of handling and speed of execution allowed. To do this the support should be given a coat of glue size which will provide a seal. Only animal based glues should be used, fish and artificial glues are not recommended. The best glue size is Parchment or Cologne glue

26 Priming canvas on a commercial scale

made from leather waste and sometimes called such, but it is expensive and the cheaper bone glue size, although inferior, is a reasonable substitute. Rabbit skin glue is another name for Cologne glue. Casein glue size may also be used. The powdered size is added to cold water and allowed to soak so that it swells, it is then heated gently until dissolved when it should be brushed onto the support while still warm.

Directions for making the size may vary according to manufacture but a rough guide would be: $1\frac{1}{2}$ oz of rabbit skin glue to 1 quart of water. It is possible to use such a solution to prime paper or card and it is ready to paint on as soon as it is dry. When cardboard or hardboard is sized it should be treated on both sides to counteract any warping. Some of the dark hardboards such as Masonite do not require sizing as they have in their composition a water-resistant binder. It may be found to be advantageous to add a little chalk or whiting to the size in order to lighten the surface but more importantly to provide a rougher surface than the pure size. This is possible when priming a rigid surface but is unsuitable for the priming of canvas where it will crack with the flexibility of the fabric. Chalk grounds, half-chalk and gesso grounds are variations on this simple notion and are used for tempera painting, and sometimes for oil paintings on wooden panels or other rigid supports. Gesso was carried over from tempera to oil painting by the early oil painters but it is not the best ground to use for oil, being too rigid and liable to crack; particularly if applied to canvas the flexibility of which is not compatible with the brittleness of chalk. Such grounds will absorb oil from the pigment and medium and unless a really absorbent ground is desired or an underpainting in egg tempera is intended prior to glazing they are really best avoided.

GESSO GROUND

Used for wood panels and other rigid supports, it is made from an equal measure of warm glue size, zinc white and gypsum or whiting. In this instance the proportion of glue size to water is usually greater: $2\frac{3}{4}$ oz to 1 quart of water. Although one or two thin coats might be sufficient for the maximum luminosity five or even six coats should be applied until no trace of the wood grain remains. Each coat may be smoothed out with a spatula or palette knife following the grain of the wood.

———————

There are numerous variations on the types of chalk and oil grounds which have been used over the years and many paintings have been adversely affected by a bad ground. However good the materials used by the artist in painting a picture there is no substitute for a well primed support and excellent pigment and medium put over a bad ground will not avoid deterioration. For oil painting on canvas some quantity of oil should be contained in the ground so that the canvas is flexible and has a coating which will not absorb too much oil from the pigment. It is essential that thin coats be applied, two probably being sufficient and the quantity of oil contained such that it will bind the ground to the canvas without making a glossy surface. A first thin coat, well brushed into the canvas grain from all directions and leaving no brush marks followed by a second is far better than one thick coat with the possibility of glossy ridges and future cracking. Should a third or even fourth thin coat be necessary this is still the best method of preparation and the time spent will not be wasted.

HALF OIL GROUND

Half oil ground (half chalk, tempera) is an equal measure of glue size mixed with an equal measure of chalk or gypsum and zinc white or white lead. When this is well mixed a third or a half measure of raw or boiled linseed oil is added slowly drop by drop whilst continuing to stir. It is better to mix the linseed oil into a cool chalk ground as heat may lead to separation. Preservation of the mixture is a tedious matter and it is a good idea to use up a half oil ground on the day of making.

OIL GROUND

The oil ground consists of equal parts of glue size, chalk and zinc white or white lead which are mixed. To this is added up to two parts of boiled linseed oil. Stand oil or other linseeds may be used but poppy oil is not recommended, taking as it does up to a year to dry. Too much oil should not be added under the misconception that this will improve the ground. It will not. Instead it will cause considerable harm through yellowing, darkening and cracking. As always, thin coats should be laid over each other when dry so that a firm but supple ground is created. Brushing on the mixture will retain the tooth of the canvas whilst a smoother surface can be created by finishing off with a spatula, scraping away the excess and smoothing the ground across the texture of the weave.

White lead has traditionally been used in the making of oil grounds but its toxic nature and tendency to yellow are distinct disadvantages. Zinc oxide is often used and although a good substitute it dries slowly and is more liable to crack. Titanium white is without these problems, it has good covering power and may be used in their place. A number of manufacturers sell it mixed or in powder form and use it themselves in their ready made primers.

An alternative to making an oil ground is the decorators undercoat which provides a matt surface without too much oil in its composition. Cheaper than a primer supplied by an artists' colourman and less trouble than a home made ground it makes an acceptable substitute. Only reputable brands should be used and even then consideration should be given to the presence of modern additives which are becoming increasingly popular with paint manufacturers.

Oil grounds give the dark colours of the palette their full rich quality whilst the more absorbent half chalk grounds are best suited to lighter more brilliant colours but this is not a strict rule which must be followed. Although oil grounds may yellow in the time between priming and painting the whiteness will return if they are exposed to daylight.

The early painters in oil soon discovered that whilst a chalk ground was excellent for work in tempera, and its smooth white surface gave luminosity to oil paintings particularly on wood panels, there were more advantages to be gained by applying an oil or half oil ground. The liability of gesso to crack when used on canvas was a major problem but it also restricted in some measure the manner of painting. A tempera picture was carefully composed and drawn on the smooth panel and colours applied, often in a flat decorative manner to that drawing. The greater freedom of oil paint with the possibilities of both layers of thin glazes and thicknesses of impasto enabled the painter to work in a looser manner and, should he so wish, alter passages of the work quite radically as it progressed. A pure white and smooth ground was no longer essential and artists began to make half oil and oil primers which they could tint and which with their elasticity were better suited to canvas. The weave of canvas was another attribute exploited by sixteenth century artists. Some of the later paintings of Titian*, for example, were on rough canvas primed with a half oil bound ground and occasionally tinted with pigment. Lighter colours could be brushed onto such a surface in a free manner and glazed when dry, and areas of coloured ground left as parts of the finished picture. Although a dimming of colour might result from the use of tinted grounds they helped to give the work a richness in the darker tones, and an overall harmony. Often a coloured half oil ground was laid over a white gesso ground so that it retained a brilliance which would not have been there had the colour been applied onto a raw or sized canvas. This is still a good practice for painting on a tinted ground, although obviously the white

* The ground of Titian's *Death of Acteon* (National Gallery, London) has been discovered to be gesso and not dark oil as previously thought. The darkness is therefore the result of deterioration and not a tinted ground (*Techniques of the World's Great Painters*, W Januszczak, Phaidon). See also figures 27, 97, and 105.

primer need not be gesso and will be less likely to crack if oil or acrylic based.

Courbet always painted upon a sombre base, on canvases prepared with brown, a convenient procedure, which he endeavoured to have me adopt. 'Upon it,' he used to say, 'you can dispose your lights, your coloured masses; you immediately see your effect.'

Claude Monet

27 Titian: *Death of Acteon, c* 1560. Detail. Oil on canvas, 1·78 m × 1·98 m
National Gallery, London

M Elder: A Giverny chez Claude Monet, Paris 1924, page 52. John Rewald: *History of Impressionism*, New York, 1946, London 1973.

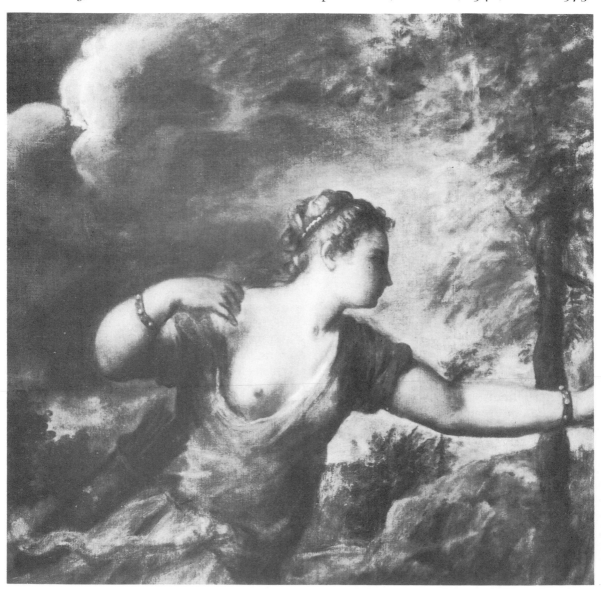

VARIATIONS

HALF OIL GROUND for priming wood panels
(Hayes: Batsford)

Zinc oxide powder 5 parts
Chalk powder ½ part
Size 1 part
Boiled linseed oil 1 part
Water 5 parts

OIL GROUND for priming wood panels not
canvas (Hayes: Batsford)

Zinc oxide powder
White lead powder equal parts
Linseed oil

Zinc oxide 5 or 6 parts
Whiting 1 part
Linseed oil equal parts

OIL GROUND (Hayes: Phaidon)

Turpentine 6 parts
Linseed 1 part
White lead paste mixed with the above to the
consistency of thick cream.

Oil grounds take a long time to dry and
canvas or board primed with such mixtures
should not be painted on for between a month
and six weeks. It is sensible to prepare a number
of supports at one time and keep them in stock.
Thorough drying of a ground will help preserv-
ation and lessen the chances of pigment dis-
colouration. Drying times of primers, like all
such compositions, are dependent upon ingre-
dients, temperature and air flow but the follow-
ing is a guide.

Chalk ground: May be painted on as soon as dry
but leave preferably for several days.
Gesso: May be painted on as soon as dry but
leave preferably for several days.
Commercial emulsion: 2–4 hours between
coats.
Half oil ground: 1 hour between coats. 1 day or
longer.
Oil ground: 1 day between coats. 4–6 weeks.

Winsor and Newton Oil Painting Primer: 24
hours between coats.
Winsor and Newton Foundation White: 3–4
days between coats.
Winsor and Newton Underpainting White: 3–4
days between coats.
Rowney Hardboard Primer: less than 3 hours
between coats, 24–48 hours before painting.
Rowney Cryla Primer: less than 3 hours be-
tween coats, 24–48 hours before painting.

COMMERCIAL EMULSIONS

Emulsions are sometimes used to prime a
support but although they dry quickly, are
tougher than chalk grounds and more absorb-
ent than oil, paintings done on them are not as
durable as those done on an oil ground.
Further, the additions which are sometimes
made to modern emulsion paints makes them
particularly suspect if preservation is to be
considered.

BINDING MEDIA (MEDIUMS)

Oil paint is composed of finely ground pigment
mixed with a binding medium in order for it to
be spread over a surface and to adhere as
permanently as possible. Linseed oil has been
found to be the most successful binding
medium although poppy oil which dries more
slowly and produces a buttery consistency is
sometimes used for the paler colours, as is
safflower oil. Many other oils have of course
been tried in the past. A number of nut oils,
such as walnut, have proved popular and there
is no reason why an artist wishing to grind his
own colours should not experiment with a
number of oils in order to obtain different
consistencies and drying rates; provided that
some research is done into the deficiencies and
attributes.

Binding medium does not evaporate like
water but solidifies when placed in contact with
the air. This process begins with the forming of
a skin and then is followed by the oxidization
of the oil so that the particles of pigment sus-

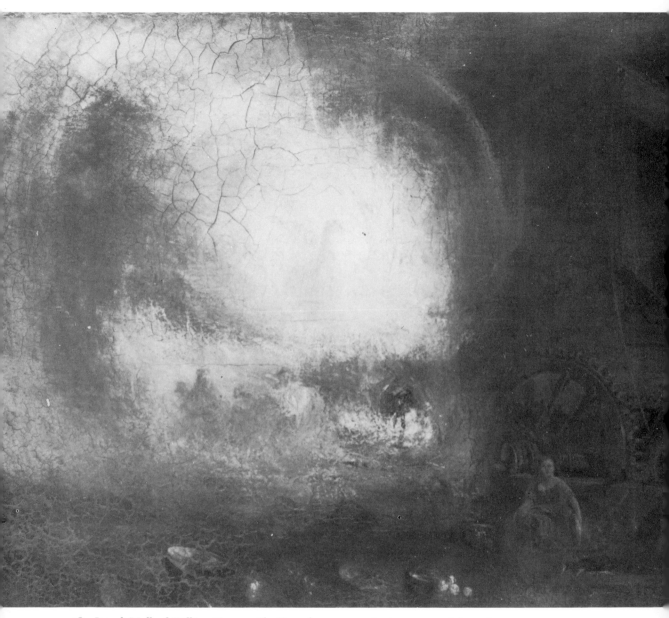

28 **Joseph Mallord William Turner:** *The Hero of a Hundred Fights* (detail) Oil on canvas, 90·5 cm × 121 cm *Tate Gallery, London*

pended in it are held within an elastic solid form which is insoluble. Obviously the rate of drying depends on the type of binding medium used, the painting medium, the thickness of the application, the temperature, air flow and the pigment itself as different pigments affect the drying rate of the oil.

Although the surface of the applied paint may dry in a matter of days it is possible for the whole depth of paint to take up to a year or even longer to dry. This may not be the disadvantage it appears as the film of paint will expand and contract according to the temperature and so be less likely to crack.

Oil paints, although made up by the manu-

facturers so that they have much the same consistency when squeezed out of the tube, are composed of pigments which have differing capacities for oil absorbtion. Some pigments soak up more binder oil than others and this, though not the tremendous problem stated by some authorities, does need consideration. Although many painters do not build up a picture with *carefully considered* layers of pigment as was the case in the past, but tend rather to mix the paint as they progress so that there is a levelling out of oil and pigment particularly in works which are completed at one sitting or painted wet into wet over a short period of time, they should still be aware that if they paint pigments with low oil absorbtion rates over pigments with high oil absorbtion then they are in danger of the top layer cracking. The mixing of pigment with white or other colour will decrease the likelihood of such deterioration, but it is as well to know of such a problem. This of course is much reduced if the first layer, even though it be made with high oil absorbtion pigment, is allowed to dry thoroughly before the application of the next layer. This will naturally take a matter of days.

The high and low percentages of oil in pigments is not necessarily an indication of the drying rate. For instance both Cobalt Blue Deep and Burnt Umber have an oil absorbtion of above 80 per cent and yet the Cobalt Blue dries fast, in about two to three days, whereas the Burnt Umber takes about a week. It will be seen from the following lists that this example applies to the Artists' Quality Oil Colours manufactured by Winsor and Newton. Their Winton colours which are a cheaper, Students' Quality, range have differing oil percentages and drying times. Cobalt Blue and Burnt Umber do not have the same oil absorbtion and their drying times are reversed. Following are lists of oil percentages in Winsor and Newton's Artists' Oil Colours and in their Winton range along with the pigment drying times. This is a guide which the reader should find useful, but it must be realised that it will not apply to all oil colours made by other manufacturers.

OIL PERCENTAGES IN PIGMENT

The following list groups Winsor and Newton's Artist Oil Colours according to percentage oil in the colour (by volume).

Above 80 per cent
Burnt Umber
Cobalt Blue Deep
Geranium Lake
Payne's Gray
Transparent Gold Ochre
Magenta

70–80 per cent
Antwerp Blue
Burnt Sienna
Cadium Green
Chrome Green Light
Chrome Yellow
Cobalt Blue
Crimson Lake
Indian Yellow
Alizarin Crimson
Lamp black
Mauve Blue Shade
Olive Green
Permanent Magenta
Permanent Rose
Raw Sienna
Viridian
Winsor Blue
Winsor Green

65–70 per cent
Aurora Yellow
Brown Madder
Cadmium Orange
Cadmium Red
Cadmium Red Deep
Cadmium Yellow Pale
Cadmium Yellow Deep
Cerulean Blue
Indian Red
Mars Black
Mars Orange
Mars Red

Permanent Green Light
Permanent Green
Prussian Blue
Purple Lake
Purple Madder
Vandyke Brown
Venetian Red
Vermilion
Winsor Orange
Winsor Violet
Winsor White
Zinc White

55–65 per cent
Blue Black
Bright Red
Cadmium Green Pale
Cadmium Lemon
Cadmium Purple
Cadmium Scarlet
Cadmium Yellow
Charcoal Gray
Chrome Lemon
Chrome Orange
Chrome Deep
Cerulean Green
Cobalt Green
Cobalt Green Deep
Cobalt Violet
Yellow Ochre Pale
Zinc Yellow
Davy's Gray
Gold Ochre
Indigo
Ivory Black
Light Red
Mars Yellow
Mauve Red Shade
Oxide of Chromium
Permanent Blue
Prussian Blue
Raw Umber
Rose Dore
Scarlet Lake
Titanium White
Winsor Yellow
Yellow Ochre

45–55 per cent
Cinnabar Green Deep
French Ultramarine
Manganese Blue
Mars Violet
New Blue
Permanent Green Deep
Rose Madder
Sap Green

40–45 per cent
Flake White
Flesh Tint
Jaune Brilliant
Lemon Yellow
Naples Yellow
Terre Verte
Winsor Red

DRYING TIMES FOR WINSOR AND NEWTON'S ARTISTS' OIL COLOURS

Fast drying (2 to 3 days)
Cobalt Blue Deep
Cremnitz White
Flesh Tint
Geranium Lake
Gold Ochre
Mars Brown
Mars Red
Mars Yellow
Olive Green
Permanent Green Light
Permanent Green Deep
Permanent Magenta
Prussian Blue
Prussian Green
Raw Sienna
Raw Umber
Terre Verte
Transparent Gold Ochre
Winsor Blue
Winsor Green
Winsor White
Yellow Ochre Pale
Yellow Ochre
Zinc Yellow

Fairly fast (3 to 5 days)
Aureolin
Blue Black
Burnt Sienna
Cobalt Green
Cobalt Turquoise
Cobalt Violets
Davy's Gray
Flake White
Indigo
Lamp Black
Lemon Yellow
Light Red
Mars Black
Mars Orange
Mars Violet
Mars Violet Dark
Cadmiums
Chromes
Cobalt Blue
Mauves
Oxide of Chromiums
Payne's Gray
Permanent Mauve
Sap Green
Terra Rose
Ultramarine Violet
Vermilion
Viridian
Winsor Violet
Zinc White

Average (5 to 7 days)
Brown Madder
Burnt Umber
Cerulean Blue
French Ultramarine
Indian Yellow
Ivory Black
Magenta
Manganese Blue
New Blue
Permanent Blue
Permanent Rose
Titanium White
Winsor Lemon
Winsor Orange

Winsor Red
Winsor Yellow

**WINTON OIL CONTENT
(percentage by volume)**

35–40 per cent
Cadmium Lemon Azo
Cadmium Red Azo
Cadmium Red Deep Azo
Chrome Green
Chrome Lemon
Chrome Orange
Chrome Yellow
Cobalt Blue
Cobalt Violet
Indian Red
Lemon Yellow
Magenta
Scarlet lake
Vandyke Brown
Vermilion

40–45 per cent
Cadmium Yellow Pale
Cadmium Yellow Azo
Cerulean Blue
Emerald Green
Flake White
Flesh Tint
French Ultramarine
Geranium Lake
Ivory Black
Light Red
Oxide of Chromium
Payne's Gray
Raw Umber
Terre Verte
Naples Yellow
Cadmium Orange Azo

45–55 per cent
Alizarin Crimson
Burnt Sienna
Burnt Umber
Chrome Lemon
Phthalo Blue

Prussian Blue
Raw Sienna
Rose Madder
Sap Green
Titanium White
Zinc White

55–60 per cent
Lamp Black
Viridian
Yellow Ochre

DRYING TIMES FOR 'WINTON' OIL COLOURS

fast drying (2 to 4 days)
Burnt Umber
Geranium Lake
Prussian Blue
Raw Umber
Terre Verte
Emerald Green
Vandyke Brown

4 to 6 days
Burnt Sienna
Cadmium Lemon Azo
Cadmium Orange Azo
Cadmium Red Azo
Cadmium Yellow Pale Azo
Cadmium Yellow Deep Azo
Chrome Green
Chrome Lemon
Cobalt Violet
Indian Red
Ivory Black
Lamp Black
Lemon Yellow
Oxide Chromium
Phthalo Blue
Raw Sienna
Rose Madder
Titanium white

6 to 9 days
Cadmium Red Azo

Cadmium Yellow Azo
Chrome Orange
Chrome Yellow
Cobalt Blue
Flake White
Flesh Tint
French Ultramarine
Magenta
Paynes Gray
Sap Green
Scarlet Lake
Vermilion
Viridian
Zinc White

Slow drying above 9 days
Alizarin Crimson
Cerulean Blue
Crimson Lake
Yellow Ochre

DRYING OILS

LINSEED OIL
This is the most common form of binder and the most popular painting oil. It is produced from the seed of the flax plant by pressing, purifying and bleaching. Although it has a tendency to darken with age this is minimal and has been found to be retarded by exposure to daylight.

COLD PRESSED LINSEED OIL
As the name implies no heat is used in the extraction of the oil from the seed and this with the fact that it is the product of the first pressing makes it the purest form of linseed and therefore the best for using as a painting medium. It is however the most expensive as there is little use for it other than as an artists' material.

SUN BLEACHED LINSEED OIL
A pale fairly fast drying oil which is useful with pale colours.

SUN THICKENED
A thicker version of sun bleached this is said to

improve the flow of the colour. With good transparency and accelerated drying, it produces an enamel-like gloss and was favoured by a number of old masters, notably Rubens.

STAND OIL
Sometimes called *boiled linseed*, this is the product of heating in an air free container. The resulting oil is thick and dries to a durable, enamel-like film. It reduces brush marks and does not yellow as much as other linseed oils.

REFINED LINSEED OIL
A pale pure oil chemically processed which is a good alternative to the more expensive cold pressed linseed. It is popular both as a binder and a painting medium but is a slow dryer.

RAW LINSEED OIL
This is produced from flax which has been steam heated prior to pressing. The result is an increased quantity of oil but of a dark colour which does not make it particularly suitable for use in painting.

SAFFLOWER OIL
A substitute for linseed oil used by some colourmen as a binding medium for their pigments. It is extracted from the seeds of *Carthamus Tinctorius* and *C Oxyacantha* which grow in India, Egypt and East Africa. It is not much in use as a painting medium.

POPPY OIL
Obtained from the pressed seeds of the white opium poppy this is a pale slow drying oil and because of the low acid content does not yellow as much as linseed oil. It is a good binder for light pigments and when used as a painting medium gives the paint a 'buttery' consistency which is attractive in alla prima painting. It is not suitable for use in paintings which are built up with succeeding layers of underpainting and glaze, taking, as it does, so long to dry, but this characteristic makes it eminently suitable for painting wet into wet over a longer period of time than would be possible with linseed oils. It

is believed that some of the French Impressionists favoured the use of poppy oil.

WALNUT OIL
This is not generally used today probably due to cost and the fact that it is possible for it to turn rancid and is therefore unsuitable for use as a binder for tube colours. The early Renaissance painters made much use of it and there are many references in the writing of Vasari, the sixteenth century painter and art historian. It is a pale thin oil with great fluidity, does not turn as yellow as linseed and is a better drier than poppy oil.

All these oils may be used as both binders and painting media. Usually when they are used as a medium they are mixed with a solvent such as turpentine. Most commercially manufactured paints need to be diluted for easy control and application. The common dilutents or solvents are pure turpentine and petroleum spirit. These are most useful to dilute the pigment in the first stages of painting so that thin layers of paint may be placed on the support prior to the later build up of pigment. It is essential not to overdo the use of such a dilutent as this may lessen the binding power of the oil or by fast evaporation cause cracking. There are painters who favour turpentine as a painting medium because of its fluidity, speed of drying and the matt effect produced, but it is sensible to use it only for alla prima or under painting. Used on top coats the solvent character may damage previous layers. More often though an artist will, if not at the first stage, then in the subsequent ones, add a little oil to the turpentine. A good practise is to begin with turpentine and after the first stage use a mixture of turpentine and oil. The exact proportions of such a mixture are a matter of personal taste but 50 per cent of each is a good base and perhaps rising to 40 per cent turpentine with 60 per cent oil. If one is painting in layers then the proportion of oil in the medium should be increased for each successive layer. This is the old and well known practice of

painting 'fat over lean' and is essential if cracking is to be avoided.

All oils should be stored in tightly closed containers, preferably as full as possible so that the air does not affect them. Exposure to air will thicken and dry them and although this is unlikely to happen to the small jars which most people have, larger quantities should be stored carefully away from sunlight and in the cool. The Old Masters used to keep the level of oil high by adding glass balls to the jar whenever they poured out liquid.

Paint as it dries absorbs oxygen and expands, but after it has dried begins to contract. This decreases in speed but goes on for a very long time and is the cause of cracking in oil paintings. As most paintings are built up with a number of layers placed on top of each other care should be taken that the under layers do not contract more than the top layers for if they do their movement will inevitably make the top layers crack. Oil is the cause of contraction, so if more oil is used in the pigment which is applied first, the final top layer will suffer. To avoid this there should be a progression in oil content as the layers of paint are built up on top of each other. It is also advisable to allow each layer to dry.

SOLVENTS

TURPENTINE
Spirit of turpentine or distilled turpentine is a most useful solvent and certainly the most popular. Distilled from the resin of pine trees, it accelerates the drying of the binding and media oils. When evaporated it should leave no residue. Storage should be in tightly stoppered containers kept in a cool dark place. Like oils it should be stored out of the light and air as it either becomes resinous or evaporates.

PETROL
Petroleum spirit is perfectly good as a dilutent evaporating completely. The main disadvantage with it is that unless mixed with oil it

makes the paint dry to a very matt finish. Other problems are its smell and inflamability.

OIL OF SPIKE LAVENDER
A suitable alternative for anyone allergic to turpentine but it is a slower drier.

WHITE SPIRIT
Turpentine substitute or White Spirit as it is sometimes called is impure and should not be used for painting. It is, however, excellent as a cleaning fluid for brushes and palette.

PAINTING MEDIA (MEDIUMS)

The most common painting medium is probably a mixture of linseed oil and distilled turpentine made by the artist in the proportions needed at the time. Similarly other oils, such as poppy, can be diluted with turpentine, and some artists add proportions of varnish which helps drying and enhances brilliance. These should be used with care though as there are very real dangers of yellowing and cracking when varnishes are added to a medium. They do however give diluted paint more body than when it is just thinned with oil and turpentine and so aid the application of glazes.

STAND OIL MEDIUM
A variation on refined linseed and turpentine can be produced by mixing one part stand oil and one part turpentine. The more resinous Venice turpentine is suitable for this and is good for brilliant glazes.

COPAL VARNISH AND OIL MEDIUM
This is a simple medium to make requiring one part Copal Varnish, one part linseed oil and one part distilled turpentine. It aids the flow of the paint, accelerates drying and produces a rich glossy effect. On drying it is very hard and may become brittle with time. It will crack if there is movement in the underpainting and it has a tendency to darken.

VENICE TURPENTINE

A resinous, non-yellowing balsam obtained from the larch tree, Venice turpentine aids the fusion of brushstrokes and helps to give oil paint an enamel-like surface. Rubens employed it as a medium mixed with thickened linseed or walnut oil and Max Doerner informs us that:

... Van Dyck used it as an intermediate varnish in portraits dissolved in the proportion of 1:1 in oil of turpentine in a water bath. He painted into the very thin film of Venice Turpentine, because through its

enamel-like flowing the hard edges caused by re-touching and over-painting could be avoided, and the work aquired the desired soft, blended effect (oil of turpentine is added until the desired degree of fluidity is obtained).

Excessive use may retard the drying of certain colours and can produce an over glossy finish.

29 **Anthony Van Dyke:** *Cornelius Van Der Geest.* Oil on wood, 375 cm × 32 cm
National Gallery, London

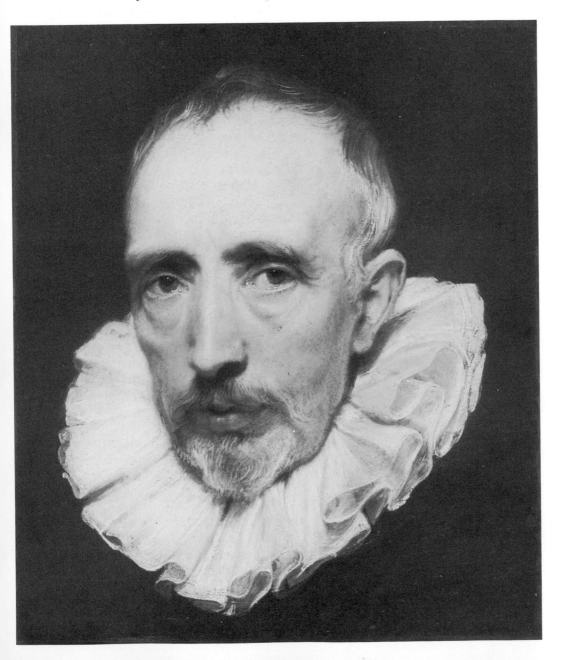

DAMAR VARNISH MEDIUM

There are numerous recipes for varnish media and they are largely a matter of personal choice. It should be remembered though that the minimum amount of varnish should be used in all cases if darkening and cracking are to be avoided. One part damar varnish, two parts linseed oil thinned with turpentine makes a good medium for glazing and adds to the brilliance of the colours. A more complicated version is four parts damar varnish, four parts refined linseed oil, two parts stand oil and one part Venice turpentine.

COMMERCIAL PAINTING MEDIA

The trade produces many variations, some contain varnish and some lead to aid drying. It is wise to use only those media of which the components are known.

Rowney's No. 700 Painting Media A mixture of stand oil, white spirit and oil of spike lavender which the manufacturers claim does not yellow with age.

Winsor and Newton Oil Vehicle No. 1 A commercial varient of oil and turpentine made with sun thickened linseed oil and turpentine which accelerates the drying time.

Winsor and Newton Oil Painting Vehicle No. 2A A mixture of sun-thickened poppy oil and turpentine which is made especially for use with pale colours as it does not yellow as much as linseed.

Winton Painting Medium A blend of stand oil and distilled petroleum which is claimed to reduce cracking and increase the flow of colour. A slow drier.

Megilp A gelatinised medium in the form of a fast-drying jelly, it is made from linseed oil, lead driers, gum mastic and turpentine and gives a 'buttery' consistency to the paint.

Rowney Gel Medium A mixture of synthetic resin and stand oil medium which halves drying time.

Winsor and Newton also produce Alkyd resin based oil media which are for use with traditional oil paint as well as the more recent Alkyd Colours. These are claimed to reduce or even eliminate yellowing, darkening and cracking. They are quick drying taking a matter of hours rather than days.

Liquin is used for thinning and glazing, and giving increased gloss.

Win-gel is similar to *Megilp* in that it is a general purpose jelly suitable for glazes, detail and moderate impasto.

Oleopasto is another jelly used for impasto work and knife painting. It is a form of paint extender.

Neither *Win-gel* nor *Oleopasto* should be mixed with a brush as they make the bristles clog which seems to be quite a disadvantage. This also happens if they are brushed around on the canvas.

BEESWAX MEDIUM

If one part beeswax in melted in three parts of warmed turpentine the resulting mixture will produce a matt finish to oil paint.

BEESWAX AND OIL MEDIUM

A thick mixture of linseed oil and beeswax which gives flexibility of handling both impasto and glazes but darkens the colour.

OPAL MEDIUM

The addition of beeswax to stand oil and turpentine slows drying and produces a matt finish.

DRIERS

Special driers or siccatives, manufactured to accelerate the drying time of pigment, are best

avoided. Even when used sparingly by the experienced painter there is the danger that the lead or manganese compound will darken the colour and, because of their continued working long after the surface is dry, they will make the paint brittle and liable to cracking. The American teacher and Art Historian, Erle Loran states in his book *Cézanne's Compositions* that the cracking which has appeared in one of the later versions of Mont Sainte-Victoire is probably due to the use of *siccatif de Harlem*, mention of which may be found in one of Cézanne's letters. Although in the past this dryer has been considered safer than others, particularly *siccatif de Courtrai* with its excessive lead and manganese content, it is still dangerous. Nowadays, commercial manufacturers produce their own brands of driers and although they may be much better than those of the past, their lead or cobalt content makes the paint darken with age.

VARNISHES AND VARNISHING

Varnishes are made by dissolving resin in either a spirit, for example turpentine, or an oil. Spirit based varnishes are made from soft resins such as mastic and oil varnishes from hard resins like copal. Both types may be used for varnishing a finished picture or as part of the painting medium, but in both cases care should be taken as ill considered use will result in either darkening or cracking of the pigment.

The varnishing of oil paintings is not essential as is sometimes thought. Many painters consider the gloss of a varnish unsuitable to their work preferring the matt effect of paint diluted with turpentine. Others find that the medium with which they paint provides the effect they desire and in most cases this will prove to be sufficient. However, in certain instances when an excessive amount of paint has 'sunk' it may be desirable to give life back to the colour with a coat of varnish. If this is the case it is probably best to use one of the modern commercial varnishes such as Winsor and Newton's *Griffin Picture Varnish* or Rowney's *No. 8000 Artist's Clear Picture Varnish*. Such varnishes are in the main better than the more traditional Copal or Mastic which have a tendency to darken and become brittle. Wax varnishes which dry to a matt finish and may be polished slightly with brush or cloth are also available for use where a high gloss is not required. The application of a coat of varnish to a painting forms a protective layer and can enhance the brilliance of the colour, but often it has the disadvantage of yellowing and cracking. If a picture is hung or stored in normal atmospheric conditions without undue heat or damp, and if care has been taken in the preparation of the oils and pigments used, there will in all probability be no need for it to be varnished and risk the darkening or cracking which might occur. Should it be considered necessary a picture must be varnished only when it is completely dry which will be after six and preferably twelve months. A light temporary varnish may be applied for protection after only a month or two but it is advisable to wait longer before using a harder more permanent one. Some of the matt and temporary varnishes manufactured by the trade are intermixable and thus different finishes may be obtained. These should not be used as part of a painting medium as being soluble in turpentine they will make the paint less permanent.

When varnish is used as a protective coating, as opposed to a painting medium, it should be applied with a wide brush in smooth even strokes with the picture slightly tilted. There is no reason for the brushstrokes to be all in the same direction, but care should be taken not to lay on too thick a coat and so run the risk of trickles and drips.

MASTIC
A mixture of mastic resin and turpentine which gives a high gloss, but becomes brittle and yellows. It has a tendency to bloom and so should be applied in a dry atmosphere.

DOUBLE MASTIC

A traditional yellow varnish giving a high gloss finish, but darkening with time.

DAMMAR

A spirit varnish made with the resin of the dammar fir dissolved in turpentine. It is useful not only as a varnish but as an additive to an oil and turpentine medium as it enhances the colour with the minimum amount of gloss. It also has the advantage of neither yellowing nor blooming.

COPAL

A hard resin mixed with oil and turpentine and although a traditional picture varnish turns yellow due to the inclusion of the oil. If there is any movement in the under layers of paint the varnish will crack. Once used because it gave a hard glossy shine or, as part of a medium it smoothed out the paint, copal varnish is no longer popular.

The drying time of varnish is reliant upon atmospheric conditions as well as upon its composition. Some of the modern temporary varnishes dry extremely quickly whilst the more traditional resins may take days.

A GUIDE TO THE DRYING TIMES OF OILS AND VARNISHES

Obviously actual drying time will depend on the mixtures used.

Boiled Linseed oil	6 to 24 hours
Linseed oil	3 to 4 days
Stand oil	5 to 8 days
Poppy oil	5 to 6 days
Nut oil	4 to 5 days
Mastic varnish	1 to 2 days
Dammar varnish	1 to 2 days
Copal varnish	24 to 36 hours

It is advisable to use the minimum amount of media but the consistency of commercially manufactured paints is such that some medium is necessary.

Too much oil and particularly varnish can cause darkening and cracking so great care should be taken both in the mixtures and the amounts used.

PIGMENTS

Pigments are the coloured substances from which paints are made, whether they be oil, acrylic, watercolour or gouache. A pigment does not dissolve in liquid but, when finely ground, is suspended in a solution which helps it to adhere to the surface onto which it is placed. In water-based paints the addition of gum, or more commonly nowadays a plastic, holds the pigment together; allowing it to stay on the surface without reverting to powder when the water evaporates. In oil paint the pigment is dispersed in oil. Usually this is linseed, occasionally walnut or in the case of the paler colours, poppy or safflower oil. Such oils do not evaporate like water but reacting to the oxygen in the air, slowly alter their form, turning into a clear solid called linoxyn. This binds the particles of pigment together and sticks them to the surface onto which they are applied. Furthermore it allows the pigment to be spread across the surface in a film which gives the maximum richness to the colour. Only when the pigment and binder are mixed together in a liquid form are they soluble. When dry they are insoluble and may not be returned to their original state.

Oil paints are usually manufactured by colourmen in two grades the purer 'Artists' Quality' and the more economical 'Students' Quality'. Sometimes the latter grade is given a trade name. In the United Kingdom for example Rowney produce the 'Georgian' range and Winsor and Newton their 'Winton'. These ranges do not offer expensive colours such as Vermillion but make use of modern organic pigments and dyes. They do however include the traditional less costly pigments such as the

30 Gamboge chipping

earth colours but do not provide as wide a selection in an attempt to keep to an economical and where possible uniform price. The difference is a matter of quality reflected in the price but this does not mean that the cheaper colours should not be used. A selection from both ranges will be found to be satisfactory in terms of both quality and cost.

'Artists' Quality' colours are made from pure pigment and the price of an individual colour is largely dependent upon the expense of the raw materials used. An earth colour such as Yellow Ochre or Terre Verte will be much cheaper than a Cadmium Yellow or a Vermilion. In the case of 'Students' Quality' paint however the price will not vary as much. The manufacturer, trying to produce an economical selction of colours may market an earth colour only slightly inferior to its counterpart in the Artists' range, but he will replace the more expensive pigments with cheaper substitutes which he

will name 'hues' or 'tints' to differentiate between them and the more genuine Artists' colours. For example, an Artist's Quality Cadmium Yellow may be made from Cadmium Sulphide but its Students' Quality equivalent will probably be composed of cheaper Arylamide Yellow. In some instances the substitute will be less permanent but this is not always so. Such variations on the pure colours will allow the manufacturer to maintain a level price range for one type of paint. It should be stated that the Students' Quality paints although acceptable in general terms are often lacking in strength and obviously will not have the finer qualities of the Artists' range.

Earth pigments, as their name implies, are found in nature and have been used in painting since the earliest times. Cave paintings are a mixture of earth pigment, chalk, charred wood

49

and bone. It is sometimes assumed that earth pigments, being natural, are better than chemical ones but this is not necessarily the case. Earth pigments have a high degree of permanence but being natural also contain varying degrees of impurity whilst chemical pigments can be produced if not with complete purity then a degree of purity which is consistent.

It is up to the artist who grinds his own colours as well as the manufacturer to ensure that the impurities are washed out of the earth pigments so that the applied colour will not alter and a standard quality may be maintained. Nowadays this standard quality may be achieved more easily by producing the earth colours artificially and this is sometimes done.

Earth pigments are composed of clay with the colour element being iron or manganese. They are: Yellow Ochre, Raw Sienna, Burnt Sienna, Raw Umber, Burnt Umber, Light Red, Indian Red, Venetian red and Terre Verte. Some of these colours as will be seen under their separate headings are derived from another, eg. Light Red is made by *calcining* Yellow Ochre (Winsor and Newton).

In addition to the chemically produced pigments like Viridian and Cobalt Blue, some colours are extracted from raw materials, for example madder root, in the form of dyes. These dyes must be made into pigment so that they will disperse in the binder oil and not simply act as a stain, consequently they are mixed with a substrate such as alumina so that when dry it may be ground.

WHITE PIGMENTS

Flake White Lead Carbonate (White Lead). This has a very good covering power which is the reason for its popularity with today's artists as well as with the Old Masters. It makes excellent impasto, is reasonably fast-drying and resists cracking, but it can yellow. The main disadvantage is that it is poisonous. Some authorities claim that Flake White is incompatible with certain colours eg Rose Madder,

Vermilion, Ultramarine. Scarlet Lake, if mixed with it will fade. Professor Max Doerner in his famous book *The Materials of the Artist and their use in Painting* states that mixtures of Flake White and Vermilion turned black in his experiments which was not the case in earlier times but that he found no bad effect when it was mixed with Ultramarine. The British colour manufacturers Winsor and Newton and George Rowney state that laboratory tests have shown that their Flake Whites do not have an adverse effect upon Vermilion, Rose Madder, Ultramarine or the Cadmiums. The best quality Flake White is called Cremnitz White so called according to Doerner because it was made originally at Kremnitz in Czechoslovakia although Harley in the Winsor and Newton *Colour Review*, Spring 1979, states that it was first manufactured in the nineteenth century at Krems in Austria and has no connection with Cremnitz in Hungary.

Zinc White Zinc Oxide. This was first introduced in 1840. It is a cooler white than Flake, has less covering power and tends to crack. However it is almost non-poisonous, slow-drying and does not yellow. Although lacking the opacity of Flake and Titanium White its clarity and permanence make it ideal for mixing with other colours.

Titanium White Titanium Dioxide, sometimes with additions of Zinc Oxide. This is a modern pigment which many artists use instead of the more traditional Flake White. It is extremely opaque, permanent, resists cracking and is the whitest of the pigments available. Compatible with other colours, it has the advantages of Flake White without that pigment's problems.

YELLOW PIGMENTS

Lemon Yellow Barium Chromate, Arylamide Yellow. A normally transparent, permanent colour which may lose a little of its strength if mixed with white or applied in a thin glaze. It is

31 A triple-roll mill at the Winsor and Newton factory
used for the grinding of oil colour pigment

a pale yellow with a hint of green making it a little cool.

Chrome Yellow Lead Chromate. An opaque, intense colour which has a good covering power but is not permanent and is poisonous. It is often supplied in different tones eg Chrome Yellow Light, Chrome Yellow Deep. The lighter tones particularly do not stand up to exposure to light.

'I know of one case where the change in chrome yellow became an artistic advantage, and this was in the sunflower paintings of Van Gogh. His yellows were originally much harder and light and not so mysterious as they are today.' DOERNER page 63

Cadmium Yellow Cadmium Sulphide. A normally permanent non-poisonous colour which is usually supplied in different tones, the lighter tones tend to fade. Cadmium lemon has less covering power than the pale, medium and deep tones of cadmium yellow.

Aureolin Potassium Cobaltinitrite. Transparent, sometimes called Cobalt Yellow, this is a mineral colour. It is only moderately permanent and although it has more covering power than Indian Yellow it has on occasion been sold under that name.

Indian Yellow Pure Indian Yellow is magnesium euxanthate which, is an organic lake made from the urine of mango leaf fed cows.

Almost unobtainable in its original form, it can be found today made from substitutes such as Tartrazine Lake. It is a brilliant transparent gold which is difficult to obtain with any other colour. Unfortunately substitute pigments fade or discolour and it is thought that the strange green-blue foliage in some sixteenth and seventeenth century paintings may be due to the discolouring of glazes made from yellow plant lakes.

Naples Yellow Lead Antimoniate. Originally a lead pigment but is now produced by the trade in various mixtures of white and cadmium

pigments and graded accordingly (light, medium, deep 1.2.3.), usually the composition is made with Flake White and is therefore as poisonous as the original. It is a permanent and very opaque colour which is extremely popular although easy to mix on the palette.

Yellow Ochre Natural earth (Ferric Hydrate) containing Iron Oxides. A permanent colour which is basic to most artist's palettes. There are both opaque and transparent yellow ochres the latter often being called Transparent Gold Ochre. Its composition is roughly the same. Other varieties are available with slight colour differences, for example, Golden Ochre, Brown Ochre, Oxford Ochre and Roman Ochre.

Mars Yellow An Oxide of Iron. A permanent pigment which contains less clay than yellow ochre and is more transparent.

Raw Sienna A transparent ochre with considerable luminosity but has the disadvantage of needing a large amount of oil which consequently makes the colour darken.

RED PIGMENTS

Cadmium Cadmium Selenide with Cadmium Sulphide. A strong, opaque red with a good degree of permanence, it is usually supplied in a range from Cadmium Red Deep through Cadmium Scarlet (Cadmium Sulphoselenide sometimes used as the basis for all the cadmium reds) to Cadmium Orange.

Vermilion Mercuric Sulphide. A brilliant red often used by the Old Masters, it is opaque but not permanent. Spots of black occur when exposed to sunlight and it is for this reason that the Old Masters glazed Madder Lake over vermilion. It was protection as well as enhancement. The vermilion panels of the Pompeii wall paintings were covered with wax in order to stop this blackening. Today Vermilion has become something of a luxury as it is very expensive.

Rose Madder Anthraquinone Lake, Quinacridone. Originally made from the root of the madder plant this transparent colour is a bluish crimson which although extremely beautiful has the disadvantage of being fugitive when used thinly. It is best as a tint for other colours. Most manufacturers now use blends of Alizarin Crimson (1:2 Dihydroxy Anthraquinone) which they claim is more permanent than the original.

Alizarin Crimson Anthraquinone Lake. Good quality products of this colour are permanent but there is the slight danger of fading and cracking if the paint is used too thinly. A more economical crimson than Rose Madder it is somewhat cruder but is useful having a strong colouring strength. It should be used with care as the intensity of its stain may overpower the palette/painting.

Light Red An Oxide of Iron. A yellowish brown red obtained from heated Yellow Ochre. It is permanent opaque and has good covering power.

Venetian Red An Oxide of Iron. Obtained from Yellow Ochre heated more than for Light Red. In colour it is between Light Red and Indian Red and is as permanent, opaque and with as good covering power as those two colours.

Indian Red An Oxide of Iron. Another red from heated Yellow Ochre with a blue, purplish tinge. It is permanent, opaque with good covering power.

VIOLET PIGMENTS

Cobalt Violet Cobalt phosphates or Arsenates. Light Cobalt Violet is made from oxide arsenate and is highly poisonous and subject to darkening when mixed with oil. The darker Cobalt Violet made from Cobalt Phosphate is permanent and therefore more common.

Mineral Violet Manganese Phosphate. This may sometimes be purchased in red and blue shades. It is a very stable colour and is on occasion marketed under the name Permanent Violet.

BLUE PIGMENTS

Cobalt Blue Cobalt Oxide and Aluminium Oxide/Cobalt Aluminate. A transparent permanent blue without strong tinting power. It has a clarity even when applied thickly which is not present in imitative mixtures.

Cerulean or Coeruleum Cobalt Stanate. A light greenish-blue, dense in composition and very opaque. It is permanent.

Ultramarine Compound of Silica, Alumina, Sulphur and Soda, sometimes called French Ultramarine. Originally this was made from ground Lapis Lazuli but nowadays it is manufactured artificially although the original may be obtained in highly priced small quantities from certain colourmen. Obviously it has always been an expensive colour and in the past a patron could display his wealth by the amount of ultramarine he instructed the artist to put into the painting*. The colour is a brilliant slightly red blue which is semi-transparent and permanent except when it comes in contact with a weak acid such as vinegar. Variations are produced by the trade

* In fifteenth century Italy finely ground Lapis Lazuli from the Levant had a series of soakings in water so that ultramarines of varying strengths were produced for purchase at different prices.

 '... and he must colour the panel at his own expense with good colours and with powdered gold on such ornament as demand it, with any other expense incurred on the same panel, and the blue must be ultramarine of the value of about four florins the ounce ...' from *Contract for the 'Adoration of the Magi'* (1488), Spedale degli Innocenti, Florence, between the painter Domenico Ghirlandaio and the Prior of the Ospedale degli Innocenti at Florence.

32 Oil colour coming through a triple-roll mill

under such names as, French Blue, Permanent Blue, New Blue.

Monastral/Monestial Blue Copper Phthalocyanine. A transparent blue manufactured from dye introduced by the British Dyestuff Corporation in 1935. It is a powerful greenish blue which becomes opaque when mixed with white and is almost completely permanent. Similar to Prussian Blue it is not so cold and green nor does it have that colour's disadvantages.

Prussian Blue Iron Ferrocyanide/Potassium Ferric-ferrocyanide. An extremely powerful colour with a strong greenish-blue stain. Transparent, it makes opaque blues of great intensity but it should be used with caution as it has the propensity to make a picture look heavy and dark and can easily take over the other colours on the palette. It is only moderately permanent. Variations are available with such names as Paris Blue, Berlin Blue and Antwerp Blue.

GREEN PIGMENTS

Viridian A Hydrated Oxide of Chromium. A permanent, transparent colour of brilliant hue it is considered by some the only necessary green. Although a cold colour it produces warm greens when mixed with lemon or cadmium yellow. Deeper greens may be obtained when mixed with Prussian Blue and with Cobalt Green the blue aspect of that pigment may be modified.

Oxide of Chromium Sometimes called Opaque Oxide of Chromium, this is an earthy green extremely dense with great covering power and permanence.

Emerald Copper Arsenate. It is highly poisonous in its genuine form. A brilliant green which is reasonably permanent in light, it has the added disadvantage of turning black when mixed with cadmium yellow or vermilion.

There are on the market today substitute emeralds which are non-poisonous made from mixtures of Cadmium Sulphide and Halogenated Copper Pthalocynanine.

Cobalt Green Cobalt and Zinc Oxides. An opaque, permanent blue-green pigment which is weak in tinting strength and somewhat gritty in composition.

Cadmium Green A mixture of viridian and cadmium yellow which may be made perfectly well by the artist. Normally permanent.

Chrome Greens A mixture of Chrome Yellow and Prussian Blue which are generally permanent. They are sometimes sold in varying tones of hues of light middle and deep but it is quite possible for them to be mixed on the palette.

Terre Vertes A Natural Earth. A semitransparent earth green which is completely permanent. Although weak in covering power it is useful for preliminary drawing and was in fact the colour used by the Old Masters as underpainting for tempera and in some cases oil painting.

BROWN PIGMENTS

Burnt Sienna Calcined Raw Sienna. A permanent transparent red-brown pigment which has like Raw Sienna the disadvantage of requiring a good deal of oil.

Raw Umber A Natural Earth containing Iron and Manganese. A permanent fast drying dark brown which in the past has been used for underpainting.

Burnt Umber Calcined Raw Umber. A permanent, opaque warm brown.

BLACK PIGMENTS

Ivory Black Bone Black (charred bone). A permanent, opaque black which is the commonest in use.

Lamp Black Hydrocarbon Black. A permanent, opaque but slow-drying colour slightly warmer but without the depth of Ivory Black.

Oil colours may be transparent, semi-transparent or opaque. They are intermixable and in fact it is necessary to use a selection if a full range of colour is to be employed. Transparent colours may be glazed over a light toned area and can of course be mixed with semi-transparent and opaque pigment, thus extending the range. The true quality of transparent colours is best seen when they are glazed over a white or light ground or underpainting, laid over dark colours they lose not only their brilliance but something of their colour quality as well. Delicate tints may be produced by mixing transparent colours such as Alizarin Crimson or Cobalt Blue with white and deeper tints with the stronger Viridian Green or Prussian Blue.

The covering power of some transparent colours, such as the last two mentioned, may be great but this does not mean that they have the obliterating power of opaque colours. Other transparent colours, for example Cobalt Green and Rose Madder are exceedingly thin and weak in covering power. Likewise when mixed with white they stain that pigment only slightly, producing delicate tints whereas other colours, although transparent, have a greater staining power and produce strong, opaque tones when mixed with white.

Opaque colours reflect the light and obscure the ground whilst transparent colours allow the light of the ground to glow through. Applied thickly they loose this quality becoming dark and treacly. Mixed with white or other pigments they become opaque and their colour is altered in a manner which effectively extends the palette.

The permanence of pigments is relative to many factors. As may be supposed, different manufacturers submit their products to different types of tests and allocate them gradings which whilst consistent with their own goods may be dissimilar to those produced by other colourmen. This fact along with the usual elements affecting permanence; composition, temperature, atmospheric conditions such as humidity and chemical compound when combined with the condition of the support, the type of ground, the thickness of pigment applied and the medium used, make it difficult to provide an absolutely correct evaluation of the permanent qualities of oil colours. However it is possible to give an indication of the degrees of permanence which if not completely accurate in all cases may serve as some help.

Colours which are not permanent either because they change when exposed to light or alter radically when mixed with other pigments are known as fugitive colours. There are few of these perhaps the most notorious being Italian Pink, but there are several which although they may not be completely fugitive are only moderately permanent; the Chrome Yellows and those greens which contain an amount of them, for example Cinnabar, are definitely suspect. The following is a guide to the permanent and fugitive qualities of pigments with an indication of their toxic dangers.

PERMANENCE OF PIGMENTS

Colours which in most cases are permanent
Ivory Black
Lamp Black
Raw Umber
Raw Sienna
Burnt Sienna
Yellow Ochre
Transparent gold ochre
Burnt Umber
Mars Red
Mars Yellow
Mars Brown
Mars Violet
Light Red
Venetian Red
Indian Red
Sepia
Mars Orange
Terre Vert

Viridian
Mineral Violet
Cobalt Blue
Cobalt Violet
Cerulean
Cobalt Green
Opaque Oxide of Chromium

Colours which are 'almost' permanent
Cadmium Orange
Cadmium Yellow
Lemon Yellow
Naples Yellow
Cadmium Red
Cadmium Scarlet
Alizarin Crimson
Crimson Lake
Permanent Magenta
Ultramarine
Monestial Blue
Cadmium Green
Monestial Green
Emerald
Payne's Grey
Flake White
Zinc White
Titanium White
Prussian Green
Manganese Blue

Colours which are only moderately permanent
Aureolin
Chrome Lemon
Chrome Yellow
Chrome Orange
Cinnabar Green
Olive Green
Indian Yellow
Chrome Green
Sap Green
Hookers Green
Alizarin Green
Scarlet Vermilion
Scarlet Lake
Purple Lake
Brown Pink
Prussian Blue
Antwerp Blue

Indigo
Purple Lake
Van Dyke Brown

Fugitive colours (not all makes are completely fugitive)
Italian Pink
Carmine
Geranium Lake
Mauve

Transparent or semi-transparent colours
Crimson Lake
Rose Madder
Scarlet Lake
Cobalt Violet
Cobalt Blue
Monestial Blue
Prussian Blue
Alizarin Green
Hookers Green
Sap Green
Terre Vert
Viridian
Italian Pink
Indian Yellow
Yellow Ochre
Rose Madder
Crimson Alizarin
Aureolin
Cadmium Orange
Raw Sienna
Burnt Sienna
Van Dyke Brown
Lemon Yellow
Carmine
Scarlet Lake
Lamp Black
Mauve
Transparent Gold Ochre
Ultramarine
Indigo
Geranium Lake
Olive Green
Prussian Green
Scarlet Vermilion
Permanent magenta
Cobalt Turquoise

33 **Tom Fairs:** *Garden Wedmore, Somerset,* 1980. Oil
pastel on paper, 12·7 cm × 20·3 cm
Collection of the artist

Oil pastel is on the whole a good tempered and resilient medium, but there are times when its good nature is abused by a roughness in handling which leaves an exhausted grey sludge on the canvas. There is no magic medium which remains always pliable permitting infinite choice and change while retaining the freshness and spontaneity of the first strokes. The painter who struggles through the changing states of his work, seeking imaginative solutions, finds a rewarding flexibility in the use of the comparatively new medium, oil pastel.

Dry Surface

The colour is applied straight from the stick. This method allows for a certain amount of mixing of colour to take place on the paper. However, the success of this does depend upon the composition of the individual pastels because some are too hard and remove the underlying colour. With the softer pastels it is possible for the artist to build up an impasto which can be scraped or scratched into.

Wet Surface

I find that the best results are obtained by working into a paper surface which has been soaked in white spirit. On application the colour is dissolved from the stick and develops some of the properties of oil paint: one colour can be mixed with another directly on the surface. The need to make changes in work in progress is facilitated by being able to wipe out areas of the design with a rag soaked in spirit.

When the painting is finished and the surface is dry the colour has a tendency to sink. I find that colour richness can be restored by using a fixative solution made by dissolving clear shellac in methylated spirits and applied with an atomiser. The solution must be made strong enough to obtain a slight glazing of the surface.

Oil pastel can be used on papers of various grades according to taste.

TOM FAIRS to the author 1983

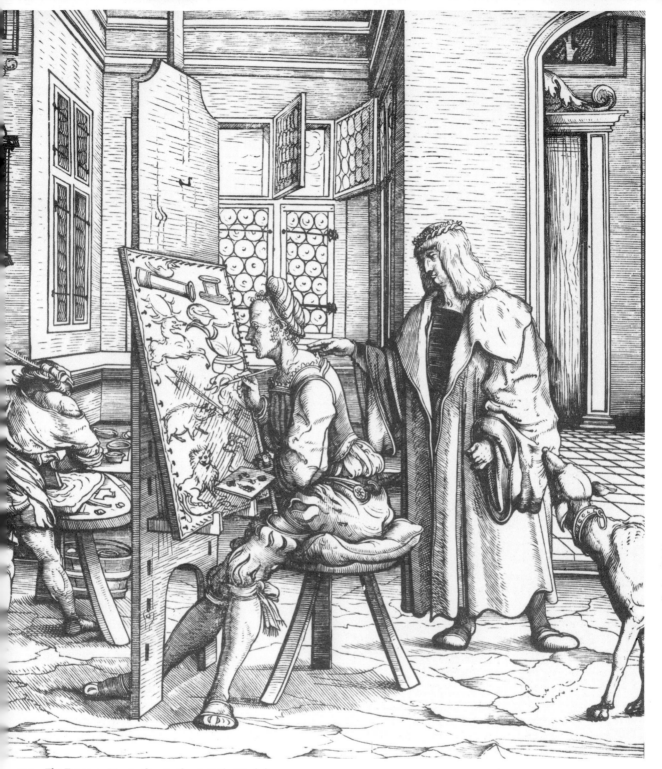

34 *The Emperor Maximilian in the Artist's Workshop*
(from *Weisskunig* 1514–16)
British Museum, London

59

POISONOUS COLOURS
(These colours are only poisonous if used in unconventional ways, eg application with the fingers. Normal use is not dangerous)
Flake White
Naples Yellow
Chrome Lemon
Chrome Yellow
Chrome Orange
Chrome Green
Cinnabar Green
Mauve
Geranium Lake
Cadmium Green
Cadmium Lemon
Cadmium Yellow
Cadmium Orange
Cadmium Red
Cremnitz White
Silver White
Lemon Yellow
Manganese Blue
Emerald

Flake White and the Chromes are the pigments most likely to be found to be poisonous. On some colourman's lists the remaining pigments are listed as being safe.

COLOUR

'... colour is a basic human need like fire and water ... a raw material indispensable to life.'
FERNAND LEGER

'Colours, the materials of the painter; colours in their own lives, weeping and laughing, dream and bliss, hot and sacred, like love songs and the erotic, like songs and glorious chorals! Colours in vibration, pealing like silver bells and clanging like bronze bells, proclaiming happiness, passion and love, soul, blood and death.'
EMIL NOLDE

'Colour has me. I no longer need reach out for it. It has me forever and knows it. That is the meaning of this happy hour. Colour and I are one. I am a painter.'
PAUL KLEE
Kairouan, 16 April 1914

Colour is a complex subject related as it is to physics, symbolism, psychology, physiology and a host of other areas as well as the many aspects of art. This section is not intended to give a scientific account of colour theories but to set out in a simple manner those elements of colour which the student or serious amateur of painting should know.

There have been many attempts to analyse and categorise colour and at different times in history the current scientific discoveries have influenced the contemporary painters. Goethe's experiments begun in 1890 were of interest to the English painter Turner who produced works based on the German poet's ideas*, and also to the lesser known painter friend of Goethe's, Philip Runge who was himself involved in organising the spectrum into a colour sphere. The researches of the French chemist Michael E Chevreul (1786–1889) who was director of the Gobelin tapestry's dye works had influenced Delacroix and his theories published in *The Laws of Contrast of Colour and their Application to the Arts* interested a number of Impressionist and Post-Impressionist painters and have continued to be influential during this century as well. Another book, Ogden Rood's *Modern Chromatics* dealing with the differences between light colour and pigment colour was of particular interest to the Pointilliste Georges Seurat.

It is the colour reflected from surfaces rather than the colour of direct light which is of interest to the artist unless he is concerned with those aspects of art which deal with light as a medium of expression for example, film-making, laser and holograph art. Surfaces reflect and absorb elements of the light which falls on them in differing quantities. The white light which is a mixture of all the colours of the

* Light and Colour (Goethe's Theory), *The Morning After the Deluge*. Tate Gallery, Exhibited 1843.

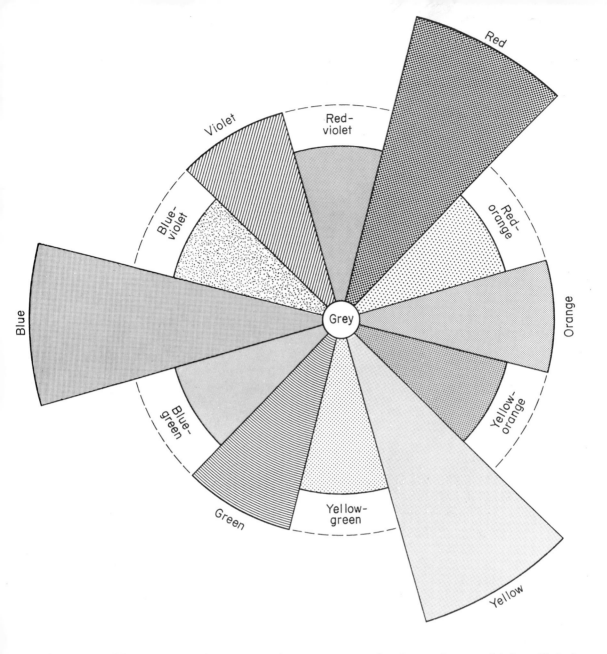

35 The position of the pigments on the 12-part circle *according to Klee*. The importance of blue, yellow, and red as primary colours is emphasised by the space they occupy

spectrum will when shining on a red object reflect mainly red. Yellow and blue may also be reflected in quantities dependent upon the type of red, but they will mainly be absorbed. A yellow or orange red will reflect more of the yellow light than a crimson red which contains more blue. Consequently a red three-dimensional object, for example, will reflect a variety of other colours which will help to define its form.

PRIMARY COLOURS

The three Primary pigment colours are Red, Yellow and Blue. These cannot be mixed on the palette from other colours and they form the basis of the Secondary and Tertiary colours. This is a practical description for the painter as differing scientific light theories add green or use it to replace yellow.

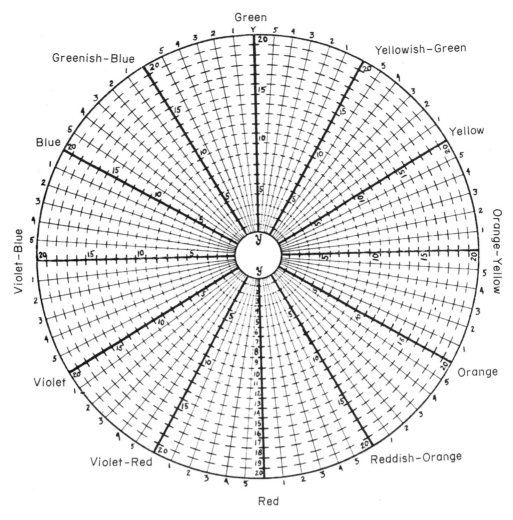

Green
Yellowish–Green
Greenish–Blue
Yellow
Blue
Orange-Yellow
Violet–Blue
Orange
Violet
Reddish–Orange
Violet–Red
Red

36 (a) M E Chevreul's chromatic diagram containing twelve major hues

SECONDARY COLOURS

These are the colours which are made from mixtures of the three primaries and are: Orange made with Red and Yellow, Green made with Yellow and Blue and Violet made with Red and Blue.

TERTIARY COLOURS

This is the name given to those colours made by adding larger amounts of one primary to another, for example the orange-red which is between red and orange and the yellow-orange which is between those two colours. In order for this to work properly with pigments it is necessary to use different colours for the basic primaries. A vermilion will allow the mixture of

the yellow-reds and oranges which is impossible with crimson, a red which when mixed with blue produces the red-violet tertiary.

The colour circle or wheel is probably the simplest form of diagram we have for showing the division of colour. There have been variants of colour solids and strips but the flat circular layout is the commonest. It will be immediately apparent that any such diagram is not comprehensive and that further divisions showing the various hues of colour could be made almost ad infinitum. Different authorities have used differing numbers of colours: ten, twelve or sixteen seem to be the usual divisions. Chevreul's chromatic circle contained twelve colours, the American, Albert Munsell, used ten.

(b) Munsell's colour wheel divided into ten major hues

A look at the colour wheel such as the one reproduced here, based on that used by Paul Klee with his students at the Bauhaus, will show the arrangement's relationship to the rainbow with the colours 'moving' towards and into each other. Thus, red 'moves' towards yellow through scarlet and orange each containing more yellow and towards blue through crimson and violet.

On the opposite side of the circle the greens contain varying amounts of yellow or blue, making hues which may loosely be termed yellow-green and green-yellow near the yellow part of the scale and blue-green and green-blue towards the blue. The mergers of one colour into another can be clearly seen in such a diagram as may their affinities and contrasts.

Hue is the name given to indicate a type of colour according to its redness, blueness or yellowness. The colours around the colour circle are, whatever their similarities, each individual hues.

Saturation is sometimes referred to as intensity or strength. The saturation of a colour is its degree of brilliance. This will vary not only according to the colour itself, the method of its application and the amounts of medium but also according to its juxtaposition with other colours and the light conditions under which it is seen.

Strong, contrasting colours when placed together may be reduced in saturation. Such juxtapositions may be unified, their strengths retained without loss or offence to the eye if individual hues are outlined in black or white. By such means disparate colours can be integrated into a whole and still retain their maximum saturation. Such a device may be seen in stained glass and in the works of Henri Matisse, Pablo Picasso, George Braque and Paul Klee.

TONE AND BLACK AND WHITE
The tone of a colour is its lightness or darkness. Black and white, although not strictly colours but neutrals, represent the two extremes of the tonal range and all other colours fall between them. The painter extends the tonal range of his colours through the addition of black and white and through mixtures of colour. By such means a considerable number of tones of one colour can be achieved. Sometimes these tones are referred to as tints and shades; the tints being the lighter range of tones made with the addition of white and the shades the darker, often made with the addition of black. It should perhaps be stated that the painter mixes white with his colour much more than black. Black tends to dull and if used indiscriminately it dirties the colours in a painting. Darker tones can be achieved with the addition of other colours. Any such additions will naturally lessen the colour's original saturation value. There are painters whose work is not concerned with the intensity of bright colours but relies on the subtle interplay of tone; Corot, Chardin, Daumier, Braque and Ben Nicholson. This does not mean that they were not great colourists, nor should it be assumed that the painters in bright saturated colours, such as the

Fauves, did not concern themselves with tone. All paintings should be careful considerations of both colour and tone; their organisation and balance are inseparable.

The first thing to concern us is the great wealth of tonal values between the two poles. Ascending from the abyss to the source of light we are assailed by a sense of the unmatched grandeur and breadth of enchantment from pole to pole. A darksome subterranean rumbling below, and shadowy blurring in the middle, as though we were under water, and the hissing edge of superlight above. The impact of such a progression is memorable ...

PAUL KLEE
The Nature of Nature

Tone values, sometimes referred to simply as values, are the variations of light and dark which we see around us. The black and white photograph, or 'half-tone' as it is called by printers, is a tonal representation of a coloured reality. Colours of differing hue may have the same tonal value and so the colour and tonal organisations of a picture, linked though they are, may not be identical. Two colours of the same tone may describe two separate shapes but tonally they will produce on the canvas one larger shape. Therefore there has to be careful consideration given to the balance of light and dark as well as to the balance of form and colour and the other elements in a picture.

Some paintings may be produced with little tonal contrast; certain dark coloured interiors by Sickert, the medium toned *Nocturnes* of Whistler and the high-keyed late landscapes of Monet. Indeed, at times there has been a preference for works with little contrast of tone and colour. In a fifteenth century Italian treatise on painting the writer, Girolamo di Manfredi comments:

'Why our vision is better with green colours than with whites and blacks: Every extreme weakens our perception, whereas the moderate and temperate strengthens it, since extremes affect the organ of perception immoderately. Thus white has an expansive effect, while intense black has an excessively concentrating effect. But a moderate colour, like green, has a temperate effect, not expanding nor concentrating too much; and therefore it strengthens our vision.'

GIROLAMO DI MANFREDI
'Albertus Magnus',
El libro chiamato della vita, costumi natura dellomo
(Naples 1478)

'Much to be blamed is the painter who uses white or black without much moderation. ... It would be a good thing if white and black were made of pearls ... because the painters would then be as sparing and moderate with them as they ought, and their works would be more true, more agreeable, and more *vezzoso.*'

ALBERTI

Michael Baxandall from whose excellent book, *Painting and Experience in Fifteenth Century Italy* this and the previous quotation have been taken, defines *vezzoso* as 'delightful in a caressing way' and 'blandly as well as blithely charming'. Neither of which terms could be used to describe the paintings of Van Gogh from one of whose letters comes the following comment on the use of black and white:

'But tell me *black* and *white*, may they be used or may they not, are they forbidden fruit?

'I don't think so; Franz Hals has no less than twenty-seven blacks. White – but you know yourself what striking pictures some modern colourists make of white on white. What is the meaning of that phrase: *one must not?* Delacroix called them *rests*, used them as such. You must not have a prejudice against them, for if used only in their places, and in harmony with the rest, one may of course use all tones.'

VAN GOGH
Letter 428
Nuenen October 1885

Painters, and for that matter good photographers, have to select tones for their work, in a manner which the camera cannot if used simply to record. By such selection the painter may:
1 Convey a sense of harmony, calm or dramatic contrast.
2 Establish a structure to his work with balanced light and dark areas.

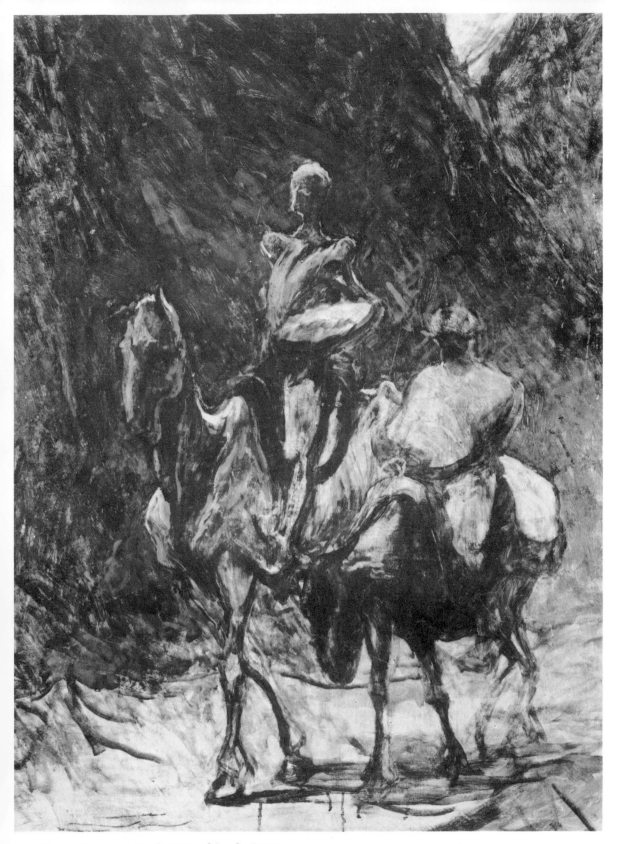

37 **Honoré Daumier:** *Don Quixote and Sancho Panza*
Home House Society Trustees, Courtauld Institute Galleries,
London, Courtauld Collection

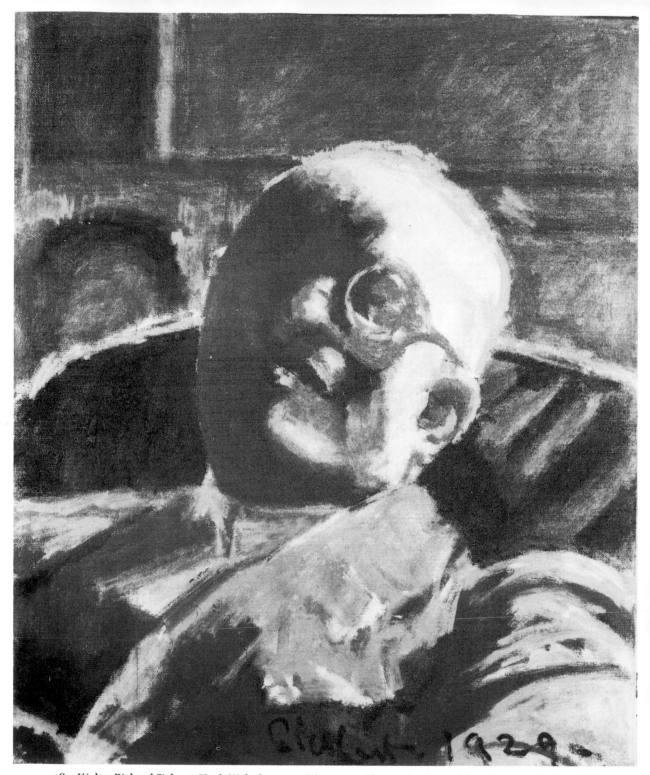

38 Walter Richard Sickert: *Hugh Walpole*, 1929. Oil on canvas, 76 cm × 63·5 cm
Glasgow Art Gallery and Museum
This is a second version of a commissioned portrait and was probably painted from memory with the aid of photographs.

The sombre tone of the picture, with the simplification of detail by shadow and the contrasting highlighted areas, give the work a dramatic, almost theatrical quality

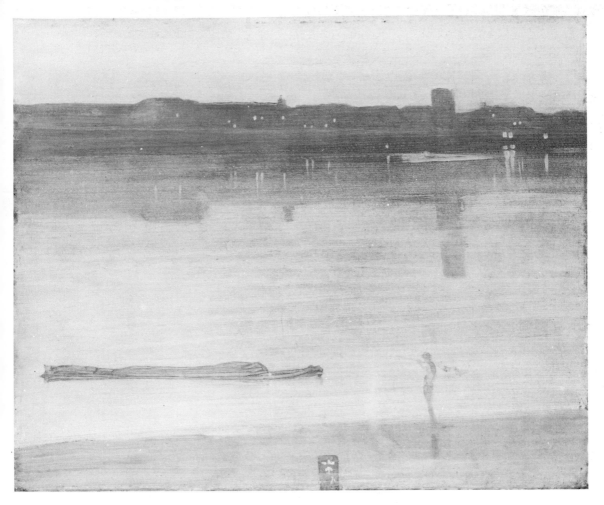

3 Express rhythms across the picture-plane.
4 Create patterns of positive and negative shapes and areas of counter change.
5 Indicate distance and different qualities of light.
6 Create a feeling of solidity.

'A technical question. Just give me your opinion on it in your next letter. I am going to put the *black* and the *white*, just as the colour merchant sells them to us, boldly on my palette and use them just as they are. When – and observe that I am speaking of the simplification of colour in the Japanese manner – when in a green park with pink paths I see a gentleman dressed in black and a justice of the peace by trade (the Arab Jew in Daudet's *Tartarin* calls this honorable functionary *zouge de paix*) who is reading *L'Intransigeant* . . .

'Over him and the park a sky of simple cobalt.

'. . . then why not paint the zouge de paix with ordinary bone black and the *L'Intransigeant* with simple, quite raw white? For the Japanese artist

39 James McNeil Whistler: *Nocturne in Blue-Green*, 1871. Oil on panel, 50 cm × 59 cm
Tate Gallery, London
The harmony of the scene is due mainly to the overall colour, but also limited tonal contrast. Calmness is emphasised by the use of middle tones along with the horizontal composition and brushstrokes

ignores reflected colours, and puts the flat tones side by side, with characteristic lines marking off the movements and the forms.'

<div align="right">

VAN GOGH
Letter B6 (6)
Arles, Second half of June 1888

</div>

'White does not exist in nature. You admit that you have a sky above that snow. Your sky is blue. That blue must show up in the snow. In the morning there is green and yellow in the sky. These colours also must show up in the snow when you say that you painted your picture in the morning. Had you done it in the evening, red and yellow would have to appear in the snow. And look at the shadows. They

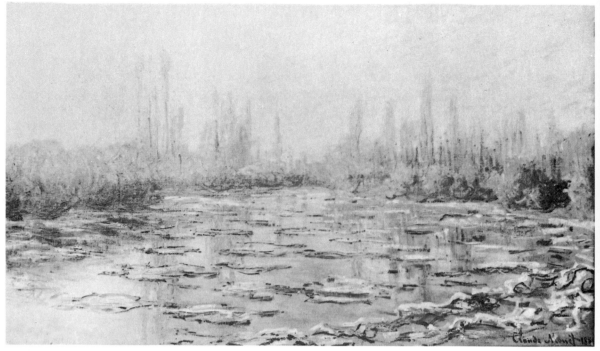

are much too dark. That tree, for example, has the *same* local colour on the side where the sun shines as on the side where the shadow is. But you paint it as if it were two different objects, one light and one dark. Yet the colour of the object is the same, only with a veil thrown over it. Sometimes that veil is thin, sometimes thick, but always it remains a veil. You should paint it that way; paint the object and then throw a veil over it. ... Look at Titian, look at Rubens – see how thin their shadows are, so thin that you can look through them. Shadows are not black; no shadow is black. It always has a colour. Nature knows only colours. ... White and black are not colours.'

<div align="right">AUGUSTE RENOIR</div>

Notes taken during an interview in Munich in 1910 while Renoir examined some snow scenes submitted by German painters; Dr Ernest L Tross, Denver, Colorado, who served as interpreter.

<div align="right">REWALD

History of Impressionism,

New York 1946

Secker and Warburg, London 1973

page 210, note 28 page 236</div>

WARM AND COOL COLOURS

The organisation of the colour circle shows the relationships between the colours and their division into the warm yellow and red range and the cool blues and greens. However a closer look shows that it is possible to have cool as well

40 **Claude Monet:** *Floating Ice*, 1880. Oil on canvas, 97 cm × 148 cm
Shelburne Museum, Shelburne, Vermont, USA
The closeness of tones in this high-keyed Monet landscape gives the scene a unity which is enlivened by the darker lines of dry brush work

as warm reds and warm blues and greens. A crimson is nearer the blue part of the circle and contains more of that colour than a cadmium red which is yellower and closer to the orange yellow section of the circle. An Ultramarine blue is warmer than a Prussian blue, a Violet cooler than a Purple. Obviously the juxtaposition of colours will also play a part in how their 'temperature' appears to the viewer. A cool red-violet will appear warmer placed next to a blue-green than when it is near to an orange-red. Each colour has its warm and cool hues which must naturally be considered when mixing pigment on the palette. It is useless attempting to produce an orange with a mixture of Lemon Yellow and Crimson Red; the warmer Cadmiums or Chrome Yellow and Scarlet will be more successful, similarly a cooler green will be made with Lemon Yellow and Prussian Blue than with Chrome yellow and Ultramarine.

Most paintings are composed with a mixture of warm and cool colours so as not to appear too hot or too cold. This is not to say that a painter

may not work in a different manner should he so wish. (Picasso's Blue Period pictures are a well-known, but not an isolated case). Nor does it mean that warm and cool colours are used in equal quantities but that their organisation is usually such that each enhances the other and the finished picture is whilst having an overall warm or cool 'key' a sum total of both. It is important for the painter to decide on the colour key of his picture if he is to avoid the confusion which often occurs in the work of the beginner.

Many of the Tahitian paintings of Gauguin contain a number of cool hues whilst having an overall effect of warmth. Furthermore he used the qualities of the colours to help indicate depth. Warm colours appear to advance towards the spectator whilst cool ones seem to recede and these attributes Gauguin sometimes employed in an almost diagrammatic fashion using warm reds, pinks and oranges in the foreground of his work with a change to cool greens, violets and blues from the middle to far distance. The simple nature of such an arrangement is but the basis for further harmonies and contrasts with the interplay of warm and cool over the whole picture-plane.

41 **Bridget Riley:** *Fall*, 1963. Emulsion on hardboard.
141 cm × 140·5 cm
Tate Gallery, London
Strong tonal contrast and repetition used to produce an optical illusion of movement

COMPLEMENTARY COLOURS

The colours which appear opposite each other on the colour circle are known as 'complementary colours'. It will be seen that the complementary to each of the primary colours is a mixture of the other two primaries. Thus orange is the complementary of blue, green of red and violet of yellow. Furthermore the remaining hues around the colour circle each have their complementary; orange-yellow and violet-blue, red-orange and green-blue, violet-red (purple) and yellow-green.

Each colour has its complementary after-image which may be seen by placing an area of colour onto a sheet of white paper and after staring at it for several seconds superimposing a clean sheet of white paper. There then appears to be an area the same shape as the painted one but in the complementary colour. A vermilion coloured shape will produce an after-image in the complementary of blue-green. Such shapes appearing as they do on the white surface will, because they are not solid pigment, take up something of that whiteness and be slightly lighter than their pigment counterparts. This phenomenon is the same as the negative reversal experienced when the eye moves to a white surface after looking at the strong light; a dark area in the shape of the light is seen.

Mixed together the complementaries cancel each other out and produce what are sometimes called complementary greys quite different from the greys obtained by a mixture of black and white. Red and green for instance create a brownish grey colour. Such mixtures may be of use in building up the harmony of a painting and keeping the more neutral colours in direct relationship to the stronger more dominant hues. Care must be taken, however, if the muddy rather dirty effects sometimes achieved by the beginner are to be avoided.

As has been stated the theories of Michael Chevreul have influenced a number of painters and particularly in the use of complementary colour. This is not to say that painters before the nineteenth century were not aware of the possibilities but that Chevreul's ideas about colour and contrast came at a time when painters were becoming increasingly interested in the use of colour not simply as a subordinate to form, which had often been the case previously, but as a major element. Chevreul's theory of the 'law of simultaneous contrast' which maintained that a colour placed next to its complementary was made more powerful by the contrast and consequently made the complementary more powerful, was of particular interest to the Neo-Impressionist or Pointillist painters Georges Seurat and Paul Signac but also influenced other Impressionists and Post-Impressionist painters. Van Gogh mentions his use of complementaries in several of his letters.

'Just to explain how that study was painted – simply this: green and red are complementary colours. Now in the apples there is a red which is very vulgar in itself; further, next to it some greenish things. But there are also one or two apples of another colour, of a certain pink which makes the whole thing right.

'That pink is the broken colour, got by mixing the above-mentioned green.

'That's why there is harmony between the colours.'

VAN GOGH
Letter 428
Nuenen October 1885

'... I have made a series of colour studies in painting, simply flowers, red poppies, blue corn flowers and myosotys, white and rose roses, yellow chrysanthemums – seeking oppositions of blue and orange, red and green, yellow and violet seeking *les tons rompus et neutres* to harmonise brutal extremes. Trying to render intense colour and not a grey harmony.'

VAN GOGH
Letter 459a
Paris August–October 1887

The complementary colours of objects were also painted into their shadows by Impressionist and Post-Impressionist painters or a colour heightened by being given a contour in its complementary. The blue outlines used by Cézanne serve to enhance orange coloured rocks or an orange itself. They also help to create depth and a harmonious link with all the

colours across the picture-plane.

The Pointillists in particular exploited Chevreul's idea that a range of colours is more vibrant when placed next to a sequence of its complementaries. They also developed a technique of painting with small dots or points of pure colour which 'mixed' in the eye of the spectator. (See section on Painting with Optical Mixtures of Colour, page 169.)

This technique was also used for a period by Camille Pissarro who later rejected it as too limiting; and Van Gogh also worked a freer, looser variation on it as did both Matisse and Picasso at various times in their careers.

Such pictorial devices were to lead the way to much of the colour experiments of painters during the twentieth century perhaps seen most notably in the work of Henri Matisse and the Fauves. Bold use of complementary colours in the paintings of Maurice Vlaminck, André Derain and Georges Braque executed during

42　Georges Seurat: *The Bridge at Courbevoie*, 1887. Oil on canvas. 45·7 cm × 54·7 cm
Home House Society Trustees, Courtauld Institute Galleries, London (Courtauld Collection)
Detail showing Pointillist technique

their Fauvist Period in the early years of this century show an expressive and emotional use of colour which at that time was new to Western European Art. Later Op Artists such as Victor Vasarély have also on occasion used the contrasts of complementary colours for their optical illusions.

'The paintings of the Impressionists, constructed with pure colours, proved to the next generation that these colours, while they might be used to describe objects or the phenomena of nature contain within them, independently of the objects that they serve to express, the power to affect the feeling of those who look at them.'

HENRI MATISSE
La Chapelle du Rosaire

COLOUR CONTRASTS AND HARMONY

Colours cannot be considered in isolation. Placed on a white surface a colour will have an intensity related to that surface but when another colour is placed next to it both will be altered and diminished. If identical shapes of the same hue of red for example are painted in the centre of a series of white squares, they will obviously be the same in saturation and brightness, but this will not be the case if the surrounding areas are painted in a number of different colours. Each background colour will affect the red shape so that it will alter in tone, appearing darker on yellow than on violet, and seem also to change in hue. The same will of course happen to the different colours used for the backgrounds. A bright colour will produce an after-image of its complementary which will affect other colours nearby. This may be used to add colour to delicate greys or other neutral areas in a painting or to produce the visual sensation seen in some Op Art pictures.

A painting needs a certain amount of contrast if it is not to appear too flat and dull. This may be a slight tonal contrast as sometimes seen in the late works of Claude Monet or a strong, vibrant colour one as often used by Van Gogh or El Greco in order to draw the spectator's attention to the principal character or focal point of the painting. El Greco's *Agony in the Garden* (c 1590) and *Christ Driving the Traders from the Temple* (1600) (colour plate 2) are examples of this with the figure of Christ in traditional red and blue robes against the yellow, greens and greys of the surrounding picture area.

Matisse in many of his Fauve paintings used the strong contrasts of complementary colours to give his work the power and brilliance he desired. In his *Portrait of André Derain* (1905) the contrast is achieved through colour rather than tone although there is obviously a certain amount of tonal contrast. The warm colours of the face, strong cadmium orange, scarlet lake and vermilion are placed against the cool cobalt blues, greens and viridian of the background; with some of these 'receding' hues repeated in the hair, moustache and shadows an interlocking colour structure of juxtaposed complementaries has been created; reds against greens, blues against oranges and yellows against violets. Even the artist's initials, painted as they are in violet, are complementary to the yellow smock or shirt of the sitter.

Although a painter may wish to use contrasting colours for their vibrancy and the startling effect which they cause, he has to be aware that the indiscriminate use of such contrasts might be too disquieting for the spectator. Some painters may actually attempt this, but in the main the artist, even whilst wishing his work to startle and shock, will not want it to be actively unpleasant. If strong, contrasting colours such as a pair of complementaries are placed near to each other in equal amounts the eye of the spectator will move from one to the other and there will be a sense of disquiet which is the result of the conflict between the two. Should one of the colours be smaller in area it will become a foil to the larger and whilst strong contrast and excitement remain the unpleasant qualities are removed. It is worth studying the work of such great colourists as Delacroix, Matisse, Klee, Gauguin and Miro and the huge flooded colour fields of such Abstract Expressionists as Mark Rothko and Clyfford Still and then making notes of the proportion of all the colours used in a particular painting, their importance in the picture, their differences and similarities and then using these discoveries in a painting of ones own in order to learn how a related selection of colours have been used not only to give effects of contrast, but also to produce a

For detailed captions to colour plates see pages 81 and 82

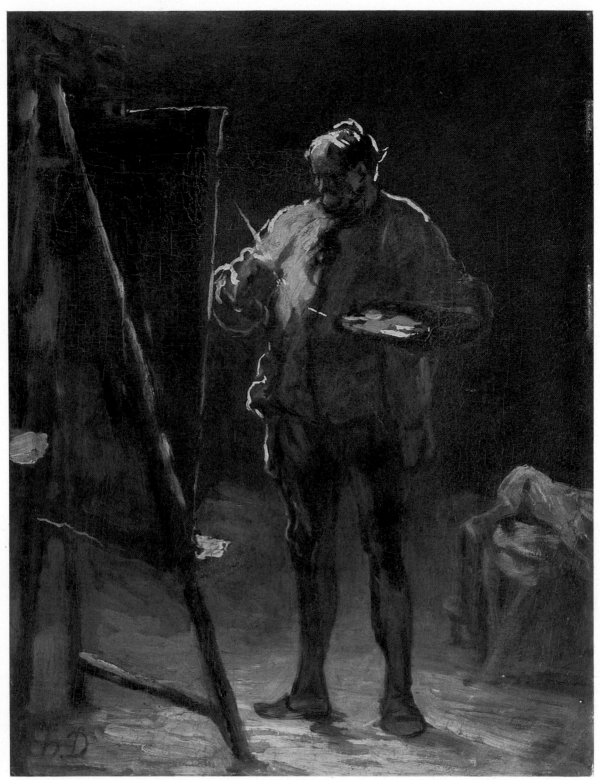

Plate 1
Honoré Daumier: *The Painter before his Easel, c 1870, 33.4 cm x 25.7 cm*
The Phillips Collection, Washington. Acquired from Bignou Gallery Inc,
New York, 1944

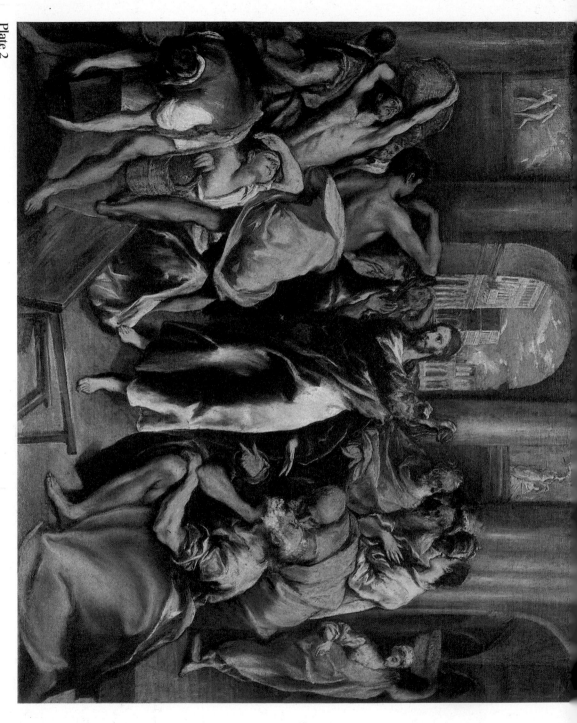

Plate 2
El Greco: *Christ Driving the Traders from the Temple.* 1600. Oil on canvas.
106 cm x 130 cm
National Gallery, London

Plate 3
William Holman Hunt: *The Hireling Shepherd* 1851. Oil on canvas.
76 cm x 108 cm
City Art Galleries, Manchester

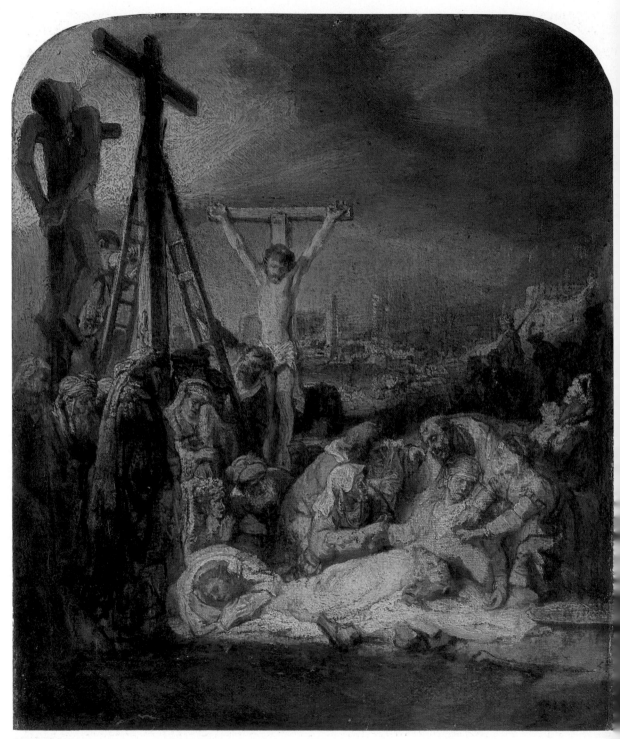

Plate 4
Rembrandt: *Lamentation over the Dead Christ*, between 1637-1640. Oil on
paper and canvas on panel, 31.9 cm x 26.7 cm
National Gallery, London

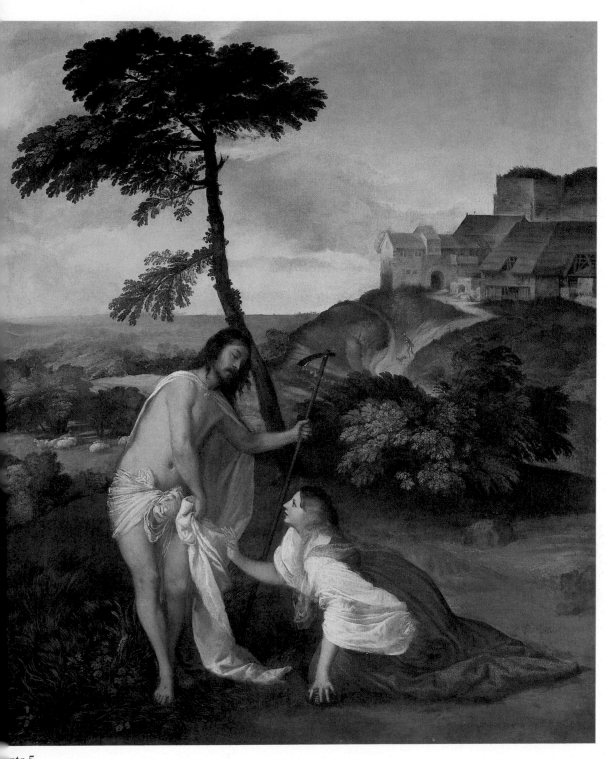

Plate 5
Tiziano Vecelli Titian: *Noli me tangere*, early sixteenth century. Oil on canvas,
108 cm x 90 cm
National Gallery, London

Plate 6
Joseph Mallord William Turner: *Hastings*, *c* 1835. Oil on canvas, 90 cm x 122 cm
Tate Gallery, London

Plate 7
Georges Seurat: *Rower off the Island of La Grande Jatte in Spring*, 1887.
Oil on canvas
Musées Royaux des Beaux-Arts, Belgium

Plate 8
Cosimo Tura:
The Virgin and Child Enthroned,
c 1480. Oil on wood panel,
239.5 cm x 101.5 cm
National Gallery, London

43 Mary Cassatt: *Child in a Straw Hat, c* 1886. Oil on canvas, 65 cm × 49 cm
National Gallery of Art, Washington. Collection of Mr and Mrs Paul Mellon

The dark tones on the hat, hair and eyes draw the spectator to what is the most important part of the picture

harmonious work; that is a work which is a unity, which holds together even when strong contrasts or brilliant colours have been used. A similar experiment dealing with close colour relationships with a contrast in tone might usefully be undertaken with one of Georges Braque's muted still lifes. Careful study of the works of the masters will reveal many ways in which contrasts and harmonies of colour have been used.

Main colours are sometimes repeated as paler tints in the background.

A picture predominently cool in key may have a strong warm accent to arrest the attention of the spectator.

Similarly a dark painting might have an area of light indicating the focal point. A painting of muted tones could have its main subject in a lighter, stronger hue in the same colour range.

The principal character or object may be in a colour complementary to the surrounding ones.

A harmony might be achieved by leaving parts of the canvas the colour of the priming or outlining objects in the same colour.

Contrasting accents might be placed on a field of colour which covers the entire picture-plane.

eries. This is not however the only method he might decide upon. It is possible for the three-dimensional aspects to be shown in a more diagramatic form with drawing over a flat area of local colour. A look at some of the paintings of interiors by Pierre Bonnard and Henri Matisse will show these two approaches. A painter not wishing to indicate the three-dimensional form of an object in space might simply paint the area of that object with unmodulated colour. Thus a still life on a table might be a selection of flat shapes each apple, orange and bottle shown in its local colour.

Bonnard scumbled colours over each other and juxtaposed a wide variety of hues in order to obtain the shimmering play of light across coloured surfaces; layers of glazes with dabs and streaks of opaque pigment on them create the sensation of light and shade and the constantly changing patterns of sun and shadow over objects, flowers and figures.

Certain interiors by Matisse or still lifes by Fernand Léger show a completely different approach with objects represented by flat areas of local colour sometimes with lines drawn over them to indicate their form in space and sometimes painted simply as flat shapes; the colour unaltered by light, shadow or distance.

LOCAL AND LIGHT COLOUR

Local colour is the name given to the actual colour of an object. That is its colour unaltered by the play of light or the nearness of another hue. A curtain may be red or blue and this is its local colour which will be changed by light and shadow and the adjacent colours of a wall, other furnishings in the room and the view through the window. If the painter wishes to express the form of the curtain with its folds and their position in space he will probably take into account the light which falls onto the fabric and so change the colours according to their alteration by that light. This attention to light colour, the alteration of the local colour by the play of light upon it, will allow him to show the three-dimensional nature of the hanging drap-

GREYS

Greys are an important part of the artist's palette, not the ones mixed purely from the two neutrals black and white nor even those produced commercially, but the greys which are mixed by the painter himself in the course of his work. These may be produced by adding colour to a mixture of black and white or by mixing complementary or near complementary colours. In such manner it is possible to produce warm and cool greys which have an extremely wide tonal range. The greys which appear in nature or the man-made environment are coloured greys not the dead grey of black and white for even if this is produced in the form of print or paint it is altered by light and appears as a coloured grey. It is not only in

44　**Sir William Nicholson:** *Mushrooms*, 1940. Oil on board, 34·9 cm × 45 cm.
Tate Gallery, London
A simple subject, a limited palette, economy of means have been used to produce an intricate harmony of shape and tone, a richness of greys between black and white

the representation of grey objects that greys are important. Their introduction into a picture may help to 'calm' the violent contrasts between other colours, a contrast which may retain its striking effect without harshness. Coloured greys can be used to echo in a more muted form the hue of a major element in the painting or may help to produce a harmony across the picture plane. They can act as a foil to lighter, darker and brighter colours and can help to evoke a sense of atmosphere or mood. It is worth looking carefully at the subtle use of greys in the paintings of Velasquez, Chardin, Corot, Constable, Turner and Giacometti.

Much can be learned from one or two practical experiments with greys. A simple grid pattern, even a freely drawn one will serve as the basis for a first exercise. The squares or rectangles can be filled with as wide a range of greys as desired in a number of arrangements. For example working in a sequential manner from the top left to bottom right a selection of greys can be applied which run from light to dark or working from the edge of the area to the centre the arrangement might run from warm to cool.

Obviously there are many variations on such a theme. A second more difficult exercise is also

76

valuable. If a selection of white objects such as a plate of eggs, a bottle of milk or objects which have been given a coat of matt white paint, are placed on a sheet of paper or white cloth against a white background it will readily be seen that the colours of the greys vary according to the type of light which falls on the group. The painting of such a still life is a difficult but extremely useful experience making the painter look very carefully at the objects and the spaces between them and taking trouble to mix his colours as accurately as possible. A look at the paintings of the Italian Morandi could be helpful when working on this problem.

COLOUR AND SPACE

Colours when placed on a flat surface can indicate positions in space. In the main it may be said that the warm colours tend to advance and the cool colours recede. Thus the red of a traffic signal jumps out from amongst the surrounding colours whilst the blue of the sky gives the impression of limitless space. There are though other factors which govern the advancing and receding attributes of colour and it is as well to consider each individual case when painting a picture and not to take the simple basic warm and cool rule as being true in all instances. As might be expected the relationship between colours will affect any feelings of their position in space and according to how they are juxtaposed it is possible for a warm colour to look further away from the spectator than another colour which might be near it and may even be from the cool range of hues on the colour circle. Other factors which will affect how a coloured area appears are its tonal quality. Muted tones normally look further away than strong light or dark ones and shapes which are intense in colour appear nearer than those which are subdued. Hard edged shapes also seem to advance whilst those with softer

45 Alberto Giacometti: *Interior*, 1949. Oil on canvas, 65 cm × 53·6 cm
Tate Gallery, London. Copyright ADAGP 1983

contours look further away. Many landscape painters have indicated distance through the use of slightly blurred shapes painted in subdued cool colours, which is after all how distant objects often appear to us in nature.

'Nature is more in depth than in surface, whence the necessity of introducing into our vibrations of light, represented by reds and yellows, a sufficient sum of bluish tones, in order to give a feeling of air.'

PAUL CÉZANNE
Letter to Emile Bernard

LIMITED PALETTES

There is little point in buying a large number of pigments, particularly when first starting to paint. All pictures are the result of a carefully selected group of colours and often the more limited that selection the more cohesive and inventive is the colour key. One has only to look at the works of such painters as Chardin, Daumier, Sickert and Cézanne to appreciate that a limited number of colours does not need to inhibit, but can produce a wealth of exciting relationships. The term 'limited palette' does not necessarily mean one which is composed of low keyed colours, although such a selection can be a stimulating discipline. Certain colours are associated with the traditional limited palette and it is well worth the beginner attempting to work within such restricted ranges, but it should be remembered that the complementary range of oranges and blues supported by green which Cézanne used for much of his work also constitute a limited palette and that similar 'high keyed' or bright ranges of colours can be used to great effect. A versatile but nonetheless limited palette may be composed of the following:
Flake White (Zinc or the more powerful Titanium may be used instead)
Yellow Ochre (Raw Sienna is a possible alternative)
Light Red
Prussian Blue
Ivory Black
This range, consisting as it does of variants of

the primary colours with the addition of black and white is sufficient for the production of tonally harmonious works and can be extended with other colours, particularly those from the earth range, as desired. There is nothing sacrosanct about such a selection and the individual may wish to create a more personal 'limited palette', but this very basic one does allow for the mixture of a wide range of colours although in a somewhat muted form. Not a bad restriction for the beginner. With Yellow Ochre and Prussian Blue excellent greens may be produced as may ones with Yellow Ochre and Black, but should these be insufficient there is no reason why the subdued Terre Verte should not be included to extend the range. Rich violet/purples may be made with Light Red and Prussian Blue and their tonal range widened with black or white. With such limitations many painters have worked and the study of pictures by Sickert will show that with a similar, if not identical palette, it is possible to produce images of rich and complex colour variations. Since the French Impressionists many painters have renounced the earth colours and those at the more subdued end of the artist's colour range, but there are no right or wrong colours and the choice is for the individual. The perceptive and creative painter will, in his early days, make use of as wide a variety of palettes as possible in order not simply to experiment for its own sake, but to learn and decide what is possible and appropriate to his needs.

In his book: *Notes on the Technique of Painting* (London 1934) Hilaire Hiler gives what he calls a Basic Nine-Colour Palette which was published in *The Portfolio* (1876 page 132) by P G Hamerton.

Flake White
Pale Cadmium (yellow)
Yellow Ochre
Vermilion
Rose Madder
Ultramarine
Emerald Oxide of Chromium
Vandyke Brown
Black

Hiler goes on to state that with this selection Hamerton was able to mix the following colours (and many more besides). Its inclusion here might be useful to the student.

1 Naples Yellow: Flake White, Cadmium Yellow and a trace of Yellow Ochre. Exact.
2 Lemon Yellow: Flake White, Cadmium Yellow, trace of Viridian. Less brilliant.
3 Cadmium Orange: Cadmium Yellow and Vermilion. Less brilliant.
4 Light Red: Vermilion, Yellow Ochre, Vandyke Brown.
5 Venetian Red: Vermilion, Yellow Ochre, Rose Madder, Vandyke Brown.
6 Indian Red: The same with a little Black. Less transparent.
7 Cobalt Blue: Ultramarine, trace of Viridian, White. Less transparent.
8 Prussian Blue: Ultramarine, Black, trace of Viridian. Somewhat less deep and translucent.
9 Burnt Sienna: Yellow Ochre, Rose Madder, Vandyke Brown, trace of Vermilion. Less translucent.
10 Emerald Green: White, Cadmium Yellow, Viridian. Less brilliant.
11 Malachite Green: White, Cadmium Yellow, Viridian, Yellow Ochre.
12 Cobalt Green: Ultramarine, Viridian, trace of White.
13 Indigo: Ultramarine, Viridian, Black. Very closely matched.

Colin Hayes in his book *The Technique of Oil Painting*, Batsford, London 1965, gives the following list of colours for the production of a 'tonal' still life painting and although it is no more definitive than any other range of colours it is a simple and helpful start:

Flake White or Zinc White.
Titanium is a very good white but so powerful a 'cover' that a little tends to flood other colours with its own whiteness. Introduce it gradually to your palette.

Yellow Ochre – an opaque colour.
Light Red – an opaque colour.
Ivory Black – a semi-transparent colour.
Raw Umber – a semi-transparent colour.

46 **Adrian Ryan:** *Sancreed Church, Cornwall,* 1963. Oil
on canvas, 71 cm × 91 cm
Private Collection

Such a palette is indeed useful in the painting of a 'tonal' picture particularly one based on a subject such as still life which is before the artist and which may be studied in terms of light and dark without too great an alteration by atmospheric conditions. The lack of a blue may be a difficult restriction within which to work but the black may be used in its place particularly for the mixing of green and it should be remembered that such a loss from the palette will make the painter concentrate on the tonal qualities of the work and not the more colourful aspects, for which a wider range of colours would obviously be more appropriate. It is essential that the painter knows at the outset what he is attempting, organises his materials and himself towards that end and works within the confines he has established. To change direction mid-way through a work is to create difficulties with which the beginner may not be able to contend. There is no rule which says such a course of action is forbidden, but it is a sure way of creating new problems. The experienced may capitalise successfully, the beginner may meet disaster. A student should treat each work as a learning experience, a change of course is best dealt with by a fresh start. The aim for all beginners is not the production of a 'work of art' (indeed for whom is that the aim of painting?) but an exercise in learning the fundamentals of a craft, a means of expression, a study of ideas or nature which will eventually enable him to produce works which communicate his personal thoughts and vision in an individual way.

'I never do a picture as a work of Art. Paintings are researches.'

PICASSO

A brighter, lighter toned, but still restricted palette might be composed of the following:

Flake White (or Titanium)
Cadmium Yellow
Cadmium Red
Cobalt Blue

With these three 'Primaries' and White an infinite number of mixtures are possible. Titian claimed that a great painter needed only three colours.*

A cooler yellow and red with a warmer blue would extend the range allowing for the mixture of more varied greens and violets:

Lemon Yellow
Alizarin Crimson
French Ultramarine

According to some authorities a mixture of Ultramarine and Alizarin Crimson will impair the permanence of both. Perhaps this was the case in the past when the ingredients of the pigments were different from today for tests at the Winsor and Newton laboratory have exposed no problems. This palette then seems to be one with good permanent qualities from which a wide range of colours can be made. The main defect is probably the cost of the cadmiums. These could be replaced in the interests of economy with proprietary brand colours of *similar* hue. In place of the two blues mentioned above the versatile Monastral/Monestial Blue could be used, but there is really no substitute for the two with their warm and cool qualities.

RESPONSES TO COLOUR

'Everyone knows that yellow, orange and red suggest ideas of "Joy and plenty".'

DELACROIX

Apart from being able to indicate spatial relationships, colour also gives the spectator a variety of sensations. The fact that certain sections of the colour circle are labelled warm and cool is evidence of this with the associations of sunlight and fire on the one hand and sea and shadow on the other. Consequently people use colour to express their moods and ideas, decorating their homes in particular ways and dressing in a manner which is in keeping with how they feel on a particular day. The warmer colours usually suggest lively, happy feelings whilst the cooler ones are calmer.

Colours are therefore associated with different events and the arousal of different emotions. This is partly due to the nature of the colour itself but also to the role which has been assigned to it by a particular society. Red is traditionally connected with love and passion and gaiety but it is also an international road signal for stop. A fact which apparently annoyed certain of the Red Guard in Communist China during the Cultural Revolution of the fifties who thought that the colour symbolising Communism should not also be used as the symbol for 'Stop'. Numerous cultures have placed a great deal of emphasis on symbolic colours, for instance the ancient Egyptians believed that the colours in dreams were indicative of a whole range of emotions and portents from the white of home happiness through the red of ardent love, the dark blue of success, the light green of a bad omen to the black of death.

The Greek physician Galen, whose ideas persisted into the Middle Ages, wrote about the 'four humours' and their relationship with illness, the elements and colour.*

* Giacomo Palma (Student of Titian). See Boschini: *Le Ricche minere della Pittura*, Veneziana, 1674.

* Galen's Commentary on Hippocrates' *De humoribus* in Karl Gottlob Kuhn (ed), *Claudii Galeni opera omnia* XVI, Leipzig 1829; 'Alberti's Colour Theory' by Samuel Y Edgerton Jr *Journal of the Warburg and Courtauld Institute* Vol XXXII 1969

Humour	Colour	Element
Sanguine	Red (blood)	Air
Choleric	Yellow (gall)	Fire
Melancholic	Black (gall)	Earth
Phlegmatic	White (phlegm)	Water

Colour and the elements have been linked in different ways throughout history.

Yellow or Red – Fire
White – Air, Water or Earth
Black – Elements in 'transmutation'
Aristotelian School

Red —Fire Green—Water
Blue—Air Grey —Earth
Leon Battista Alberti

In the Middle Ages and the Renaissance colour was not only equated with the elements, but with aspects of astronomy, alchemy, the emotions and religious attributes.

Red —Charity White—Purity
Yellow-Gold—Dignity Black —Humility
St Antoninus

In Western European Art the Madonna is usually dressed in blue robes, a colour symbolising happiness and calm; and Christian hope is signified by yellow. In Oriental art Krishna is given blue skin so that the spectator is in no doubt which is the figure of the god.

Certain North American Indian tribes assigned colours to the points of the compass and used them as directional signs as well as ways of predicting the future. Contemporary Western Art, however, rarely uses the idea of symbolic colours, relying more on the physical properties and our responses to them rather than a knowledge of literary associations.

'How important it is to know how to mix on the palette those colours which have no name and yet are the real foundation of everything.'
VAN GOGH

CATIONS TO COLOUR PLATES BETWEEN PAGES 72 AND 73, AND 168 AND 169

PLATE 1
Honoré Daumier: *The Painter before his Picture,* 1865–68. 32 cm × 0·25 cm
The Phillips Collection, Washington
Devoid of unnecessary detail this work is the result of careful observation and selection. Nothing detracts from the essential image that the painter wishes to present; the fall of light in the room, the poise of the figure

PLATE 2
El Greco: *Christ Driving the Traders from the Temple,* 1600. Oil on canvas, 106 cm × 130 cm
National Gallery, London
Across a neutral ground the clothes of the subsidiary figures make a yellow, green and orange support to the central figure of Christ in his red robe. A blue drape across it links the two sides. On an almost symmetrical base El Greco has organised a complex interplay of forms the movement of which is expressed as much by the fluid brushwork as in the placing of figures and draperies.

Pigment has been applied in a near impressionistic way with short brush strokes and paint dragged and scumbled in some areas and painted wet into wet in others. El Greco, however, did not deal with light and shade in the same way as the Impressionists. There is no searching for colour in the shadows, tints and shades of the same colour are used and the flesh is created by blurring charcoal black into a mixture of lead white, red and yellow

PLATE 3
William Holman Hunt: *The Hireling Shepherd,* 1851. Oil on canvas, 76 cm × 108 cm
City Art Galleries, Manchester
'Select a prepared ground originally for its brightness, and renovate if necessary with fresh white when first it comes into the studio, the white to be mixed with a very little amber or copal varnish. Let this last coat become of a thoroughly stone-like hardness.

'Upon this surface complete with exactness the

outline of the part in hand. On the morning for the painting with fresh white (from which all superfluous oil has been extracted by means of absorbent paper, and to which again a small drop of varnish has been added) spread a further coat very evenly with a palette knife over the part for the day's work, of such consistency that the drawing should faintly shine through. In some cases the thickened white may be applied to the pieces needing brilliancy with a brush, by the aid of the rectified spirit over this wet ground; the colours (transparent and semi-transparent) should be laid with light sable brushes and the touches must be made so *tenderly* that the ground below shall not be worked up, yet so far *enticed* to blend with the superimposed tints as to correct the qualities of thinness and stainness which, over a dry ground, transparent colours used would invariably exhibit. painting of this type cannot be retouched, except with an entire loss of luminosity.'

WILLIAM HOLMAN HUNT

PLATE 4

Rembrandt: *Lamentation over the Dead Christ*, between 1637–1640. Oil on paper and canvas on panel, 31·9 cm × 26·7 cm
National Gallery, London
There is in this work, which may be a grisaille (monochrome) underpainting or a study for an etching, a complex interplay of light against dark, eg the almost central crucifixion and the group with the dead Christ and dark against light, eg the crucified thief on the left and the cross to his right. The main areas, of light and dark show us the basis of the composition, but other relationships of light and dark form a major element in the drama. There are continuous repetitions in the smaller areas of the picture, eg the light against dark of the woman on the right, the dark against light of the horsemen beyond her, echoed in the light diagonal of landscape further on. The arch created by the lamenting group is inverted in the illuminated area behind them and on the left the rungs of the two ladders and cross are a counterchange pattern above the rich interweaving of the dramatically lit figures below

PLATE 5

Titian: *Noli me Tangere*, c 1511. Oil on canvas. 108·6 cm × 90·8 cm.
National Gallery, London
Although there is some indication of linear perspective the mixture of blue with the colours adds to the sense of recession and distance, as does the diminution and blurring of forms

PLATE 6

Joseph Mallord William Turner: *Hastings*, c 1835. Oil on canvas, 90 cm × 122 cm
Tate Gallery, London
Over a ground of cool greys the warm colours of the foreground and the gold in the sky are dragged, scumbled and streaked not only to describe the liquid forms but also to evoke a mood. The fluidity of the application, the near abstract quality of the scene are held together by the strong horizontal where sea and cliffs meet, the dark bar of the breakwater and the vertical orange sail which is the focal point to which the movements of sea and sky are directed

PLATE 7

Georges Seurat: *Rower off the Island of La Grande Jatte in Spring*, 1887. Oil on canvas
Musées Royaux des Beaux-Arts, Belgium
In this picture complementary contrasts of colour are juxtaposed, not by a rigid application of dots as was sometimes done by Seurat's followers, but in a free, more varied manner. Such a mingling of small brushstrokes and spots of colour enabled Seurat to avoid the mechanical appearance which results from a too formal interpretation of Pointillism or as he preferred to call it, Divisionism

PLATE 8

Cosimo Tura: *The Virgin and Child Enthroned*, c 1840. Oil on wood panel, 239·5 cm × 101·5 cm
National Gallery, London

In addition to using colour symbolism, eg the blue of eternity for the robe of the Virgin, Cosimo Tura has arranged his colour in two series of complementary contrasts; red and green, and blue and orange. Each hue enhances the other and there are variations on them with mixtures of black and white giving shades and tints in highlights and shadows. Patterns of colour have also been used with repetitions of hue taking the eye around the picture. In the use of complementary contrasts the painter has also juxtaposed a series of warm and cool colours which reinforce the compositional balance of the work

PLATE 9

Vincent van Gogh: *Sunflowers*, 1887. Oil on canvas, 59 cm × 100 cm
Kröller-Müller, Otterlo, The Netherlands Collection: State Museum

'I have now reached the point at which I have decided no longer to begin a painting with a charcoal sketch. It leads to nothing; one should attack a drawing directly with colour in order to draw well.'

Letter to Theo, September 1888

Although this statement was made the following year it could well apply to this picture for in it paint is used to draw the forms not to colour a drawing. Painted wet into wet with muted complementaries the brushstrokes describe the forms, the growth patterns and structure in an almost analytical way. But there is more. There is a personal response to the subject, not an emotional interpretation, but an expression disciplined and heightened by intense study

PLATE 10

Vincent Van Gogh: *Entrance to the Public Gardens at Arles*, 1888. Oil on canvas, 72 cm × 90 cm
The Phillips Collection, Washington
The simple almost flat plane of the foreground path complements the varigated texture of the surrounding trees and sky. Such contrasts appear elsewhere in the picture; line against

shape, complementary contrasts between blue and orange, red and green and yellow and violet, static figures against the movement of foliage and the interweaving of light and dark. Painted with thick impasto wet into wet this work has obvious references to one of van Gogh's favourite painters Adolphe Monticelli. This is one of a series of paintings of the public garden in Arles which van Gogh painted for the room Gauguin was to occupy when he came to stay at the Yellow House.

'I have expressly made a decoration for the room you will be staying in, a poet's garden. The ordinary public garden contains plants and shrubs that make one dream of landscapes in which one likes to imagine the presence of Botticelli, Giotto, Petrarch, Dante and Boccaccio. In the decoration I have tried to disentangle the essential from what constitutes the immutable character of the country.
 'And what I wanted was to paint the garden in such a way that one would think of the poet from here (or rather from Avignon), Petrarch, and at the same time of the new poet living here – Paul Gauguin . . .'

Letter to Gauguin
Arles 29 September 1888

PLATE 11

Paul Cézanne: *Garden of Les Lauves*, c 1906. Oil on canvas, 65·5 cm × 81·3 cm
The Phillips Collection, Washington
Three horizontal strips divide the picture-plane and it is evident that at this early stage the painter has been concerned with establishing colour and tonal values across the whole of the canvas rather than with the resolution of one particular area. Herbert Read used this picture to illustrate the meaning of *modulation* in Cézanne's work.

'Modulation means rather the adjustment of one area of colour to its neighbouring areas of colour: a continuous process of reconciling multiplicity with an overall unity' Cézanne discovered that solidity or monumentality in a painting depends just as much on patient 'masonry' as on the generalized architectural conception. The result, in terms of paint application, is an apparent breaking up of the flat surface of the colour-area into a mosaic of separate

colour facets. This procedure became more and more evident during the course of Cézanne's development, and is very obvious in a painting like *Le Jardin des Lauves* ...'

<div align="right">HERBERT READ

A Concise History of Modern Painting

London, 1959</div>

PLATE 12

Claude Monet: *Wisteria*, *c* 1920. Oil on canvas, 1 m × 3 m
Collection of the Musée Marmottan, Paris Photograph by Routhier
Copyright SPADEM 1983
At the same time as he was working on the famous series of Waterlilies, Monet was painting other parts of his garden at Giverny. These pictures, perhaps not so well-known as the waterlilies and many of them apparently incomplete, are a valuable record of Monet's working procedure showing as they do various stages of development of the same motif. This picture is one of a number on the wisteria theme. It is easy to see the relationships between a painting such as this and those of the American Abstract Expressionists of the 1950s.

PLATE 13

Claude Monet: *Water Lilies*, *c* 1920. Oil on canvas, 1 m × 3 m
Collection of the Musée Marmottan, Paris Photograph by Routhier
Copyright SPADEM Paris 1983
This unfinished work shows how Monet began his late paintings with colour indicating movements and directions. Although parts of the canvas are almost covered with pigment the emphasis has been on establishing compositional rhythms and colour relationships in a linear manner.

'These landscapes of water and reflection have become an obsession. This is beyond the strength of an old man, and yet I want to express what I feel. I have destroyed some of the canvases. I begin once again ...'

<div align="right">CLAUDE MONET

11 August 1908</div>

PLATE 14

Paul Gauguin: *La Belle Angéle*, 1889. Oil on canvas, 89 cm × 72 cm
Jeu de Paume Museum, Paris
An example of what is sometimes called dual space, this picture is organised in a way which emphasises the fact that it is a painting and not an illusionistic representation of nature. The colour organisation in both areas is the same with mainly red and orange in the foreground and blue and green in the background forming a link between the two parts. Apart from the obvious use of complementary contrast the colour also serves to indicate space. There is little linear perspective in the work but the advancing warm colours and the receding cool ones reinforce the simple spatial convention that what is placed at the bottom of the picture-plane is nearer to the spectator than that which appears at the top.

'Gauguin has sent me a few new canvases ... there is *one* painting which is again a really beautiful Gauguin. He calls it *La Belle Angéle*. It is a portrait arranged on the canvas like the big heads in Japanese prints; there is the bust-length portrait with its frame, and then the background. It shows a seated Breton woman, her hands joined, black costume, violet apron, and white collar; the frame is grey and the background is of a beautiful lilac-blue with pink and red flowers. The expression of the head and the position are very well achieved. The woman somewhat resembles a young cow, but there is something so fresh and also so full of rustic flavour that it is very pleasant to behold.'

<div align="right">THEO VAN GOGH

Letter to his brother

5 September 1889</div>

This painting, rejected by the sitter, Mme Satre the wife of a builder in Pont Aven was later purchased by Edgar Degas at Gauguin's auction in 1891

PLATE 15

Henri Matisse: *The Piano Lesson*, 1916–17. Oil on canvas, 245 cm × 212 cm
Museum of Modern Art, New York. Mrs Simon Guggenheim Fund
Copyright Spadem 1983

There is no concern with a naturalistic interpretation of space in this picture. Matisse establishes the flatness of the picture-plane by means of unmodulated areas of colour and a neutral grey which extends from the top of the canvas to the bottom linking garden and room. On this ground he has placed simple geometric areas of complementary pink and green, blue and orange in distinct horizontal and vertical shapes.

The whole of this large painting is a series of analogies, contrasts and repetitions. The head of the artist's son is placed between the un-finished painting of a clothed and formally posed woman and a sculpture of a casually seated nude. An obvious link is made between the curves of the music rack and the wrought iron of the balcony and further relationships are made between the triangular area of grass, the metronome and the inverted triangles of grey and orange on the boy's face. The strong vertical and horizontal composition suggests a tranquility emphasised by the emptiness of the central part of the canvas. Curves running across the lower portion complement the rigidity, the perspective rendition of the metronome breaks the overall flatness.

PLATE 16
Adrian Ryan: *Villas in Provence*, 1976. Oil on canvas, 50 cm × 66 cm
Private Collection

This picture was painted on a closely woven flax yarn which had been given a coating of glue size, and several layers of white lead diluted with white spirit.

I prefer a smooth canvas to one of coarser grain as I like to start my paintings with washes of transparent pigments using them like watercolours

Only when the local colours have been washed on, and the darkest values established in this way, do I introduce white to my palette. Opaque paint is now used to build up the half tones and thicker impasto employed in the lightest areas. I use a quicker drying medium than turpentine – ie lighter fuel – and no oil medium as this delays the drying process. I am anxious to continue dry on dry as soon as possible. Another benefit for me of using a fine grained canvas, is the ease with which unwanted paint can be removed with the palette knife, and the original surface recovered. How often this needs to be done is reflected in the words of Chardin – 'how many attempts now happy – now unhappy.'

ADRIAN RYAN
to the author 1982

85

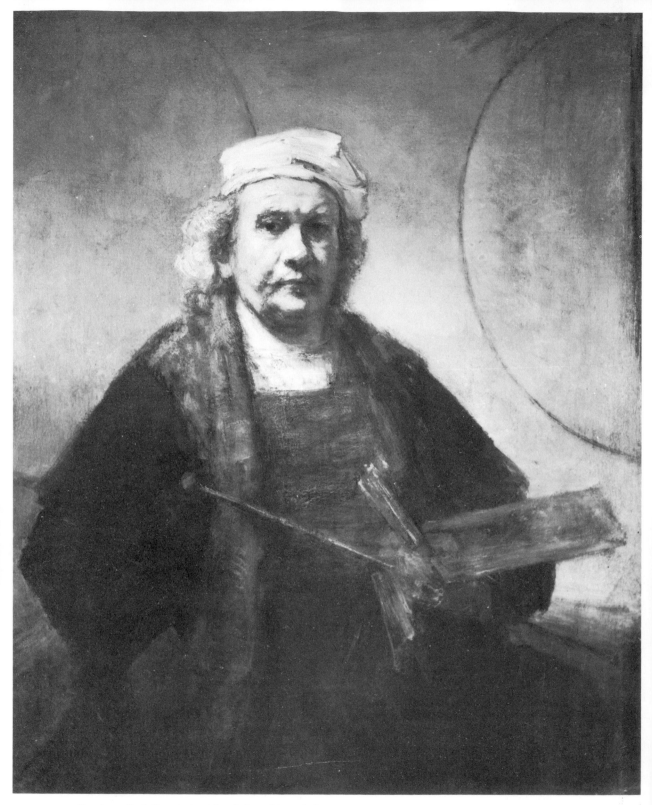

47 **Rembrandt:** *Self-portrait with palette and two circles,*
c 1659–60. Oil on canvas, 114 cm × 94 cm
Kenwood House, London. The Iveagh Bequest

Techniques

'Be a good workman first of all, it won't prevent you from being a genius.'

Renoir to Georges Rivière

'When we look at the work of the old masters, we have nothing to congratulate ourselves on. What marvellous craftsmen they were! They knew their job; that's the whole secret. Painting isn't just day-dreaming; it's primarily a manual skill, and one has to be a good workman.'

Renoir to Albert André

GENERAL

Technique for the artist is not the aquisition of a set of clever tricks which will enable him to produce work of a similar nature over and over again with the minimum of effort, or make the spectator comment on his ability; it is the way in which he, as an individual, applies his materials so that they express most forcefully what it is that he wishes to communicate. Although, through continuing use, certain methods concerning what the materials will and will not do, how they should be applied if they are not to deteriorate, may well become a habit, the good painting will be the result of hard work not sleight of hand. There are no easy rules to learn, each new painting presents a new challenge and the painter responds not by avoiding the problems but by attempting to solve them in an honest manner. The means of expression used will be those most appropriate to the work, extended and invented upon when necessary; Titian pushing the pigment around with his fingers, Rubens leaving patches of streaky grey ground exposed, Van Gogh squeezing colour onto the canvas directly from the tube, Bonnard scratching the paint with palette knife or brush handle, Picasso sticking oilcloth onto the picture-plane to make the first Cubist collage, Jackson Pollock dripping decorator's paint from brush or can and Morris Louis staining large areas of bare untreated canvas.

There is no one correct method of painting in oil colours for the medium is such that it may be used in a number of ways allowing greater flexibility than probably any other medium. If a degree of permanence is to be maintained though it is essential that certain rules or procedures are followed. The indiscriminate application of pigment and oil may result in cracking, darkening and colour alteration and although not everyone is painting for posterity no artist wishes to see his work deteriorate. Careful choice of colours and an awareness of their properties, a sensible use of oils and dilutents in recommended mixtures and carefully prepared grounds and supports are of paramount importance. This does not mean large amounts of time and effort which impinge upon the act of painting, but simply a little intelligent care.

The nature of oil paint is such that it may be applied either in transparent glazes or in opaque layers. The oxidization of the binding oils used gives a depth to the colours unobtainable with other media and the ability of the artist to alter the consistency of the pigment with different oils and varnishes allows for a great deal of variation. Opaque paint may be used to build up areas to varying thicknesses, to form a basis for glazes or as direct painting, in certain instances obliterating any underpainting. These two qualities of the medium, its transparency and opacity, do in some measure reflect what may be termed the two main

methods of painting, namely the planned picture built up with successive layers of colour and sometimes making use of glazes and the more immediate and direct method of alla prima. This description of two technical approaches to oil painting is, of course, a very rough approximation and there are numerous combinations and variations.

GLAZES

A thin transparent glaze of oil paint laid over a white ground, a light toned underpainting or an area of heavy impasto is given a deep glowing luminosity which is unobtainable with any other medium. The overlay of colours applied in this way is different from a mixture of colours made on the palette. The successful use of glazes involves the overlaying of many, not just the one; with details of light and dark worked into each whilst wet to give greater depth.

UNDERPAINTING

It is necessary to have some form of underpainting if one wishes to use glazes so that details of drawing and tone may be united by the glaze and give some substance to the coloured shape. Many of the Old Masters painted their subjects in tones of grey, terre verte or some form of monochrome (grisaille), often starting with a mid tone into which they worked the shadows and highlights prior to the application of the glaze. In such a manner a painting could have its three-dimensional form developed before the addition of detailed colour. Unfinished works by Leonardo da Vinci, Michaelangelo and Rubens show evidence of this. Not all underpainting is a prelude to the use of glazes. Many painters begin their work by brushing in large areas with diluted paint in order to organise their picture in terms of its simplest shapes and

48 Detail of an unfinished painting showing glazed areas of dark

49 Cecil Collins: *The Artist and His Wife*, 1939. Oil on
canvas, 91 cm × 119 cm
Private Collection

'I built the painting up in layers on a white
lead ground to allow the light to reflect
back off the ground, giving an inner light
to the colours.'

CECIL COLLINS to the author, 1982

colour masses. To determine the balance and basic tonal relationships in this way is a sensible approach breaking down, as it does, the complicated production of a picture into smaller more manageable stages. After the work has been so organised in its most basic form other more detailed aspects may be developed so that the painter, progressing from the broad general concept of the work to the particular will not be distracted by considerations which are best kept until a later time.

50 **Michaelangelo:** *Entombment* (unfinished), begun *c* 1506. Oil on panel, 1·61 m × 1·49 m.
National Gallery, London
This incomplete work shows how the painter has developed different parts of the picture. It is quite probable that no section is complete and that in addition to those areas which are obviously unfinished the heads, figures and draperies would have received further layers of glaze

a The first stage underpainting with mixtures of raw umber and white may be seen in the tree and logs. The artist prefers the coarseness of cotton duck to canvas for his large paintings.

b This detail of the picture shows partial glazing on the house and tree and dry paint scumbled on the roof.

51 **John Plumb:** *Clougy House No. 4.* Oil on cotton duck, 1982. 1·7 m × 1·2 m
Collection of the artist

'When painting studio pictures which could perhaps take some considerable time to finish, I like to begin with an underpainting. This traditional method of working has, for me, many advantages. It enables me to keep the painting in a changeable state, and consequently I can alter the drawing and the design at any stage. The underpainting is carried out with raw umber and titanium white mixed to achieve all the varying tones of the composition. At the end of each day's painting I like to blot the whole surface of the picture with tissue, so removing excess paint, Any succeeding changes are unobstructed by ridges of paint that might have been there if the surface had not been blotted. When the drawing and design are fully realised I allow the underpainting to dry thoroughly. I then proceed to apply the colour, directly, glazing and scumbling according to the necessary resolution of the experience.'

JOHN PLUMB
to the author 1982

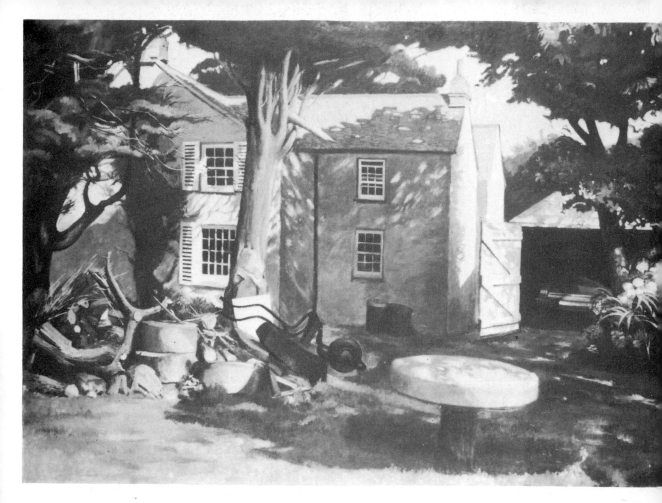

c The entire picture. This unfinished work shows the various stages and methods. The underpainting on the left, the glazes, scumbles and directly applied pigment of the more finished central and right-hand sections. Cool glazes have been applied on the shadows whilst the garage and rhodedendrons are in direct paint.

ALLA PRIMA

This is a direct and immediate way of painting usually with opaque colours which obliterate all sign of underpainting or preliminary drawing. The Old Masters used it for making studies and sketches mainly from nature and for completing a work over an underpainting done by their assistants. The Italian name means 'at first' (the French is Au Premier Coup) and consequently describes those paintings which are completed at one 'sitting'. The distinction between definitions is hazy and it is but a short step from the alla prima paintings of Constable or Van Gogh to the Wet into Wet techniques of the French Impressionists or Picasso.

For examples of alla prima painting it is worth looking at the later works of Van Gogh, particularly those pictures which were painted after 1887 and which in all probability were done at one sitting. Most of the landscapes which he produced in Arles and St Rémy were done from the motif in one session and in his letters to his brother Theo he describes his method of taking one or more canvases on his trips into the countryside and completing them during the course of one day. A comparison between the sketches and finished paintings of the later works of Constable is also worth making for it will readily be seen that in the large scale sketches for such works as 'The Hay Wain' and 'The Leaping Horse' the preliminary studies have a liveliness and freedom of brush-work, a sense of light and spontaneity which the more finished works lack.

52 Vincent Van Gogh: *Long Grass with Butterflies,* 1890, detail. Oil on canvas, 645 cm × 807 cm
National Gallery, London

53 Camille Pissarro: *Boulevard Monmartre, Night Effect,* 1897. Oil on canvas, 53·5 cm × 64 cm
National Gallery, London
The sky and road have pigment scumbled over dry dark paint whilst the lights, pavements and people are painted wet into wet

54 Detail

'It is a question of houses in groups, crossing carriages, moving pedestrians. One has no time to see a man, a carriage and the painter who lingers over detail will fail to catch the confusion of movements and the multiple spots which form the whole.'
GUSTAVE GEFFROY

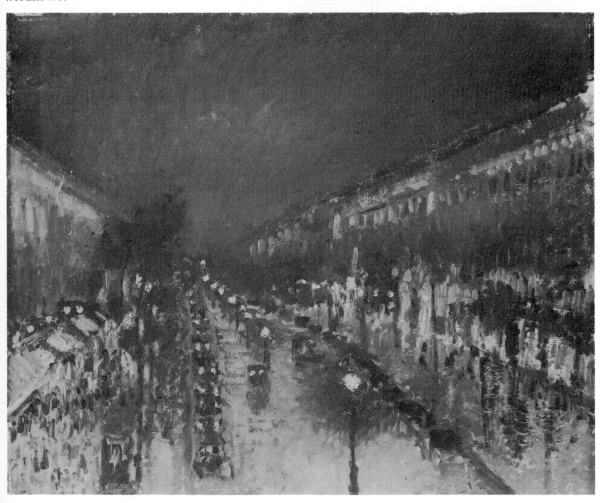

55 Detail of painting wet into wet

WET INTO WET

This type of approach is a variation of alla prima and means that a work if not completed at one session is continued whilst the first application of paint is still wet so producing a work which may seem to have been finished at one time but which has taken longer and enabled the artist to paint his colours into each other in a way which has allowed alterations to be made and colours to be fused together. A number of the French Impressionists often worked in this way most notably; Monet, Pissarro, Sisley and Renoir.

IMPASTO

Thick paint laid onto the canvas with brush or knife is called impasto. The work of Van Gogh, Soutine and de Stael, show the use of impasto as direct painting, but it has often been used as the

basis for glazing and the building of solid three-dimensional forms as may be seen in the underpainting of certain parts in the pictures of Rembrandt who applied heavy encrusted areas prior to glazing; as did Turner and Courbet.

56 Rembrandt: *Woman Bathing in a Stream*, 1655
Detail, Oil on panel, 62 cm × 47 cm
National Gallery, London
Dark glazes over an underpainting with opaque impasto for the lights

57 Detail of impasto photographed in a raking light

SCUMBLING

Paint brushed freely over a preceeding layer is said to be 'scumbled' on. Usually it is dry opaque colour which is applied in this way and it is done in such a manner that the underpainting shows through in irregular patches. The manner of application depends on the results that the painter desires and so the pigment may be loosely laid dark on light or light on dark with stipples or streaks from a brush or smudges with a finger or rag. Examples of such a treatment may be found in the works of painters as diverse as Titian and Bonnard. Indeed, the study of paintings by both artists will reveal a variety of colour combinations and textural contrasts which excite the eye with a richness and mystery from which the student of painting can learn a great deal about the application of pigment; its affinities and contrasts.

58 Roderick O'Connor: *Still Life with Bottles,* 1892
Tate Gallery, London
The heavy impasto and strong directional brushmarks
give this work a textural quality. Perhaps such treatment
makes the spectator more aware of the technique than
the form and content of the painting

59 Detail showing dark glazed area and light impasto

60 Detail showing light pigment brushed over a mid-toned ground

61 Detail showing light pigment scumbled over a
darker ground (lower part) and wet into wet (upper part)

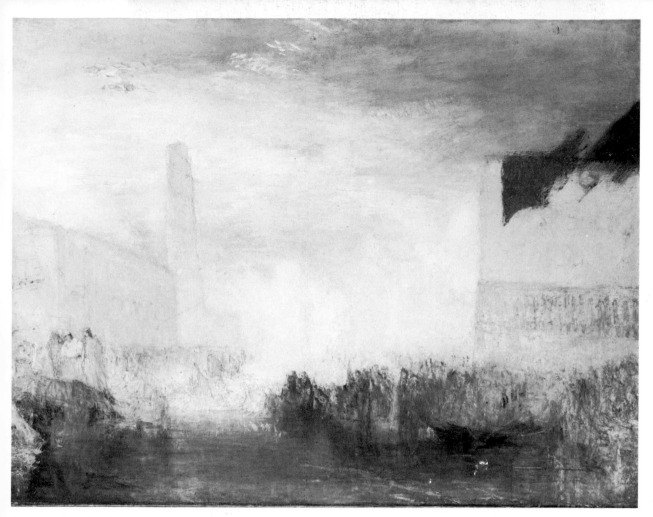

62 Joseph Mallord William Turner: *Venice, The Piazzeta with the Ceremony of the Doge Marrying the Sea, c 1835.*
Oil on canvas, 91 cm × 122 cm
Tate Gallery, London
This almost abstract painting by Turner shows areas of impasto, glaze, and scumble

ENCAUSTIC

This is an ancient method of painting and consists of mixing molten beeswax with pigment. Sometimes a resin is included as a hardening agent. The mixture is applied whilst hot and may be modelled by brush, spatula or other instrument. After application the colours are fused with heat. The Romans used hot irons to merge the pigments of encaustic murals into the walls on which they were painted but any form of radiant heat can be used. If a resin has been used the result will be hard and can be polished. The Fayum mummy portraits, pro-

duced between the first century BC and the third century AD are probably the best known examples of ancient encaustic painting. There is an account of the technique in Pliny and Leonardo da Vinci made unsuccessful attempts between 1503–1505. The plastic consistency of the medium lends itself to works done with thick impasto and on occasion Van Gogh would add beeswax to his pigment in order to create thicker and more pronounced brush marks.

The contemporary American artist Jasper Johns has used encaustic, sometimes in conjunction with collage and sometimes as a means of fusing the wax and paint with other materials. Pieces of paper or cloth dipped into molten encaustic can be applied to the surface of the picture to build up layers of differing levels and if done with transparent colour or the wax on its own, their textures, and patterns will be visible.

63 *Mummy of Artemidorous*, detail. Encaustic. From the
Fayum, Egypt
British Museum, London

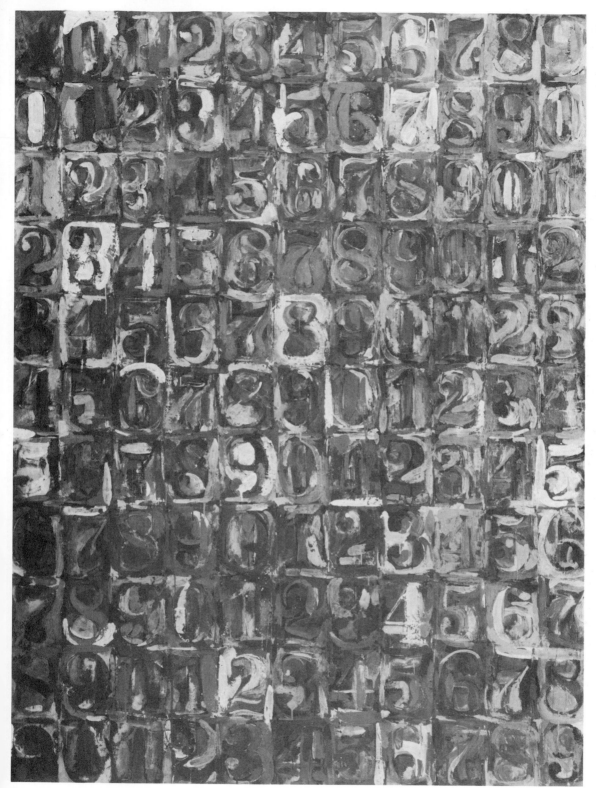

64 Jaspar Johns: *Numbers in Color*, 1959. Encaustic
and collage on canvas, 1·6 m × 1·2 m
*Albright-Knox Art Gallery, Buffalo, New York, Gift of
Seymour H. Knox, 1959*

PAINTING WITH A KNIFE

Although most painters use a brush for the application of colour to the canvas there is no restriction and it is possible to use a variety of implements according to the results desired. Obviously, over the centuries it has been proved that the brush, or rather a selection of brushes, is the most versatile tool for painting, but a painter should be prepared to apply or alter an area of pigment with a knife, rag or finger. What is important is that whatever implement is used the 'technique' does not come between the spectator and what the painter is expressing. This sometimes happens with the excessive and unsubtle use of a knife often seen in amateur painting, but one has only to look at the works of Turner and Courbet to see how in the hands of a sensitive and intelligent artist

65 **Jaspar Johns:** Numbers in Color (detail)

66 The application of pigment with a painting knife

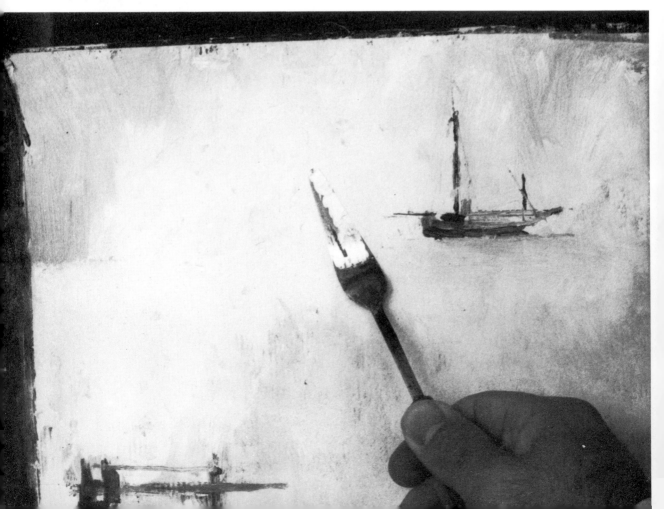

this method of painting can be a means of fusing the paint and the subject; the form and the content.

Not that everyone has always thought Courbet a great painter. Walter Richard Sickert in an article, *French Painters of the Nineteenth Century at the Lefèvre Galleries* attacked him on a number of counts one of which was his use of the palette knife for painting. Although one may be out of sympathy with the criticism of Courbet as an artist what Sickert had to say about the technique is worth consideration.

'Good painters have sometimes dallied with this trick. But to the extent that they have, such passages have suffered. Their avoidance of it may be said to be the measure of their aesthetic instinct. That instinct has told them, firstly, that the knife cannot draw with the sensitiveness of the brush. Their knowledge of the very stuff of their craft has also told them that oil paint needs air – that a surface spread with a knife produces two things, a bag of wet paint sealed up in a glassy skin. The wet paint dries too slowly and shrivels, and the impervious skin darkens. The painter's traditional instrument produces, with its bristles, the minute furrows in the surface of the painting which have a double effect. The air has access to the paint and dries it soundly through and through. And secondly, the tooth thus given by the brush to the surface gives a hold to each subsequent coat of paint.'

WALTER RICHARD SICKERT
in *The Nation and Atheneum*
19 May 1923

STAINING

Canvas may be stained with applications of thinned pigment rather in the manner of watercolour. Such an approach makes considerable use of the tooth of the canvas and some painters prefer to stain unprimed canvas which not only shows the weave in a more pronounced way but is absorbed into the canvas rather than just staining the ground. Some artists, for example, Morris Louis produce their work entirely with stains of colour whilst others, such as Francis Bacon, stain only parts in contrast to the more thickly painted areas.

'... I work on the reverse side of the canvas and a great deal of the canvas is only stained and it's impossible to give it a texture with varnish or anything, which might bring up the life of it. By glazing them (putting them behind glass) I feel that it gives an added depth and texture to the quality of the paint that I use. I couldn't do the particular thing I'm trying to do, which is to make a chaos in an isolated area, with other types of paint. I need this absolutely thin stained background, against which I can do this image that I'm trying to do and have never really achieved.'

FRANCIS BACON
Interview with David Sylvester,
Sunday Times Magazine
(London), 14 July 1963

67 **Francis Bacon:** *Three Studies for a Crucifixion*, 1962. Oil on canvas, each panel 198 cm × 145 cm
The Soloman R. Guggenheim Museum, New York

68 **Francis Bacon:** *Three Studies for a Crucifixion*, 1962, detail of right hand of triptych showing dry brushwork and imapsto over a stained ground

Spraying

Paint may be sprayed onto the picture surface with an implement as simple as a spray diffuser through which one normally blows fixative onto a charcoal or pastel drawing. Larger areas may be covered with a spray gun – but for fine drawing and delicate gradations of colour an air brush will be essential. (See section on air brushes.)

The contemporary British painter Michael Andrews has on occasion matched the technique of the spray gun with the subject of his painting. In 1970 he began a series of works based on the theme of an air balloon and for this he sprayed the paint onto the canvas; on some of his paintings of fish he used aquarium gravel to mask certain areas and on others applied the paint with sponges. Such technical 'puns' are interesting but may quickly become meaningless games if given undue emphasis by the over-zealous student. Often the paint used for spraying is acrylic, as on the Andrews' pictures, the quick drying nature of this type of pigment allows for overlapping layers and the optical mixture of colour. Work in oil paint may be done on top of it without harm to either. Acrylic, however, should not be applied over oil paint.

STENCILLING

On occasion some painters use stencils to repeat a motif a number of times or use established letter and number forms. Apart from such readymade ones, stencils may be cut from card or the specially prepared waterproof papers such as are used in the making of silk-screens for printing, or some readymade material such as wire mesh may be used. Roy Lichtenstein, the American Pop Artist has for some of his work, like the comic-strip based 'Whaam' (1963) used perforated metal sheeting in order to simulate the dots associated with cheap colour printing. Paint may be applied through stencils with almost any type of brush or rag.

Staining differs from glazing in that it is applied to the support rather than to an underpainting and as the name implies there is an element of absorbtion in the technqiue. Certain colours with little strength in themselves and normally used for mixing tints are obviously unsuitable. Terre Verte produces a weak somewhat insipid stain whilst Viridian has much greater strength, and these differences exist throughout the colour range; Prussian Blue has more staining power than Cobalt Blue, Light Red more than Rose Madder and Chrome Yellow more than Lemon.

69 **Sam Francis:** *Around the Blues*, 1957–1962. Oil and magna color on canvas, 274 cm × 487·5 cm
Tate Gallery, London

70 **Roy Lichtenstein:** *Whaam*, 1963. Magna color on canvas, 172 cm × 269 cm
Tate Gallery, London. Copyright SPADEM 1983

71 **Roy Lichtenstein:** *Whaam* (detail)
The 'dot for dot' effect similar to that used in commercial
reproduction processes was obtained by brushing paint
through a perforated metal sheet with a toothbrush. Flat
areas of colour were painted light to dark with the black
lines finally drawn over the coloured areas

Special stencil brushes are not necessary. An old toothbrush will make an acceptable substitute. Finer work may require gentler treatments and a hog hair or sable brush can be used. For making straight lines masking tape, which may be purchased in varying widths, is sometimes of use, particularly if the work is of a decorative nature. Care should be taken to ensure that the tape is stuck properly to the picture surface to avoid paint seeping under and the tape should not be allowed to remain stuck to the picture for longer than is absolutely necessary. Despite manufacturers' claims to the contrary, masking tape can become difficult to remove and will, if left too long, leave traces of adhesive.

AIRBRUSHING

Airbrushes are not in common use with painters in oil colour, being suited more to the gradual modulations of colour desired by commercial artists and designers and those requiring effects similar to the photograph rather than painting. First patented by a British artist, Charles Burdick in 1893 the airbrush has been developed into a highly sophisticated precision instrument capable of producing, in skilled hands, the most delicate of colour gradations and the finest of lines. It may also be used for creating areas of solid colour and roughly textured surfaces with a variety of 'splatter' or dotted effects. Originally airbrushes were used to re-touch photographs and simulate photographic images and are in the main still used for these purposes, especially in the fields of technical illustration where realistic pictures are required of details which cannot be reached by the camera.

Works done by airbrush are usually created with water soluble paints or inks rather than those bound with oil. Quick drying, finely ground pigments are better suited to the techniques of airbrushing, but it is possible to use good quality 'Artists' oil colour providing that it is evenly diluted with turpentine. Free flowing, completely dissolved pigment is essential for all airbrush work otherwise the nozzle of the airbrush will produce unwanted and uncontrolled 'splatter' and become clogged.

Straight lines are airbrushed by holding a steel rule a few inches above the picture-plane and sliding the nozzle of the airbrush along the edge. They may also be made by masking the surface of the picture with paper, card, masking film or fluid and spraying along the edge at a 90 degree angle. Different angles produce different results. Wide lines are made by holding the airbrush away from the mask so that a larger area of the picture is covered and thin lines drawn by keeping the airbrush closer to the surface of the picture. Masking film is used to protect part of the image so that lines and gradations of colour may be made with the maximum control. Such a method, it will readily be appreciated, means that slow drying oil paint is something of a disadvantage. Smudging and the unintentional mixing of colour are problems not easily resolved in the short term.

Solid areas of colour are created by holding the airbrush three or four inches above the surface of the picture and making a number of overlapping horizontal sweeps at the end of which the nozzle should be cleared of paint so that inadvertent blotches do not occur. By altering the shade of colour gradated tones may be produced so that areas such as a sky may be lightened or darkened. Colours may also be made to merge in the same way. Additions of colour and changes of tone can, in the hand of the practiced artist, produce the most subtle blends. Such a use of the airbrush may indicate depth and the third dimension in a manner difficult to achieve by other means. Whether using transparent or opaque colour it is best to work from light to dark as this will not only retain the luminosity of the ground and the qualities of the underpainting but make easier the obliteration of any mistakes.

Most difficulties with airbrushing are caused by inadequate cleaning and may be overcome by careful preparation of the equipment and

paint and intelligent maintainence. The most usual problem is that of spitting colour when the needle of the airbrush is blocked with coarse particles of paint. This may be cured by manipulating the needle in a circular manner. Such rotation usually clears the blockage but if it does not this is probably because the pigment is too thick and unless the air pressure can be substantially increased it will be necessary to remove the paint from the reservoir and thin it to allow for easier flow. The painter should always remember that if he is to avoid blobs and splotches of paint at the end of a stroke he must release the control button forwards before upwards. Failure to do this will result in blots of colour being emitted at the end of spraying and the build-up of paint in the nozzle which will produce more blots when the next spraying action takes place. In other words, the paint flow must cease before the air flow at the end of each spraying motion.

Careful attention to the manufacturer's instructions for use and maintainence is essential in order to avoid difficulties. Constant checks should be made to the alignment of the needle and the tightness of its fitting if the irregular flow of paint is to be avoided.

The work of the American Ralph Goings and others of the Super-realist painters of the nineteen-sixties and seventies should be studied by the student interested in the airbrush technique.

COLLAGE

Although there was nothing new in the technique of collage when the Cubists first introduced it into their pictures during the early years of this century, it had not previously been used as an element in painting. Scrapbooks, Victorian screens and other objects might have been decorated with stuck paper, but as an element in painting it was unusual to say the least. Nowadays the collage picture is almost commonplace although often produced without the reasoning which was behind the works of the Cubists, the Dadaists and other twentieth century artists.

The Cubists used collage mainly for two reasons. One was to retain a link with visual reality in pictures which were becoming increasingly abstract and the second was to emphasise the picture-plane; that is, make the spectator aware that rather than viewing an illusion through a window or a proscenium arch, he was looking at a picture which was, whatever the subject matter, first and foremost a painting. Picasso made the first Cubist collage in May 1912 when he stuck a piece of oilcloth onto his canvas to represent the cane of a chair seat; *Still Life with Chair Caning*. Both he and Braque developed the technique until they were producing pictures which were made entirely from stuck paper. Logical and perhaps inevitable variations occurred in the Surrealist, narrative fantasies of Max Ernst, the photomontage of Richard Heartfield, the scrap-paper creations of Kurt Schwitters and the late *papier collé* works of Henri Matisse.

Although not strictly collage, on occasion it is useful to stick a piece of coloured paper temporarily onto the painting in order to see what a particular shape or hue looks like before applying pigment. It is a helpful device and may be extended even to the point of painting onto the paper not just colour but more definite imagery so that an idea can be carried out in several forms before a decision is made and committed to canvas.

72 **Juan Gris:** *Fruit Dish and Carafe*, 1914. Oil and collage on canvas, 92 cm × 65 cm
Rijksmuseum Kröller-Müller Museum, Otterlo,
Holland Copyright ADAGP 1983
As with the Cubist collages of Picasso and Braque the addition of other surfaces to the picture-plane helps to retain links with reality. Lettering, newspaper and patterned wallpapers, sometimes simulating wood or marble, were used by the Cubists to give the spectator 'clues' and ensure that the ever increasing abstraction did not become completely unintelligible

ADDITIONS TO THE PAINT

By adding sand, sawdust, woodshavings and similar materials to the pigment it is possible for the painter to create contrasts of texture which rely not on illusionistic devices but on the actuality of the picture's surface. Such mixtures were used by some of the Cubists in a way which emphasised the reality of the painting as an object in its own right. The building out from the picture-plane evokes in the spectator a response different from the usual one of looking into a picture through a window or proscenium arch, emphasising the fact that the canvas, board or paper is in fact the furthest point from the eye.

Since the Cubists there have been artists who have developed this manner of working until the painting has become a form of relief. Indeed some of Picasso's Cubist works became, with the addition of wood and other materials, a form of sculpture. The line between painting and sculpture has on occasion during this century been difficult to ascertain. Works by the Catalan, Antoni Tàpies and the Italian, Alberto Burri are worth consideration by the student wishing to explore the tactile possi-

73 **Alberto Burri:** *Sacking and Red*, 1954. Sacking, glue and plastic paint on canvas, 86 cm × 100 cm
Tate Gallery, London
Additions to the picture-plane may be such that there is little between what is painting and what relief sculpture. This work, although chronologically later, lies somewhere between the Cubist collage and the wood, paper and paint assemblages of Kurt Schwitters and the painted reliefs of Jean Arp

74 Antonio Tàpies: *Ochre Gris LXX*, 1958. Oil latex and
marble dust on canvas, 260 cm × 190 cm
Tate Gallery, London

75 **Ian Marshall:** *Hill Town,* 1967. Oil and sand on canvas, 61 cm × 76 cm
Private Collection

bilities of painting. The former for his concern with texture and the application of paint, conveying a sense of corrosion and time, the latter for his involvement with waste explored through a wide range of materials.

There is of course a limit to the adhesive quality of oil paint. Pigment mixed with too much foreign matter will not stay on the support. This may also prove to be something of a problem during the painting of the work and for this reason it is sometimes advantageous to apply the 'mixed' paint with the support in a horizontal position on a table or floor. Application with a palette or painting knife is, in this instance, usually better than with a brush.

'The canvas was primed with a flat white paint. I did a very thin, almost colour wash underpainting on top of which I worked directly with pigment, silver sand and white lead mixed with linseed oil. This was applied with brush and knife. The white lead was a coarse, commercial preparation and amazingly it hasn't yellowed.'

IAN MARSHALL
to the author, 1982

76 Sandra Blow: *Blue and White*, 1983. Oil, acrylic and canvas on Gaterfoam Board, 122 cm × 122 cm
Collection of the artist

Notes from the artist state that the work is on one inch thick Gaterfoam board which is polystyrene between two boards low in acid content, light to handle and suitable for applying paper, canvas, etc. The background is an acrylic wash and the canvas shapes are glued onto the surface with Tenaxatex adhesive

113

77 Kürt Schwitters: *Opened by Customs*, 1937–38
Oil and collage on canvas, 33 cm × 25 cm
Copyright ADAGP 1983
Tate Gallery, London

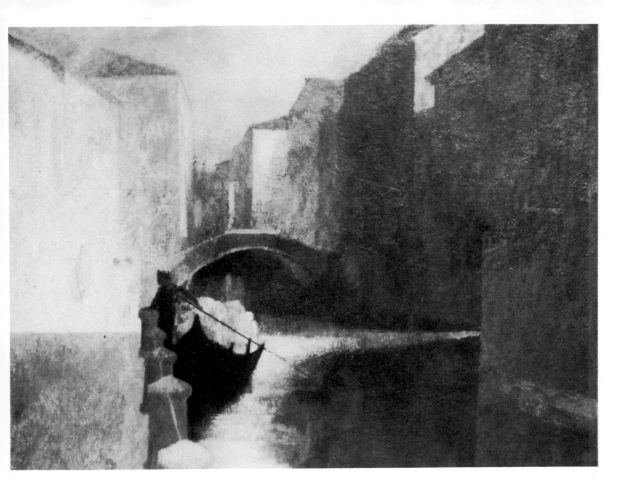

'Painted on hardboard over a ground of grey emulsion paint.

'The scene was laid in broadly with tones of white emulsion varying from transparent to impasto and the colouring applied by mixing oil paint with the white emulsion.

'This required rapid handling as oil paint and emulsion soon begin to separate and become intractable. Scumbling with thin white emulsion was used to modify passages; this in turn was overlaid with oil colour and working directly into emulsion also produced interesting surface qualities which were exploited.

'This use of alternating layers of thin paint allowing underpainting to show through owes something to techniques learned earlier in working in egg tempera.

'Painted over fifteen years ago the surface is in perfect condition, no cracking, no lifting of surfaces and no signs of deterioration in the colouring.'

ARNOLD KEEFE
to the author, 1982

78 **Arnold Keefe:** *Venice, c* 1960. Oil on board
102 cm × 76 cm
Private Collection

79 **Arnold Keefe:** *Venice* detail

SERIGRAPHY

Increased interest in printing techniques over the past twenty years has led to the extension of traditional and, in some instances, commercial methods of reproduction and to the breakdown of strict category definitions. Consequently there is now less distinction between the techniques employed for the so-called areas of Fine and Applied Art than in previous times with correspondingly fewer restrictions on the techniques of printing available to the artist. Prints themselves may not be restricted to one form but may be created with mixed media techniques and so it is hardly surprising that on occasion painters have used forms of printmaking not simply to create an edition or folio but as a basis for painting. Serigraphy, or silkscreen printing is the type which has been most commonly used, allowing as it does for large scale images to be reproduced with either flat or textured colour. The medium's adaptability, with the facility for reproducing photographic images, had considerable appeal to painters in the 1960s and 1970s. The American Pop Artists were amongst the first to exploit this possibility, but whereas Andy Warhol and Robert Rauchenburg may leave the screen printed image obvious as such, either as the main part or an individual section of a picture with little or no additional development of that

image by painting, other artists have used the print as a base upon which to work. Such printed imagery reproduced on a number of canvases can supply the starting point for several interpretations. Upon them the painter may extend his ideas in different ways without having to repeat what are common elements. The triptych *Good and Bad at Games* 1964–68 by Michael Andrews is an example of such a technique. Originally, Andrews thought that he might paint a number of pictures showing the linear progression of a party with the hotel building as the setting and consequently he had several canvases printed. The ink used was water soluble and the artist could therefore stick torn paper shapes across the picture-plane. varnish the surface and then, removing the paper, wash away the unvarnished printing ink from beneath. Into these areas he proceeded to paint the figures. The possibility of silk screening the constant element in a narrative sequence or a series of works is something which has been exploited by another British artist, Richard Hamilton particularly in his *Patricia Knight* and *Interior* pictures of 1964 and the famous *Swinging London* series of 1968–69. In his larger series, *Fashion Plate* (cosmetic study) 1969, Hamilton used a lithographed print on paper to which he added variations in combinations of enamel, acrylic, collage, pastel and cosmetics themselves.

80 Michael Andrews: *Good and Bad at Games*
(Triptych), 1964–68. Oil and silkscreen on canvas,
152·4 cm × 203·4 cm
Australian National Gallery, Canberra
Lawrence Gowing, in his introduction to the catalogue for the Arts Council exhibition of Michael Andrews' work 1981, describes how the artist had a number of canvases screen-printed with a chocolate-brown image of lighted buildings (a hotel on the Costa Smeralda) by a commercial printer. Strips of torn paper were stuck on the canvas and the outlines fixed with varnish. When these masks were removed the printing ink beneath was washed away and the artist painted the figures in the irregular shapes which had been left

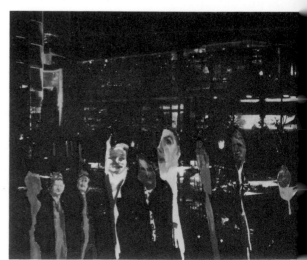

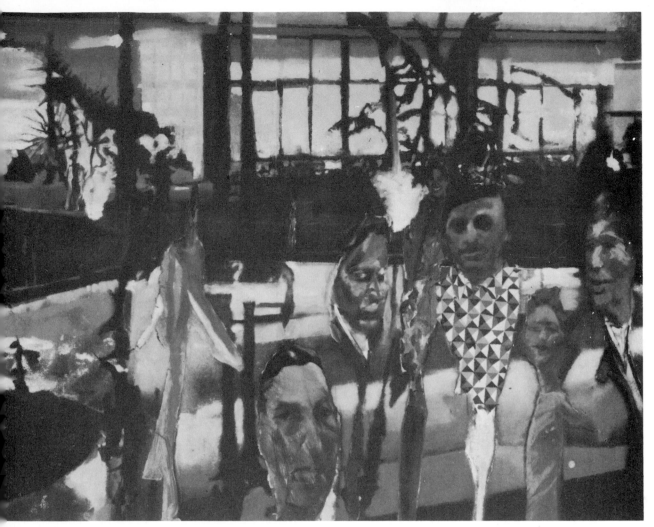

81 **Michael Andrews:** *Good and Bad at Games*, detail of centre panel

82 Richard Hamilton: *Interior II*, 1964. Oil, metal relief and assemblage on board, 122 cm × 162·5 cm
Tate Gallery, London
The woman (Patricia Knight co-star with Cornell Wilde in the 1940s movie *Shockproof*) has been photographed from a still from the film and silk-screened onto the board. Around this figure Hamilton has created an interior of disturbing perspectives with a photograph of the assassination of President Kennedy on the television, a metal back to the chair and an area of free brushwork which corresponds to the dead body found by Patricia Knight in the film scene on which the picture is based

PAINTING FROM PHOTOGRAPHS

Painting from photographs has not always met with the approval of critics, nor indeed with many artists. The need for primary source material in the painting of representational work has been, and in some quarters, still is, considered to be of paramount importance.

Many teachers believe that the practice of working from photographs is to be deplored and can only lead to the production of inferior pictures even when painted by established artists.

There is danger in working from photographs, especially for the beginner. Not always aware of the alterations to reality and the type of information presented by such images, it is possible to be seduced by the superficial. Contrary to popular belief the photograph is not a true representation of reality. Alterations to spatial relationships, distortions of perspective and colour, lack of definition or even excessive detail may lead the unsuspecting beginner into difficulties from which he may not easily be extricated. Furthermore, there is the loss of that communion with the subject through which the student learns to see and which at times can become an act of contemplation.

However, it must be said that the photograph may well become the subject itself. To copy blindly a postcard, or illustration from a brochure or a photograph not taken by himself will usually be a futile occupation for the beginner. In the hands of the intelligent painter it may well become a useful piece of reference or the basis on which some statement about technical processes or mass communication may be made. Until fairly recently it was not widely known that many painters during the last century used photographs as source material. Delacroix and Courbet both drew and

84 Edgar Degas: *Beach Scene*
Detail showing how the striped blouse has been painted so that the pattern describes the form. This pattern is placed against the soft quality of the young girl's hair and the more textural paint of the nurse's blouse, brushed on in strokes which suggest its starched crispness.

83 Edgar Degas: *Beach Scene, c* 1877. Oil on canvas, 47 cm × 82·6 cm
National Gallery, London
Although it is not certain that Degas painted this picture from a photograph there is something of the 'snapshot' in the seemingly casual arrangement emphasised not only by the asymmetrical composition of light and dark forms, but also by the figures walking out of the frame at the left and the towel touching the right-hand side of the picture-plane

85 Sickert and Gwen Ffrançon-Davies **walking to the Royal Academy,** *Sunday Graphic*, 24 July 1932

painted from photographs of the nude, The Pre-Raphaelites William Morris, Edward Burne-Jones and Ford Maddox Brown used photographs for information on landscape and costume as well as for portraiture. The experienced artist may of course learn much from the medium and use it to advantage. Degas, a keen photographer himself, fused the snapshot effect of haphazardly composed photographs with the pictorial organisation of Japanese woodcuts; Sickert worked from newspaper photographs and photographs of specially created figure compositions; Gustave Caillebotte exploited the wide-angled distortions of streets and buildings; and Marcel Duchamp and the Italian Futurists took the sequential photographs of motion by Eadweard Muybridge and the chronophotographs of Etienne-Jules Marey along with aspects of cinematography as reference for their experiments in the painting of movement.

Developments in photographic reproduction have provided painters during this century with a basis for their work. Andy Warhol, Tom Phillips, Richard Hamilton, and Alain Jacquet are examples. Later interest in the sharp focus and incredible detail possible with modern lenses and film emulsions has produced in the

work of such Super- and Hyper-realist artists as, Philip Pearlstein, Chuck Close, Ralph Goings and Claudio Bravo paintings which at times, especially in reproduction, look remarkably like photographs themselves. Such verisimilitude, often created with a reliance on an airbrush technique not dissimilar to that of the advertising designer and photo-retoucher, may not be to everyone's liking, but it is one more manifestation that the photograph has become, during the course of this century, both an aid and a subject for the artist.

86 Gustave Caillebotte: *Rue de Paris; temps de pluie* (Paris, A Rainy Day, Intersection of the rue de Turin and the rue de Moscou), 1877. Oil on canvas, 209 cm × 300 cm
Art Institute of Chicago. Charles H and Mary F S Worcester Fund Income
Caillebotte's use of photography in the composition of his paintings is well known. This work, in company with several of his formal compositions, presents a spatial organisation with acute perspectives. A broadened foreground and reduced distance relate not to that which may be seen in one view by the eye or the normal lens of a camera, but to the distortion created by a wide-angled lens
See also figures 151 and 152

87 **Dorothy Russell:** *The Mettam Family* – 1909, 1982.
Oil on canvas, 92 cm × 122 cm
Collection of the artist

'Early photographs record important occasions.

'The family was gathered together, dressed up in its best clothes and arranged carefully, according to status. Mostly, the groups were posed in a photographic studio, with a painted background showing drapery, parlour palms or stained glass windows. The picture illustrated here is unusual in that the setting of the original photograph is in a real place.

'My mother's family was summoned to be present in the orchard on that summer's day so long ago – Yorkshire men in their cloth caps and their dark suits, the women in spotless aprons – one can now only guess at the reason for their gathering.

'I started my series of paintings taken from old family photographs using sepia based monochrome, like the actual photographs, making a freely executed interpretation, and adding lettering as a kind of title to the work, naming people, date and sometimes place. As the series developed I started using full colour, placing the figures in an ornamented and gilded border to produce a substantial decorative effect.

'The painting here is in oil on canvas sized with rabbit-skin glue and primed with an oil based primer. I usually work from an enlarged print taken from the original photograph (any good high street photographer will be able to do this and it is surprising how much detail emerges). The print is then squared up and transferred to the canvas. This rather meticulous start, drawn in pencil, of the figures, acts as a framework for the free development of the border, group and lettering which are drawn with a brush onto a coloured (burnt sienna) ground. The picture then stays as a coherent whole.'

DOROTHY RUSSELL
to the author, 1982

PHOTOGRAPHY

Photography can also provide a physical base for painting as well as the starting idea in terms of subject or viewpoint. The two main problems with using a photograph as the basis upon which to paint are the limitations which such a definite image imposes upon all but the most skilled and experienced painter and the practical difficulty of applying pigment to photographic paper. In some measure this latter problem may be overcome by the use of special black and white document paper which, instead of the more usual surface which is found on photographic paper, has a texture something similar to cartridge paper. It is therefore perfectly possible to paint on this although it is really more suited to work being done with pencil, pastel or watercolour paint. The problem of overcoming the positive and uncompromising character of the photographic image itself is less easily solved. Firstly the painter has to decide why he particularly wishes to work on a photograph. If it is just to tint it, then he is wasting his time as a painter. Enjoyable though that approach may be it has nothing to do with painting. If on the other hand he wishes to make some statement about the nature of painting and photography, the relationship between the mechanical and the hand-made or create a series or sequence of images upon a mass produced base he may well find that a photograph is appropriate. Two main methods of working are worth consideration. One is to make statements which are in the character of the photograph itself, that is to work within the realm of the photo re-toucher and make deletions and additions which do not look too different from the mechanically made image

88 Richard Hamilton: *Trafalgar Square*, 1965–67. Oil on photograph on panel, 81 cm × 122 cm
Sammlung Ludwig, Wallraf-Richartz Museum, Cologne
The distortions created by the over-enlargement of a photographic image, the exaggeration of the dot-for-dot effect of a photo-litho screen and the haphazard arrangement of the figures have been exploited by Hamilton in a manner which links the man-made and the mechanically reproduced image. There is a similarity between these figures and those in the Impressionist streetscapes by Monet and Pissarro

but are nonetheless painted. For this it is almost essential to use an air brush. The other approach is to alter quite radically the character of the photograph with pigment which makes no concession to the mechanical imagery but appears in conjunction with it in an uncompromising manner leaving the spectator in little doubt as to which parts of the picture are photograph and which paint. Richard Hamilton has made many experiments with photographs working on them with airbrush and collage as in *Still Life* 1965 where the alterations are almost unnoticeable, or more obviously with thicker pigment as in his *My Marilyn* 1965 and some of the *Whitley Bay* and *Trafalgar*

89 **Richard Hamilton:** *My Marilyn*, 1965. Oil and collage on photograph on panel, 102·5 cm × 122 cm
Dr Peter Ludwig
This painting is based on sheets of contact prints which had been submitted to Marilyn Monroe for her approval and which she disfigured with nailfile and lipstick. The placing of the large close-up in the bottom right of the frame gives the work an almost sequential character

'It's an old obsession of mine to see conventions mix – I like the difference between a diagram and a photograph and a mark which is simply sensuous paint, even the addition of real, or simulations of real objects. These relationships multiply the levels of meaning and way of reading.'

RICHARD HAMILTON
'Photography and Painting'
Studio International March 1969

Square series done between 1965 and 1967. The works of Richard Hamilton with their inventiveness upon photographic themes, positive and negative colour, the breakdown of shape through over-enlarging, the relationships between the mechanically reproduced image and the hand-made will provide a rich source of ideas for the student intrigued by the interplay of painting and photography. It is worth noting that earlier artists, for example: Edward Burne-Jones, Edouard Manet and Edgar Degas would sometimes work over faint photographic prints of their own drawings and paintings.

As is well known the Venetian painter Canaletto used a *camera obscura*. This device invented around 1559 and made popular with artists by Giovanni Battista della Porta (sixteenth century) was a means of reflecting a view from a mirror through a lens onto a flat surface. The image could then be outlined by the artist who,

allowing for slight distortions, had a fairly accurate basis over which to work.

Other artists have used the *camera obscura*, perhaps most notably Sir Joshua Reynolds who owned a portable, folding model.

TONKING

Named after the Slade professor of painting Henry Tonks, Tonking is a method of removing surplus oil paint from a canvas by means of laying a sheet of absorbent paper such as

Henry Tonks: *The Hat Shop*, 1892. Oil on canvas, 67·3 cm × 92·5 cm
Birmingham City Art Gallery
The soft, blurred outlines and hazy quality of this picture has been partially achieved through 'tonking' or blotting the paint after each day's work. The cracking has probably been caused through the excessive use of oil in the under layers

newsprint over the picture area and, after rubbing it gently with the palm of the hand, peeling it off so that excess pigment is removed. Such blotting may be advantageously used at the end of a day's work so that on the following day there is a sympathetic surface on which to work; still wet, but not thick with paint. Not all the picture need be treated in this way but at times during painting it might be helpful to remove areas of pigment if scraping them off with a palette knife seems too drastic a method.

Tonking, it will readily be appreciated, is closely related to monoprinting, the removal of surplus paint being a way of transferring an image from one surface to another. Such prints make a good basis for developments of the original idea and additions to them may be made with a variety of media. There is of course an accidental element in such a procedure, but this in itself may suggest variations. The transference of an image onto a canvas by this method was sometimes used by Max Ernst. Fairly liquid paint was used and the resulting textures altered to make figurative images. The name *Decolcomania* has been given to this process.

91 **Edgar Degas:** *Sieste au Salon* (Deux Femmes sur un Canape), *c* 1879. Monotype. Oil bound printing ink on china paper. 16 cm × 21 cm
Private Collection
Although not usually achieved by tonking a painting the principle of the monotype is the same. In this picture printing ink has been applied to a metal plate and the image printed onto paper. There are exciting contrasts between the different areas: the straight streaky brushstrokes describing the curtains, the stippled brushmarks suggesting the texture of the carpet, the soft turpentine diluted grey of the wallpaper pattern and the thin, crisp lines defining the figures

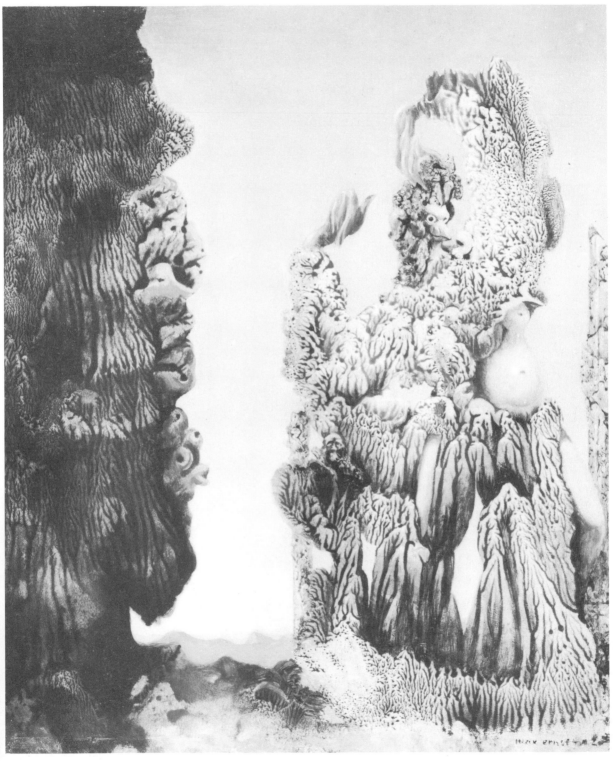

92 Max Ernst: *Mythological Figure – Woman,* 1925.
Monotype and oil paint
Private Collection, USA Copyright SPADEM 1983

FROTTAGE

Frottage is the name given by the painter Max Ernst to the process of obtaining images by placing paper over a surface and rubbing it with wax crayon or pencil. A thin hard paper is required and a large wax crayon, cobbler's wax, heelball or a soft pencil. Max Ernst did not invent the process – there are many examples from different countries and times – but he did develop it as a serious means of expression. His collection of frottages published in his book *Histoire Naturelle* is one of the most important works of the Surrealist movement. Ernst describes how he came to make his first frottages.

On 10 August 1925 ... finding myself one rainy day in an inn by the seacoast, I was struck by the obsession exerted upon my excited gaze by the floor – its grain accented by a thousand scrubbings. I then

93 **Max Ernst:** *The Whole Town*, 1934/5. Oil on canvas (frottage) 50 cm × 61·5 cm
Tate Gallery, London Copyright SPADEM 1983
Black pigment dragged across paper which has been laid over textured objects has produced this complex pattern. The paper is stuck onto canvas

decided to explore the symbolism of this obsession and, to assist my contemplative and hallucinatory faculties, I took a series of drawings from the floorboards by covering them at random with sheets of paper which I rubbed with a soft pencil. When gazing attentively at these drawings, I was surprised at the sudden intensification of my visionary faculties and at the hallucinatory succession of contradictory images being superimposed on each other with the persistence and rapidity of amorous memories.

As my curiosity was now awakened and amazed, I began to explore indiscriminately, by the same methods, all kinds of material – whatever happened to be within my visual range – leaves and their veins, the unravelled edges of a piece of sackcloth, the brushstrokes of a 'modern' painting, thread unrolled from the spool, etc, etc.

Au Dela de la Peinture, 1936
First published in Cahiers d'Art, Max Ernst
Special Issue, 1937

Ernst also comments on the relationship between his first frottage works and the advice put forward by Leonardo da Vinci in his *Treatise on Painting*:

In my opinion it does no harm to remember, when you stop to contemplate the spots on walls, certain aspects of ashes on the hearth, or clouds, or streams; and if you consider them carefully you will discover most admirable inventions which the painter's genius can turn to good account in composing battles (both of animals and men), landscaping or monsters, demons and other fantastic things that will do credit to you.

These remarks seem to be particularly appropriate to monoprinting.

Although with care it is possible to produce near identical images, as in the case of brass rubbings, the varying pressures are likely to create different intensities of tone so that prints are not identical. In the creation of a frottage such as those made by Max Ernst, in which different shapes and surfaces are assembled to create one image, the likelihood of exact repitition is even less.

A method similar to the frottage or rubbing, but more likely to produce individual prints is that of rolling the paper with an evenly inked roller. A sheet of paper placed over any reasonably rough surface and rolled with ink will become textured with a rich complex of lines and shapes. It is improbable that a number of prints taken in this way will be identical. Although a simple static surface such as a manhole cover or grating will allow for a certain duplication, uneven inking and pressure will create differences. More complicated surfaces, particularly if not completely static such as shingle or grass, will make repetition impossible. The overprinting of a number of surfaces will help to create even more fascinating images.

Frottage is nothing other than a technical means of intensifying the hallucinatory faculties of the spirit in such a way that 'visions' automatically appear, a means of ridding oneself of one's blindness.

MAX ERNST
Exhibition catalogue
Cologne, Wallraf-Richartz-Museum and Zurich
Kunsthaus, 1962–3

SCRAPING

It is often necessary to remove areas of paint which have become too thick, congealed with overwork, or have dried in a manner which makes painting over them difficult. Such parts of the picture may be removed with a palette knife, a spatula or even a razor blade. If care is taken it is possible to take off surplus pigment without disturbing too much the quality of the statement made, but on occasion it might be desirable to remove the paint so that the ground is once more visible. This should then be wiped over with a rag dipped in a little turpentine to clear as much of the colour as possible.

SINKING

When a colour becomes dull and dead-looking it is said to have sunk. This is usually due to an over-absorbent ground or underpainting but can also be caused by evaporation. It is essential

to apply to the sunken area a little linseed, or whatever oil medium is being used, with a soft rag and rub it in gently to revive the colour and provide a sound base on which to overpaint. Some painters believe that to breathe on the sunken paint before applying the oil is an advantage.

THE APPLICATION OF COLOUR

It is when ways of painting take over from what is being said that the spectator becomes too aware of the technique. No really great work of art is admired firstly for its technique and it is important for the beginner to realise that to indulge in technical gymnastics for their own sake is simply to put barriers between the work and the spectator. Experiments with different materials and methods may be an excellent way of learning the craft of painting but they should not be confused with the act of painting itself; the aquisition of mere technical expertise is an empty and self-indulgent occupation.

Hog hair or nylon brushes are the most commonly used implements for applying oil paint and the beginner will soon discover which types and shapes he prefers. To begin with a small selection is useful and the different marks made by each may be used within the same painting to advantage; a rectangular stroke with a square-ended brush, a scumble with a round and a line with a filbert or a softer hair brush such as a sable will give variety to the work. A fan blender will smooth and help fuse those brush strokes which are considered obtrusive, but care should be taken that this does not become unpleasant, giving the work a too smooth and slimy appearance. Edges of form may be smudged with the finger to soften the hardness of a contour and excesses may be 'tonked' or scraped with a knife to leave blotted textures or reveal parts of the underpainting or ground. There is no reason why liquid pigment should not be sprayed onto the surface of the canvas with a spray diffuser or an air brush, flicked on with the finger from an old tooth brush or stencil brush, but in all instances

excess should be avoided and the means used be relevent to what is being said. To seek to create an 'effect' either for its own sake or in an attempt to conceal an area of incompetence is dishonest and will deceive none but the most unintelligent observer. The true painter is not interested in 'creating effects', a term which is usually despised. Such a practice is against the very essence of serious painting which does not deal with the superficial even when expressing a delight in the surface of objects or exploiting the accidental qualities inherent in certain methods of application. The American Abstract Expressionist, Jackson Pollock may have dribbled liquid paint from cans and flicked it from brush or stick but he was not seeking to impress with facile effects rather expressing through his overlapping skins of colour ideas about painting and the *act of painting* itself.

'I don't work from drawings or colour sketches. My painting is direct ... the method of painting is the natural growth out of a need. I want to express my feelings rather than illustrate them. Technique is just a means of arriving at a statement. When I am painting I have a general notion as to what it is I am about. I *can* control the flow of paint: there is no accident, just as there is no beginning and no end.'

JACKSON POLLOCK
from his narration to the film:
'Jackson Pollock'
1951 by Hans Namuth and
Paul Falkenberg

'My painting does not come from the easel. I hardly ever stretch my canvas before painting. I prefer to tack the unstretched canvas to the hard wall or to the floor. I need the resistence of a hard surface. On the floor I am more at ease. I feel nearer, more a part of the painting, since this way I can walk around it, work from the four sides and literally be *in* the painting. This is akin to the method of the Indian sand painters of the West.

'I continue to get further away from the usual painter's tools such as easel, palette, brushes, etc. I prefer sticks, trowels, knives and dripping fluid paint or a heavy impasto with sand, broken glass and other foreign matter added.'

JACKSON POLLOCK
My Painting 1947/8

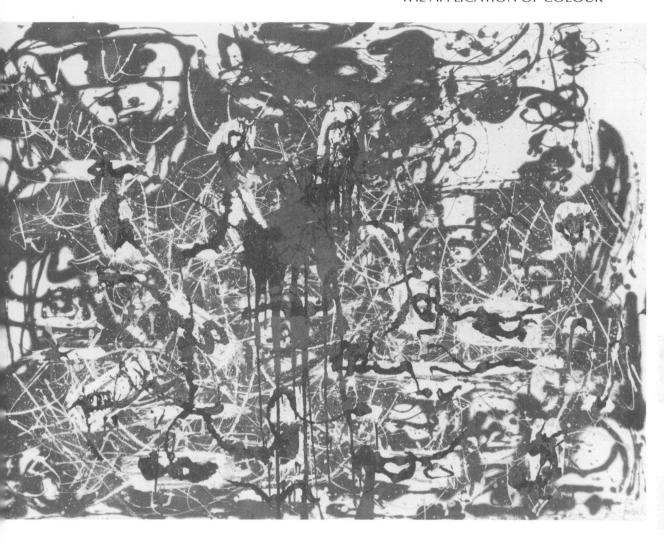

94 Jackson Pollock: *Yellow Islands*, 1952. Oil on canvas, 143·5 cm × 190·5 cm
Tate Gallery, London
Paint dribbled and thrown onto a raw, unprimed surface has soft blurred edges in places with extensions of oil soaked canvas. Wide lines and shapes of black pigment have been applied around and across small areas of yellow on white to leave nine 'islands'. These have been touched with red for greater emphasis. Thin flickering lines of white have been scattered across the picture-plane and the main black portion of the canvas has been made to run to produce the vertical form in the centre.

There is much in common here with the 'automatic writing' of André Masson who spilled and dribbled paint onto sand covered canvas to produce images from which he could extract more representational forms

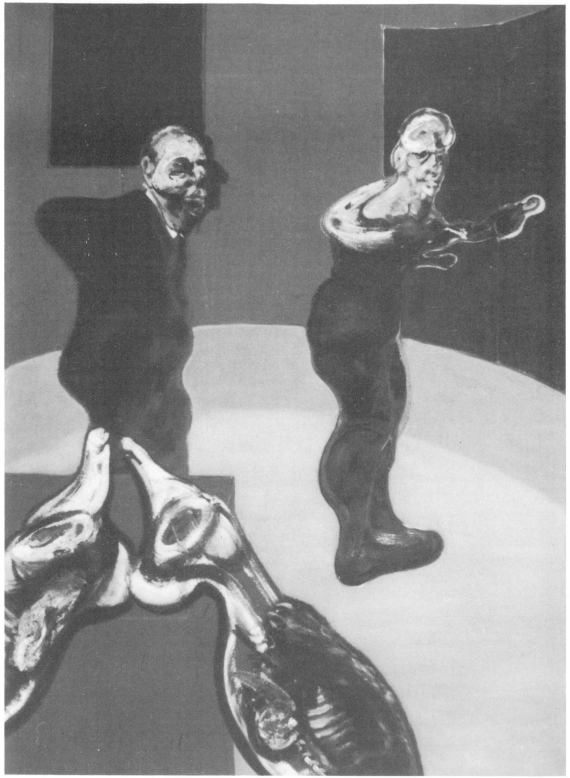

95 **Francis Bacon:** *Three Figures for a Crucifixion*, 1962.
Triptych (detail of left figure), each 198 cm × 145 cm
The Soloman R. Guggenheim Museum, New York

F.B. '... but I do, of course, work very much more by chance now than I did when I was young. For instance, I throw an awful lot of paint onto things, and I don't know what is going to happen to it. But I do it much more than I used to.

DS Do you throw it with a brush?

FB No, I throw it with my hand. I just squeeze it into my hand and throw it on.

DS I remember you used to use a rag a lot.

FB I do use it a lot too, still. I use anything. I use scrubbing brushes and sweeping brushes and any of those things that I think painters have used. They've always used everything. I don't know, but I'm certain Rembrandt used an enormous amount of things.'

FRANCIS BACON *in conversation*
with David Sylvester

THREE BASIC TECHNIQUES

The three basic procedures explained below are not inviolate rules from which no deviation is allowed. They are simple descriptions of methods which may be employed and, should the artist so desire, can be used in conjunction with each other providing that care is taken to ensure permanence.

GLAZING

Most glazes are produced with transparent colours laid over lighter opaque ones, but it is equally possible to glaze over dark colours although obviously there are limitations to this method. When starting a picture, on which he wishes to use glazes, the painter has to decide whether he intends to produce the entire work by means of a glazing technique or to combine it with direct painting. More often it is the latter. However, should it be that most of the picture area is to be glazed, the procedure is as follows:

1 On either a white ground, or a tint laid over a white ground, the main areas of the composition can be drawn with either charcoal or diluted paint. Should charcoal be used it will need to be dusted with a cloth before the application of paint in order to remove the excess particles and so keep the pigment clean.

2 The main areas of light and dark can be blocked in with broad hog hair brushes and a middle tone established either by leaving the toned ground or with the addition of a neutral, preferably mixed from colour and not with black and white (see Grey: Colour Section). This tonal approach should produce an image which is somewhat lighter than the finished work will be, for the added glazes will darken it. Contrasts may also be too great but a glaze does soften contrasts somewhat and helps to fuse disparate tones.

3 When the underpainting is completely dry, which will be a matter of days and not hours, the glazes may be applied. For speed some of the Old Masters underpainted with egg tempera, but this is rarely done today. For the glaze, pigment should be mixed with a suitable medium and this will be a matter of personal choice, dependent upon the requirements of the artist; whether he wishes to add subsequent glazes and how soon he wishes the picture to be dry. A simple slow drying medium, such as that used by Rubens, is safer than one which contains quick drying oils or too much varnish (see Media section). It will, in all probability, be insufficient to give the areas of the picture just one coat of glaze without the result appearing thin and weak in substance and colour. Additional layers, added when the preceding one is thoroughly dry, will allow the painter, not just to obtain greater brilliance of hue, but also to draw the forms with the paint rather than letting them 'sit' flatly on the underpainting. Different colours, laid over each other, will produce richer more resonant depths than one glaze upon a neutral underpainting; and although this may be suitable for parts of the work, a mixture of both will provide greater interest. Titian states that on occasion he used as many as 30 to 40 overlaid glazes. Furthermore, it is often advisable to paint opaque lines and small areas into the glaze whilst it is still wet. In this manner Titian, Rembrandt and others of the great masters gave lively detail and sparkle to their works.

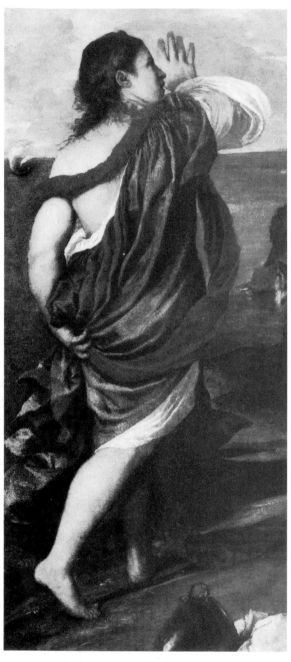

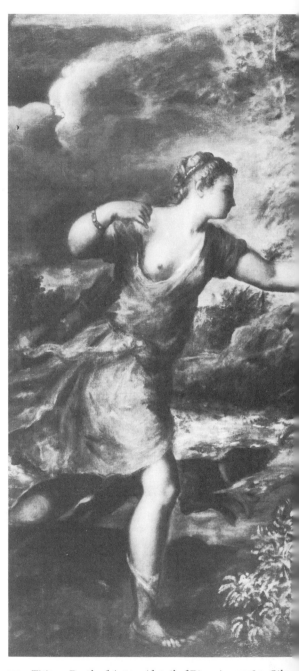

96 Titian: *Bacchus and Ariadne* (detail of Ariadne),
c 1520–22. Oil on canvas, 1·75 m × 1·9 m
National Gallery, London

97 Titian: *Death of Acteon* (detail of Diana), *c* 1560. Oil
on canvas, 178 cm × 198 cm
National Gallery, London
A comparison between these two figures shows how
Titian extended the tight, crisp glazing technique of his
time to the freer drawing and paint application which
anticipated later artists

A glaze may be applied to selected parts of the picture rather than to the whole area and may thus be combined with direct painting and the building up of the image with additional layers as described below. Many painters, instead of glazing the whole of a picture, have employed glazes to give additional depth to the shadows and brilliance to the lighter areas. To this end Rembrandt would brush thin glazes over each other in the shadows and lay brighter transparent colours over thickly applied impasto for some of the lighter parts. This impasto was usually white and so gave the glaze considerable brilliance.

The paintings of Rembrandt, with their mixtures of glazing and direct painting in opaque colour, should be studied by anyone interested in this technique.

When glazing it is essential to ensure that the medium used is not so liquid as to result in trickles and runs of paint. Excessive dilution will lead to a blotchy appearance, the slight separation of pigment and medium and irregular drying. Care should also be taken not to use too much oil in the medium so that the result becomes harsh and unpleasantly shiny. If this occurs there will be difficulty in applying successive glazes or opaque pigment. It is often a good idea to wipe, or even apply, the glaze with a soft cloth. As a glaze applied over impasto or underpainting will emphasise the brushmarks of that underpainting it is neces-

98 Rembrandt: *Margaretha de Geer, Wife of Jacob Trip* (detail), Oil on canvas
National Gallery, London
A mixture of overlaid glazes and directly applied colour
The head is an integrated series of light and dark curves of hair, eyes, cheeks and chin held in the two larger almost semi-circular curves of the dark outer edge of the hair and the light ruff

sary for the painter to make sure that the texture of his brushmarks is intentional. When the glaze is drying it should be protected from any dust which might settle and impair its purity.

PAINTING WITH ADDITIONAL LAYERS

It is of course, perfectly possible to build up a picture with layers of opaque paint as well as with transparent glazes. If such a method is used it is, as has been stated, absolutely essential that each layer of pigment is dry before the application of the next; and that the first layers

99 Paul Cézanne: *Mont Sainte-Victoire*, 1900–1902. Oil on canvas, 54·6 cm × 64·8 cm
National Gallery of Scotland, Edinburgh
This late unfinished painting by Cézanne shows his method of working all over the canvas with thin paint in the early stages and his use of additional layers of pigment to constantly redraw and redefine the whole composition; even whilst leaving certain small areas of the canvas showing. There is no concern for unnecessary detail or the superficial, but a commitment to the unity and structure of the painting.
'I cannot convey my sensation immediately; so I put colour on again, and I keep putting it on as best I can. But when I begin, I always try to paint sweepingly, like Manet, by giving form with the brush.'

PAUL CÉZANNE
to Maurice Denis

contain as little oil in the medium as pract-icable. This applies also to the binding medium as well as to the painting medium Consequent-ly, those pigments which have a high oil content in their manufacture should not be used for the underpainting or the first layers of the work if later cracking is to be avoided.

How the painter proceeds when painting with different layers of pigment is a matter of choice providing the essential rules relating to permanence are respected. He may make his first objective the blocking in of the light and dark parts in a rough approximation of their colours, or he may wish to render them whole in terms of neutral tones of grey, grey green or brown which will add a certain unity to the later layers. Alternatively he may begin with the middle tones, to which are later added the light and dark areas. To paint with additional layers of colour does not mean that it is necessary for each layer to cover the entire canvas. A look at the unfinished works of Paul Cézanne will show how different levels occur over different parts of the picture plane and how the drawing of line and shape goes hand in hand with the creation of coloured areas across the canvas, so that some sections are devloped in relationship to passages of underpainting which are left as an integral part of the whole.

To apply thick paint in the early stages is to make problems. When alterations are required they will be difficult to make and much scrap-ing down with a palette knife may be neces-sary; moreover the pigment may become clogged and tired-looking from being overworked and the dangers of shrinkage and later cracking will be multiplied. When paint-ing with layers of paint laid over each other, considerable alterations are possible, with re-drawing and colour modifications, right through the entire process. There is also the further flexibility of using both opaque and transparent colour so that an element of glaz-ing might occur in certain parts of the work, of scumbling elsewhere and with fragments of the different layers adding to the overall image. This mixture of covered and half-covered

colours can have considerable beauty and adds greatly to the interest of the painting. It is advantageous when working in this manner to keep the whole loose and fluid looking to ensure that the work retains a freshness which might easily be lost through overworking the paint.

'The difficulty of achieving in paint the abstract qualities conspicuous in his etchings was overcome when a painting was left in an unfinished state, with a scatter of patches of bare canvas. In his final phase, a cool colour rapidly brushed over a warm under-painting (or vice versa) on a coarse canvas and in a restricted range allowed the undercoat to 'grin through', and this, together with the higher key and broad simplifications, acted like the luminosity of the paper as a containing plane.'

HELEN LESSORE
Sickert's Late Work

ALLA PRIMA

As has been said this method aims at producing a painting in one session, but it may also be the final coat over an underpainting, or a series of layers. Usually the process is simple, although the ability of the painter is not if the work is to have any value. What is required is an under-standing of the possibilities of the materials and a clear concept of what is intended; for the artist has to deal with all the disparate elements of picture making at one go. He must work simultaneously with line, shape, form, texture, pattern, colour and tone in an attempt to realise in one creative effort the finished picture. When painting alla prima it is the overall unity of the work which should be borne in mind, there is no room for the inessential; for the detail which does not subscribe to the unity will detract. A clear intention and a simple straightforward technique of placing colours and tones without too much complicated colour mixing and app-lication will give the best results. One may work from dark to light, perhaps on a toned ground, or conversely from light to dark; there is much to be said for leaving the extreme light and dark areas of the painting until last, when they may be put in with freshness and less fear of their becoming muddied with alterations.

100 **John Constable:** *Stoke-by-Nayland*, 1819.
18 cm × 27 cm
Tate Gallery, London
A study from nature with paint loosely applied over a
toned ground

101 **Sir William Orpen:** *View from the Old British Trenches. Looking towards La Boisselle on the left, Martinpuich on the right, c* 1917–18. Oil on canvas
Imperial War Museum, London

102 **Sir Matthew Smith:** *White Roses and Pears*, not dated. Oil on canvas, 76 cm × 63·5 cm
Bradford Art Galleries and Museums – Cartwright Hall
The large areas of table and wall are painted with no attempt to disguise the brushstrokes or completely cover the ground. The flowers, fruit and jug have, however, been taken a stage further; their forms described with light and dark painted wet into wet

VAN EYCK AND THE DEVELOPMENT OF OIL PAINTING

There has been much speculation as to the 'invention' of oil painting and its development from the tempera technique used by classical Western artists and the ancient Orientals. The once accepted version given by Giorgio Vasari (in his prefix to *Lives of the Painters, Sculptors and Architects* 1550 and 1568 2nd edition) that oil painting was the invention of Jan van Eyck is questionable. That Jan van Eyck and his elder brother Hubert developed the technique and through their considerable abilities brought the possibilities of oil painting to the attention of other artists is perfectly true, but they were expanding a known technique and not inventing a completely new one. As Professor G Baldwin Brown has pointed out in his notes to Vasari's *Lives*;

'The technique of oil painting is described by Theophilus about AD 1100; in the *Hermeneia* or Mount Athos Handbook; and in the "Trattato" of Cennini, while numerous accounts and records of the thirteenth and fourteenth centuries establish incontestably, at any rate for the lands north of the Alps, the employment of oils and varnishes for artistic wall and panel painting.'

Vasari: *Lives of the Painters, Sculptors and Architects, second edition 1568 Translated by Maclehose, Edited, Introduction and Notes by Professor G. Baldwin Brown, Dover publications, New York, 1960*

It would seem logical that the experiments of many artists over a period of time would lead eventually to the development of an oil based painting medium, rather than for it to be an entirely new invention by one man. Tempera, from which oil painting developed, is produced by mixing pigment with egg yolk or in some cases the whole egg, but as it dries extremely quickly it is difficult to rework or create blends of colour. Modelling usually has to be done by cross hatching, a technique which may be seen in many Illuminated Manuscripts. Painters, prior to van Eyck had known that pigment could be mixed with oil and applied over tempera in order to bring together the picture with a unifying glaze. The mixing of oils and varnishes with pigment produces colours which when applied in transparent layers or glazes have an 'inner light' not possible to obtain with tempera even if it is varnished. Furthermore, subtle blends can be made with both opaque and transparent colour. Vasari's attribution of the invention of oil painting to Jan van Eyck (John of Bruges in Flanders) was probably due to the considerable mastery with which van Eyck applied layer upon layer of glaze to produce colours which glow from within and express a feeling for light and reality in a highly personal way. His experiments with oil and varnish led to a painting medium particularly suited to his rendering of surfaces and details. Although it is not known for certain what oils and varnishes he used a recent suggestion, based on practical research, has been put forward by Professor G Baldwin Brown:

'. . . the use of a natural pine balsam, with probably a small proportion of drying oil and rendered more workable by emulsifying with egg, may be the real secret of which so many investigators have been in search.'

Van Eyck painted on wooden panels prepared with smooth chalk grounds similar to those used for tempera painting. Made non-porous by a coat of drying oil it is this white ground which gives the thin layers of paint, mixed with van Eyck's oil medium, such brilliance and depth. Each glaze of colour, progressively more transparent, made full use of the reflective white ground and the glow of the underpainting. This was a tight, highly controlled technique well suited to the creation of intimate easel paintings or altar pieces which, never being very large, could be studied closely and their rich detail and simulated textures enjoyed at close quarters. It was not particularly apt for the large and somewhat grandiose paintings for public places which the Venetians began to desire as their city state became more prosperous and commercially important. Large works, hung so that they might be seen from a distance, needed a

103 **Jan van Eyck**: *The Marriage of Giovanni Arnolfini and Giovanna Cenami, c* 1434. Tempera, and oil on oak panel, 80·8 cm × 58·8 cm
National Gallery, London

freer technique if the forms were not to appear confused. Vasari credited Antonello da Messina a follower of van Eyck, with the introduction of oil painting to Italy. There has been much conjecture about this and although some historians have doubts as to the dating of Antonello by Vasari, a recent authority Dr von Wurtzbach in his *Niederlandisches Kunstler-Lexicon* claims that Antonello da Messina visited Flanders at roughly the time Vasari states and introduced the new aspects of oil painting then being practised by the Flemish to Venice somewhere around 1475. The interest in the medium by the Venetians was partly due to the fact that it withstood the humidity of Venice better than did the fresco. Also it allowed for larger works than tempera, particularly if canvas, with its advantages of size, lightness and ease of transport, was used.

THE TECHNIQUE OF TITIAN

The youngest of the Bellini brothers, Giovanni, learned much about the technical aspects of oil painting from Antonello and extended the medium with a freedom which indicated the possibilities that were to be developed by his pupils Giorgione, Palma Vecchio (Jacopo Palma) and Titian (Tiziano Vecelli). Of the three it was Titian who achieved the greatest freedom with the medium. He learned a great deal in his early days from his companion Giorgione who is credited with producing the first small oil paintings in Venice for private collectors rather than Church or State. Giorgione died from plague in 1510 whilst in his thirties, but although his career was short many have considered him as great an innovator as Titian. His intense, mysterious pictures made Vasari place him level with Leonardo da Vinci as one of the first of the modern painters. However, it is Titian whom most people regard as the artist of the time who made the greatest innovations in the art of oil painting and whose work, developing as it did from tight, rather formal pictures based on earlier techniques of oil and tempera

became freer and more fluid in his later years. A comparison between his *Bacchus and Ariadne* (1520–22) and the later *Death of Acteon* (1560s) both in the National Gallery, London, will show this change in style. In the later work there is a broad use of paint with the weave of the canvas showing and shapes drawn into areas of colour rather than colour simply filling shapes. The handling of the paint, particularly in the foliage and water, is almost Impressionist in style; suggesting rather than illustrating in detail. The overall tone of the painting is not due to the use of a coloured ground, as has been previously thought, but to the white ground becoming transluscent and so allowing the colour of the canvas to show through the paint. Although the colour values may have changed from Titian's original, the brushwork and quality of paint give a clear indication of the freedom which he achieved towards the end of his life. His pictures were painted by a method which was to become the basis for future techniques. Drawn in monochrome on white, or a colour laid over white, the shadows were created with a series of glazes whilst the lights were built up with opaque colour usually prior to glazing. Some free alla prima painting was often added, but as Palma Giovane tells us, not to the figures.

Palma Giovane the grand-nephew of Palma Vecchio and a pupil of Titian has left us an account of his master's technique:

'He laid in his pictures with a mass of colour which served as a groundwork for what he wanted to express. I myself have seen such vigorous underpainting in plain red earth (terra rossa, probably Venetian Red) for the half-tones, or in white lead. With the same brush dipped in red, black or yellow he worked up the light parts and in four strokes he could create a remarkably fine figure Then he turned the picture to the wall and left it for months without looking at it, until he returned to it and stared critically at it, as if it were a mortal enemy If he found something which displeased him he went to work like a surgeon Thus by repeated revisions he brought his pictures to a high state of perfection and while one was drying he worked on another. This quintessence of a composition he then

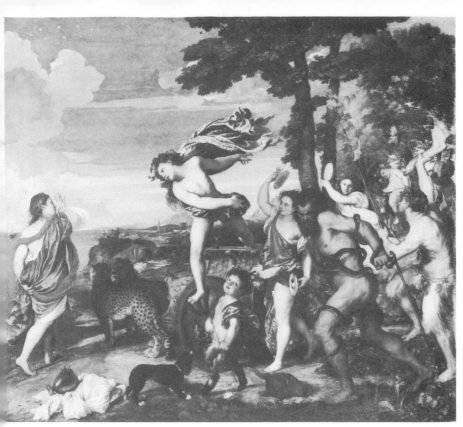

104 **Titian:** *Bacchus and Ariadne, c* 1520–22. Oil on canvas, 175 cm × 190 cm
National Gallery

105 **Titian:** *Death of Acteon, c* 1560. Oil on canvas, 178 cm × 198 cm
National Gallery, London

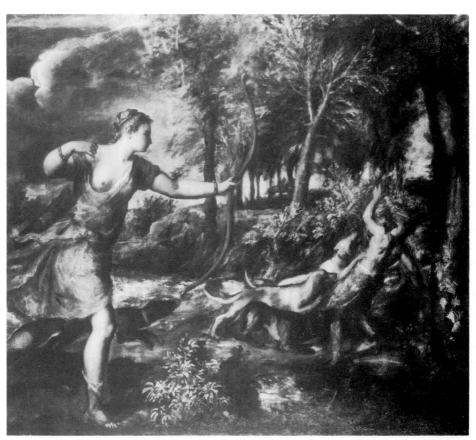

covered with many layers of living flesh He never painted a figure *alla prima*, and used to say that he who improvises can never make a perfect line of poetry. The final touches he softened, occasionally modulating the highest lights into the half-tones and local colours with his finger; sometimes he used his finger to dab a dark patch in a corner as an accent, or to heighten the surface with a bit of red like a drop of blood. He finished his figures like this and in the last stages he used his fingers more than his brush.'

<div align="right">

PETER AND LINDA MURRAY
The Penguin Dictionary of Art and Artists
page 448

</div>

THE TECHNIQUE OF RUBENS

It is worth looking at the technique of Peter Paul Rubens for it has had a tremendous influence on the painters who came after him even into the present century; and the results of his method are exceptionally well preserved. For small works, Rubens generally used wooden panels first primed with a white gypsum ground over which was streaked a grey or brown tone sometimes this was tempera or glue based and sometimes oil.

Onto this he painted alla prima allowing the ground to show through in places. His light tones were placed with opaque paint whilst the darks were scumbled on leaving parts of the streaked ground exposed. This ground may be seen in many of Rubens smaller pictures notably the sketches for the Medici series of paintings in the Pinakothek (Museum) in Munich.

The irregularity of its application allows the white ground to show through and gives a broken fresh lightness to the subsequent layers of paint. Rubens employed a toned ground of grey or brown on his larger works on canvas but these were more often of an all-over colour. This was, however placed on top of a white ground usually chalk, essential if a painting is to retain any element of freshness and light. Pictures by those artists of the latter part of the sixteenth century who dispensed with white grounds have suffered greatly from darkening. Only those where red or green grounds have been laid over an initial white priming have retained anything of their original quality. Rubens reintroduced the use of a white ground as a basic priming over which a tone ground was laid. Onto this he drew his image and then built up his picture with thin applications of paint mixed with a medium consisting of sun-thickened linseed (stand oil) and Venice turpentine to give an enamel quality. His darks he kept thin and usually transparent whilst the light areas were built up with layers of cool and warm tones.

'Begin by painting your shadows lightly. Guard against bringing white into them; it is the poison of a picture, except in the lights. Once white has dulled the transparency and golden warmth of your shadows, your colour is no longer luminous but matt and grey.

'The same is not the case with light areas; there one can set in the colour as one thinks proper. They have body, still one must keep them pure. Good results are obtained if one sets down each tone in its place, one next to the other, Lightly mixing them with the brush while taking pains not to 'torment' them.'

<div align="right">

Attributed to RUBENS
(after Descamps) Doerner, page 355

</div>

106 **Peter Paul Rubens:** *The Miraculous Draught of Fishes,* 1618–19. Pencil, pen and oil on paper, stuck on canvas, 54·5 cm × 84·5 cm
National Gallery, London
In this study Rubens has been concerned with the establishing of the diagonals and curves which give the picture its movement and sense of vitality. The paint, applied in broad strokes and sinuous lines emphasises the directional aspects of the work and even in the details, such as the edge of foam in the foreground and the pen drawn starfish and shells on the beach, there is a vitality supporting the quality of the whole

107(a) **Rubens:** *Le Chateau de Steen* 1635 (details).

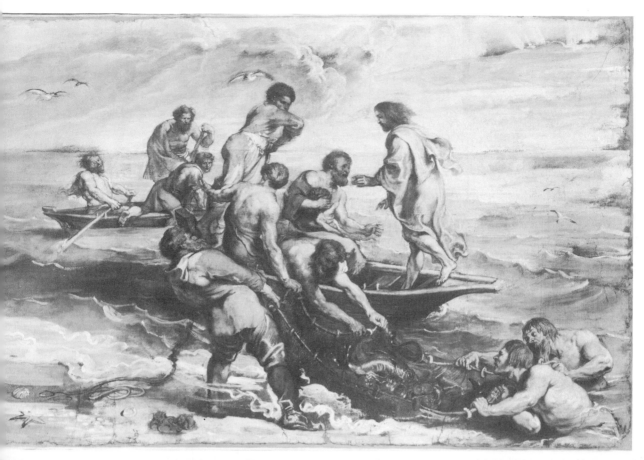

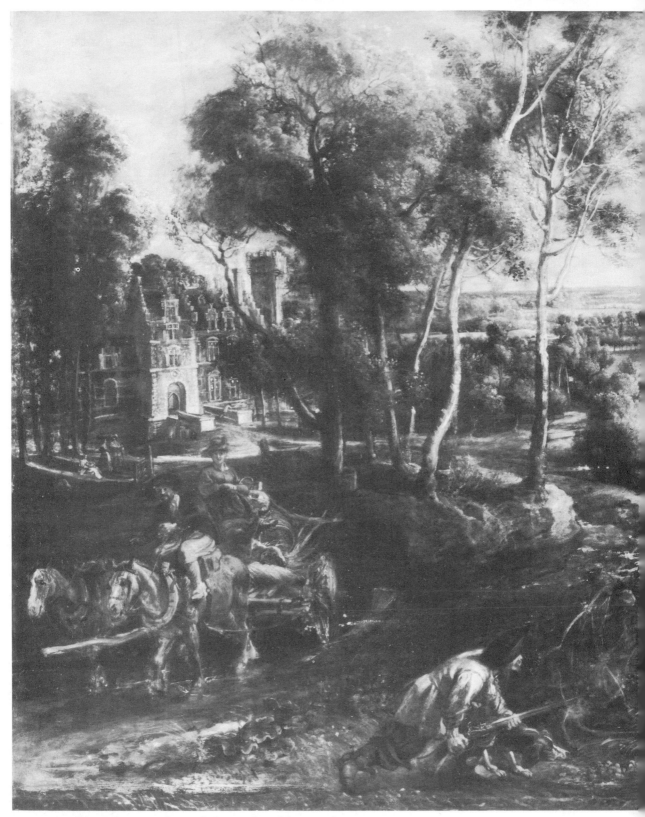

107(b) **Rubens:** *Le Chateau de Steen*, 1635. Oil on wood
panel, 1·34 m × 2·36 m
National Gallery, London
Le Chateau de Steen was purchased by Rubens in 1635
and he enthusiastically painted his newly acquired
property using studies of the different parts of the
landscape to compose an almost cinemascopic
panorama. The picture was begun on a panel some
91 cm wide which now forms the central part of the
completed work. To this were added 16 further panels as
the artist's intentions expanded

147

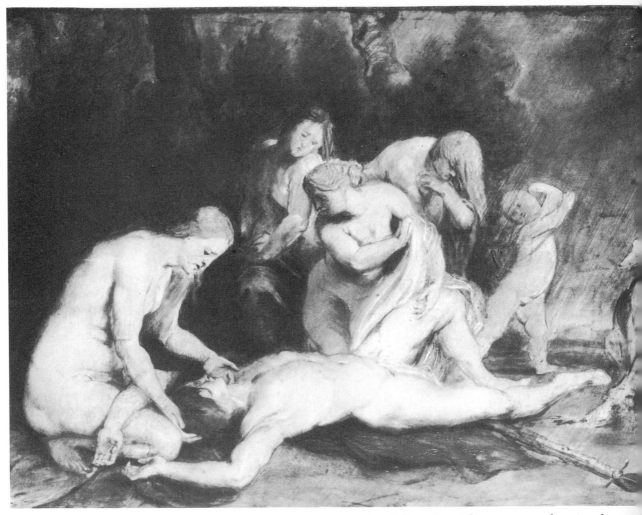

108 Peter Paul Rubens: *Venus Mourning Adonis,*
c 1614. Oil on wood panel, 48·5 cm × 66·5 cm
Dulwich Picture Gallery, London
The fact that this work is executed on wood suggests that
it is a sketch rather than an unfinished painting. Rubens
used small panels for such sketches whilst his
commissions and paintings which he intended to
complete were nearly always on canvas. As may be seen
elsewhere in this book the Chateau Steen, begun on a
small panel, was extended with additions as the painter's
ideas progressed.

Rubens may have painted this sketch as a plan for his
students to develop into a larger more complete work, or
to show a client how a particular commission might look
or, of course, he may have painted it simply for his own
pleasure

THE TECHNIQUE OF REMBRANDT

Rembrandt van Ryn created his technique by
fusing the various attributes of oil painting. He
painted directly with many overlapping layers
of pigment and he made extensive use of glazes
and impasto. With a sound understanding of
the craft of painting and the potentials and
problems of materials he extended both the
technical and aesthetic aspects of painting. The
works of Titian and Rubens with their free
applications of colour and loose web of brush-
strokes had considerable influence on Rem-
brandt and he rejected the smooth surfaces and
tight manner of painting which were popular
with his contemporaries and which he himself
had used in his early work in favour of a freer
approach.

From a monochromatic underpainting
which was done on a toned ground, he worked
towards the lighter forms so that they appeared
to emerge from shadow to hang, glittering and

solid in a semi-transparent film of dark mysterious colour. Many overlapping glazes as well as direct painting produced these rich depths of tone whilst the forms themselves were painted in monochromatic mixtures to which were added body colours and sometimes further glazes. Thick impasto on head, hand, fabric and jewellery might also be a foundation for glazing or could describe a form with brushstrokes which modelled the paint and were applied at times wet into wet. The loose open brushwork was not always to the taste of his contemporaries some of whom considered the paintings unfinished, but Rembrandt was involved with suggesting form rather than copying it and with creating that fusion between paint and what it expresses, between form and content, which is the mark of the truly great artist.

From a surprisingly limited palette Rembrandt produced works with considerable richness and complexity of colour, mixing from his basic selection those variations of warm greys and browns with their yellow and red gradations which his pupil Hoogstraten calls 'friendly' colours and which give the works their warm, resonant harmonies. Wlademar Januszczak gives the palette for *The Feast of Belshazzar: The Writing on the Wall*, as follows:

Lead White (sometimes mixed with 25 per cent chalk)
Black
Brown
Red Ochre
Unidentifiable transparent browns (probably Cologne earth and bistre)
Vermilion and organic red lakes
Lead tin yellow (usually mixed with lead white)
Azurite
Smalt (a type of blue now replaced by Cobalt Blue)
Greens were made by mixing lead tin yellow with azurite or smalt.

Doerner suggests that a resinous medium not unlike that used by Rubens was composed from Venice turpentine, mastic and sun-thickened oil which would dry quickly, in a matter of hours, and so facilitate overpainting and the combination of opaque colours and glazes.

Colours used by Jan van Eyck

Brown, *verdaccio*
Madder
Lapis Lazuli, or
genuine ultramarine
Yellow Ochre
Terre Verte
Orpiment (yellow)
Sinopis – red ochre
Peach Black

Colours used by Titian

Lead White
Genuine Ultramarine
Madder Lake
Burnt Sienna
Malachite Green
Yellow Ochre
Red Ochre
Orpiment (rarely used alone, but usually in mixing greens)
Ivory Black

Colours used by Rubens

Lead White
Orpiment
Yellow Ochre
Yellow Lake
Madder
Vermilion
Red Ochre
Genuine Ultramarine
Azur d'Allemagne (Cobalt)
Terre Verte
Vert Azur (oxide of cobalt)
Malachite Green
Burnt Sienna
Ivory Black

From: *Technique Moderne du Tableau* by Maurice Busset, Paris 1929
Notes on the Technique of Painting by Hilaire Hiler, London 1934

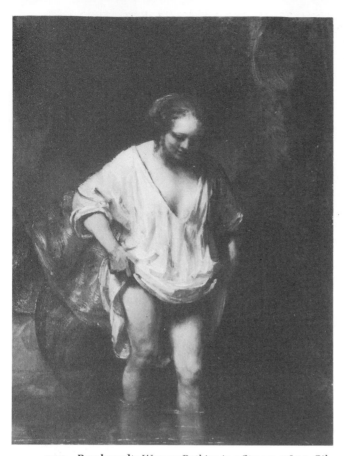

109 Rembrandt: *Woman Bathing in a Stream*, 1655. Oil on panel, 618 cm × 470 cm
National Gallery, London
A monochrome underpainting has been glazed in the dark and middle tones and many of the lighter areas applied with bold strokes of impasto. There is a range of warm, transparent glazes contrasting with the lively application of opaque pigment some of which does itself form an underpainting for a glaze

110 Rembrandt: *Woman Bathing in a Stream* (detail)

111 Rembrandt: *Margaretha de Geer, Wife of Jacob Trip*, c 1661 (detail) Oil on canvas 130 cm × 97·5 cm
National Gallery London

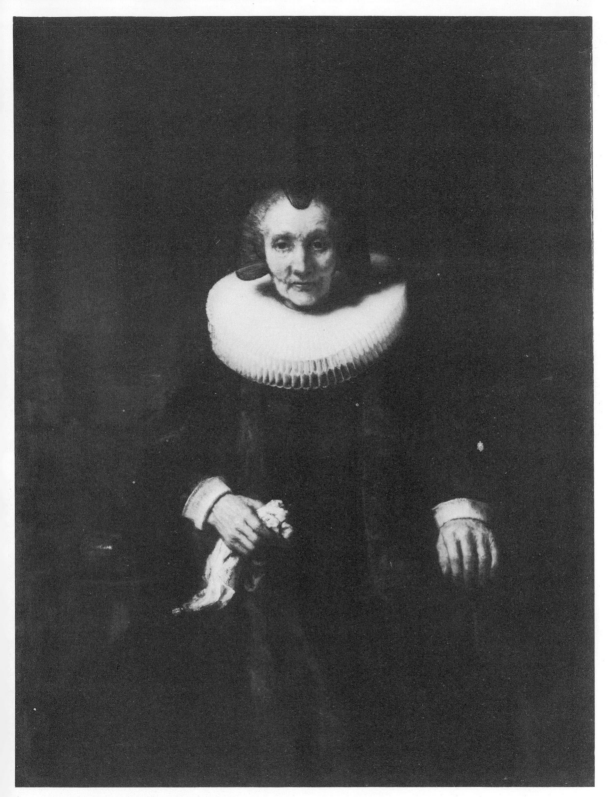

112 Rembrandt: *Margaretha de Geer, Wife of Jacob Trip.*
Oil on canvas, 1·305 m × 0·975 m.
National Gallery, London
The dark areas have been created with a series of glazes whilst the head has an underpainting of impasto which almost models the form in relief. Over this, glazes have been laid, then some further direct painting in opaque pigment. Thinner paint has been used to draw the details of hair and ruff

152

113 Thomas Gainsborough: *The Painter's Daughters Teasing a Cat, c* 1759. Oil on canvas, 755 cm × 625 cm
National Gallery, London
The main forms have been delineated in diluted umber on a warm toned ground. Light and dark areas brushed loosely on the canvas, not in monochrome, but in local colour leave in some places on the figures the warm ground to act as the middle tone. The stage before this would have shown the entire canvas in the state of the lower half. Only after establishing the overall composition, proportions and distribution of light and dark would the painter concern himself with the detail

Towards the end of the eighteenth century there were painters who thought that the technique of building up a picture by under-painting and glazing had become rather limiting. It did not allow for the freedom and spontaneity which they desired. Thomas Gainsborough, Francisco Goya, John Constable and William Turner used a freer, more direct technique; a combination of glazing and alla prima which, although not new, was different from that of most of their contemporaries in that there was greater fluidity of brushwork; a looser application of paint. This was particular-

114 Joseph Mallord William Turner: *The Thames near Walton Bridge, c* 1807. Oil on wood panel,
37 cm × 73.5 cm
Tate Gallery, London

ly the case in the sketches which Constable and Turner painted from nature, and which were to influence the 'plein air' pictures of the French Impressionists during the nineteenth century. Their insistence on painting directly from the motif was aided by new developments in colour manufacture, and the creation of a wider range of pigments than had been available previously. It was further facilitated by the introduction around 1841 of the metal collapsible tube which allowed the artist to take a selection of paint to the motif without difficulty. Previously he had had to either grind the colours himself in the studio or purchase them ready-made in small bladders which some eighteenth century colourmen supplied.

THE IMPRESSIONIST TECHNIQUE

The ideas which were developed by the French Impressionists during the latter part of the nineteenth century have had considerable effect on the way in which artists now look at nature and attempt to translate it onto canvas; also how they handle the technical aspects of painting. Impressionism did not simply alter the way artists see; it changed quite radically the methods of applying paint to canvas.

115 Containers for oil paint: pig bladders, glass syringes, Winsor and Newton tubes and Rand's collapsible tubes

Dissatisfied with the traditional techniques of painting which had become stultified by a narrow academic system of teaching and exhibiting, they developed notions of colour which had been of interest to Delacroix and the colour theorists of the time, mainly Chevreul and Rood, in attempts to depict a greater sense of naturalism than was possible with the conventional approaches. Rather than attempt to portray form through line and chiaroscuro, they pursued the idea that the play of light on objects and surfaces changed the colour of both the light and shadowed areas with relationships of colours not to be found in the traditional palettes of the academic painters; with a range of mainly earth colours and a reliance on 'brown sauce' or bitumen to depict shadows.

That shadows cast by an object contain colours which are complementary to that of the object, was a notion greatly exploited by them. Their concern with light and colour led to a brightening of the palette, a rejection of many pigments, particularly browns and black and a realisation that a stronger sense of light and movement can be conveyed if the paint is applied not in flat areas, or even tonally modelled planes, but in short strokes or dabs. One of the influences on the early Impressionists was Delacroix; his use of colour and later the murals he painted in the church of Saint-Sulpice, Paris (1881). There the artist used large simple brushstrokes which he had not attempted to blend together, but applied in an open manner so that their separateness gave vitality to the work and became joined in the eye of the spectator. This way of painting, although in the case of Delacroix's murals done so that they could be more easily seen from a distance, was extended

116 **Camille Pissarro:** *Lower Norwood, London,* 1870.
Oil on canvas, 35 cm × 41 cm
National Gallery, London

by the Impressionists in order to give greater brilliance to their works, and also to convey a sense of movement, of quivering space, of flickering, ephemeral light; the freshness of an immediate impression. This concern with rendering the different and constantly altering effects of light led the Impressionists towards a painting which was sometimes accused of lacking form. But if form and structure were not as important to them as it had been to artists of previous generations their experiments dealt with different problems, the solutions to which were to influence the abstract painters of the twentieth century. From the now acceptable and seemingly 'natural' early landscapes of Monet, Pissarro, Renoir and Sisley, there developed works which extolled the concept that all is a combination of local and reflected colour, altered by atmosphere. Works which expressed a reaction to the world we see in terms of strong and vigorous brushwork; varied marks which captured the fleeting moment and the vibrations of light. Attempts to depict each altering effect made Monet paint different pictures of the same motif, changing canvases as the light conditions changed and returning to them as

TECHNIQUES

the light returned or at the same hour on another day. So were the great series of Haystacks, Rouen Cathedral and the late Water Lilies produced; paintings which are almost abstract in their bold use of colour, fluidity of brushstroke and freedom of technique.

'He accumulated the brushstrokes, as one can see in his canvases, he accumulated them with prodigious certainty, knowing exactly to which phenomena of light they corresponded.'

GUSTAVE GEFFROY

'I am grinding a great deal, stubbornly insisting on striving for a series of different effects, but at this season of the year the sun sets so quickly that I cannot follow it . . . It is deplorable how slowly I am working . . . The further I go the more I see how hard I must work to render what I am trying for, that "instantaneousness" above all the outer surface, the same light spread everywhere, and more than ever the things which come easily disgust me.'

CLAUDE MONET
7 October 1890

'I often followed Claude Monet in his search of impressions.'

(In *Etretat*, 1885)

'He was no longer a painter, in truth, but a hunter. He proceeded, followed by children (possibly his own and Mme. Hoschedé's) who carried his canvases, five or six canvases representing the same subject at different times of day and with different effects. He took them up and put them aside in turn, according to the changes in the sky. Before his subject, the painter lay in wait for the sun and shadows, capturing in a few brushstrokes the ray that fell or the cloud that passed . . . I have seen him thus seize a glittering shower of light on the white cliff and fix it in a flood of yellow tones which, strangely, rendered the surprising and fugitive effect of the unseizable and dazzling brilliance. On another occasion he took a downpour beating on the sea in his hands and dashed it on the canvas – and indeed it was the rain that he had thus painted . . .'

GUY DE MAUPASSANT
La vie d'un paysagiste
Le Gil Blas
28 September 1886

(Reprinted in Maupassant: oeuvres complètes, Couard, v II, pages 85–86. W C Seitz: *Claude Monet –*

Seasons and Moments, New York 1960, page 20 R Lindon: *Etretat et les peintres, Gazette des Beaux-Arts* April 1958. J Rewald: *The History of Impressionism*, London, 1973, page 517.)

Jean Renoir tells how his father, the great Impressionist painter, Auguste used to work on his pictures. After applying a coat of Flake White mixed with a medium of two thirds turpentine and one third linseed oil which after drying provided the smooth surface on which he liked to paint, Renoir would begin with small strokes of either blue or pink well diluted.

Frequently the mixture was so fluid that it ran down the canvas. In this way a haze of curved strokes began to define the form of the subject he was painting which eventually, and not necessarily at the first session, began to emerge. There was a gradual build up of brushstrokes, nothing was rushed and the unity of the whole picture-plane constantly considered to create a harmony between all the pictorial elements.

Like all artists Renoir changed the colours of his palette from time to time. Certain hues, black for instance, would be eliminated only to reappear later. As he grew older his range of colours became smaller which is astonishing when one considers the brilliance of his late works. The following is a list of pigments and materials made by the artist himself and used during the Impressionist period of his life, that is 1870–80+.

Silver White	Madder Red
Chrome Yellow	Veronese Green
Naples Yellow	Viridian
Yellow Ochre	Cobalt Blue
Raw Sienna	Ultramarine Blue
Vermilion	

Palette knife, scraper, oil, turpentine – everything necessary for painting.

The Yellow Ochre, Naples Yellow and Sienna Earth are intermediate tones only, and can be omitted since their equivalents can be made with other colours. Brushes made of marten hair; flat silk brushes.

117 Auguste Renoir: *Regatta at Argenteuil*, 1874. Oil on canvas, 32·4 cm × 45·6 cm
Ailsa Mellon Bruce Collection 1970, National Gallery of Art, Washington DC

His palette in later years, according to his son, was limited to:

Silver White	Madder Red
Naples Yellow	Terre Verte
Yellow Ochre	Veronese Green
Sienna Earth	Cobalt Blue
Red Ochre	Ivory Black.

From this he would, on occasion, omit either the Red Ochre or the Terre Verte.

Another account of Renoir's working method is given by the painter Albert André.

'When the subject is a simple one, he begins by tracing with the brush, usually in reddish-brown, a few very summary indications to give the proportions of the elements which compose his picture. "The volumes . . ." he announces, with a knowing air. Then using pure colours thinned with spirit, as if he were painting a water-colour, he quickly brushes over the canvas and something vague and iridescent appears, with the colours all flowing into one another – it looks wonderful even before one can grasp its meaning. At the second session, when the spirit has evaporated a little, he goes over this preparatory work, following almost the same procedure, but using a mixture of oil and spirit and a little more colour. He brightens the luminous areas by putting pure white on the canvas; he scarcely ever mixes the paint on the palette, which is covered with little blobs of almost pure colours. Little by little

157

he defines the forms; a few more strokes ... and out of the original coloured mist emerge the gentle, rounded shapes, sparkling like jewels and wrapped in transparent golden shadows.'

In 1908 Renoir was visited by the American painter and critic Walter Pach who writes that the artist talked to him about his way of working:

'I arrange my subject as I want it, then I start painting it, like a child. Suppose I want a good singing red: I go on adding more reds and other colours until I get that effect. There's nothing more to it than that. I haven't any rules and methods; anyone can come and look at what I use, or watch how I paint; he will find that I haven't any secrets. I look at a nude; I can see myriads of little colours. I have to find those which will make the flesh seem to live and vibrate on my canvas. Nowadays they try to find an explanation for everything. But if you could explain a picture, it would no longer be art. Shall I tell you what I consider to be the two essential qualities of art? It must be indescribable, and it must be inimitable ... A work of art should grip you, envelop you, carry you away. It is the artist's way of expressing his passion; it is the current which springs from him and carries you along with it.'

Most good artists believe that whilst a knowledge of the theories of art are indespensible too much concern with them can easily stultify the work. There can also be too much involvement with materials and technique, rather in the manner of the amateur photographer who after buying all the latest gadgets realises that his pictures are not improved by them but might in fact be lessening in interest. Nevertheless a sound knowledge of the craft of painting gives the painter the confidence to proceed without constantly thinking about the more mechanical aspects of his work. This was something which Renoir knew to be true and which was not incompatible with his views on the dangers of too much art theory. In the preface to the fourteenth century treatise on painting by Cennino Cennini (c 1390) which Renoir wrote in 1911 he stated that;

'The severe apprenticeship undergone by young painters never stiffled their originality. Raphael was the studious pupil of Perugino; but he still became the divine Raphael.'

RENOIR'S PALETTE
(Moise, the artist's colour merchant, gave the following list of pigments which he said Renoir had not altered during the last twenty-five years of his life)

White Lead	Venetian Red
Antimony Yellow	French Vermilion
Naples Yellow	Madder Lake
Yellow Ochre	Emerald Green
Raw Umber	Cobalt Blue
Superfine Carmine	Ivory Black

MONET'S PALETTE
White Lead
Cadmium Yellow (Light)
Cadmium Yellow (Deep)
Cadmium Lemon
Lemon Yellow
Ultramarine
Superfine Ultramarine
Cobalt Violet (Light)
Vermilion
Emerald Green

(Tabarant: Couleurs, *Bulletin de la vie artistique,* July 1923.) NY 1946
Rewald : *History of Impressionism,* London 1973, page 589 n. 61
R Gimpel: At Giverny with Claude Monet, *Art in America,* June 1927.

PISSARRO'S PALETTE
White Lead
Chrome Yellow (Light)
Veronese Green
Ultramarine or Cobalt Blue
Vermilion
Madder Lake (Dark)
(Louis Le Bail: private notes. J Rewald: *History of Impressionism,* London 1973, page 590, n. 61)

118 **Claude Monet:** *Rue Montogueil,* 1978. Oil on canvas, 61 cm × 32.4 cm
Musée de Rouen

PAINTING WITH FLAT COLOUR

Paul Gauguin began his painting life with works of an Impressionistic character, but his interest in Primitive, Romanesque, and Far Eastern Art, particularly Japanese, led him towards the simplification of his forms into flat or almost flat shapes and a heightening of his colour which were to make him one of the major influences, not only on the younger artists of his day, but on many non-figurative artists of the twentieth century. He reduced forms in his later work, not to abstract their geometric qualities, but to accentuate their essential characteristics which developed into a painting which was both decorative and monumental. Colour was a matter of great concern to him and he used it for its emotive and emotional qualities rather than for the representation of nature. The symbolic aspects of both shape and colour also interested him as did the spectators' reaction to the picture's movement, harmony and other 'abstract' qualities. There is a strong emotional content in his work and although his paintings were carefully considered and not the productions of impulse, it is that emotion which communicates to us most directly; pure hues, bold lines and simple forms created by contours and flat colour rather than by modelling. With his painter friends, namely Emile Bernard and Paul Sérusier he created an art which became known as Synthetism which was related to the literary movement, Symbolism. The advice which he gave Sérusier on their first meeting in Pont-Aven, Brittany, 1888, resulted in the now famous painting: *Landscape of the Bois d'Amour at Pont-Aven – The 'Talisman'.*

'How do you see these trees? They are yellow. Well then, put down yellow. And that shadow is rather blue. So render it with pure ultramarine. Those red leaves? Use vermilion.'

GAUGUIN to Sérusier 1888
M Denis: P Sérusier: *ABC de la Pienture*
Paris 1942 pages 42–44
J Rewald: *Post-Impressionism,*
New York 1962

Painting in flat, or almost flat areas of colour, is not confined to Gauguin and the Synthetists. The strength of colour which can be maintained by such an approach has been the concern of many artists throughout the centuries. Sometimes, as in Gauguin's case opaque pigment has been applied to rough textured surfaces such as coarse hessian or sacking (for Gauguin this was often due to lack of funds rather than artistic choice), whilst other artists have laid flat washes of colour over fine grained canvas, or some other smooth surface, in order to allow the brilliance of a white ground to shine through rather in the manner of a watercolour. If such a technique is used care should be taken that the work does not become more of a patterned decoration than a painting; the Japanese printmakers of the eighteenth and nineteenth centuries, Toulouse Lautrec, Henri Matisse, and twentieth century abstract artists such as Piet Mondrian, Kasimir Malevich, Josef Albers, Robert Motherwell and Ben Nicholson may have achieved great things with such an approach, but there is the danger of facile pattern making.

'I have never wanted and I shall never accept the absence of modelling or of gradations; it's nonsense. Gauguin isn't a painter, he has only made Chinese images.'

PAUL CEZANNE

'Without ethical consciousness, a painter is only a decorator.'

ROBERT MOTHERWELL

Cézanne's comment may sound amusing to us now with the benefit of hindsight; and we may take it as a sign of limitation, or the dedicated commitment of an artist to a personal concept; but what is certain is that, as the statement by Motherwell suggests, without a serious philosophy of art, without principles, there is no art.

119 **Berthe Morisot:** *In the Dining Room,* 1886. Oil on canvas, 61·3 cm × 50 cm
Chester Dale Collection, National Gallery of Art, Washington DC

120 Paul Klee: *A Leaf from the Town Records*, 1928. Oil
on chalk, paper on wood, 42·5 cm × 31·5 cm
Kunstmuseum, Basle Copyright ADAGP 1983
Paul Klee: *Ein Blatt aus dem Staedtebuch*, 1928 N 6(46).
Gemälde, Olfarben, Papier auf Karton geklebt.
Originalleisten. 42,5 : 31,5/signiert rechts unten
Sammlung Kunstmuseum Basel

In this picture Klee has not used colour to imitate nature
or to create an illusionistic effect. Rather in the manner c
a medieval manuscript or a sheet from the Koran, he has
presented the spectator with an image within an image
which relates painting to writing and emphasises the
non-imitative attributes of both

121 **Victor Vasarely**: *Supernovae*, 1911. Oil on canvas,
240 cm × 152 cm
Tate Gallery, London Copyright SPADEM 1983
Flat colour used to create an optical illusion of light and
dark shapes

PAINTING WITH IMPASTO

A technique which does not deal in flat areas of colour was used by Gauguin's contemporary Vincent Van Gogh whose work relied heavily upon the expressive use of impasto, in a way which extended the pigment to almost three-dimensional proportions. He was not content to put thick paint only in certain selected areas of the picture; building up a textured section, or laying slabs of paint to be glazed over when dry like Rembrandt and Courbet had done. His direct alla prima pictures are heavy with pigment which has been applied with a loaded brush, a knife, finger or straight from the tube. The encrustations of paint were often built up wet into wet, the lines made by the brush emphasising the form of an object, giving directional force to a space or surface; or expressing pattern or structure. Details might be added when the larger areas of a work were dry, but more often than not Van Gogh completed his mature works at one sitting, sometimes taking more than one canvas out with him to a motif in the countryside for the day's work. Although his completed paintings are the result of feverish activity and reflect the intense feelings of the artist, it should not be thought that they are the products of an unthinking person. Van Gogh was an intelligent, educated man with a wide appreciation of literature and philosophy as well as a deep understanding of the language of painting. To read the letters which he wrote to his brother, Theo, is to realise that in spite of illness and contrary to popular myth, Van Gogh gave serious consideration to all aspects of his work; the materials he used, the various elements of composition and colour, form and space and that he was concerned also with the future of his paintings in terms of framing and permanence.

Van Gogh used different types of canvas during his life ranging from smooth, commercially produced ones to rough, raw hessian. In the case of the former he sometimes painted on pale, coloured grounds as well as white, whilst

122 Vincent Van Gogh: *Long Grass with Butterflies,* *c* 1890 (detail). Oil on canvas, 645 cm × 807 cm *National Gallery, London*
The impasto in this work creates a strong textural quality related to the linear formation of the grass and the overall feeling of the meadow

leaving the latter without priming and painting directly onto the fabric, the colour of which occasionally shows through. His range of pigments during the Arles and St Rémy periods of his life, from which his most well-known works stem, was usually without earth colour and consisted of:
Flake White
Cadmium Yellow
Vermilion
Red Lake
Ultramarine
Cobalt Blue
Emerald Green
Viridian
Cobalt Violet

His style is now well known; the brush-strokes' swirling and staccato lines, the intense colour contrasts conveying a sense of deep involvement with the subject; a strong emotional, expressive type of painting. It should not

be forgotten though, that the later works are built upon a basis of sound drawing, the result of early rigorous self-discipline even though they may appear to be haphazard in execution.

'At the moment I am absorbed in the blooming fruit trees, pink peach trees, yellow-white pear trees. My brushstroke has no system at all. I hit the canvas with irregular touches of the brush, which I leave as they are. Patches of thickly laid-on colour, spots of canvas left uncovered, here and there portions that are left absolutely unfinished, repetitions, savageries; in short I am inclined to think that the result is so disquieting and intimidating as to be a godsend to those people who have fixed, preconceived ideas about technique. For that matter here is a sketch, the entrance to a Provençal orchard with its yellow fences, its enclosures of black cypresses (against the mistral), its characteristic vegetables of varying greens: yellow lettuces, onions, garlic, emerald leeks.

Working directly on the spot all the time, I try to grasp what is essential in the drawing – later I fill in the spaces which are bounded by contours – either expressed or not, but in any case *felt* – with tones which are also simplified . . .'

VAN GOGH
Letter to Emile Bernard
Arles, April 1888

Always the emphasis on drawing, in this case with colour; establishing the areas of the painting, the shapes of objects and spaces which are as he states 'essential'.

It should not be assumed that what he describes here is the colouring of a finished drawing. His lines, shapes and colours, 'grew' together as the work progressed; with statements re-emphasized, or modified until the final integrated unity was achieved.

Colour was of paramount importance to him in his work and the vivid, opaque pigments were juxtaposed for maximum brilliance and visual impact. He was, like the Impressionists and his fellow Post-Impressionists, concerned with the concept of simultaneous contrasts and the feelings which colours could evoke in the spectator, (see Colour Section) but he always based his work on a study of either nature or the masters whom he admired, particularly

Jean Francois Millet, and did not attempt to express dream or fantasy as the later Synthetists did. At one time in 1889 he actually wrote to Emile Bernard reprimanding him for painting quasi-historical and religious pictures. He called some of Bernard's recent work: 'counterfeit', 'affected', 'atrocious' and 'banal' and went on to make a statement about the expression of feeling in a painting which all students might remember to advantage:

Describing two of his paintings he wrote:

'You will realize that this combination of red-ochre, of green gloomed over by grey, the black streaks surrounding the contours, produces something of the sensation of anguish, called 'noir-rouge', from which certain of my companions in misfortune frequently suffer. Moreover the motif of the great tree struck by lightening, the sickly green-pink smile of the last flower of autumn serve to confirm this impression.

'Another canvas shows the sun rising over a field of young wheat; lines fleeting away, furrows rising up high into the picture toward a wall and a row of lilac hills. The field is violet and yellow-green. The white sun is surrounded by a great yellow halo. Here, in contrast to the other canvas, I have tried to express calmness, a great peace.

'I am telling you about these two canvases, especially about the first one, to remind you that one can try to give an impression of anguish without aiming straight at the historic Garden of Gethsemene; that it is not necessary to portray the characters of the Sermon on the Mount in order to produce a consoling and gentle motif.'

VAN GOGH
Letter to Emile Bernard
St Remy, December 1889
B21

Van Gogh's use of impasto and expressive colour has had enormous influence on artists of the twentieth century. Soutine, although on occasion stating a dislike for the Dutchman's work, must surely have been excited by it and seen in it an emotional freedom which he could himself extend. His method of working was similar to Van Gogh's. He would paint alla prima attempting to complete a picture at one sitting. Although his works often show consi-

123　**David Bomberg:** *Tregor and Tregoff*, Cornwall, 1947. Oil on canvas, 81 cm × 100 cm
Tate Gallery, London

derable distortions of reality he painted from the motif or model, exaggerating form and movement with colours which ranged between rich depths of jewel-like intensity to the soft opalescence of pink, blue and green greys. In order to ensure cleanness of colour he would use a different brush for each hue, sometimes up to as many as forty, putting them aside after only a stroke or two.

There is an affinity between the landscapes which Soutine painted at Céret in the French Pyrenees during the early nineteen twenties and the paintings which Claude Monet was doing at the time in the garden of his house at Giverny. Although the colour of Monet's pictures is usually higher in key and the forms somewhat more dissolved in light, there are similarities in the way in which the swirling arabesques and thick encrustations of pigment have been applied. Often in the work of both painters the motif is almost lost, the subject of the work becoming the paint itself, the brush-strokes and the reasonance of colour. The hills surrounding Céret, the village square, rooftops and gnarled trees of Soutine, the pathways, trellises entwined with flowers, the famous Japanese footbridge and lily pond of Monet foretell the later Abstract Expressionist painters of the nineteen sixties especially, Willem de Kooning, Philip Guston and Jackson Pollock.

124 **Chaim Soutine:** *Landscape at Céret, c* 1920–21. Oil on canvas, 61 cm × 84 cm
Tate Gallery, London Copyright SPADEM 1983

The late work of the British painter David Bomberg is also worthy of consideration in this context.

PAINTING WITH MODULATED COLOUR

The Post-Impressionist Paul Cézanne rendered solid forms with colour modulations. This system was similar to the way in which form had been painted in the past with changes of tone, particularly in chiaroscuro painting, occurring as a form moved into or out of shadow. What Cézanne did was to emphasise the planes of a solid with colours which changed from warm to cool as the form receded from the spectator. These modulations of colour, small brushstrokes describing related planes, created not only the structure of the forms but helped to fuse together the various elements of the picture plane; so building the overall structure of the painting. The brushstrokes drawing the planes described solids with both shape and colour.

'Drawing and colour are not separate, everything in nature being coloured. During the process of painting one draws; the more the colour harmonizes the more the drawing becomes precise. When the colour has attained richness, the form has reached its plenitude.'

PAUL CÉZANNE *to Emile Bernard*

167

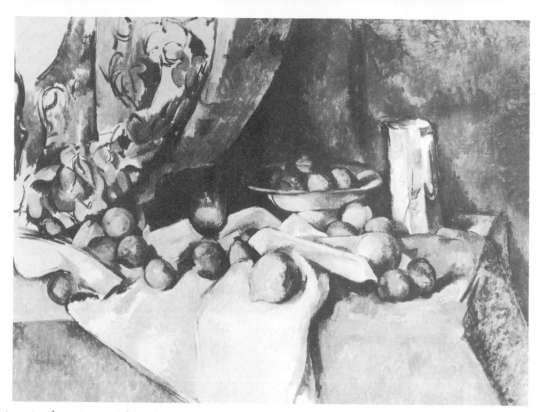

Painting is drawing with colour and for no painter is this old statement more true than for Cézanne. He developed a technique which has been as important to the artists since as have his theories, his way of composing a painting and his modulations of colour. His method was to work on all parts of the canvas simultaneously, drawing and redrawing contours at the same time as he coloured areas; continuously altering, adding new contours over shapes, lines over colours not afraid to alter the shapes yet again and again so that the work grew with a controlled fluidity preserving a freshness of drawing and building a depth of colour quite different from other methods of painting. Fortunately for the student Cézanne left many unfinished works so it is easy to see how he constructed his compositions and how he applied his paint. Most of his mature work was done with pigment diluted with turpentine, thin blocks of colour laid over each other. Sometimes there was excessive use of the dilutent which has lead to an over-matt appearance in some of the works, but the method suited Cézanne, for he would return day after day to the same motif with the canvas which

125 Paul Cézanne: *Still Life with Apples,* 1895–98. Oil on canvas, 68·6 cm × 92·7 cm
The Museum of Modern Art, New York, Lillie P. Bliss Collection
Various stages of the painting's development are shown in this unfinished work. The light areas of the curtain, the central cloth and the jug are white primed canvas whilst the fruit and the immediate adjoining passages have been defined with contours and colour juxtopositions which could be considered almost complete. Multi-directional brushstrokes have been used to apply paint to the surrounding areas in a manner which suggests a quick covering of the priming, an establishing of tones which will be developed later

For detailed captions to colour plates see pages 83 and 84

126 Paul Cézanne: *Still Life with Apples* (detail)

168

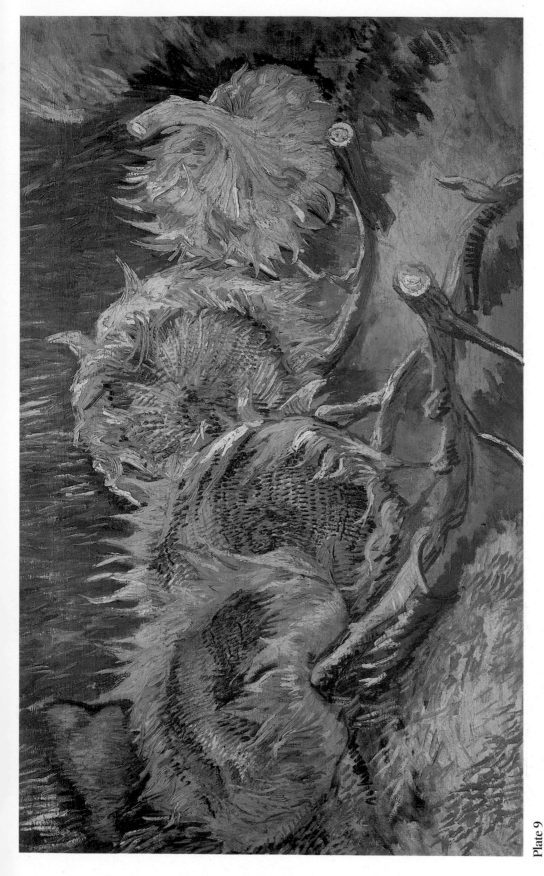

Plate 9
Vincent Van Gogh: *Sunflowers*, 1887. Oil on canvas. 30.5 cm x 98 cm
Kröller-Müller Museum, Otterlo

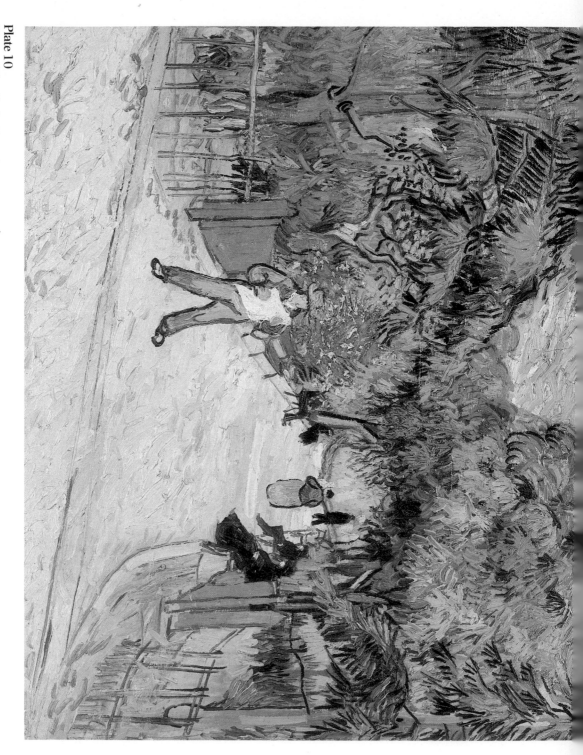

Plate 10
Vincent Van Gogh: *Entrance to the Public Gardens in Arles*, 1888. Oil on canvas,
72.5 cm x 91 cm
The Phillips Collection, Washington. Acquired through Wildenstein and Co.
New York, 1930

Plate 11
Paul Cézanne: *Garden of Les Lauves, c 1906. Oil on canvas. 65.5 cm x 81.3 cm*
The Phillips Collection. Washington. Acquired through Wildenstein and Co,
New York, 1955

Plate 12
Claude Monet: *Wisteria, c* 1920. Oil on canvas, 100 cm x 301 cm
Collection of the Musée Marmottan, Paris

Plate 13
Claude Monet: *Water Lilies, c* 1920. Oil on canvas, 100 cm x 300 cm
Collection of the Musée Marmottan, Paris

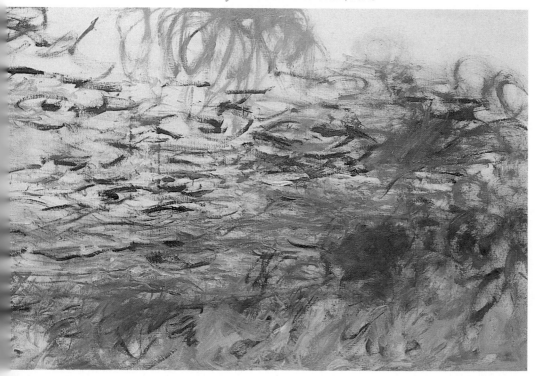

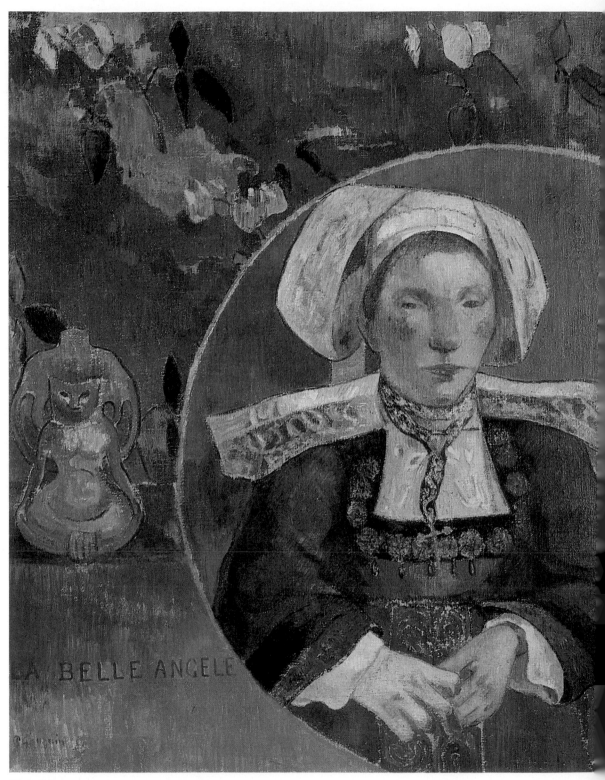

Plate 14
Paul Gaugin: *La Belle Angele*, 1889. Oil on canvas, 89 cm x 72 cm
Musée d'Orsay, Galerie du Jeu de Paume, Paris

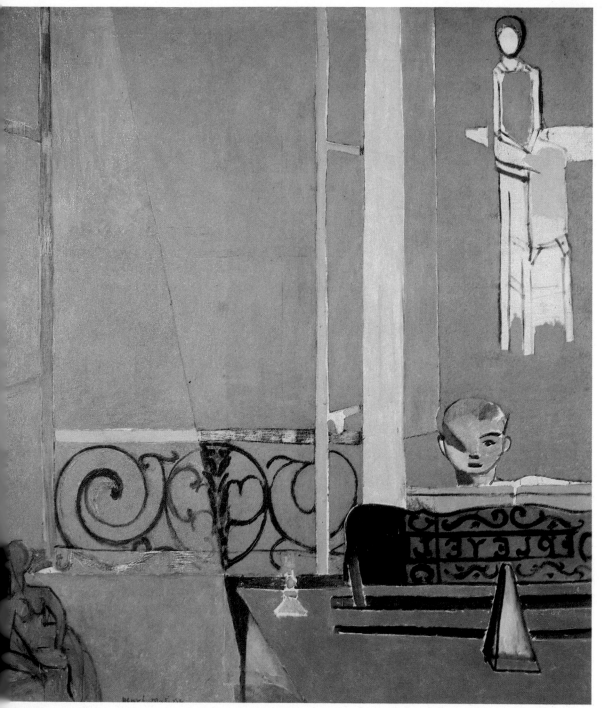

Plate 15
Henri Matisse: *The Music Lesson*, 1916-17. Oil on canvas.
Museum of Modern Art, New York. Mrs Simon Guggenheim Fund.
Copyright SPADEM 1983

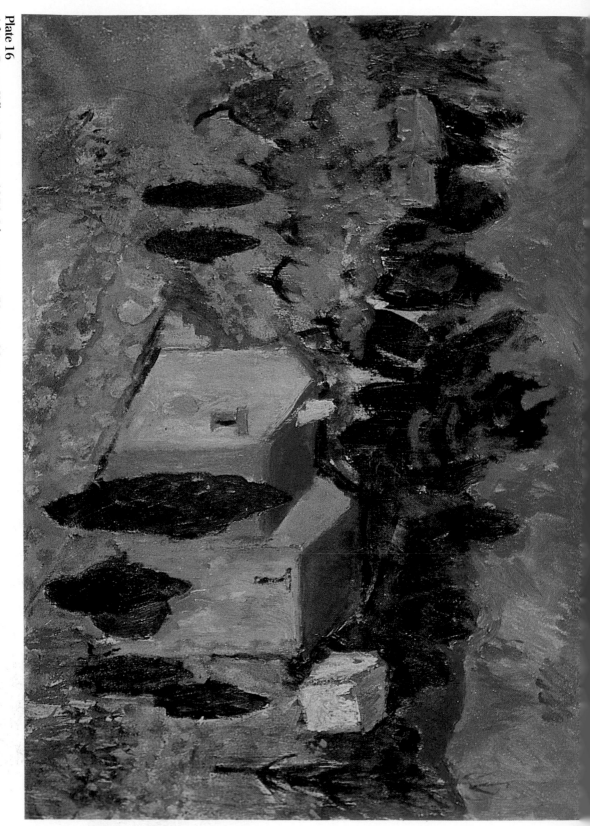

Plate 16
Adrian Ryan: *Villas in Provence*, 1976. Oil on canvas, 50 cm x 66 cm
Private Collection

had dried overnight. Towards the end of his life his brushstrokes became freer and he applied his pigment thicker, as indeed he had done as a young man, and it is thought that he might have added quick drying oils to the medium for some of these late works, which are now showing signs of cracking.

Not all great artists have used a palette of colours which is completely permanent as many paintings testify. There is a number which are doubtful in the list of Cézanne's colours given by Emile Bernard and it is possible that in the future there might be a certain amount of discolouration:

Yellow: Brilliant Yellow, Naples Yellow, Chrome Yellow, Yellow Ochre, Raw Sienna.
Reds: Vermilion, Red Ochre, Burnt Sienna, Rose Madder, Carmine Lake, Burnt Lake.
Greens: Emerald Green, Viridian, Terre Verte.
Blues: Cobalt Blue, Ultramarine, Prussian Blue.
Silver White (White Lead)
Peach Black (a permanent black made from burned peach kernels).

PAINTING WITH OPTICAL MIXTURES OF COLOUR

There were, and still are, those who believe that the concern of the Impressionists with light and the instantaneous moment produced a painting which was structurally loose and intellectually weak. It is not surprising that after the great decade of Impressionism 1870–80, although the Impressionists themselves continued to develop their ideas, other painters proceeded to extend the notions of their collegues in new directions; Cézanne to concern himself with spatial structure and colour modulations, Van Gogh and Gauguin to experiment with the emotional and symbolic uses of colour. Another painter of this time was Georges Seurat, the creator of Pointillism, or Divisionism as the group of Neo-Impressionists, who were influenced by Seurat's theories, preferred it to be called. This was a method of painting which was directly derived from the

Impressionist's ideas and those of Delacroix whose theories Seurat had studied and whose paintings, including the murals in St Sulpice, he had carefully examined. These two sources, along with the works of Chevreul, Rood and the other scientists formulating new ideas about light and colour, helped Seurat to develop the concept of optical mixtures: that is that adjacent, but separate colours, mix in the eye of the spectator and so produce other colours. Such a procedure gives the work greater brilliance. Although there was nothing new in the basic idea of optical mixtures Seurat made of it a system which was more organised than it had been previously. He was not content to allow separate strokes of colour to be applied to the canvas in an almost arbitary fashion, on occasion physically mixing on the picture plane as had been done by the Impressionists; he believed that the full potential of the system could only be achieved through strict adherence to the principle. He therefore placed small dots of different colours and tones on the surface of the canvas so that when viewed from a certain distance they fused together. Naturally, the distance at which they appeared to merge together was reliant on the size of the dots used. It was not just a matter of producing secondary and tertiary colours through obvious mixtures, but of composing areas of greater complexity and ingenuity than such a simplification would allow. Seurat would create different tones and great vibrancy of hue with the addition of complementaries and reflected colours. The law of simultaneous contrasts (see Colour Section) was one which he continually respected.

Seurat believed that his large compositions should be carefully worked out in terms of organisation and colour before they were begun; and to this end he produced a number of small oil studies on wooden panels as well as numerous drawings. Both types of work deserve close study, the former for the use of complementary contrasts exploited with free brushwork and a fluidity of approach not found in the larger works, and the latter for the use of tonal relationships and the organisation of

127 Georges Seurat: *Le Bec du Hoc, Grandcamp,* 1885.
Oil on canvas, 64·5 cm × 81·5 cm
Tate Gallery, London

mass and form. Examination of Seurat's compositions will reveal his deep concern with the structure of painting; the architecture which holds together all the disparate elements of a work of art. His involvement with creating works which were harmonious, not only in their balance of colour and tone, but in their spatial as well as their two-dimensional aspects, make him an heir to the great Classical masters of composition: Piero della Francesca, and Nicolas Poussin particularly come to mind (see *Composition*).

Aesthetic

Art is Harmony. Harmony is the analogy of contrary and of similar elements of *tone*, of *colour* and of *line*, considered according to their dominants and under the influence of light, in gay, calm, or sad combinations.
The contraries are:

For *tone*, a more $\begin{cases} \text{luminous} \\ \text{lighter} \end{cases}$ shade against a darker
For *colour*, the complementaries, ie, a certain red opposed to its complementary, etc (red-green; orange-blue; yellow-violet).
For *line*, those forming a right angle.
Gaiety of *tone* is given by the luminous dominant; of *colour*, by the warm dominant; of *line*, by lines above the horizontal.

128 Georges Seurat: *Rue Saint-Vincent, Monmartre,* 1884. Oil on panel, 25 cm × 16 cm
Fitzwilliam Museum, Cambridge
The dark tones are loosely brushed on the panel, the middle tone of which is in places allowed to remain uncovered. The sunlit parts of the path and the building in the distance have the thickest pigment and there is contrast between their yellow-white lights and the violet, blue-black darks as there is in the further complementaries of red and green in the foliage at the top of the picture. Although freely painted with dabs and streaks of pigment which give the work movement and a sense of light there is a strong geometric structure underpining the apparent spontaneity

129 Georges Seurat: *Bridge at Courbevoie*, 1886–7. Oil
on canvas, 46 cm × 55 cm
*Home House Society Trustees, Courtauld Institute Galleries,
London, Courtauld Collection*
This small painting, its obvious geometry foretelling the
non-figurative paintings of the twentieth century, has a
monumentality linking it to the great pictorial composers
of the past

Calm of *tone* is given by an equivalence of light and
dark; of *colour*, by an equivalence of warm and cold;
and of *line*, by horizontals.
Sadness of *tone* is given by the dominance of dark; of

colour, by the dominance of cold colours; and of *line*,
by downward directions.

Technique

Taking for granted the phenomena of the duration
of a light-impression on the retina: a synthesis
follows as a result. The means of expression is the
optical mixture of tones and colours (both of local
colour and of the illuminating colour – sun, oil lamp,
gas lamp, etc) ie of the lights and their reactions
(shadows) according to the laws of *contrast*, grad-
ation and irradiation.
The frame is in the harmony opposed to that of the

172

tones, colours, and lines of the picture:

La Renaissance du sentiment classique
Paris 1931
SEURAT to Beaubourg
28 August 1890

'If you consider a few square inches of uniform tone in Monsieur Seurat's *La Grande Jatte*, you will find on each inch of this surface, in a whirling host of tiny spots, all the elements which make up the tone. Take this grass plot in the shadow: most of the strokes render the local value of the grass; others, orange-tinted and thinly scattered, express the scarcely-felt action of the sun; bits of purple introduce the complement to green; a cyanic blue, provoked by the proximity of a plot of grass in the sunlight, accumulates its siftings towards the line of demarcation, and beyond that point, progressively rarefies them. Only two elements come together to produce the grass in the sun: green and orange-tinted light, any interacting being impossible under the furious beat of the sun's rays. Black being a non-light, the black dog is coloured by the reactions of the grass; its dominant colour is therefore deep purple; but it is also attacked by the dark blue arising from the neighbouring spaces of light. ... These colours, isolated on the canvas, recombine on the retina: we have, therefore, not a mixture of material colours (pigments), but a mixture of differently coloured rays of light.'

FÉLIX FÉNÉON
Les Impressionists en 1886
Oeuvres, pages 79–80
JOHN REWALD
Post Impressionism
Museum of Modern Art, New York
2nd edition 1962

PROCEDURES

'When you go out to paint, try to forget what objects you have before you, a tree, a house, a field, or whatever. Merely think, here is a little square of blue, here an oblong of pink, here a streak of yellow, and paint it just as it looks to you, the exact colour and shape, until it gives you your own naive impression of the scene before you.'

CLAUDE MONET

'To see is to forget the names of the things one sees.'

PAUL VALERY

'I did not begin to do anything tolerable until I forgot the small details and remembered only the striking, poetical aspect. Until then I had been dogged by a love of exactitude which most people mistake for truth.'

EUGÈNE DELACROIX

A painting is not a coloured drawing. This statement might seem obvious but many people starting to paint for the first time think that the tinting or 'colouring in' of a drawing constitutes painting. Nothing could be further from the truth. Painting is drawing with colour and that is different. The drawing of the shapes and forms alter continually as the work progresses until the painter has made his statement with a balance and pictorial harmony no part of which can be altered without destroying the whole.

Drawing is of paramount importance to the painter for without the ability to put down marks where he wishes them to be, his work, however exciting the colour or other elements, will in the end be meaningless. Drawing does not necessarily mean working from nature in a representational manner. Drawing may be non-figurative, but for the student a study of nature is probably the best way to begin. Only after careful observation and analysis is it possible to be imaginative. The 'intake' and experience which continuous and detailed observation of our environment provides is a sound basis for all painting. Such an approach makes us aware of how objects relate to the space around them and to each other. Careful analysis of natural and man-made forms teaches us to look and extends our creative faculties. It is a sensible idea to carry a small sketchbook on all occasions and to make drawings of anything and everything whenever it is at all possible.

'Lead your students to Nature, into Nature! Let them learn by experience how a bud is formed, how a tree grows, how a butterfly opens its wings, so that they will become as rich, as variable, as capricious, as

173

Nature herself. Perception is revelation, it is an insight into the workshop of creation. That is where the secret lies.'

PAUL KLEE *to H F Geist*

Some painters make a series of preparatory drawings before beginning a painting; working into a completed design detailed studies and colour sketches. Such a method is reminiscent of that used by the Old Masters and has much to commend it if the aim is to produce a complex composition created from a number of disparate sources. Before a work of this nature can be begun it is essential for many different arrangements of form and colour to be tried otherwise, for all but the most skilful and

experienced, there will be insurmountable difficulties. Many painters of the past, for example Raphael, would make large 'cartoóns' the actual size of the projected work. Some, after pricking holes along the contour lines, would rub powdered charcoal through so that an indication of the shapes was made onto the canvas or wall. The large Holbein drawing of Henry VIII in the National Portrait Gallery, London, is an example of this method. Other artists have 'squared up' (see Section on Squaring up) their drawings in order to transpose

130 **Walter Richard Sickert:** *Study for Ennui, c 1913.*
Pen on paper, 38 cm × 28 cm
Ashmolean Museum, Oxford

131 **Walter Richard Sickert:** *Study for Ennui, c 1913.*
Pencil on paper, squared drawing, 38 cm × 28 cm
Ashmolean Museum, Oxford
There are a number of drawings related to the theme of Ennui. In addition to others similar to these dealing with the whole composition there are also studies for various details

132 Walter Richard Sickert: *Ennui, c* 1913. Oil on canvas, 76 cm × 56 cm
Ashmolean Museum, Oxford

them onto the canvas. Many works by Walter Richard Sickert show evidence of this, in some cases to such a degree that the squares form a structural part of the completed work. In one of his last paintings, 'Temple Bar' (c 1941), he emphasised the grid of lines by painting over them as part of the picture in order to re-emphasise the surface quality of the picture-plane. Other artists, such as Mattise, reject the process of 'squaring-up' believing that each statement should be made anew in relationship to the size and shape of the surface onto which it is drawn or painted. As is the case with all approaches to painting, there is no one correct way. Only in terms of the permanence of materials are there any rules.

Even when painting directly from the motif some painters make a number of studies in order to familiarise themselves with it and to ascertain which viewpoint and composition will serve their purpose best. In order to do this they sometimes use a viewfinder so as to isolate a part of the scene or subject from the surrounding area which can easily confuse. A view finder cut from a piece of card, rather like a small window mount, can be of enormous assistance in helping the painter to select a 'long shot' or more detailed 'close-up'. Such a simple piece of card may be clipped to the easel or the edge of the canvas or drawing board.

Van Gogh used a similar device for much of his early work finding that it helped him concentrate on the essentials of what he was painting, eliminating all the extraneous passages from a scene. His viewfinder or 'perspective frame' though was more complex than a card window mount, having vertical, horizontal and diagonal lines across the opening rather like one of the drawing devices depicted by Albrecht Dürer in his woodcuts; one of which had a number of squares defined by threads which corresponded to a grid of squares on the artist's picture-plane. By such a method the painter could set down lines and shapes in correct proportion to each other and overcome in large measure the difficulties of perspective and foreshortening. Van Gogh's frame was similar and seems to have assisted him greatly.

'Dear Theo,
In my last letter you will have found a little sketch of that perspective frame I mentioned. I just came back from the blacksmith, who made iron points for the sticks and iron corners for the frame. It consists of two long stakes; the frame can be attached to them either way with strong wooden pegs.

So on the shore, or in the meadows or in the fields one can look through it like a window. The vertical lines and the horizontal lines of the frame and the diagonal lines and the intersection, or else the division in squares, certainly give a few fundamental pointers which help one make a solid drawing and which indicate the main lines and proportions – at least for those who have some instinct for perspective and some understanding of why and how the perspective causes an apparent change of direction and change of size in the planes and in the whole mass. Without this, the instrument is of little use, and looking through it makes one *dizzy*. I think you can imagine how delightful it is to turn this 'spy-hole' frame on the sea, on the green meadows, or on the snowy fields in winter, or on the fantastic network of thin and thick branches and trunks in autumn or on a stormy sky.

VAN GOGH to his brother Theo
Letter 223, The Hague
5 August 1882

133 **Vincent Van Gogh:** *A page from a letter to his brother Theo,* written from The Hague on the 5th August 1882
Stedelijk Museum, Amsterdam
Sketch of the drawing frame or viewfinder which Van Gogh had made for him

Waarde Theo,

In myn vorigen brief zult ge een krabbeltje gevonden hebben van dat bewuste perspectiefraam. Daar net kom ik van den Smid vandaan die yzeren punten aan de stokken heeft gemaakt en yzeren hoeken aan het raam.

Het bestaat uit twee lange palen:

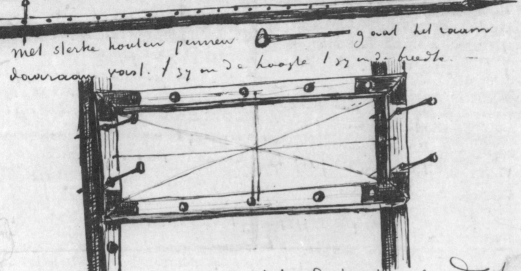

met sterke houten pennen goat het raam daaraan vast. / zy in de hoogte / zy in de breedte. —

Dit maakt dat men op t strand of op t weeland of op een akker een kykje heeft als door 't venster. De loodlynen & waterpas lynen van 'traam verder de dragonalen 3 het kruis ——— of anders een verdeeling in kwadraten geven vast & zeker eenige hoofdpunt waardoor men met vastheid een teekening kan maken die de groote lynen & proporties aangeeft. Dan ten minste wanneer men gevoel heeft voor de perspectief en begrip van de reden waarom en de wyze waarop de perspectief de lynen een schynbare verandering van rigting & de massa's & vlakken verandering van grootte geeft. Zonder dat helpt het raam niets of byna niets en duizelt men als men er door kykt. Ny dunkt gy zult wel voelen dat het een heerlyk ding is dit vizier te braqueeren op de zee op de groene velden — of s'winters op de besneeuwde vlakte of in den herfst op het grillig netwerk van dunne & dikke tam men & takken, of een storm lucht.

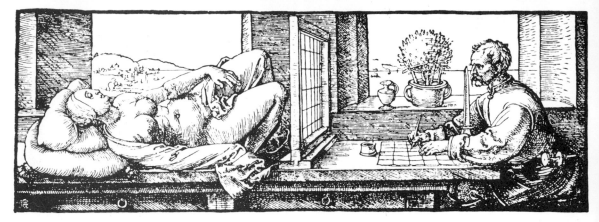

134 **Albrecht Dürer:** *A Man Drawing a Recumbent Woman*, 1538. Woodcut, 6·5 cm × 18·3 cm
From *Underweysnng der messung* Nürnberg

135 **Albrecht Dürer:** *Method of Drawing a Portrait*, 1525. Woodcut, 13 cm × 14·9 cm
From *Underweysung der messung* Nürnberg

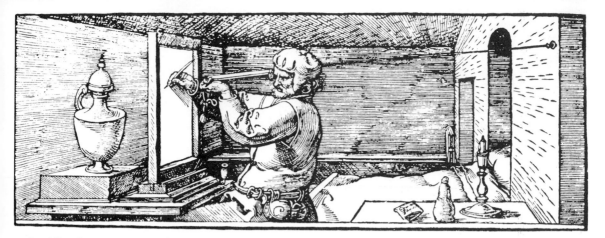

136 **Albrecht Dürer:** *A Man Drawing a Vase*, 1538.
Woodcut, 7 cm × 18·2 cm
From *Underweysung der messung* Nürnberg

137 **Albrecht Dürer:** *A Man Drawing a Lute*, 1525.
Woodcut, 13·1 cm × 18·3 cm
From *Underweysung der messung* Nürnberg

a The subject

b The first main lines are drawn with cobalt blue onto the paper

138 Sequence of photographs showing work in progress

e Thick paint and excess oil are removed by tonking

f A sheet from a telephone directory having been pressed onto the picture surface is peeled away

c The motif is developed and the picture-plane covered with a fluid wash of turpentine and pigment to tone the white ground and make it less absorbent

d Further drawing with thicker paint particularly on the lighter parts of the flowers

g The flowers are not painted in isolation, but in conjunction with the rest of the picture-plane

h A darker tone has been applied to the background, but nothing is unalterable and in order to regain something of the freshness of the first impression a further change is made

i At the next stage thicker, lighter colour is applied, redrawing the vase and giving greater tonal contrast. The study is not completed for, as Bonnard said, 'Paintings are not finished, simply abandoned' Oil on paper, 77 cm × 53 cm

How a painter lays out the colours on his palette is a matter of choice, but it is sensible to have a consistent method. A common practice is to place small quantities of pigment around the outer edge of the palette which are in an order running from the lighter, warmer yellows through reds to greens and blues; with white either at the extreme right or somewhere in the centre for convenience. Thus a palette layout might from right to left be as follows: White, Yellow Ochre, Cadmium Yellow, Lemon Yellow, Cadmium Red, Alizarin Crimson, Viridian, Ultramarine, Prussian Blue, Ivory Black. Earth colours might be grouped together somewhere towards the left hand side or be placed with the reds and yellows.

Such a layout of colour, prior to starting a painting, may be desirable but is not always necessary. If the work in hand is to be painted alla prima then placing the colours around the palette before beginning will allow for concentration on the work without the interruption of looking for tubes of paint. However, it is sometimes advantageous to let the colour key of a work evolve according to the ideas of the artist as he sees the painting change. To begin with two colours and white, to mix them in varying tones and then to add a third colour, and the variations which its introduction allows, is to establish a harmony which with its limitations nonetheless offers extensive permutations and is at the same time more controlable than an extensive range of colours. For example, begin the painting with Yellow Ochre, organising the main areas of the image. Mixed with white the less important, or perhaps distant areas, might be indicated. Cobalt Blue will enable darker marks to be made, to emphasise or indicate a shadow. Mixed with white further suggestions of distance occur and the addition of the Yellow Ochre creates a green. A later stage might require a red and so Light, Venetian or Indian Red is all that is needed to extend the range enormously. Alternatively, a selection might be made from the earth colours alone, so that choosing from the Ochres, Umbers, Siennas and Earth Reds a play may be made upon warm and cool as well as light and dark. White and possibly Black would be necessary.

Both these approaches to assembling the palette are worth experimenting with, but whichever is being used, it is practical to lay out one's pigments in a consistent order.

When starting a painting care should be taken not to attempt everything at once. It is important to know what it is one wishes to say in the work, to have an overall idea about what is to be expressed and communicated. Those aspects of the subject which have been strong enough to provoke a desire to paint them should be borne in mind throughout so that the

painter has one aim in view and is not side-tracked by other, possibly less important, ones which are discovered as the work progresses. Without adherence to his original concept the beginner will lose himself in inessentials, and the resulting picture will present to the spectator a number of unresolved ideas. This applies not simply to that aspect of the subject which interests the painter but also to those elements which go to make the picture. So a decision should be made by the beginner if he is not to become confused; what it is about the subject that he wishes to paint and what degree of importance is to be given to the means of making that statement. Is it to be the form, the colour, the composition or some simple combination of the different elements? To attempt too much in the beginning is to invite problems.

The placing and composition of the subject on the canvas is the first thing to be decided in terms of practical application. The initial marks made are the start of this but it should be understood that, even by the experienced, these marks may be revised. Major alterations to the placing of the main shapes on the picture-plane should, however, be made fairly early on in the process. This does not mean that a mark is unalterable. On the contrary it is essential to maintain a sense of freedom about the alteration of shapes throughout, but the main, 'roughly' correct positions should be established early if the painting is not to become overworked and the paint quality somewhat turgid in appearance. The structure should be related to what it is that is being depicted. Obviously the arrangement of a motif which is before the painter will, in large measure, dictate how it is to be placed on the canvas, but within the confines presented by painting from life there is enormous opportunity for invention. Avoid absolute symmetry, but achieve a sense of balance with the play of small shapes against large, or light against dark, positive shape against negative. See how Degas in many of his works achieves harmony and equilibrium by placing off-centre figures which are held in position by areas of space or colour. Even those

compositions by the masters which appear to be symmetrical at first glance have within them asymmetrical elements which give vitality to them. The completely symmetrical painting can be boring.

Concentration on the establishment of the basic areas is the primary concern. There is no advantage to be gained by making a detailed drawing on the canvas before the application of paint as this will be obliterated. A rough indication of the main parts of the composition might be drawn in with charcoal (not pencil as this tends to come through the thin areas of paint), but this is really not essential and it is much better to get used to the practice of painting directly; using the brush and pigment to place lines and shapes rather than be tempted to 'fill in' a completed drawing.

Transparent or semi-transparent pigment such as Terre Verte, Cobalt Blue or Yellow Ochre are suitable for the drawing of any basic construction lines which might be desired. Alterations can easily be made either by using a darker tone of the colour or another colour entirely. Should the work become confused with too much alteration the whole may be washed down with a soft cloth dipped in turpentine or white spirit.

No statement is irrevocable. There is no shape or colour which may not be altered. Keep the whole painting fluid partly in the consistency of the paint, but mainly in the arrangement. Constantly re-draw, changing lines and shapes, correcting tones and colours; playing always the contrast of one element against another; line against shape, complex against simple, light against dark, warm against cool, curve against straight. Think of the juxtaposition of opposites so that the work contains interest; and also in terms of areas which dovetail and overlap, forming a network of shapes existing both on the surface and in depth; building an architecture which relates to the shape of the canvas and in which there is relationship of large and small inter-dependent areas. To continually reassess the main construction of the picture is of great importance.

To be tempted by detail is to become involved with the inessential. There is plenty of time to add small points of interest, should these be required, when the basic structure has been built, the inter-relationships of shapes and colours and the tonal balance achieved. Only when these are successfully established is it possible to introduce those finer details which may complete the work but are not necessarily its essence.

This way of beginning a painting is applicable whether the completed work is to be produced with glazes, successive applications of paint or created alla prima. This does not mean that it is the only way of proceeding. Without doubt there are those who would prefer to work from a much more rigid base; such as a detailed drawing, but certainly for the beginner this more 'fluid' approach offers a less restricted introduction. From this starting point, and with the notion of flexibility constantly in mind, the painter may develop the work in whichever manner he pleases.

There are of course painters who prefer to make a detailed drawing on the canvas before they begin to paint and may even, somewhat in the manner of the fresco painter dictated to by the rapid drying of a plaster surface, complete a small area of the work before going on to another. Stanley Spencer worked mainly in this way as may be seen from his unfinished works. There is the danger for the less skilful artist that this method of working leads to a type of painting within which the formal relationships and emotional content are as serious as those in painting by numbers or the filling in of a child's colouring book. This might be a hard judgement, but the results of such an approach by the beginner unfortunately often prove the difficulties of coping with such a method. In work of an illustrational nature, or in large scale murals it may have a place but in easel painting there is, in addition to the dangers already stated, the problem of continually trying to 'bring up' one part of the picture to the completeness of another. In order to control the painting as a growing work with continual

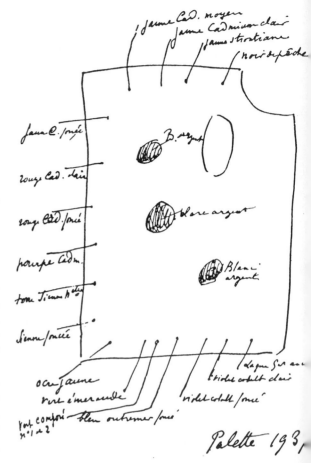

139 Henri Matisse: *Sketch of palette and layout of colours, 1937 Copyright SPADEM 1983*

consideration for the relationships of all the elements which make a painting it is a good idea to work all over the canvas and not get involved with one passage to the detriment of others. Developed in this way it is more possible for the student to attain a degree of unity and cohesion which would be difficult to achieve if he concentrated on finishing details. Control of the whole work should be maintained throughout, for each part of a picture is dependent upon all others.

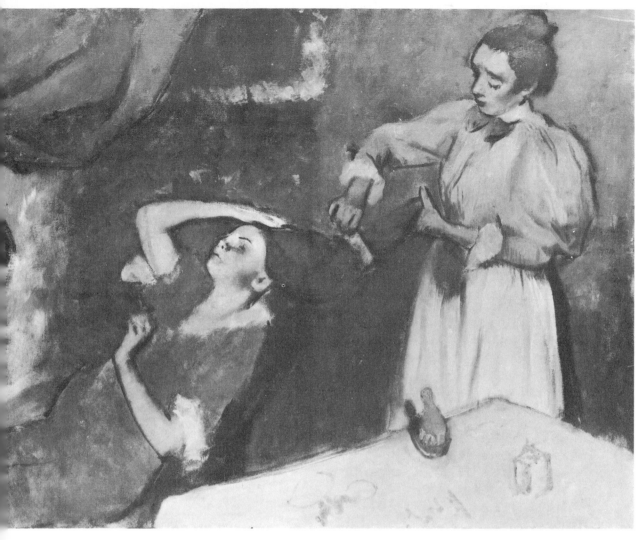

140 Edgar Degas: *Combing the Hair, c* 1892. Oil on canvas, 1·143 m × 1·461 m
National Gallery, London
An unfinished canvas on which Degas has limited himself to a small range of reds with white and an umber in order to concentrate on the sweep of the composition and the repetition of interlocking shapes. Movement based on the diagonal is created by a broadly painted series of figure eights created by the positions of the arms and also by the 'positive and negative' areas between

141 Kenneth Martin: *Reclining Nude,* 1955. Oil on unprimed canvas. 55 cm × 45 cm.
Collection of the author
This 'demonstration' painting in cobalt blue on the unprimed reverse side of a canvas shows a concern with the overall design of the picture and the interwoven relationships between figure, couch and surrounding space.

142 **Titian:** X-Ray photograph of Acteon being devoured by hounds. Detail from *Death of Acteon*, *c* 1560. Oil on canvas
National Gallery, London
This X-ray photograph shows that even with the greatest painters no statement is unalterable. Titian has been prepared to change his original drawing as the painting has developed

143 **Paul Cézanne:** *Garden of Les Lauves*, *c* 1906 (detail). Oil on canvas, 65·5 cm × 81·3 cm
The Phillips Collection, Washington
This detail from the late, unfinished work shows how Cézanne built his painting up with mosaic-like areas of colour across the picture-plane. He has not been captivated by the inessentials. With thin washes of colour (which he has not been afraid to let trickle at this early stage), and layers of thicker pigment, he has played contrasting tones, variations in size, vertical, horizontal, curve and straight against each other to create an image which may be seen as either two or three-dimensional; figurative or abstract. See also colour plate 11

144 **Stanley Spencer:** *Christ Preaching at Cookham Regatta* (detail), 1959. Begun in the early 1950s. Oil on canvas, 205·7 cm × 535·9 cm.
Stanley Spencer Museum, Cookham
'The painting clearly shows Spencer's working methods. Beginning at the top and working down and outwards, the artist first filled in the background detail before starting on the figures. The underdrawing seen on the left was traced onto the canvas from the six preparatory studies.'

KEITH BELL,
Catalogue for the Royal Academy
Exhibition 1980

186

COMPOSITION

'Remember that a painting, before it is a war horse, a female nude or some little genre scene, is primarily a flat surface covered with colours arranged in a certain order.'

MAURICE DENIS
Theories, Du Symbolisme au Classicisme

Most great paintings are composed with areas. They are not made with images placed indiscriminately against backgrounds or marks, which have no relationship to other parts of the picture-plane; but with a series of inter-locking areas which by their relationship create a 'woven' surface of large and small areas dovetailing and overlapping in a manner which emphasises the importance of all parts of the picture-plane. It cannot be overstated that in the painting of a picture the whole of the picture-plane needs equal consideration. The space between objects is as necessary to the painting as the shapes of the objects themselves and the alteration of either affects the other. These 'negative' shapes or spaces must be given as much thought as the shapes of the actual or 'positive' objects if the work is to be a cohesive unity and not simply a superficial illustration or insubstantial arrangement of forms. In music and architecture silences and spaces are an integral part of the whole and it is no less so in painting. Firstly a mark made on the blank surface relates to the dimensions of that surface and then to the other marks made, each of which in their turn relate to previous marks and again to the shape of the picture-plane.

'If I take a sheet of paper of given dimensions, I shall make a drawing necessarily related to its proporations. I should not repeat the same drawing on a sheet of paper differently proportioned, which was rectangular, for instance, instead of being square. And I should not be content to enlarge it if I had to reproduce it on a similar sheet, but ten times bigger.'

HENRI MATISSE
1908

A look at Matisse's own painting *The Music Lesson* 1916–17 (see colour plate 15) will emphasise the importance of area and the interraction between large and small, curved and angular shapes which overlap and interweave. It is worth taking a piece of tracing paper and after measuring the square on it, see what lines and points in the work are placed on that square. A line, half the length of the short side of the canvas (ie half the side of the square) may also be taken and used similarly and as an aid to establish other smaller squares and rectangles within the picture. Such a simple breakdown may be employed to establish the basic compositional construction of many great paintings and it would be helpful in order to gain further appreciation of the use of area in painting to consider in some detail the more complex works of Piero della Francesca, Paolo Veronese, Jacopo Tintoretto, Jacque Louis David, Jan Vermeer, Nicolas Poussin, Georges Seurat and Paul Cézanne, all of whom were concerned with constructing the architecture of a painting in a manner which avoided the accidental and used established concepts of classical organisation.

THE STRUCTURE OF A PAINTING

Man has constantly invented ways of producing what to him are integrated and visually acceptable divisions of area. Structural organisation is a way in which art is created out of apparent chaos. There are many systems which the artist may incorporate into his work to advantage and although it should be stressed that the simple employment of such geometry does not provide the inept with a means of creating works of art, a knowledge and judicial use of them will help to give the expression of ideas a form which might well strengthen them. Strong, meaningful expressions are those in which the emotional content has been tempered and 'honed' by structure and form. We have only to consider the youthful efforts of the romantic Cézanne and then look at his later work to realize that his concern with construction did not lessen the expression of feeling but rather helped emphasize its power.

Many divisions of the picture-plane are of course possible and the painter may make numerous and different types of grids which will assist him in his placing of shapes within the picture. He may draw a symmetrical basic

145 17 March

146 22 March

147 6 April

145–7 **Henri Matisse:** *La Musique*, 1939.
Progress photographs
Copyright SPADEM 1983

148 **Henri Matisse:** *La Musique*, 1939 (completed 8 April). Oil on canvas, 115 cm square
Albright-Knox Art Gallery, Buffalo, New York. Room of Contemporary Art Fund Copyright SPADEM 1983
Nothing is unalterable. Matisse has not been restricted by his original plan, but realizing the possibilities for development as the work progressed he has been prepared to move the positions of the figures, redraw the details and alter tones. The composition, whilst similar to his first intention, has not been limited by inflexibility or an unwillingness to change what has already been achieved

TECHNIQUES

149 Finding the square on a canvas by drawing an arc from the short side

150 Drawing verticals for the basic grid

151 Gustave Caillebotte: Sketch for Paris. *A Rainy Day*, 1877. Oil on canvas, 54 cm × 65 cm
Academie des Beaux-Arts, Musée Marmottan, Paris. Bequest of Michel Monet
This study, showing as it does the artist's concern with light and atmosphere, may well have been painted from the motif. The figures though would have been placed according to earlier compositional plans and drawings

152 **Gustave Caillebotte:** *Paris, A Rainy Day –*
Intersection of the rue de Turin and the rue de Moscou, 1877.
Detail. Oil on canvas, 209 cm × 300 cm
The Art Institute of Chicago, Charles II and Mary F S
Worcester Fund Income. See also figure 86

structure from whicn he can 'abstract' and select as he works using arcs as well as verticals, horizontals and diagonals on which to establish points of intersection or contour lines. Over use of such a grid is of course futile, leading only to sterility and an appearance of ridgidity in the hands of all but the most accomplished artist.

A simple way in which to break down a given rectangle into related areas is to take the short sides as a starting point and by dropping them down onto the base line create squares which either by their overlap or the space they leave create another rectangle within the given frame. It will readily be seen that from this base

it is perfectly easy to draw further squares and rectangles and have vertical and horizontal lines to aid the work's construction. Use of this system may be found in the work of many artists, for example Giotto.

THE GOLDEN SECTION

Since Euclid the proportion of the Golden Section, known to him as the Golden Ratio, has been used by artists to divide lines and create shapes which have been considered to be aesthetically harmonious. Throughout the Renaissance the system, which was known then as the Divine Proportion, was employed as

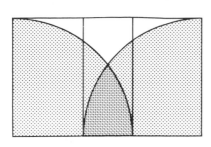

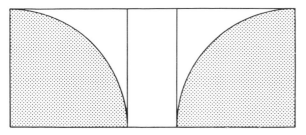

153 Diagram showing simple division of the picture plane

154 de Hoogh's painting *The Courtyard of a House in Delft* (detail)

the basis of construction in works of art and may be found in many paintings not only of that period but throughout history. It has been believed that there is some natural relationship between this man-made scheme of geometric division and the universe and indeed it is possible to discover within nature constructions which appear to conform to certain mathematical principles. D'Arcy Thompson in his book *Growth and Form* gives examples of plant growth, shell and horn formations which substantiate this thesis.

The basic premise of the Golden Section or Golden Mean as it is sometimes called is that the proportion of the smaller to the larger is the same as the larger is to the whole, eg GSB:AGS::AGS:AB.

To divide a line AB at the point of the Golden Section draw a perpendicular from B to D which is equal to one half of the line AB.

Draw a line to join the points A and D.

Place a compass on the point D and describe an arc from the radius point B to cut the line AD at Point X.

From the centre point A and X as the radius point describe another arc to cut the line AB at the Golden Section point.

To create a Golden Section rectangle from a square ABCD (or within an already established rectangle) take a point along the base line of the square which divides the square in half and with this point X as the centre describe an arc from point B to an extension of the line DC at point F. The resulting rectangle is a Golden Section rectangle.

As may be seen from the diagram it is possible to divide a Golden Section rectangle into a series of related squares and smaller golden Section rectangles which, decreasing in size, create a spiral formation. A square drawn within a Golden Section rectangle produces another Golden Section rectangle. A continuation of the process will give the base on which to draw the circle segments which make the spiral. It will

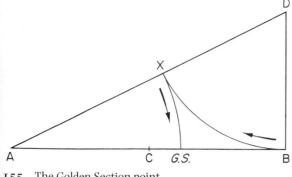

155 The Golden Section point

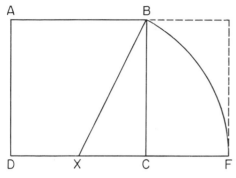

156 The Golden Section rectangle

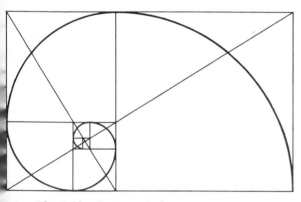

157 The Golden Section spiral

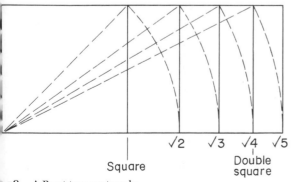

158 A Root two rectangle and extensions

readily be seen that a structure such as this could be the means whereby the eye of the spectator is taken around the picture composition from one point of interest to another (nodal points) to the main focal point of the work.

Analysis of many great paintings will reveal an underlying structure based on the Golden Section and for further study it is worth looking closely at the works of Piero della Fancesca, Nicolas Poussin and Georges Seurat although there are also less obvious sources such as certain portraits by Rembrandt.

Another method of establishing harmoniously pleasing rectangles is to take the diagonal of a square and describe an arc from that diagonal to extend the base line. Such a rectangle is called a root 2 rectangle. The dropping of an arc from the diagonal of that will produce a root 3 rectangle. Continuation creates a double square and then root 5, etc.

The Fibonacci series is a system of establishing related areas or proportions based on the concept that each succeeding number is the sum of the two preceeding ones, ie 1,1,2,3,5,8,13 etc. Examples of this are to be seen in Renaissance works of art and also in the Modular system devised by the twentieth century architect Le Corbusier. His mathematical system took into account the scale of human beings and with the combination of that scale, ie a (6 ft) man and the proportion of the Golden

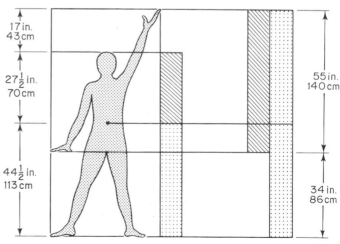

159 Le Corbusier's modular

160 Plan for a Japanese four and a half mat room

Section provided a modular which Le Corbusier used in his architecture. A figure with an upraised arm has three areas relating to his occupation of space. These are from the tips of his outstretched fingers and his head, from there to the solar plexus and thence to the foot. These three areas relate to the Golden Section division of space and to the Fibonacci series.

The use of some form of modular can be very helpful to the painter providing that he does not allow it to become dictatorial and boring. The Tatami straw mat which is used in Japanese houses is a form of modular which is used to create the size of 'flexible' rooms and the plan of the house itself. It is approximately six feet by three feet and about 50 mm (2 in) thick. The double square format is a particularly pleasing proportion.

'The architect invariably plans his rooms to accommodate a certain number of mats; and since these mats have a definite size, any indication on the plan of the number of mats a room is to contain gives at once its dimensions also. The mats are laid in the following numbers: two, three, four and one half, six, eight, ten, twelve, fourteen, sixteen and so on.'

EDWARD MORSE
Japanese Homes

LINES AND SHAPES

'Let us develop: let us draw up a topographical plan and take a little journey to the land of better understanding. The first act of movement (line) takes us far beyond the dead point. After a short while we stop to get our breath (interrupted line or, if we stop several times, an articulated line). And now a glance back to see how far we have come (counter-movement). We consider the road in this way and that (bundles of lines). A river is in the way, we use a boat (wavy motion). Farther up stream we should have found a bridge (series of arches) . . .'

PAUL KLEE
Creative Credo, 1918

'Shape is one of the essential characteristics of objects grasped by the eyes. It refers to the spatial aspects of things, excepting location and orientation. That is, shape does not tell us where an object is and whether it lies upside down or right side up. It concerns, first of all, the boundaries of masses.'

RUDOLPH ARNHEIM
Art and Visual Perception

Wassily Kandinsky in his *Concerning the Spiritual in Art*, 1911 and *Point and Line to Plane*, 1926 related forms and colours to different meanings, but appreciated that a highly structured visual language based on such ideas was limiting. However, it is possible for the painter to use, in a simple manner, the qualities which he knows are possessed by lines, shapes and colours in order to arouse in the spectator those ideas and responses which he is attempting to communicate. It is not just the image which is important, it is the way in which the image is presented as well. Just as colours affect us when we look at them so to do lines and shapes. The vertical tends to indicate strength and growth. A feeling of stability is associated with the square and with rectangular shapes in general. Horizontals express calm whilst diagonals excite us with their vitality and movement. Zigzags, articulated lines and jagged shapes will express agitation whilst those which are uninterrupted and flowing are smooth; the eye passing over them in a gentler fashion. Circles and similar shapes express continuity and movement, triangles are stable but take the eye upwards, if inverted they give a feeling of uncertain balance and tension. Such associations between lines, shapes and the

emotions they arouse are as important to the painter as his knowledge of his materials. They are part of his visual vocabulary and when considered in relationship to the other aspects of his visual language help him, not simply to express his feelings in a self-indulgent manner, but to communicate them and his ideas to the spectator.

Study of the great masters will show how the 'emotional' qualities of lines and shapes as well as colours are inseparable from what is presented. The triangular composition of so many paintings of the 'Holy Family' for example, have a movement upwards towards Heaven from a 'stable' base. The square or rectangular composition of many portraits is also indicative of stability as are some of the figure compositions by Piero della Francesca, Jan Vermeer and Georges Seurat. It may be that the overall composition of a painting depicting some event of great action is not itself based on the diagonal, but rather that the agitation of the moment is seen in the action of individual

161

162

figures, the shapes of the clothing and the manner in which the pigment has been applied. *Christ Expelling the Money Lenders from the Temple*, by El Greco is such a work (see colour plate 2). At the other extreme are the horizontal, sleeping or reclining nudes of Piero di Cosimo, Rubens and Courbet; the languid odalisques of Delacroix and Matisse.

In addition much may be learned from the non-figurative works of painters such as Piet Mondrian, Paul Klee and Wassily Kandinsky. Notions of space, movement, sorrow, joy can be communicated in works which use colour and shape, not to imitate or represent the world around us, but to communicate through their 'abstract' relationships.

'Just as sounds and rhythms combine in music, so must forms and colours be united in painting by the play of their manifold relationships.'

WASSILY KANDINSKY

163 **Wassilly Kandinsky:** *Cossacks* (sometimes called *Battle*), 1910. Oil on canvas, 94·5 cm × 130 cm *Tate Gallery, London Copyright ADAGP Paris 1983*

'One line alone has no meaning; a second one is needed to give it expression. This is a great law. Example: In musical harmonies a note has no expression, two together form a whole, expressive idea.'

EUGENE DELACROIX
Journal (Supplement after 1840)

Line is an analogy, a means by which it is possible to express what is seen felt or thought in a visual way. There is no line as such in nature but rather a continuous point where two areas meet; the edge of two shapes. All the lines we see around us are either such or are elongated shapes: the lines of a tree's branches, telephone wires, and scaffolding. Line is a way we use to translate such things and is itself a form of 'elongated' shape.

Line may express the contour of an object describe its shape in space and its relationship to that space and other objects. The contour may be used to separate a shape from the surrounding area, but as soon as this is done the surrounding area does itself become another shape directly related to that object.

164 **Piet Mondrian:** *Composition with Red, Yellow and Blue,* 1939–42. Oil on canvas, 72·5 cm × 69 cm
Tate Gallery, London Copyright SPADEM 1983

The contour of one object, placed over another will serve to describe both objects and will consequently give some indication of space. Shapes placed over each other in this manner fit together rather like a jig-saw, each one dependent upon the other; their shared contours creating the interlocking shapes.

Line moves. The eye travels along it in a way dependent upon the directional aspect of the line and the manner in which it has been applied to the surface; shooting diagonally across the picture plane, langorously curving or jumping in staccato fashion across a series of articulated marks. The painter exploits this quality of line not only to express particular notions of movement or abstract feelings but also to take the eye of the spectator around the picture from one point of interest to another

guiding it to the place of ultimate interest, the focal point of the painting.

Some painters rely heavily upon line in their work using it to animate the surface or to indicate space upon that surface whilst to others the linear quality of their work seems almost coincidental. As with all aspects of painting the individual must select. It is not possible, nor desirable, to do all things within one work and as with the organisation of colour for a painting so must there be decisions made about such aspects of the painters vocabulary as line and shape.

165 **Spencer Gore:** *The Cinder Path*, 1912. Oil on canvas, 68·6 cm × 78·7 cm
Tate Gallery, London
The eye is led into and around this painting by a careful integration of line and shape. The simplified forms presented as blocks of colour have also a linear quality, their contours directing the spectator along the straight edges of field, furrow and cinder path, the articulated lines of fence and hedge to that focal point at the centre left of the canvas. From there the eye is taken again upwards and along the far hedgerow to the distant village. Further exploration to either left or right will bring us back into the painting through the foliage and trunks of trees

166 Pablo Picasso: *The Three Dancers*, 1925. Oil on canvas, 215·2 cm × 142·2 cm
Tate Gallery, London Copyright SPADEM 1983
A strongly linear work, this painting has also a fusion of positive and negative shapes which express the movement and emotion in a symbolic rather than representational way. Drawn pattern and the texture of paint are also important elements but in the case of the latter this is in some places more accidental than intentional. As may be seen from the X-radiograph the completed work is different from earlier stages and Picasso's method of continuously altering a painting as he progressed did not always allow for the changes which would occur to the surface if layers of pigment were placed over each other without being absolutely dry. Picasso's use of resins and other media has not always aided the permanence of his pictures. The thickness of paint on certain areas of this work has on contraction cracked the surface revealing underpainting; and around the head of the left-hand figure, the white pigment applied to obliterate earlier marks and provide a fresh ground. Degeneration of the medium in some of the dark passages has led to a mattness and deadening of the colour. Varnishing is inadvisable because of the delicacy of much of the paint surface

199

167 X-ray photograph of The Three Dancers
Tate Gallery, London Copyright SPADEM 1983

200

Line may be used to analyse, describe or express; it can indicate movement, rhythm, direction and the shape of objects; it may be used to suggest space. Shapes may be representational or non-representational and like lines can show depth or emphasise the flatness of the pictorial surface.

An awareness of the positive and negative qualities of shapes is important whether they be organic, inorganic, functional or decorative for the acting together of all shapes on the picture plane is essential if the work is to be in any way a cohesive statement. All shapes in a picture are of importance and should be considered each in relation to another so that the alteration of one, changing as it does another, is not a matter of accident but of intention. The space (negative shape) between two objects (positive shapes) is as important as the shapes of the objects themselves and the alteration of both is a considered act on the part of the painter. Such interdependence means that any compositional alteration or adjustment of shape takes into account the overall effect of such a change; an appreciation that the painting is a constantly; altering inter-related set of shapes which, dependent upon each other, achieve their final position only when the painting is finished.

'Lines parallel to the horizon give extension (L'etendue) whether it be a section of nature or, if you prefer, of the spectacle that the *Pater Omnipotens aeterne Deus* spreads before our eyes. The lines perpendicular to this horizon give depth. Now for us, nature is more in depth than in surface.'

PAUL CEZANNE
Letter to Emile Bernard
15 April 1904

PATTERN AND TEXTURE

Pattern making is not a self-conscious process where we set out to make a "good" pattern. Pattern develops naturally or "grows" organically and is the ordered growth, repetition or development of a basic unit ... pattern is not just a decorative addition to objects and planes but it is a logical and inherent part of natural and man-made form.'

PETER GREEN
Surface Printing 1975

'It is not sufficient to make people see what one has painted, one must also make them touch it.'

GEORGES BRAQUE
Cahier

Pattern is made by the repetition of similar, not necessarily identical, lines, shapes, colours or forms and as such may be natural as well as man-made. Usually natural patterns are concerned with some form of function either structural or decorative which in nature is itself functional being created to either attract or disguise. In painting the organisation of similar shapes to form a composition will inevitably make some type of pattern and this may be developed by the painter who, wishing to evoke a certain response, will organise his lines, shapes and colours into a pattern the arrangement of which is related to that response. In other words the making of a pattern in a painting is not accidental, nor is it the arbitary arrangement which may be found in the environment; for even in the expressing or communicating of the accidental or some form of chaos the painter must be responsible for the organising of the components of the picture which by his arrangement will convey more forcefully the aspects of the subject which he wishes to express. Chaos is not expressed by chaos in a painting but by carefully selected elements of the subject presented in an organised and intelligent arrangement.

As an extension of this concept it should be appreciated that painters often compose their works with a series of visual rhymes or 'echoes' in a manner similar to the rhymes, repetitions and variations upon a stated theme which are to be found in poetry and music. The pattern of such relationships is to be seen in works by most of the masters. Within a painting by Poussin, for example, the curve of shoulder may be echoed in the curve of a buttock, the

horns or tail of a goat, the twist of a tree trunk. Such small echoes are placed within the context of larger rhymes involving the interlocking of similar areas, the counterchange of light on dark and dark on light, the repetition of one shape elsewhere in the picture. By such 'pattern-making' is the painting brought together, not with arbitary or purely decorative repetitions but with careful dovetailing and structural organisation which help to give the work unity and strength as well as excitement and interest.

'My eye becoming riveted to some sea-eroded rocks would notice that they were precisely reproducing in miniature, the forms of the inland hills.'

GRAHAM SUTHERLAND

Other aspects of pattern are concerned with the progression of ideas as well as the components of visual language and therefore involve a certain amount of change which may be expressed within the one picture or over a num-

168

ber; the formulation of matrices and the organisation of tesselations and rhythms.

The difference between pattern and texture is not always appreciated and even in books dealing with the subject confusion has sometimes occurred. Admittedly there are points at which pattern merges into texture and texture takes on some of the attributes of pattern but nonetheless there is a difference which should be understood by anyone dealing with the visual arts.

Visual pattern is the organisation of similar lines, shapes, colours or forms which are seen and presented in the second or third dimension. Such arrangements may sometimes be confused with texture, their close association taking on textural or surface qualities which all but obscure the element of pattern arrangement. Indeed, many patterned surfaces have a textural quality independent from that

169

170 **British School:** *The Cholmondeley Sisters,*
c 1600–20. Oil on panel, 89 cm × 173 cm
Tate Gallery, London

171 **Nicholas Poussin:** *Bacchanalian Revel Before a Term*
of Pan, late 1630s. Oil on canvas, 1 m × 1·425 m
National Gallery, London

pattern as may be seen by examination of animal pelts or hides. There is a strong pattern on tiger or zebra skin but that tonal and colour difference is an arrangement of shape creating a pattern not a texture whilst the hairs of the animal have a surface quality which is the texture. It is this tactile quality of the surface, its roughness and smoothness which is the texture. This does not mean that all textures can be felt, but rather that the surface of an object has a texture relating to its tactile attributes even though those may only be appreciated optically. Consequently the painter is faced with a number of choices when attempting to represent the surfaces of different objects. Some will have a strong tactile quality which may in reality be experienced through the sense of touch whilst others, such as a slab of grained wood or marble will feel smooth although presenting an uneven surface; there

172 Nicholas Poussin: *Nurture of Jupiter, c* 1636. Oil on canvas, 96·2 cm × 119·6 cm
Dulwich Gallery, London
When embarking on a painting such as this Poussin would begin by reading all that he could about the subject. He would then sketch a rough plan of the composition, organising the structure, its movement and rhythms, its harmonies and contrasts. This basic plan he would extend by making small wax models, dressing them in fabric and setting them on a stage; a sort of toy theatre which he could light and for which he could paint different backgrounds. This would serve as the scene from which to work with many drawings being made and figure positions being altered until he was satisfied that the organisation clarified his intentions.

 The next stage was to make larger models, to drape them and light them and then to paint directly from them. Although he would from time to time refer to the live figure it is from puppet-like models based on Greek and Roman statues that Poussin painted. Reference to classical antiquity in this way, he believed, enabled him to portray the ideal, but it did on occasion give his figures a somewhat cold and lifeless look

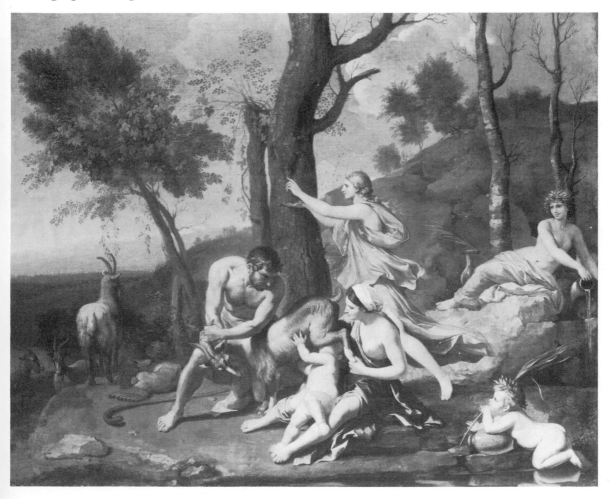

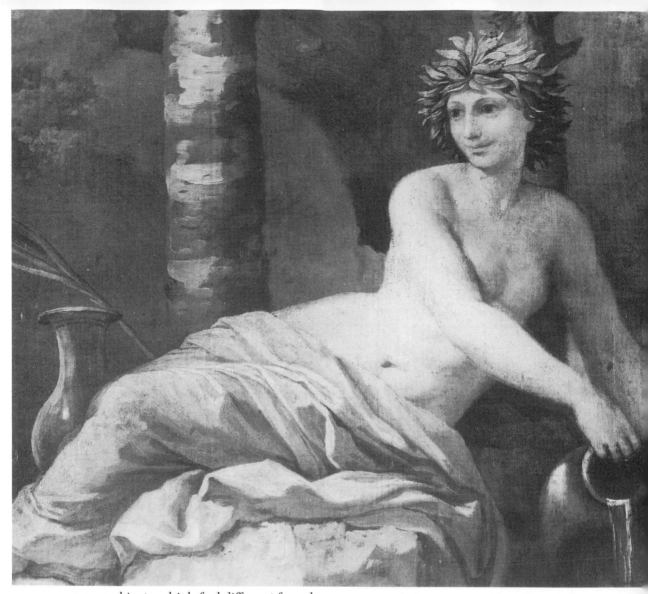

173 **Nicholas Poussin:** *Nurture of Jupiter*, detail

are many objects which feel different from how they appear. In addition there are also textures which it is possible to experience only through looking, even though it is known that they are tactile; a web of branches against the sky, a field of grass or corn, the foam of a breaking wave. Similarly those ephemeral textures which disappear with time or dissolve when touched; frost on a window-pane, a froth of bubbles on water, fungus and ash.

The painter may wish to show any or all of these at some time but he will be aware that there are many decisions to be made concerning how best to do this, whether by detailed representation or semi-abstract suggestion; re-

membering all the while that whatever he does will be an illusion; the presenting of tactile information in a purely visual way, for the work will, in all probability, be appreciated only visually. An additional interesting fact is that the painting surface, whatever it might be describing or expressing in terms of texture may well have another textural quality of its own, one which will alter according to the conditions of light in which it is seen.

Pattern is related very much to the organisation and structural harmony of the painting, yet it may also be a decorative feature within

the work. It might also constitute a formal presentation of ideas showing both recapitulations and thematic developments. Texture may be closely linked with it particularly in the decorative elements but it might also be evident in the creating of the visual equivalents of surfaces and describe the tactile qualities of the objects shown. As such it can attract, disguise or repel and may be used to alter a form, to enhance or modify part of the picture.

174 Willem Kalf: *Still Life with Drinking Horn of the St Sebastian Archers', c* 1653
National Gallery, London
Detail showing the rendition of smooth and rough surfaces. Paint has been used in this picture not to approximate to texture, but to describe as accurately as possible the tactile quality of the still life items.

In the twentieth century Georges Braque, whose father was a painter and decorator, employed the techniques of marbling and woodgraining which he learned when working in the family firm

175 **Wilson Steer:** *Knucklebones Walberswick*, 1888. Oil
on canvas, 61 cm × 76 cm
Ipswich Museum
In this work there is no attempt at verisimilitude, but a
concern to make paint suggest the texture of shingle
whilst still remaining paint which can be appreciated as
such. The subject, viewpoint and pattern of figures make
an interesting comparison with the Degas *Beach Scene*
See figure 83

176 **Vincent Van Gogh:** *Long Grass with Butterflies*,
c 1890. Oil on canvas, 645 cm × 807 cm
National Gallery, London
The definite pattern of the grass growth and the texture
of its surface have here been described by pigment the
tactile quality of which is an important part of the work.

177 **John Constable:** *Sketch for Hadleigh Castle*,
c 1828–9. Oil on canvas, 122·5 cm × 167·5 cm
Tate Gallery, London
A full scale study for the final version now in the *Mr and
Mrs Paul Mellon Collection, USA*

176

Constable had great concern for the materials he used, he was a friend of one of the foremost colourmen of the day George Field, and was prepared to try the latest pigments and media; traces of chrome yellow introduced in 1820 and emerald green were found on his palette after his death. In the main though the pigments he used were of the traditional type which had been in use for many years. His greens were not so much the result of contemporary chemistry as the mixture of Prussian Blue with Yellow Ochre, Raw and Burnt Sienna; his famous skies created with Ultramarine (Cobalt Blue was not used, as far as is known, by him although it was first listed in 1816), this mixed with madder and white made the purple grey for the clouds in his later work. Earlier in place of the madder he had used light red and vermilion. In an essay on 'Flatford Mill' Anna Southall quotes Constable's complaint about the inadequacies of the available colours: 'When we speak of the perfection of Art, we must recollect what the materials are with which a painter contends with nature. For the light of the sun he has but patent yellow and white lead – for the darkest shade, umber and soot.' Southall goes on to say: 'This led to Constable developing a most personal style and technique, using texture and accents of pure white to capture more of the dews and freshness of nature.' These accents of white paint, sometimes called 'Constable's snow' were often mixed with a medium of linseed oil, copal varnish and turpentine and were applied with a spatula or palette knife.

The basis for this painting was a pencil sketch made by Constable on his only visit to Hadleigh Castle in June 1814, some considerable time before the painting was done.

'I walked upon the beach at Southend. I was always delighted with the melancholy grandeur of a sea shore. At Hadleigh there is a ruin of a castle which from its situation is a really fine place – it commands a view of the Kent hills, the Nore and North Foreland and looking many miles to sea.'

JOHN CONSTABLE
to Maria Constable

Maria died the year in which this painting was probably begun and its desolation can not be divorced from the grief which the painter felt for the loss of his wife. After Constable's own death the work was sold by his executor on 16 May 1838 for the minute sum of £3.13s.6d.

SPACE AND THE THIRD DIMENSION

'Art does not reproduce the visible, but makes visible.'

PAUL KLEE

One of the main concerns of Western European artists over the centuries has been how to represent the third dimension on a two-dimensional surface; that is, how to show solid forms and the space in which they exist. The difficulties of presenting form and space have been dealt with in various ways and although during the Renaissance and until fairly recent times the solving of the problem has been directly related to showing a representation of the world as we actually see it, there is no reason to suppose that this is a more commendable aim or solution than any other. Paintings are paintings and not reality and the organisation of reality which the artist chooses to make in terms of form and space may be only one of many. He may make use of illusionistic devices such as perspective and chiaroscuro but the results will not be 'better' than a portrayal of

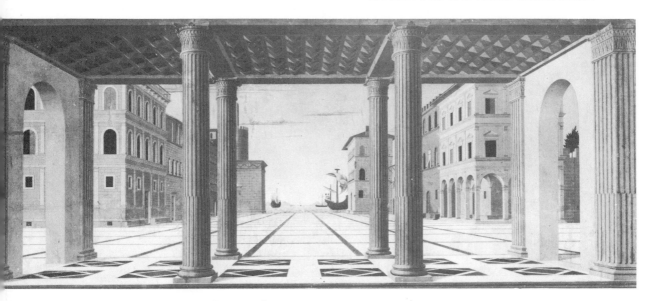

the external world in some other perhaps diagramatic form. They will be simply different. Painting has numerous possibilities and although we may well have been conditioned through education or fashion to consider one type of work to be superior to another, if we wish to enjoy painting as both practitioner and spectator we should have open minds and be prepared to examine closely what is presented to us without prejudice limiting our appreciation. To judge painting by one set of concepts or to aspire to only one type of work, without investigation of a range of others, is to be a poor student and ultimately a limited person. Consideration should be given to the different ways in which artists of the past have attempted to portray forms in space so that individual decisions may be made about how best to solve particular problems. There is no one 'correct' formula and the painter wishing to understand more fully and attain a level of appreciation above the superficial, should be aware of as many approaches as he possibly can. Then he may select and combine in order to express and communicate his ideas in the manner which he believes to be the most suitable to his needs. One which has been arrived at after thoughtful consideration and not by chance or ignorance.

178 **Francesco di Giorgio Martini,** fifteenth century. Tempera on wood panel, 124 cm × 234 cm
Gemälde Gallery, Staatliche Museum, Berlin

179 **Rembrandt:** *Self Portrait with Palette and Two Circles* (detail) *c* 1659–1660. Oil on canvas, 114 cm × 94 cm
Kenwood House, London. The Iveagh Bequest

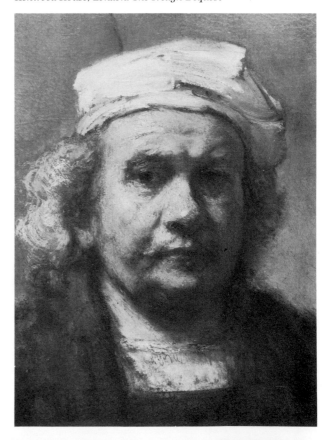

180 **Paul Cézanne:** *Still Life with Apples*, 1895–98
(detail). Oil on canvas, 68·6 cm × 92·7 cm
The Museum of Art, New York, Lillie P Bliss Collection

181 **Juan Gris:** *Fruit Dish and Carafe* (detail), 1914. Oil
and collage on canvas, 91·7 cm × 64·7 cm
Rijksmuseum Kröller-Müller Museum, Otterlo, Holland
Copyright ADAGP 1983

POSITION ON THE PICTURE PLANE

An indication of space may be achieved by the arrangement of shapes and forms placed, without overlap, onto the picture-plane. The spectator accepts that those which are at the bottom of the picture are nearer than those placed at the top. This device, seen in perhaps its simplest form in the painting of young children, certain types of primitive art, and in Byzantine and early Renaissance Art is nonetheless present in many paintings in which the artist may have employed a combination of methods to show the forms in space. It is a direct and obvious way of translating what we see onto a flat surface; the distance before us appears above the foreground.

182 Alfred Wallis: *St Ives*, 1928. Oil, pencil and crayon on cardboard, 25·7 cm × 38·4 cm
Tate Gallery, London
The primitive painter Alfred Wallis used paper or cardboard as supports for many of his pictures, often, as in this instance, working on torn or cut oddly shaped fragments. In this mixed media picture the houses and boats are placed on the picture-plane as if seen from slightly above, but the individual items are shown mainly in straightforward elevation with only the extra amount of rooftop and the plan of the ground to suggest the viewpoint. Neither linear nor aerial perspective is used but a sense of distance is achieved by placing the houses and boats 'up the picture'; but even this is done in the simplest manner without overlap. Nor is scale an indication of distance. Although the ships are small so are the foreground cottages.

Perhaps size relates to importance rather than actuality or space

183 William Scott: *Ochre Painting,* 1958. Oil on canvas, 86 cm × 112 cm
Tate Gallery, London
Based on objects on a table this work is less about still life than about paint. The eye might move naturally towards the line at the top of the canvas interpreting it as table edge or horizon, but the colour and the drawing retain the two-dimensional quality of the image. The thick textured pigment does nothing to alter this or to create allusions to reality, but remains insistently paint.

There are obvious yet interesting similarities between this work and the picture by Alfred Wallis

SCALE

The size of a shape or form can also indicate space and distance particularly when used in conjunction with other methods such as that stated above. This is not always the case, as some art forms use scale to indicate importance rather than a situation in space. In Egyptian painting and Assyrian relief the King is usually portrayed larger than his subjects, the conqueror bigger than his enemies. This is also found in examples of Christian painting where God, Christ or Saint may be larger than the other figures in the work. The spectator therefore has a choice when looking at a painting showing similar forms of varying size, either some are of greater importance than others or they occupy different positions in space. In making a decision, a knowledge of the convention being used as well as an understanding of the relative proportions of objects in reality is required. Inversions of scale have often been used to express fantasy, induce fear, arouse feelings of unease or simply to shock. Examples may be found in the works of the Netherlandish painter Hieronymus Bosch and the twentieth century Belgian Surrealist René Magritte.

184 *The Children of Israel Crossing the Red Sea.*
Illustration from an eighteenth century Ethiopic
manuscript of the Hymn Tebaba Tabibān
British Museum, London

This illustration shows the normal scale values, to which most Western Europeans are accustomed, ignored in favour of scale which is indicative of importance.

God is larger than any other figure. Pharaoh, the earthly ruler, is placed parallel to Him but is somewhat smaller, although his head is larger than the lesser Israelites. Moses being the most important of these has the largest human head and the human heads are larger than those of the horses. The arrangement of the composition, with four almost equal sections surmounted by text has little to do with representing a naturalistic scene, but a great deal to do with presenting information in a visual form. A sense of distance is established by overlapping as well as placing; two conventions which are readily understandable by most people

185 **Fra Angelico:** *Christ Glorified in the Court of Heaven*
on panel 32 cm × 73 cm
National Gallery, London

OVERLAPPING

Spatial relationships may also be indicated by the use of overlapping shapes and in many instances the device has been used in conjunction with variations in scale and the positioning of forms 'up' the picture plane. It has also been used as a method of taking the eye into the depth of the picture rather in the manner of theatrical 'flats' placed at the sides of a stage. The cubist painters often employed the device of overlapping planes, some of which were transparent or semi-transparent, to bring their forms out from the surface rather than lead the spectator into the work.

186 **Fra Angelico:** *Christ Glorified in the Court of Heaven.*
Detail of centre panel

187 Claude Lorraine: *Seaport: The Embarkation of the Queen of Sheba*, 1648. Oil on canvas, 1·485 m × 1·94 m *National Gallery, London*
A sense of the third dimension is created by use of those devices associated with Western European Classical Art; linear and aerial perspective, light and shade, scale and overlap. This last device may be readily seen in the way in which Claude has organised building, ships and trees on either side of the picture to lead the spectator into the work rather in the manner of a stage set

188 Richard Smith: *Vista*, 1963. Oil on canvas,
195·5 cm × 298 cm
Tate Gallery, London
An unusual-shaped canvas which relates to the
procenium arch of a theatre or cinema with overlapped
areas which lead the eye into the central portion of the
work. When seen in colour the centre portion, painted as
it is with red lines comes forward and returns the eye to
the surface thus preserving the actual two-dimensional
character of the picture-plane

189 Georges Braque: *Still Life with Clarinet and Violin*,
1912–13. Oil on canvas, 55 cm × 43 cm
Narodni Galerie, Prague, Kramar Collection
Copyright SPADEM 1983
Rather than take the eye deep into the picture the Cubists
attempted to produce a shallow space with the canvas
the point furthest away and overlapping planes between
it and the spectator

219

COLOUR

As will be seen from the section dealing with colour in this book it is possible to use the receding and advancing aspects of colours to give indications of space and the simple method of 'cooling' the colours in the distance is a basis on which variations may be made. Many landscape painters in the past have used the addition of blue to the colours of distant objects to emphasise their spatial position. Some nineteenth and twentieth century painters have used colour in a more direct way to indicate space. Paul Gauguin on occasion used warm reds and oranges for the foreground and cool violets and blues for the distance.

AERIAL PERSPECTIVE

Closely related to the notion of colour changes to show distance is aerial perspective; the alteration of colour and tone to give a sense of space. More often than not it is used in conjunction with Linear Perspective but this is not exclusively the case. Aerial Perspective uses a combination of softened contours with colours less brilliant than those in the foreground of a painting to give an impression of distance. Subdued colours, less distinct forms and usually progressively lighter and cooler tints leading the eye further and further away gives this method an affinity with the atmospheric changes we experience when looking at distance in nature.

'There is another kind of perspective which I call aerial, because by the difference in atmosphere one is able to distinguish the various distances of different buildings when their bases appear to end on a single line, for this would be the appearance presented by a group of buildings on the far side of a wall all of which as seen above the top of the wall look to be the same size; and if in a painting you wish to make one of them seem farther away than another you must make the atmosphere somewhat heavy. You know that in an atmosphere of uniform density the most distant things seen through it, such as the mountains, in consequence of the greater quantity of atmosphere which is between your eye and them, will appear blue, almost of the same colour as the atmosphere when the sun is in the east. Therefore you should make the building which is nearest above the wall of its natural colour, and that which is more distant make less defined and bluer; and one which you wish should seem as far away again make of double the depth of blue, and one you desire should seem five times as far away make five times as blue. And as a consequence of this rule it will come about that the buildings which above a given line appear to be of the same size will be plainly distinguished as to which are the more distant and which larger than the others.'

<div align="right">

LEONARDO DA VINCI
Notebooks (E MacCurdy trans 1938)
page 237

</div>

LINEAR PERSPECTIVE

Known in the past as artificial or scientific perspective, this device with mathematical (pseudo-mathematical) overtones may be traced back to the map-making efforts of Ptolemy (second century AD) and further to the work of Euclid (c 300 BC) but in the form in which it is most often seen, relies heavily on the experiments of the Italian architects Brunelleschi, Alberti and other Renaissance artists such as Paolo Uccello, Piero della Francesca and Luca Signorelli. Perspective fascinated, even obsessed, the Renaissance painters; 'Oh, what a sweet thing this perspective is', said Paolo Uccello, but Mariotto Albertinelli is reputed to have stated that he was '... sick of this everlasting talk of perspective' and stopped painting to become an innkeeper. Leonardo da Vinci was greatly involved with the notion of linear perspective and made many visual experiments. Written comments may be found in his notebooks.

There are affinities between the photographic image and that produced by means of Linear Perspective. The use of one viewpoint is common to both although it is possible to extend this in a painting whilst still observing the basic rules of perspective; namely that all lines which are parallel in nature appear to converge as they move away from the spectator eventually to meet at a position, either within or outside the picture-plane, known as the

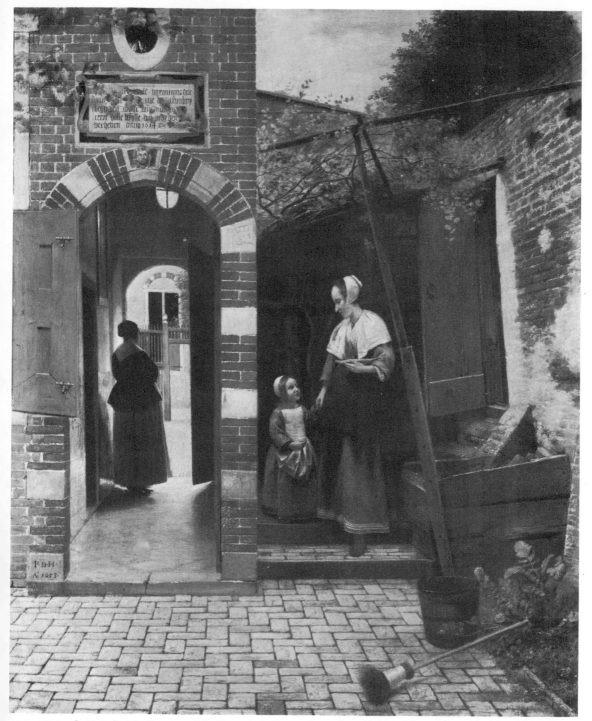

190 **Pieter de Hoogh:** *The Courtyard of a House in Delft*, 1658. Oil on canvas, 73·5 cm × 60 cm
National Gallery, London

The geometry of this 'realistic' scene is no less important than that which appears in a Braque and Picasso or in a Mondrian, for that matter. An absorbing investigation might be made by tracing the large and small areas, their overlaps and repetitions, the right-angles which help to keep the stability of the work even when not square to the frame and the curves, light against dark and dark against light, of arches, windows, shoulders and arms. However, it is not for the visual rhymes and intricate construction that this painting is reproduced here, but as an example of linear perspective clearly shown in the courtyard paving, the passageway and the bricks in the right-hand wall

'vanishing point' and which is on a level with the eye or horizon; such a line is called the eye level or the horizon line. Consequently lines or points moving away from the spectator and which are below the eye level move upwards towards it and those which are above it descend. These basic principles have more intrictate applications for the solving of complicated problems. A simple example is the famous landscape *The Avenue, Middelharnis* by the Dutch painter Meindert Hobbema which is in the National Gallery, London. More complex examples, having a number of vanishing points rather than just a single one, may be found in many painters' work sometimes coupled with 'virtuoso performances' of foreshortening. Signorelli and Caravaggio are such artists, whilst in a less dramatic vein are the interior compositions of Jan Vermeer.

Complete adherence to the rules of perspective can, in some instances, lead to distortion and the great masters, aware of this factor, were not averse to altering their works so that although the representation of object or figure might not be completely correct in terms of perspective its appearance was more acceptable to the spectator's notion of reality.

One Point perspective. The parallel lines all appear to converge at one vanishing point. Thus, two sides of a cube may be shown with a sense of depth.

Two Point perspective. As the name implies with this method two separate vanishing points are required in order to show more of an object; in this case three sides of a cube.

Three Point perspective. Sometimes used by architects when drawing a building seen from below or above. In addition to the converging horizontals are the converging verticals which meet at a third vanishing point.

'Perspectives are of three kinds. The first has to do with the causes of the diminution or as it is called the diminishing perspective of objects as they recede from the eye. The second, the manner in which colours are changed as they recede from the eye. The third and last consists in defining in what way objects ought to be less carefully finished as they are farther away. And the names are these:

Linear Perspective
Perspective of Colour
Vanishing Perspective.

LEONARDO DA VINCI
Notebooks (E MacCurdy trans 1938)
pages 222–3

191b Leonardo's method

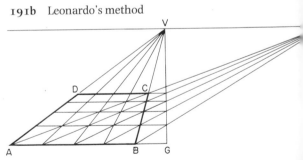

Circular forms. In order to draw circular forms in linear perspective it is sometimes helpful to enclose them in rectangles so that 'imaginary' horizontals and where needed, verticals can be drawn as guides.

Cones of vision is the name given to the organisation of an image which is a combin-

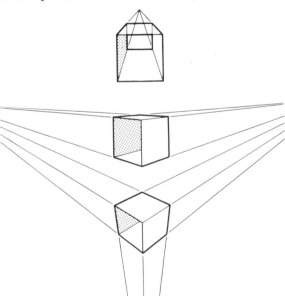

191a One, two, and three point perspective

ation of viewpoints across the picture-plane, rather in the manner of a pan shot in the cinema. The use of a number of cones of vision enables the artist to present a wide angle view of the scene which in all probability will distort the image but not as much as if a wide view were presented from a single viewpoint. It is the equivalent of turning the head so that the eye scans the subject.

Exaggerated perspective can be used to convey a greater sense of urgency and drama than normal Linear Perspective. It may take the spectator quickly into the picture, foreshortening figures, lessening the distance between him and the focal point; it will emphasise the dramatic moment or evoke a sense of unease. Jacopo Tinteretto and the Italian Mannerists (c 1520–1600) made use of exaggerated perspective elongating and overemphasising to stress the emotional content of their pictures. Such a device is not limited to the Italian Mannerists and examples may be found in the works of Vincent Van Gogh, Edvard Munch, Chaim Soutine and Expressionist artists in general.
See also figure 151

'Geometry is lily-white, unspotted by error and most certain, both in itself and in its handmaid, whose name is Perspective.'

DANTE

MULTIPLE VIEWPOINTS
Although we are used to looking at paintings which present us with objects or a scene viewed from one position it is perfectly possible for the painting to show more than one viewpoint; something which the still camera does not do. By such means we may be made aware of the three-dimensional character of objects or figures, we may be made to see things in a new way and we may become conscious of movement either of ourselves as spectators, the painter or the object itself. Movement implies time and so a further element is brought into our appreciation. Different viewpoints of a figure or object have from time to time in the

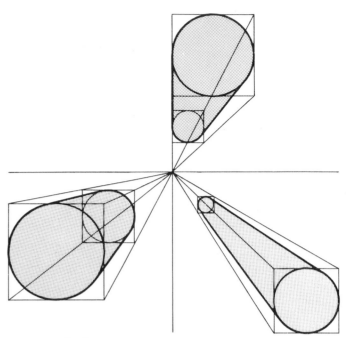

192 Circular forms in perspective

past been painted on one canvas. This was particularly the case when a painter wished to show a head from different angles and might have produced a study of full face and profiles prior to a commissioned portrait. Pages from sketchbooks are obvious examples of a collection of views of one object, but the *combination* of different viewpoints within the one image is another thing.

Paul Cézanne often altered linear perspective in order to combine two or more views of one object and present it to the spectator as if seen from different positions and from different eyelevels. Such distortion not only makes us more aware of the three dimensional character of the forms in space but also refers us to the fact that it is a painting at which we are looking and not an actual object or scene. Cézanne distorted reality and manipulated perspective not to produce an illusion of space but to interpret it in a way which respected the actual surface of the picture-plane. We 'read' them as solid forms but also as flat shapes; there is a continual interplay between the two.

193 Paul Cézanne: *Still Life with Jug*, 1888–90.
Detail. Oil on canvas, 69 cm × 73 cm.
National Gallery, Oslo
By painting in touches of small wash-like brush strokes
for a considerable time in the build up of the picture, and
by avoiding laying in an overall wash of the local colour.
Cézanne left many small areas of canvas uncovered.
Such was the difficulty of the task he had set himself, and
such his integrity, that he frequently found he was
unable to put down the exact harmony, and rather than
make an approximate attempt he could leave the canvas
bare.

The notion of multiple or simultaneous view-
point was further developed by the Cubists:
Pablo Picasso, Georges Braque and Juan Gris.
They made no attempt to reproduce space but
rather invented it with overlapping and inter-
locking planes; in some instances reversing the
'rules' of linear perspective, creating the es-
sence, or idea of a form and not an illusionistic
copy. Consequently there is in many of their
works a curiously ambivalent quality which
allows the eye to 'read' advancing and receding
forms and planes in different ways.

194 Pablo Picasso: *Musical Instruments*, 1913. Oil on
canvas, 100 cm × 80 cm
The Hermitage Museum, Leningrad
Copyright SPADEM 1983

PROJECTION SYSTEMS

One has only to compare a work of linear perspective for example with Roman frescoes or early Renaissance paintings to see how the concept of converging parallel lines makes the image conform more to our normal vision than most methods of describing objects in space. However, other less naturalistic means are available and their potential should not be disregarded for the sake of attempting to make a painting look more 'real'. Information about the third dimension may be given on a picture plane in many exciting ways and the adventurous painter can explore them to advantage.

This is not the place for a detailed account of the many drawing or projection systems which are available for the artist to use but an investigation into such as the Isometric projection and the Oblique projection could well benefit the beginner. The graphic works of engineers, architects, cartographers and industrial designers are full of ways of communicating information about forms in space and there is no reason why the painter should not make use of them. A map is a representation of the third dimension on a two dimensional plane. So too is the plan of a building. Combined with the elevation, the information is such that the spectator has knowledge about both the shape and form; and the building's occupation of space. This idea of plan and elevation was used by the Cubist painters in much of their work during the early years of this century and has continued to be used by painters since then. Objects shown in both plan and elevation may not look as they do in reality, when seen from one position but they are being presented as they actually 'exist' in reality; that is their true essence as three-dimensional forms within a spatial context is stated on the canvas. The 'plans' of a glass's rim and base are shown as circles and the elevation or side view placed between. By such means is the spectator made aware of the height, width and depth of the object although traditional methods of perspective and light and shade may not have been used.

A painter may, if he so desires, show his images in linear perspective or by some schematic or diagrammatic means; he may present one viewpoint like a camera or a number to show different aspects of the scene, he may overlap 'cones of vision' so that different parts of the painting may be viewed almost one at a time, or the work scanned like a cinemascope screen without the distortion which such a wide angle usually produces; he may emphasise the surface quality of the picture-plane, or indulge in *trompe l'oeil* tricks; he may, in short, use whatever method or combination of methods he desires to deal with the problem of presenting the third dimension on a two dimensional plane, but his decision should be a considered one and not an arbitrary choice unrelated to what it is he wishes to say.

The form of an object, that is, its solidity in space can be expressed by contour alone or by modelling with light and shade and colour. Often the artist uses these devices to a greater or lesser degree within the same painting. The contour may enclose all or part of the form, be superimposed over areas of colour rather than confine them, so establishing visual links between different forms whilst still defining shapes and volumes. Light and shade may be used to define the volume further, to emphasise the three-dimensional in space and thus represent form as we experience it in nature, with a range of light and dark areas related to a particular source of illumination. Where extensive use of light and dark is employed for dramatic effect the result is called 'chiarascuro' the true definition of which means the balance of light and shade. Rembrandt made considerable use of this, but he is by no means alone, and although the balance of light and dark in his work may create a sense of drama his use of chaiarascuro, with the light emerging from dark, is directed towards the creation of form, not just the illuminating of it for theatrical effect. Many painters have dealt with light and shade in terms of lightening or darkening the 'local' colour. Thus a vermilion dress might be

pinker in the light areas and either deeper vermilion or crimson in the shadows.

Such an approach may be used with considerable success by a great painter and one has only to look at Renaissance painting to appreciate this, but it is nonetheless limited and later painters began to study the changes of forms and surfaces under differing light conditions and to paint them not just in tones of one colour, but with a variety of colours as well. Works by Peter Paul Rubens and Eugène Delacroix are evidence of this.

195 David Hockney: *The First Marriage* (A Marriage of Styles), 1962. Oil on canvas, 183 cm × 153 cm
Tate Gallery, London Copyright David Hockney 1962
Painted on raw unprimed canvas this work shows a 'marriage' of techniques as well as the 'marriage of styles' described by the artist below. Flat and broken colour, thin stains, dry brush scumbles and impasto are all used in a direct and obvious way

196 **David Hockney:** *The Second Marriage,* 1963. Oil on
canvas. 198 cm × 229 cm
National Gallery of Victoria, Melbourne, Australia
Copyright David Hockney 1963
In this second variation on the marriage of styles theme
Hockney has taken a three section-shaped canvas as the
basis for his oblique projection of the setting. However,
there is conflict within the illusion of space. Paint
textures remind us that we are looking at a painting,
patterns of wallpaper preserve the flatness of the picture-
plane
In 1963 the artist made the following comment on these
two pictures. See overleaf

'In August 1962, I visited Berlin with an American friend. Whilst in a musuem in the Eastern half of the city (it was either the Bode or the Pergamon Museum) I wandered off and lost my friend. When I realized this I went to look for him. (I do remember that it was in the museum with the enormous replicas of Babylonian streets and temples). I eventually caught sight of him standing at the end of a long corridor looking at something on a wall – so I saw him in profile. To one side of him, also in profile, was a sculpture in wood of a seated woman, of a heavily stylized kind (Egyptian, I believe). For a moment they seemed held together – like a couple posing.

At first I was amused at the sight of them together; but later I made some drawings, incorporating both my friend and the sculpture. When I returned to London I decided to use the drawings to make a painting.

The first painting I did from the drawings (*The Marriage*) was very much like the original statements I had made in Berlin. I did not alter the position of the figures ... I had made no notes there, and so I placed them in the painting in a rather ambiguous setting. It looks as though they are standing on a desert island with white sand and a palm tree. But the white at the bottom is only a base for them to stand on, and the rest of their setting is intended to be slightly out of focus, apart from the ecclesiastical shape in the bottom left-hand corner (an association with marriage).

I called it *The Marriage*, because I regarded it as a sort of marriage of styles. The heavily stylized female figure with the not so stylized 'bridegroom'.

On completing this picture, I decided to do another version of the same theme, and expand on it.

Taking the idea of 'marriage' literally I decided to put them in a definite setting – a domestic interior. I decided to use a device that I'd used before (in the *Tea Painting* – shown at the Young Contemporaries in February 1962 – with a figure in an illusionistic style) and build up a sort of isometric projection of a cube (a room) to place my figures in. This, I thought, would make the setting more theatrical – and appropriate to the subject.

The major difference in these paintings is of course their space and 'flatness'.

In the first painting both figures are flat and there is no real attempt at an illusionary 'form'. In the second painting the whole picture has an illusionary form, by nature of its shape and sections alone. The head of the bride has volume, although her shoes are shown perfectly flat and stand on the bottom of the picture – making it the floor.

I spent about three months painting this picture, along with a smaller and simpler picture of a domestic scene in Los Angeles.'

DAVID HOCKNEY
in *Cambridge Opinion 37, 1963*,
quoted in *David Hockney Paintings,
Prints and Drawings 1960–1970,
Whitechapel Art Gallery, 1970*

SQUARING UP

Squaring up is a procedure whereby a drawing may be transferred to the larger picture-plane of canvas or board. Not all painters use it and some are hostile to the method believing that a literal transference from one size to another automatically loses the quality of the drawing. Others have used it to such an extent that the squares have become on occasion an integral part of the final work.

If a drawing has a grid of squares drawn over it and an equal number of squares are measured onto the canvas, it is possible to draw the 'content' of each square so that the original drawing is enlarged. It will be readily appreciated that there is indeed a very strong likelihood that the transferred image will have a mechanical appearance, but nonetheless it may serve as a basis for the painting.

In order that there is accuracy in the method there are one or two points to be borne in mind: Make sure that the proportions of the drawing and the canvas are the same. That is that the frame drawn around the original design corresponds to the proportion of the canvas to be used.

Begin by ruling the centre vertical and horizontal line and from these two measure the points which will make the squares. The fact that some squares will overlap the edges of the canvas is not important.

197 **Malcolm Drummond:** *Townscape, c* 1914. Pen and pencil with colour notes on paper. Squared in red
24 cm × 18 cm
University of Leeds Collection

Divide the canvas beginning in the same way from the centre and use a long rule or batten which is marked with the points to establish the squares. To rule from the centre is important as canvases are often not exact rectangles.

There is no need to draw squares over those parts of the drawing and canvas which do not contain detail. Should there be insufficient squares for a complex portion of the work then obviously further lines, diagonal as well as vertical and horizontal can be drawn over the relevant areas. Charcoal or diluted paint should be used on the canvas and not pencil which tends to break through all but the thickest layer of pigment.

THE SUBJECT

What does one paint? The answer is really anything and everything but of course it is not as simple as that. Cézanne used to say that to learn the student should paint his stove pipe. In other words, one should concentrate not on finding beautiful objects or meaningful subjects with religious, mystical or mythological associations, but deal with that which surrounds us. By painting the tones, colours and forms of simple objects, the student is learning how to handle his materials and how to render that which occurs again and again in whatever subject painted. So it is possible to discover delicate harmonies of colour and exciting relationships of shape in the most mundane situations: the kitchen utensils upon a draining board, the areas of light and space between furniture, the leftovers of a meal, the corner of a bathroom, the view through an open doorway, the inside of a cupboard or fridge, the haphazard arrangement of books on a shelf or papers on a table. All these are around us, available as subjects for painting without the artificial look of the arranged or the exotic character of the unusual and long-sought subject. The serious student will explore his environment not for the picturesque but for the visually stimulating,

perhaps the unusual, if not subject, then viewpoint. He will discover that the variations to be found in one aspect of a scene are considerable if he takes the trouble to consider it not simply as a straightforward view, but in terms of longshot, of close-up, of viewpoint from above or below or as a scene which will appear new and stimulating to himself and the spectator if he portrays it in conjunction with other things; past the nearby fragment of figure or object, or in an unusual light. In a way the subject can be unimportant but the painting, the image which the artist creates with its multiplicity of associations and pictorial relationships, that is what really counts. An apple painted by Cézanne and a Crucifixion by Rubens are both paintings of the highest order and one is not greater than the other because of its subject matter.

There is an amusing, although not completely accurate description of what constitutes a fit subject for painting by Picasso:

'Paintings have always been made as princes made their children: with shepherdesses. One never makes a portrait of the Parthenon; one never paints a Louis XV chair. One makes paintings with a village in the *midi*, a package of tobacco, an old chair.'

PICASSO
Tériade, 1932

Such a suggestion has a grain of truth in it in so much as painters tend to work from humble subjects, particularly in the twentieth century. The opposite can of course be proved quite simply by considering the great series of Monet's Rouen Cathedral (or was the subject really light?) as well as the numerous paintings of ancient buildings, sculpture and other works of art. And Matisse painted antique chairs!

However, one does not need to paint the beautiful or picturesque in order to produce the beautiful. The student will make collections of all sorts of objects in order to study their colour, form and texture and to draw and paint them singly or in various relationships. As well as the more obvious stones, shells, fossils, fragments of dried root, flowers, leaves and vegetables there is everything around us. Clocks, tele-

phones, sewing machines, kettles, pans, clothing hanging behind doors or over chairs, are all stimulating and exacting subjects for the painter. There is no need to look further and there is certainly no reason to seek the subject which conforms to some accepted, though possibly outdated, notion of beauty. Nature and art are different. There is no competition.

'They speak of naturalism in opposition to modern painting. I would like to know if anyone has ever seen a natural work of art. Nature and art, being different things, cannot be the same thing. Through art we express our conception of what nature is not.'

<div align="right">PICASSO
De Zayas, 1923</div>

If it is the student's aim to paint in a representational manner then there is probably no substitute for studying that which surrounds him. It is better for the beginner to paint a view from the window, however ordinary and drab that might be at first glance, than to invent landscapes based on some notion of romantic

198 Fantin-Latour: *Cup and Saucer, c* 1864. Oil on canvas, 19·4 cm × 28·9 cm
Fitzwilliam Museum, Cambridge

pastoral. There is more to be learned about reality by studying the play of light and the relationships between forms than the student can invent. Even if the ultimate wish is to portray some aspect of dream or fantasy such an approach will be valuable experience.

Although working from the immediate environment is an excellent practice, providing as it does a wealth of motifs and moreover sharpening the student's visual awareness, there is no rule which states that such an approach is the only correct one.

It may be that the beginner wishes to work in a non-figurative idiom concerning himself with the organisation of simple geometric shapes and primary hues, balancing large and small areas and light and dark colours. If so study of the works of Piet Mondrian, the painters of the de Stijl and the Constructivist movement as well as later Hard Edge painters would be

231

199 **Richard Diebenkorn:** *Berkley No. 54*, 1955. Oil on canvas, 155 cm × 147 cm
Albright-Knox Art Gallery, Buffalo, New York, The Martha Jackson Collection 1977

advisable. Much could be learned from the work of the contemporary British artists, Kenneth Martin and Victor Pasmore with their mixture of kinetics, mathematics and chance.

An alternative might be based on the free approach of Wassily Kandinsky, and the American Abstract Expressionists of the 1960s: Jackson Pollock, Mark Tobey and Clyfford Still.

In his response to a Monet 'Haystack' which he saw in Moscow, 1895, Kandinsky wrote:

'Before this I only knew realistic painting and indeed mainly the Russians. . . . And then, suddenly, for the first time, I saw a real picture. I did not realise that it represented a haystack until I read it in the catalogue. The fact that I failed to recognise the subject made me ponder; it seemed to me that a painter had

232

no right to paint in such an obscure fashion. I felt in a puzzled way that the painting had no subject and was both surprised and bewildered to note not only that the work had great fascination but that it remained fixed indelibly in my memory down to its smallest detail. But all this was still very confused in my mind and I was unable to draw the logical conclusions from it. The one thing that was clear to me was the intensity of the colour, an intensity which I had never even thought possible, which was a complete revelation to me. . . . painting seemed to me to be endowed with a marvellous power; and, without my being aware of this, even the subject, regarded as an indispensable part of painting, had begun to lose its importance for me.'

Backward Glance, 1913
Recorded in *The Masters*
KANDINSKY, PURNELL, 1966

Throughout the twentieth century there have been many artists who have developed their work from representation to the non-figurative or abstract as it is more often called. Some, such as the American Richard Diebenkorn have, after working in an abstract idiom, returned to more representational work, and then again experimented with further forms of abstraction. Such movement between one form of expression and another is an exciting element of contemporary art offering the painter possibilities which the conventions of earlier times would not have countenanced.

The thought of working in a completely non-figurative manner might be a daunting one for the beginner and the notion of simplifying nature might have more appeal, retaining some hold on the familiar. This is not the place for a

200 **Richard Diebenkorn:** *Studio Interior with View of the Ocean*, 1957. Oil on canvas, 126 cm × 146 cm *The Phillips Collection, Washington DC*

detailed discourse on abstract art, but the beginner wishing to abstract forms from nature would do well to study those works of Piet Mondrian which show that artist's concern with such an approach to nature: the great series of drawings and paintings based on trees which he did between 1909 and 1912 in which forms are simplified, the linear element is emphasised and the negative shapes, that is the spaces, become dominant. Also the series of dunes and seascapes painted between 1909 and 1914 along with the building façades and scaffolding (1910–14) which are similar to the works more usually associated with him.

The pattern of negative spaces between objects is a point of departure worth considering as is the casual arrangement of everyday objects. The British painter William Scott has derived much of his imagery from pans hanging on a wall or arranged on a table top. The tilting up of the table rather in the manner of some Cubist works along with the flattening of the objects has been used by Scott as the basis for works in which positive and negative shapes have become equally important and in which alterations of both have produced 'ghost' images which have been allowed to show through the different layers of paint.

201 **Piet Mondrian:** *Horizontal Tree,* 1911. Oil on canvas, 75 cm × 111 cm
Munson-Williams-Proctor Institute, Utica, New York
Copyright SPADEM 1983

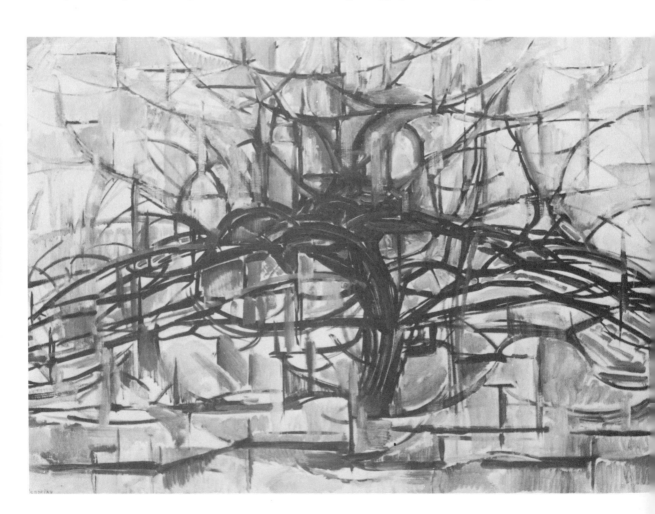

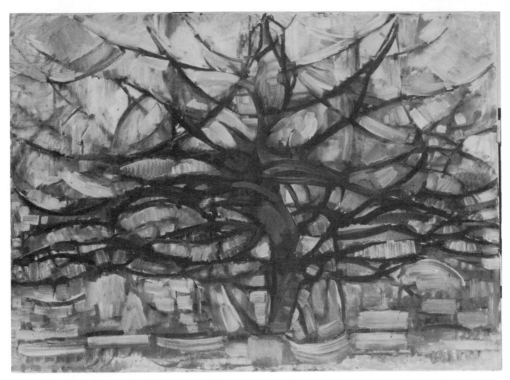

202 **Piet Mondrian:** *Grey Tree*, 1912. Oil on canvas
78·5 cm × 107·5 cm
Gemeentemuseum, The Hague, Holland
Copyright SPADEM 1983

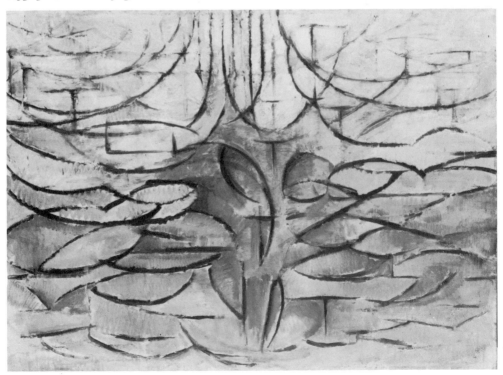

203 **Piet Mondrian:** *Flowering Appletree*, 1912. Oil on
canvas, 70 cm × 106 cm
Gemeentemuseum, The Hague, Holland
Copyright SPADEM 1983

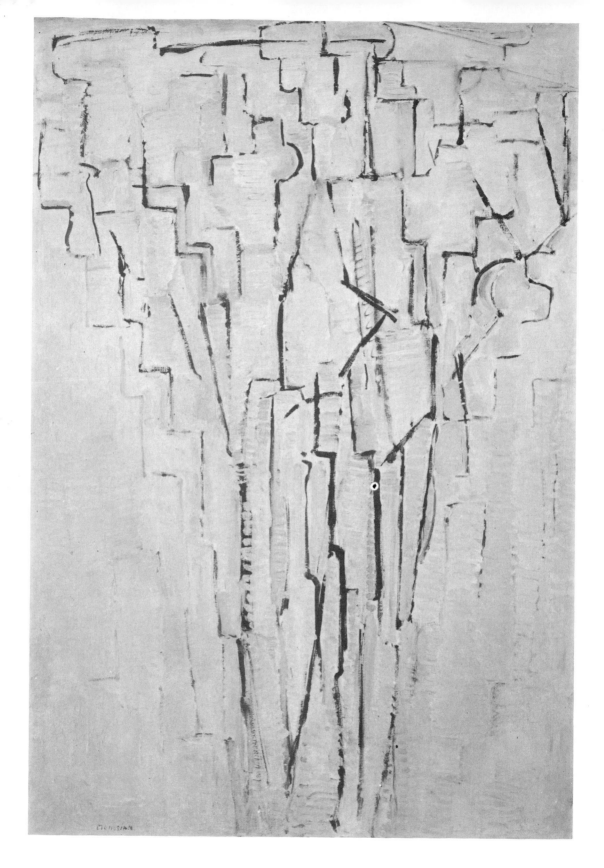

236

Other artists have taken letter and number forms as the starting point for their work. In the case of Jaspar Johns the overlapping shapes of numbers will be recognisable whilst Richard Diebenkorn, might begin with his own initials, and then will, with alteration and invention, almost obliterate them. Mark Tobey having visited the Far East and become interested in Zen took lessons in calligraphy from a Chinese artist and based many of his works upon it producing what has been called, 'white writing'. The large simple black forms of another American, Franz Kline, were also derived from oriental calligraphy. For some artists the materials and the act of painting itself are the 'subject', the starting point or stimulus being provided by a physical as well as emotional involvement. Jackson Pollock is perhaps the best known of the artists who have used such an approach, but there are obvious links with the notion of automatism as practiced by the French painter André Masson as well as the Chilean Roberto Matta and other Surrealists.

Such comments about how the beginner might find suitable subject matter are mentioned here only by way of suggestion. The intelligent student will read further about the artists whose names appear in this book, will discover for himself what it is they were attempting and the ideas behind their paintings and where possible he will study the writings and comments of the artists themselves, so that he may work and develop his own painting, not on the basis of facile influence such as might be gained by seeing reproductions of them but on a serious appraisal of what the painters believed in and the rationale behind their works. The subjects for paintings are infinite. What is more difficult to establish is the idea which enables the painter to create images in a way which corresponds to both his intellect and emotion. The mere representation of nature is insufficient; the true artist says something about

204 Piet Mondrian: *Eucalyptus Tree*, 1912. Oil on canvas, 80·5 cm × 65 cm
Courtesy Sydney Janis Gallery, New York
Copyright SPADEM 1983

205 Franz Kline: *Meryon*, 1960. Oil on canvas, 236 cm × 195·5 cm
Tate Gallery, London

himself, about the times in which he lives and not least about art itself. Painting is not self-expression which negates intelligence, a form of self-indulgence inappropriate to communication. It is about ideas; about the mind as well as the feelings of the heart and the skill of the hand. The aquisition of technical expertise like the understanding of materials is but a part of painting. The creation of pictures as with all art, requires, in addition to feeling and a skill in the particular craft, hard work and continuous intellectual involvement. There is no easy way. Those seeking simple solutions and quick effects will create little of value, but for those with an enquiring mind and a committed purpose there will be achievement; and a sense of communion, however fleeting, with the great painters of the past.

206 **Roger de Grey** R A: *St Symphorien*, 1911. Diptych.
Oil on canvas, primed with Rowney acrylic primer,
127 cm × 91 cm
Private Collection

All the paintings that I do are started in situ and mostly continued in the studio. The time is divided about half and half for each activity. The idea is generated from working directly from nature and is only subconsciously preconceived. The fact that all the paintings are started in situ imposes certain limitations. The most significant of these is the scale. The size of the paintings is conditioned by the maximum size on which it is possible to work out-of-doors. I find this a constant irritant and it is because of this that I have from time to time used the device of placing two or more canvases together in order to increase the visual angles and architectural scope. This painting is characteristic of this concept as its two components are not consecutive in the landscape but painted simultaneously. Each painting is 'true to the subject' but, together, they embrace a grander spatial idea with a multiplicity of focal points.

The first marks on the canvas are normally thin washes of colour which aim to recreate the colour sensations extracted from the subject. These non-explicit marks I try to retain for as long as I am able to resist the demands of reality which begin to emerge as opaque paint in the lighter tone range. The process of marrying opaque and limpid paint, substance and shadow, continues throughout the painting. The addition of the textural complexity of nature takes place in the studio.

ROGER DE GREY to the author 1983

207 **Richard Bonington:** *Landscape in Normandy,*
c 1823–4. Oil on canvas, 31·5 cm × 44 cm
Tate Gallery, London
With restricted colour and great economy of method
Bonington has produced a painting which is as much
about atmosphere and weather as it is about landscape
or the encounter between figures

240

208 Peter Lanyon: *Thermal*, 1960. Oil on canvas,
183 cm × 152·5 cm
Tate Gallery, London

'The experience in *Thermal* does not only refer to glider flight. It belongs to pictures which I have done before, e.g. *Bird-wind*, and which are concerned with birds describing the invisible, their flight across cliff-faces and their soaring activity. I have discovered since I began gliding that the activity is more general than I had guessed. The air is a very definite world of activity as complex and demanding as the sea . . .

'The picture refers to cloud formation and to a spiral rising activity which is the way a glider rises in an up-current. There is also a reference to storm conditions and down-currents. These are all things that arise in connection with thermals.'

PETER LANYON
Letter, 28 November 1960

'Terrific turbulent action going up on the left hand side, then slowing down completely into the deep blue below, which is almost completely static, like a threatening thunder cloud.'

PETER LANYON
Recorded talk

Speaking of his feelings and reactions when working on the final stages of a painting Lanyon has said:

'The actual materials, the things which I use, the brushes, the knife the tubes of paint, and so on, they all have an extreme sudden presence or awareness and I know exactly what quality of paint, what degree of turpentine to oil, for instance, what sort of stroke, what sort of brush I'm going to use, what the area of the paint will be. I know this, not at the same time as I'm putting it down, but I know it beforehand when I have to, for instance, make the paint itself. I do that by grinding colour, of course, making it up with the oils. I get to know exactly the sort of drag or the sort of smoothness or liquidness of certain parts of the painting. I even know, for instance, perhaps two hours before, that I shall eventually come down the centre across a piece of white with a rag. I even will put that rag aside and wait for that moment to occur. That sort of certainty is not anything magical or unusual. I think it is the logical result of this constructive process which, starting in an extreme awareness of oneself in a place, ends in an extreme awareness of oneself in a painting.'

PETER LANYON
Recorded talk 1959,
published in *Artscribe No. 34*
March 1982

242

209 **Paul Nash:** *Landscape of the Vernal Equinox,* 1944.
Oil on canvas.
Scottish National Gallery of Modern Art, Edinburgh

210· Walter Richard Sickert: *Belvedere, Bath,*
c 1917–18. 68 cm × 69 cm
Tate Gallery, London

211 Gustave Caillebotte: *Un Refuge, Boulevard Haussmann. c* 1880. Oil on canvas, 81 cm × 10 cm
Private Collection, Paris
Space has been flattened not only by the acute angle of
the viewpoint, but also by the limited use of linear
perspective and an emphasis on pattern and tonal
contrast at the top of the painting which makes this area
appear to come forward. Caillebotte would have painted
much if not all of this work from the motif as the traffic
island was situated at the end of 29–31 Boulevard
Haussman, the apartment block in which he lived at the
time

212 **Robert Delaunay:** *Study for 'The City'*, 1909–10.
Oil on canvas, 88 cm × 124·5 cm
Tate Gallery, London

Clive Gardiner always worked in the same way, according to subject. If, for example, the subject was landscape, he made a drawing on the spot and the painting followed later (sometimes as much as twenty years later); if the subject was a person, on the other hand, he made no drawings and painted directly from the sitter; if the subject was purely of the imagination (as with the Leda and the Swan series), he made infinite numbers of drawings of an idea derived from aims and construction. With landscape, the aim was the spontaneity achieved by painting from the subject (as with the sitter). The older he grew, the more he believed that large paintings were a waste of time – that everything that went into a large painting could be realised in a small one; all adjustments in scale, could, he said, be resolved in the manipulation of detail and tone. He also believed that no painting could succeed until extensive research of the subject was first done; for an example, he would not be able to paint the ear as he saw it from the front until he knew exactly how it joined the head at the back; nor would he be able, he said, to paint the front of a wall (as in *Moon*) until he knew what lay behind it.

The more interested he was in a problem, the longer was the series of paintings of the subject. With his Europa and Bull series, for instance, there were more than fifty studies, all of which, he said, revolved round the problem of how to solve the placing of a woman on the back of a bull. In the case of *Moon* (St Mary's Hugh Town in the Scilly Isles one place which became the central obsession of his painting life), he was inspired by light. The moon was rising behind the houses and the sun was setting behind him, whitening the facades and boat. He made a series of five paintings of the subject, all from one drawing.

Each one was, however, different in construction and atmosphere. Having noticed the extraordinary effect of light in the counterpoint of sun and moon, he set about organising the geometry of the subject. He was, of course drawn to the work of Cézanne when, as a schoolboy, he visited Paris alone in 1907; it is hardly surprising that he should have been, since, like Cézanne, his sense of geometry was flawless and immediate. At times, the constructional geometry was so subtle that one becomes aware of it only after years of studying the picture; at other times, as in *Moon*, the geometry had to make a clear statement in order that the static atmospheric properties of the subject could be captured. The moon, boat, pitched roofs, wall and line of reflection describe an abstract image which increases in clarity with distance, emerging as a composition derived from the triangle, sphere, parallelogram, tetrahedran that is set in a vertical and horizontal frame; hence the order of the picture, the unity and satisfaction conveyed. Only when you approach the picture again, and closely examine it do you enjoy the second image – the row of houses overlooking the magic of the little bay at evening.

Again, the images slowly reveal themselves over the years; perhaps, for instance, the geometric diagram really suggests the ghost of a sail, perched above the boat? For this artist, the painting was a poem, the discovery in form and line of underlying orders of rhyme in Nature; in this way he used the painting like a mirror, held up to reflect and frame vast numbers of sensations that passed through his mind when he fell in love with a subject.

STEPHEN GARDINER
to the author 1983

213 **Clive Gardiner:** *Moon, 1956. Oil on canvas,*
30 cm × 20 cm
Collection of Stephen Gardiner

214 Joseph Mallord William Turner: *Calais Sands,*
c 1830. Oil on canvas, 76 cm × 105 cm
Bury Art Gallery

15 Georges Seurat: *Gravelines,* 1890. Oil on canvas
Home House Society Trustees, Courtauld Institute Galleries,
Courtauld Collection

216 **Claude Monet:** *Bathers at La Grenouillère,* 1869. Oil
on canvas, 73 cm × 92 cm
National Gallery, London

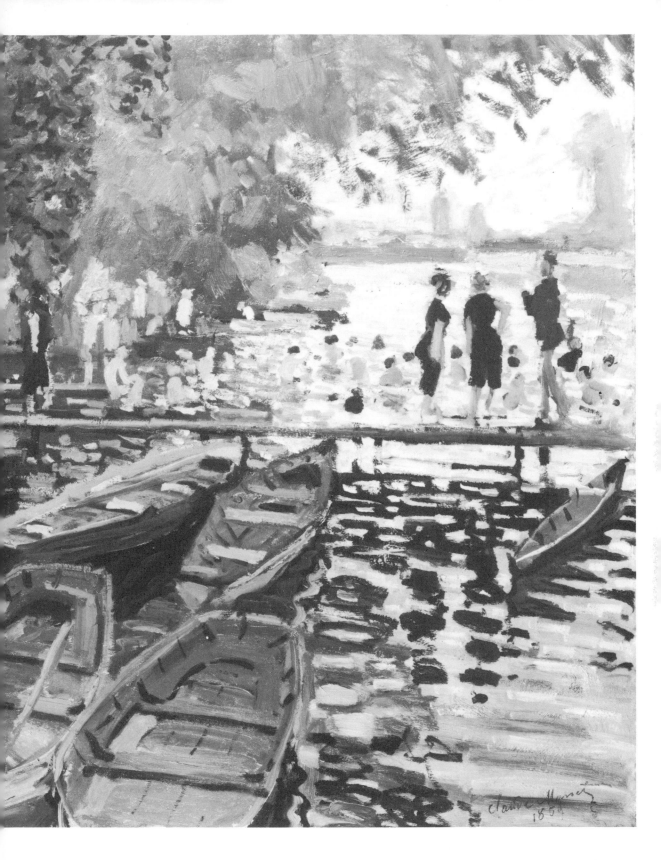

251

217 **Claude Monet:** *Bathers at La Grenouillère* (detail)

218 **John William Waterhouse:** *The Lady of Shalott* (detail)

219 **John William Waterhouse:** *The Lady of Shalott,*
1888. Oil on canvas, 153 cm × 200 cm
Tate Gallery, London

220 Thomas Gainsborough: Mr and Mrs Andrews,
1750. Oil on canvas, 69 cm × 119 cm
National Gallery, London

'I had no clear idea how the painting would end up except that there would be a frieze of figures against a strip of blue sea and there would be a large expanse of sky. This seemingly vague approach was positive in that the canvas was large and rather than have a fixed design I preferred to allow the figures to arrive out of the scene with its air and space, or in another sense, out of the canvas. If I were painting direct from nature I would have had a much clearer idea of the end result. So I started with the sky scrubbing in a blue and made loose suggestions in a warm colour where the figures would come. After a while, painting fairly thinly, I started consulting the many beach drawings I had done on the spot and began to put in individual figures and groups, subject always to what had arrived onto the canvas already. The initial idea came from a beach called Fire Island near New York where people stood watching large waves on a calm sunny day. I had done drawings, but hardly enough. I did some more on a beach in the Algarve and it was these I mostly used.

'I painted the picture on and off for over two years so there were quite a number of changes. The horizon line became lower so as to get the right spatial envelope. The man on the right with the large stomach took on greater prominence. The original drawing of him done in Portugal even suggested the source of light – from the right – and he also became a static contrast to the leaping woman to the left of him, suggested by a Hindu sculpture at Ellore, but also encouraged by the streaker at Lords I had seen, who rushed amongst the static figures of the cricketers. In the centre I felt it important to have an opening to the waves and smaller figures. All the time my main idea was to get it all as light and airy as possible so that ones eye could pass through the figures and not be held up by their being too actual. The next second many of them would have moved.'

Palette:
Titanium White
Flake White
Cadmium Lemon
Yellow Ochre
Burnt Umber
Cadmium Scarlet
Permanent Rose
Cobalt Blue
Ultramarine
Monastral Blue (touch of)
Viridian
Lamp Black
Ivory Black

ANTHONY EYTON to the author, 1982

Top left
221 Berthe Morisot: Woman and Child in a Garden. Oil on canvas, 60 cm × 73 cm
Exhibited in Paris 1922
National Gallery of Scotland, Edinburgh

◄**222 Anthony Eyton:** *Bathers*, 1973–75. Oil on canvas, 2·20 m × 3·45 m
Collection: Newham Hospital, Plaistow, London

223 Giovanni di Paolo: *St John the Baptist Retiring to the Desert* (active 1420–82). Oil on wood, 31 cm × 38.5 cm *National Gallery, London*

Eyton's beach scene shows a given moment, movement caught and held by the painter for ever. 'The next second many of them would have moved'. This picture by di Paolo depicts movement as a sequence of events. John the Baptist leaves the town and walks in the hills within the same 'frame'. Movement implies time and both are shown in this work by an artist who understood that painting and reality are not the same. In the late nineteenth and early twentieth centuries Degas, Duchamp and the Italian Futurists explored the same themes in different ways

224 **Edgar Degas:** *Women Combing their Hair*,
1875–76. Oil on canvas, 31 cm × 45 cm
Phillips Collection, Washington
Although called *Women Combing their Hair*, a title
most likely given to the work by a dealer or museum
curator, the figure is probably one model shown in three
different poses. It is apparent in the first basic lines of the
stool in the centre, the fluid juxtaposition of figures and
background and the alterations which are clearly visible,
that Degas did not colour a drawing, but drew with the
paint; constantly altering the relationships of form and
tone

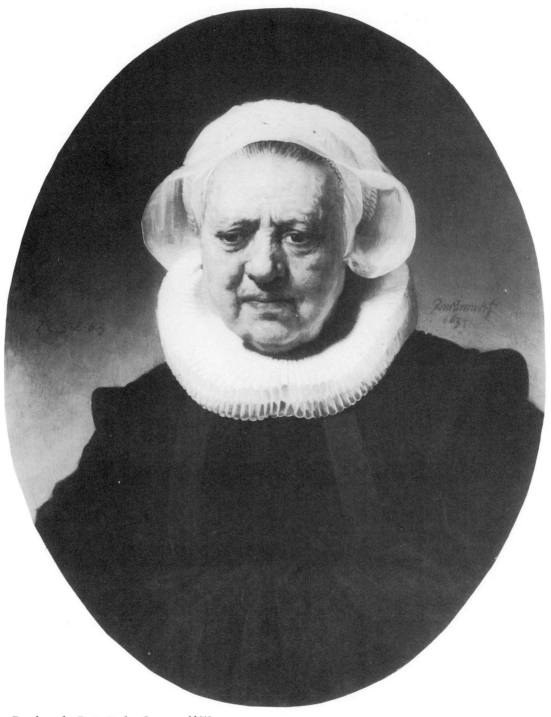

225 **Rembrandt:** *Portrait of an 83 year-old Woman,*
1634. Oil on wood panel, 68·7 cm × 53·8 cm
The National Gallery, London

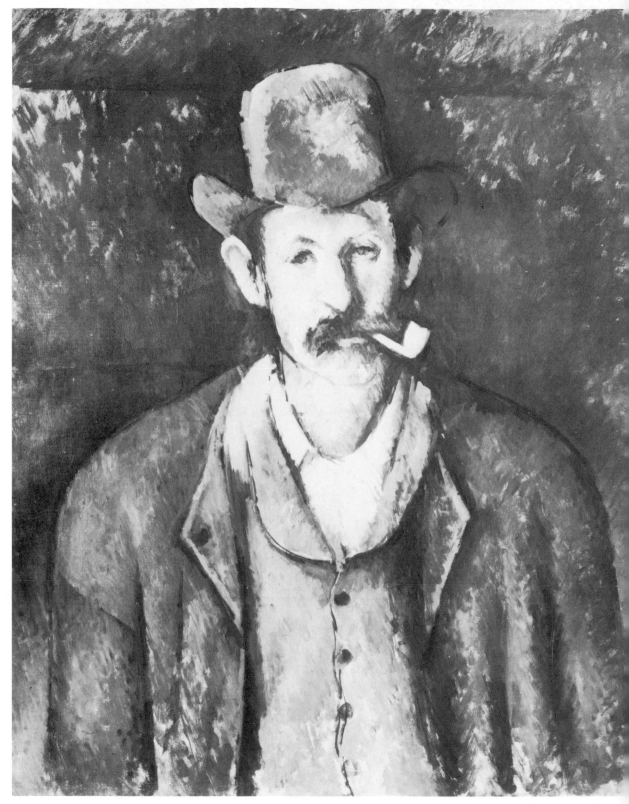

226 **Paul Cézanne:** *Man with a Pipe, c* 1892. Oil on
canvas, 73 cm × 60 cm
Home House Society trustees, Courtauld Institute Galleries,
London, Courtauld Collection

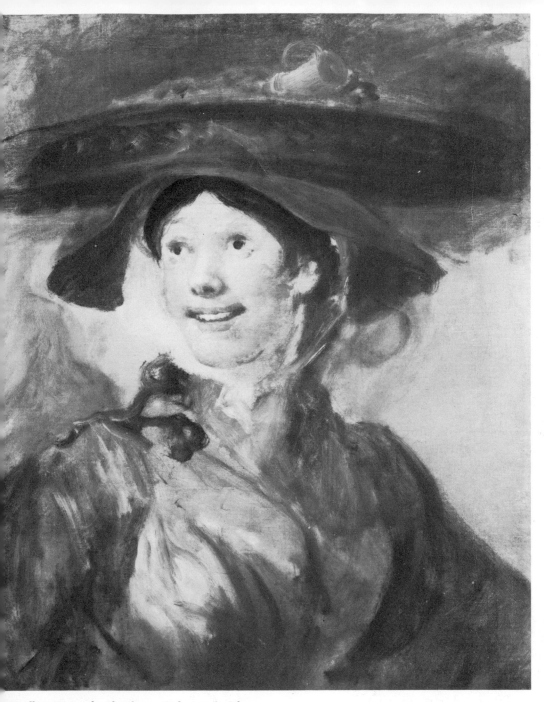

William Hogarth: *The Shrimp Girl, c* 1745. Oil on
as, 64 cm × 53 cm
nal Gallery, London

'When a subject is trifling or Dull the execution must be excellent or the picture is nothing. If a subject is good, providing such material parts are taken care of as may convey perfectly the sense, the action and the passion may be more truly and distinctly conveyed by a coarse, bold stroke than the most delicate finishing.'

WILLIAM HOGARTH

'They say he could not paint flesh. There's flesh and blood for you; – them!'

MRS HOGARTH

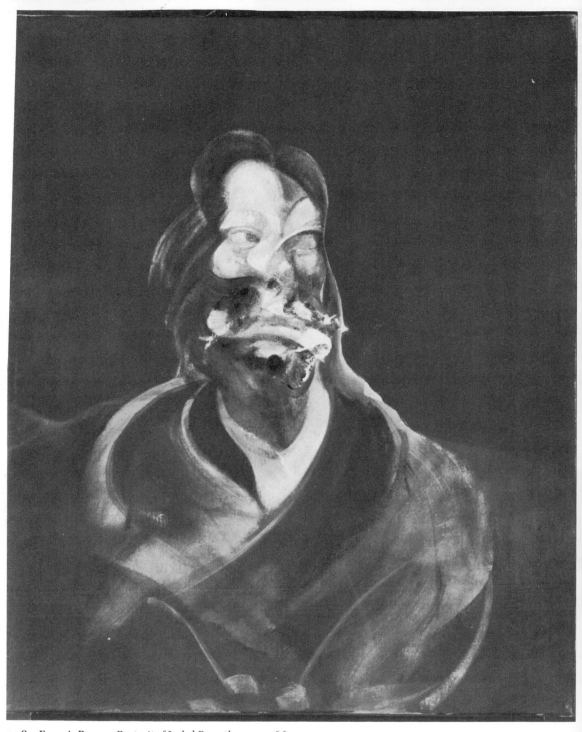

228 **Francis Bacon:** *Portrait of Isabel Rawsthorne*, 1966.
Oil on canvas, 84 cm × 68 cm
Tate Gallery, London

229 **William Harnett:** *Just Dessert*, 1891. Oil on canvas, 57·5 cm × 68 cm
The Art Institute of Chicago, Friends of American Art Collection

230 Chaim Soutine: *La Raie (Still Life with Ray Fish),*
c 1924. Oil on canvas, 81 cm × 65 cm
The Cleveland Museum of Art, Gift of Hanna Fund

231 Adolphe Monticelli: *Wild Flowers, c* 1880. Oil on
panel, 61 cm × 47 cm
Painted wet into wet with brush and knife the late still
lives and flower pieces of Monticelli were greatly admired
by Van Gogh and had considerable influence on his work
National Gallery, London

232 **Henri Rousseau:** *Bouquet of Flowers*, 1909–10.
Oil on canvas 61 cm × 49·5 cm
Tate Gallery, London

233 **Theodore Garman:** *Cyclamen,* 1980. Oil on
canvas, 55 cm × 30·5 cm (fragment of a larger painting
destroyed by the artist)
Collection Beth Lipkin, London

234 Angelo Bronzino: *Venus, Cupid, Folly and Time/An Allegory of Time and Love*, 1503–72. Oil on panel, 1·46 m × 1·16 m
National Gallery, London

235 **Francis Bacon:** *Three Studies for a Crucifixion,*
1962. Centre panel of Triptych. Oil on canvas,
198 cm × 145 cm
The Soloman R Guggenheim Museum, New York

236 Ceri Richards: *La Cathedrale Engloutie (The Sunken Cathedral)*, 1962. Oil on canvas, 25·5 cm × 30·5 cm
Copyright The Estate of the artist

A note on the technique of Ceri Richards as a Painter

There are two aspects of Ceri Richards's technique which will immediately strike an observer of his work as a whole: firstly an intensity of physical commitment in the actual *application* of the paint to the surface of the canvas; and secondly an impulse to experiment, a tendency to push the material to the limits of its expressive potentiality. Both elements are implicit in the gestural virtuosity that distinguishes his work and created its extraordinary variety of texture. For Richards the painting of a picture was the making of a *thing*, an object (his consciousness of that aspect of the process was a component of his modernity), and this meant that the very tactility of the paint was a quality to be exploited. It was the diversity of his practice, and the great range of effects he was capable of producing, that led to his being sometimes described as 'a painter's painter' – an artist, that is, especially admired by other practitioners.

Richards himself was always prepared to learn from his contemporaries, and also from those artists in the great European tradition with whom he felt a special affinity. Among the latter Delacroix was a particular favourite. Richards admired especially the tumultuous composition and the dynamically gestural vitality of the painting and studies of *The Lion Hunt*, and he assimilated what that work had to teach over many years by returning constantly to its themes and motives in what he called 'paraphrases' – freely and vigorously painted original works (often in arbitrarily decorative colours) – which take as their starting point a strongly registered impression of Delacroix's treatment of the subject, especially in its general compositional dynamism and the expressive violence of its execution.

Rubens was another of the great European masters that Richards greatly admired, particularly for his surpassing ability to handle a large number of moving figures in a single complex composition (a great problem this for modern painters who have no immediate tradition of the grand scale painting on historical or mythic themes). Richards tackled the subject of human figures in energetic interaction in numerous versions of the Rubens theme of *The Rape of the Sabines*, which indicate clearly his study of the master.

What is significant in all this is that Richards – for all the singularity of his own vision – believed as artists have in the past always believed that there is no such thing as pure originality: artists learn from other artists, and consciously take their place in a community of makers, whose productions, whenever they were painted, and for whatever purpose they may have been created to serve, exist as material objects in the present, to which the living artist may turn as he wills, and as he is able, for instruction and inspiration.

Of the specifically modern techniques that Richards exploited more or less continually, perhaps the most important was *automatism*. This approach to painting had, for a time, for certain surrealist artists an absolute value: it was the very means by which the unconscious could be liberated into objective expression. Automatism, to put it in a nutshell, is the utilization of chance effects deliberately encouraged by the absence of deliberation in the execution of the work of art. Although Richards had considerable sympathies with the Surrealists, he was never a fully paid-up member, and his use of automatic techniques was more playful and arbitrary – a means to a pictorial end; the

exploitation of accidental effects was a way of extending the repetoire of forms and surfaces available. Thus, following Ernst's example, he improvised with the configurations created by dipping pieces of string into paint and dropping them on to the canvas, and with effects not unlike those achieved by *frottage* (rubbing down onto a textured surface) by pressing pieces of wood or other material into the painted surface, or by applying the paint to the support with a textured, grained or ribbed object.

In many later paintings on the subject of *La Cathédrale Engloutie*, these practical ideas were extended more consciously, and a block of wood would be pressed into a thickly applied matrix of paint to create effects that suggest the shapes and textures of the monumental blocks of marble and stone column bases of the drowned cathedral; or in smaller, more capricious works, a paper doylie might be used as a stencil to create the delicate tracery of a rose window. These methods, and his experiments in a wide variety of other media – relief construction, lithography and *collage* especially – naturally led Richards to another characteristic technique – the incorporation of foreign objects and materials into a painting. A memorable example of this is his painting of *The Deposition*, which now hangs in St Mary's church, Swansea. In this the lifeless body of Christ is poignantly laid, upon a white sheet, amidst the mud and debris of a public place, with actual fragments of the paper litter incorporated into the paint itself. In some works, notably on the theme of the sunken cathedral, fragments of the sheet music of Debussy's prelude are assimilated into the body of the painting; in others sand has been mixed with the paint to create roughened textures suggestive of the naturally worn surfaces of rock and masonry.

Richards was particularly fond of the broad shape and the strongly ribbed pattern of the veins of the fleshy leaves of the plantain lily (*Hosta*) that grew in the paved garden of his house in Chelsea, and in several paintings that image of the leaf is rubbed down on to the surface by means of a transfer relief, or the paper-rubbing itself is attached *collage*-like to the canvas.

All of these, and other, experimental techniques were, of course, supplementary to the central activity of painting – the application of oil paint, by brush or palette knife, to the chosen support. For Richards this was a process of direct involvement with a material that could be manipulated, shifted and transformed to bring about the realisation of a visual image, complex or simple, symbolic or evocative. This image was not premeditated but discovered, not planned but chanced upon; and the necessary discovery could only be made through an active collaboration with the medium, working with its essential properties by a co-ordination of hand and eye, governed by an imaginative preoccupation with a given subject. 'A subject is a necessity', wrote the artist in 1963, 'for it presents a renewal of problems and discipline. The chances that the artist encounters when painting and with which he has to struggle, give tension to the work'. (In this we can see the persistence of automatic elements in Richards's approach.)

The destruction of images, by painting out, or by washing down with turps or scraping off, was an essential part of this business of discovery. 'Working with a greater or lesser struggle images are made and destroyed, until what I hope will happen, happens.' The struggle referred to here is physical, the moment-to-moment making of marks on the canvas by a turn

of the wrist, the arc-describing gesture of the arm. It is not surprising that when he was most fully engaged, Richards would work for fourteen or more hours at a stretch, continually stimulated and surprised by the spate of images, one succeeding another, each in its turn destroyed to remain only as a ghost behind the surface of the finished work. It must be remembered that these images were both abstract and representational, or referential, elements in the composition, and that they might be either purely formal or thematic.

In a finished work what may surprise and delight us is the variety of surface feature: a rich impasto, almost sculptural in its relief formations, its agitated surfaces casting shadows with the changing light, may be deployed against flat planes of evenly brushed undifferientiated colour; hard-edged, decoratively formal stripes in bright primary colours may provide a curved or straight horizon, in the foreground of which naturalistically variegated rocks, blossoms and water are depicted; pictoral elements may be created through a modelling of the paint's plasticity into suggestive shapes and forms, or delineated by illusionistic devices such as perspective, or figurative modelling and design; and linear motives may be incised into the surface of the paint by the technique of *sgraffito*, often by using the pointed end of the brush handle.

Richards was inhibited by no preconceptions as to what the infinitely various material of his art was capable of. In his own words: 'The object that a painting becomes is the result of a struggle with technique which implies the use of subtle substances and continual alteration of images....

'Working through from direct visual facts to a more sensory counterpart of reality of my subject, I hope that as I work I can create later on an intense metaphorical image for my subject.'

Much earlier in his career he said: 'I have to refer directly to nature for stimulus before I start my painting. Once I have transferred to the canvas an expression of that stimulus, the painting grows on its own as an entity.'

These statements, separated by thirty years, express a constant in Richards's approach that is characteristically modern: the idea, implicit in both Cubism and Surrealism, that the work itself is an autonomous object, and that its constituent physical materials participate, in a manner of speaking, in its creation.

MEL GOODING
to the author January 1983

275

237 Kenneth Martin: *Chance Order Change 13, 1980.*
Milton Park A. Oil on canvas, 91·4 cm square
The Waddington Galleries

238 Gwen John: *A Corner of the Artist's Room in Paris*
1907–09. Oil on canvas, 31·7 cm × 26·6 cm
Graves Art Gallery, Sheffield
This picture was painted in Paris, where she lived for
most of her life, at the time of great artistic excitement in
that city. Gwen John was to continue so to paint for the
next thirty years, unmoved by modern movements,
living in reclusion, and producing works of compelling
simplicity of form and colour. Her younger brother,
Augustus John, who was undoubtedly the finest portrait
painter of his time, described her as 'the greatest woman
painter of this or any age

239 **Auguste Renoir:** *Apples and Walnuts*, not dated.
Oil on canvas, 48 cm × 99 cm
Fitzwilliam Museum, Cambridge

'... as far as execution is concerned, we regard it as of little importance; art, as we see it, does not reside in the execution: originality depends only on the character of the drawing and the vision peculiar to each artist.'

CAMILLE PISSARRO
Letter to P Durand-Ruel
6 November 1886

240 **Charles Keene:** *Self-Portrait*, not dated. Oil on board, 27 cm × 18 cm
Tate Gallery, London

POINTS WORTH CONSIDERING

Although the following may be written in what might be thought to be a presctiptive way, they are only hints which the beginner might find helpful.

1 When setting up your easel try to make sure that the light is coming onto the canvas over your left shoulder (assuming that you are right-handed) so that shadows are not cast over the working area.

2 Do not stand too close to the painting. Work at arms length, holding the brush away from the metal ferrule, using the arm from the elbow and shoulder and not just limited wrist movements. A small table between yourself and the easel can be used for keeping paints and palette on as well as forming a suitable 'barrier'.

3 It is sound practice to use the simplest ingredients for a picture, providing that they are of proven quality. Limited colours and a little dilutent with the addition of oil for the later layers is really all that is needed. Drying oils are dangerous and the indiscriminate use of varnish as a medium will produce cracking. Unless painting *alla prima* and the work completed in one session, it is best to produce the picture through the accumulation of thin layers; each of which has been allowed to dry thoroughly before the addition of the next.

4 Begin thinly, mixing the paint with a little turpentine so that overlapping layers may be made with paint that dries fairly quickly and as the work evolves the added layers may be mixed with a medium of oil and turpentine which will help to eliminate sinking and a too matt effect. Such a medium and method will act as an aid to the preservation of the work. In other words: 'Paint Fat over Lean', add a little oil to each successive layer of paint. Too much oil in the underpainting can be responsible for the later cracking of the pigment.

5 When working on a detail always bear in mind the unity of the whole. From time to time stand well back from the painting, across the room if possible, so that you can see the complete work, its unity or lack of it; and consider your next move.

6 View both the subject, if you are painting from the motif, and the picture through half-closed eyes so that the details are obscured and you can appreciate the simplified tones, colours and forms. When viewing your work in this way it is sometimes helpful to see which part is the most conspicuous and remains prominent as you slowly close your eyes. Ask yourself whether or not that which you last see is an important part of the work. In all probability it will be a point of strong tonal contrast. As this will draw the eye of the spectator it should be an important part of the work and not an insignificant detail.

7 It is a good idea to view your work in a mirror. This can help you see problems of organisation and balance and give a clearer, fresher view. A 'Claude' mirror, named after the French artist Claude Lorraine, may be made by backing a sheet of glass with black paint or paper. Your painting viewed in this will show tonal relationships and defects of composition without the confusion of all the colour and detail.

8 Turn the painting upside down sometimes, or even place it on its side and work on it in that position for a while. This will enable you to consider more fully the 'abstract' qualities of colour and organisation without the subject getting in the way. Alternatively, place the canvas on the floor and work on it from a number of directions.

9 It is good policy to keep several paintings on the go at the same time. What is learned from one may well be applied to another and should you meet with a problem which, either technically or creatively, seems to be insoluable it is possible to continue working on another canvas; returning to the problem later with a fresher eye.

10 Keep your work, however unsuccessful it might appear to be on completion, until you are experienced enough to decide what is good and what is bad. This way you will be able not only to make comparisons and estimate progress, but you may well save work which is of interesting quality although unappreciated at the time of execution.

11 Be critical of your painting. It is sensible to make notes of what you consider to be the good and bad points of a piece of work, which parts you think successful and which not and why; with possible solutions to be remembered for future works.

12 Experiment with different materials: colours, grounds, supports and means of application, not in an arbitary fashion, but in a way that relates to the ideas you have in mind.

13 Draw constantly. Keep a sketchbook and draw everything and anything which happens to be around you, not in attempts to make finished drawings nor facile 'sketches', but as visual notes which may be useful for future work and will in any event make you more visually aware. Confidence and knowledge gained in this manner will be invaluable.

14 Even if you wish to work mainly in a non-figurative idiom on occasion work from 'nature'. That is the object or scene which is before you. Without a study of reality, the complex relationships between form and space, the student and amateur are in grave danger of producing work of an uninteresting banality.

WINSOR & NEWTON'S

IMPROVED SKETCHING TENT.

'I have worked for years in order that people might say, "It seems so simple to do".'

MATISSE *to Louis Aragon*

'There's never a moment when you can say, "I've worked well and tomorrow is Sunday. As soon as you stop, it's because you've started again. You can put a picture aside and say you won't touch it again. But you can never write THE END".'

PICASSO

281

Index to Artists

Figures in *italics* refer to illustration pages

Albers, Joseph (1888–1976) 160
Alberti, Leon Battista (1404–72) 64, 81, 220
Albertinelli, Mariotto (1474–1515) 220
Andrews, Michael (b 1928–) 104, 116, *116*, *117*
Antonello, da Messina (*c* 1430–79) 142
Arp, Jean (1887–1966) 110

Bacon, Francis (b 1909–) 33, 103, *103*, *104*, 132, 133, 264, *271*
Bellini, Giovane (*c* 1430–1516) 142
Bernard, Emile (1868–1941) 77, 160, 165, 167, 169, 201
Blow, Sandra *113*
Bomberg, David (1890–1957) 166, 167
Bonington, Richard Parkes (1801/2–1928) 239
Bonnard, Pierre (1867–1947) 10, 74, 81, 95, *182*
Bosch, Hieronymus (*c* 1450–1516) 214
Braque, Georges (1882–1963) 63, 71, 74, 108, *108*, 201, *207*, 219, 221, 224
Bravo, Claudio (b 1936–) 121
Bronzino, Agnolo (1503–72) 270
Brown, Ford Maddox (1821–93) 120
Brunelleschi, Filippo (1377–1446) 220
Burne-Jones, Edward (1833–98) 120, 125
Burri, Alberto (b 1915–) 110, *110*, 112

Caillebotte, Gustave (1848–94) 120, *121*, *190*, *191*, 245
Canaletto, (Giovanni) Antonio (1697–1768) 125
Caravaggio, Michelangelo Merisi da (1573–1610) 221
Cassatt, Mary (1845–1926) 73
Cézanne, Paul (1839–1906) 7, 20, 47, 73, 75, 77, 83–4, 136, *136*, 137, 160, 167–8, 169, *187*, 188, 201, *212*, 223, 224, 230, 247, *262*, *colour plate II*
Chardin, Jean Baptiste Siméon (1699–1779) 63, 75, 77, 85
Claude, Gellée (Claude Lorraine) (1600–82) *217*, *280*
Close, Chuck (b 1910–) 121
Collins, Cecil (b 1908–) 89
Constable, John (1776–1837) 20, 75, 92, *138*, 153, 209, 210
Corot, Camille (1796–1875) 63, 75
Cosimo, Piero di (*c* 1462–1521) 196
Courbet, Gustave (1819–77) 36, 94, 102, 103, 119, 164, 196

Daumier, Honoré (1808–79) 63, 65, 77, 81, *colour plate 1*
David, Jaques Louis (1748–1825) 188
Degas, Edgar (1834–1917) 20, 84, *125*, *126*, 183, *185*, 208, *258–9*, *260*
Delacroix, Eugenè (1798–1836) 20, 60, 64, 72, 80, 119, 154, 173, 196, 226, 273
Delaunay, Robert (1885–1941) 246
Denis, Maurice (1870–1943) 188
Derain, André (1880–1954) 71
Diebenkorn, Richard (b 1922–) 232, 233, *233*, 237
Drummond, Malcolm (1880–1945) 229
Duchamp, Marcel (1887–1968) 22, 120, *258–9*
Dürer, Albrecht (1471–1528) 176, *178*, *179*

El Greco, Domenikos Theotocopoulos (1541–1614) 72, 81, 196, *colour plate 2*
Ernst, Max (1891–1975) 108, 126, *127*, 128–9, 274
Eyton, Anthony (b 1923–) 256, *257*, *258–9*

Fairs, Tom (b 1925–) 58, *58*
Fantin-Latour, Henri (1836–1904) *231*
Fra Angelico, Fra Giovanni da Fiesole (*c* 1387–1455) *216–17*
Francesca, Piero della (1410/20–92) 170, 188, 193, 195, 220
Francis, Sam (b 1923–) *105*

Gainsborough, Thomas (1727–88) 21, 152, 153, *254–5*
Gardiner, Clive (1891–1960) 246, *247*
Garman, Theodore (1924–1954) 269
Gauguin, Paul (1848–1903) 19, 69, 72, 83, 84, 160, 164, 169, 220, *colour plate 14*
Ghirlandaio, Domenico (1449–94) 53
Giacometti, Alberto (1901–66) 75, *76*
Giorgione, (*c* 1476/8–1510) 142
Giotto (1266/7 or 1276–1337) 191
Giovanni di Paolo (1403–82/3) *258–9*
Goings, Ralph (b 1928–) 108, 121
Gore, Spencer (1878–1914) *198*
Goya, Francisco (1746–1828) 153
Grey, Roger de (b 1918–) 238, *238*
Gris, Juan (1887–1927) 109, *212*, 224
Guston, Philip (b 1913–) 166

Hamilton, Richard (b 1922–) 22, *118*, 120, 123, 124, *124*, 125

Harnett, William (1848–92) *265*
Heartfield, Richard (1891–1968) 108
Hobbema, Meindert (1638–1709) 221
Hockney, David (b 1937–) *226, 227, 228*
Hogarth, William (1697–1764) 263, *263*
Holbein, Hans the younger (1497/8–1543) 20
Hoogh (Hooch) Pieter de (1629–after 84) *192, 221*
Hunt, William Holman (1827–1910) 81–2, *colour plate 3*

Jacquet, Alain (b 1939–) 120
John, Gwen (1876–1939) *277*
Johns, Jaspar (b 1930–) 99, *101, 102,* 237

Kalf, Willem (1619–93) *207*
Kandinsky, Wassily (1866–1944) 194, 196, 232–3
Keefe, Arnold (b 1911–) 115, *115*
Keene, Charles (1823–91) *279*
Klee, Paul (1879–1940) 21, 60, *61,* 63, 64, 72, *162,*
 174, 194, 196, *196,* 210
Kline, Franz (1910–62) 233, *233*
Kooning, Willem de (b 1904–) 166

Lanyon, Peter (b 1918–64) 240, 241
Léger, Fernand (1881–1955) 60, 74
Leonardo da Vinci (1452–1519) 88, 99, 129, 142, 220,
 222
Lichtenstein, Roy (b 1923–) *104, 105, 106*
Louis, Morris (1912–62) 87, 103

Magritte, René (1898–1967) 214
Malevich, Vladimir (1878–1935) 160
Manet, Edouard (1832–83) 125, *136*
Marshall, Ian (b 1935–) 112, *112*
Martin, Kenneth (b 1905–) *185,* 232, *276*
Martini, Francesco di Giorgio (active 1440–80) *211*
Masson, André (b 1896–) *131,* 237
Matisse, Henri (1869–1954) 63, 71, 72, 74, 84–5, 108,
 160, 176, *184,* 188, *189,* 196, 230, 281, *colour plate
 15*
Matta, Roberto (b 1912–) 237
Michelangelo, Buonarroti (1475–1564) 88, *90*
Millet, Jean Francois (1814–75) 165
Miro, Joan (b 1893–) 72
Mondrian, Piet (1872–1944) 160, 196, *197,* 221, 231,
 234, 235, 236
Monet, Claude (1840–1926) 36, 64, *68,* 72, 84, *123,*
 155, 156, 158, *159,* 166, 173, 230, 250–51, *252,*
 colour plates 12 and 13
Monticelli, Adolphe (1824–86) 83, *266*
Morandi, Giorgio (1890–1964) 77
Morisot, Berthe (1841–95) *161, 256*
Morris, William (1834–96) 120
Motherwell, Robert (b 1915–) 160
Munch, Edvard (1863–1944) 223

Nash, Paul (1889–1946) *242–3*

Nicholson, Ben (1894–1982) 63, 160
Nicholson, William (1872–1949) *75*
Nolde, Emile (1867–1956) 60

O'Connor, Roderick (1860–1940) *96*
Orpen, William (1878–1931) *139*

Palma Giovane (1544–1628) 142
Palma Vecchio (1480–1528) 142
Pasmore, Victor (b 1908–) 232
Pearlstein, Philip (b 1924–) 121
Philips, Tom (b 1937–) 120
Picasso, Pablo (1881–1973) 10, 11, 63, 69, 71, 80, 87,
 108, *108,* 110, *199,* 221, 224, *224,* 230, 231, 281
Pissarro, Camille (1831–1903) 71, 93, 94, *123, 155,*
 155, 158, 277
Plumb, John (b 1927–) 91, *91*
Pollock, Jackson (1912–56) 10, 87, 130, *131,* 166, 232,
 237
Poussin, Nicholas (1594–1665) 170, 188, 193, 201,
 204, 205, 206

Raphael (1483–1520) 158, 174
Rauchenberg, Robert (b 1925–) 116
Rembrandt van Ryn (1606–69) 20, 82, *86,* 94, *94,* 135,
 135, 148–9, *150, 151,* 164, 193, *211,* 225, *261,*
 colour plate 4
Renoir, Auguste (1841–1919) 68, 94, 155, 156, *157,*
 158, *278*
Reynolds, Joshua (1723–92) 125
Richards, Ceri (1903–71) *272, 273–5*
Riley, Bridget (b 1931–) 69
Rothko, Mark (1903–70) 72
Rouault, Georges (1871–1958) 21
Rousseau, Henri (called Le Douanier) (1844–1910) *268*
Rubens, Peter Paul (1577–1640) 19, 20, 21, 43, 45, 68,
 87, 88, *107, 133,* 144, 145, *146–7, 148,* 149, 196,
 226, 230, 273
Runge, Philip (1777–1810) 60
Russell, Dorothy (b 1927–) 122, *122*
Ryan, Adrian (b 1920–) *79, 85, colour plate 16*

Schwitters, Kurt (1887–1948) 108, *114*
Scott, William (b 1913–) *214,* 234
Serusier, Paul (1863–1927) 160
Seurat, Georges (1859–91) 60, 70, 71, 82, 169–70, *171,*
 172, 173, 188, 193, 195, *249, colour plate 7*
Sickert, Walter Richard (1860–1942) 64, 66, 77, 78,
 103, *120, 120,* 137, *174, 175, 176, 244*
Signac, Paul (1863–1935) 70
Signorelli, Luca (*c* 1441/50–1523) 220, 221
Sisley, Alfred (1839–99) 94, 155
Smith, Matthew (1879–1959) *139*
Smith, Richard (b 1931–) *218*
Soutine, Chaim (1894–1943) 94, 165–6, *167,* 223, *266*
Spencer, Stanley 1891–1959) 9, 184, *187*

Stael, Nicholas de (1914–55) 94
Steer, Wilson (1860–1942) 9, *208*
Still, Clyfford (b 1904–) 72, 232
Sutherland, Graham (1903–80) 202

Tapies, Antonio (b 1923–) 110, *111, 112*
Tintoretto, Jacopo (1518–94) 188, 222
Titian (Tiziano Vecelli) (c 1487/90–1576) 35, *36*, 68, 80, 82, 87, 95, 133, *134*, 142, *143*, 149, *186, colour plate 5*
Toby, Mark (1890–1976) 232, 237
Tonks, Henry (1862–1937) 125, *125*
Toulouse-Lautrec, Henri (1864–1901) 70, 160
Tura, Cosimo (before 1431–95) 82–3, *colour plate 8*
Turner, Joseph Mallord William (1775–1851) 12, *38*, 60, 75, 82, 94, 99, 102, 153, *153*, 248, *colour plate 6*

Uccello, Paolo (1396/7–1475) 220

Van der Straet, Jan (1523–1605) 7
Van Dyck, Anthony (1599–1641) 21, 45, *45*
Van Eyck, Hubert (active 1424–d 1426) 140
Van Eyck, Jan (active 1422 d 1441) 18, 140, 141, 142, 149
Van Gogh, Vincent (1853–90) 52, 64, 67, 70, 71, 78, 81, 83, 87, 92, 93, 94, 99, *164, 164*, 165, 169, 176, *177, 209*, 223, 267, *colour plates 9 and 10*
Vasarély, Victor (b 1908–) 71, *163*
Velasquez, Diego Rodriguez de Silva (1599–1660) 75
Vermeer, Jan (1632–75) 188, 195, 221
Veronese, Paolo (c 1528–88) 188
Vlaminck, Maurice (1876–1958) 71
Vuillard, Édouard (1868–1940) 20

Wallis, Alfred (1855–1942) *213, 214*
Waterhouse, John William (1849–1917) 253
Whistler, James Abbott McNeil (1834–1903) 64, 67

General Index

Figures in *italics* refer to illustration pages.

Abstract art 232–4

Abstract Expressionist painters 72, 84, 130, 166; free approach of 232–3

Aerial perspective, use of *217*, 220

Airbrush(ing) 104, 107–8, 124, 130: cleaning 32; creating 'splatter' 107; development of 107; difficulties with 107–8; technique of 107–8; uses of 107

Alla prima painting 43, 88, 92, 137, 142, 144, 153, 164, 165, 184, 280: difficulties of 92; intention and technique of 137

André, Albert, description of technique of Auguste Renoir 157–8

Arnheim, Rudolph 194

Automatism 237, 273

Baxandall, Michael 64; works, *Painting and Experience in Fifteenth Century Italy* 64q

Beeswax medium 46, 99

Beeswax and oil medium 46

Beginning, and determining subject matter 237

Bell, Keith *186*

Binding media 37–9, 137; use of oils as 43

Black pigments 55, 56

Blue pigments 53, 55

Box, use of for painting requirements 9

Brown, Professor G. Baldwin 140

Brown pigments 55

Brushes 25–32: airbrush 32; cleaning 28–31; hog hair 25–7, *28*, 107, 130, 133; brights 26; filbert-shaped 26, 27, *29*, 130; flats 25, 27, *29*; rounds 25, 27, *29*; nylon 26, 130; sable hair 26, *26*, 27, *28*, *29*, 82, 107; rounds 26; shape of 27; varnishing 29, *29*

Burdick, Charles 107; patent airbrush 107

Calico 19

Camera obscura device 125

Canvas, as support 17–19: cotton 19; first use of 18; hessian 19; jute-based 19; linen 18; linen and cotton mixture 19

Canvas, staining of 103

Canvas, stretching 23–4

Cardboard, as support 20

Cave paintings 49–50

Charcoal 133, 174, 183, 230

Chevreul, Michael E. 60, *62*, 70, 154, 169: chromatic diagram of 62, *62*; works, *The Laws of Contrast of Colour and their Application to the Arts* 60q

Chiaroscuro device 154, 167, 210, 225

Chipboard, as support 17

Collage 87, 99, *101*, 108, *108*, 110, 124, 274

Colour(s) 60–85, 220: application of 130, 133; attempts to analyse and categorise 60; c. contrasts and harmony 72–4; c. and space 77; complementary 70–71, 73; greys 74–5, 77; hue 63; local and light 74; poisonous 60; primary 61, 80; responses to 80–81; saturation 63; secondary 62, 169; tertiary 62–3, 169; to determine division of c. 62–3; tone and black and white 63–4, 67–8; warm and cool 68–9

Commercial painting media 46

Composition 188

Constructivist movement 231

Copal varnish and oil medium 44, 47, 48

Cradling 16

Cubism(ts) 108, *108*, 110, *110*, 219, 224, 234, 275

Dadaists 108

Damar varnish medium 46

Dammar 48

Dante, Alighieri 223

Decolcomania process 126

Denis, Maurice 188

de Stijl movement 231

Dilutents 43, 168

Dippers 14

Divisionism 169

Document paper, use of in photography 123

Doerner, Max 45, 50, 52, 149; works, *The Materials of the Artist and their use in Painting* 50q

Drawing, as paramount importance to painter 173–4, 184

Driers 46–7

Drying oils 42–4: linseed 42–3; cold pressed 42; raw, 43; refined 43; sun bleached 42; sun thickened 42–3; poppy 43; safflower 43; stand 43; storing 44; walnut 43

Drying times of oils and varnishes, guide to 48

Dual space 84
Dyes 50

Easels 9–11: box 10, *11*; combination studio e. and table 10; desk 10; radial 10, *10*; sketching 9, 10, *11*; studio 10, *10*
Emulsions, commercial 37
Encaustic method 99, *100, 101*
Equipment and material 9–85
Essex board, as support 20
Euclid 220
Expressionist artists 223

Fan blenders 27, 130
Fauves painting 64, 71, 72
Fayum mummy portraits 99
Fénéon, Félix 173
Fibonacci series 193–4
Field, George 210
Flake white 50, 156
Form, creation and changes of 225–6
Fresco painting 17
Frottage process 128–9, 274
Futurists, Italian 120, *258–9*

Galen 80 and n
Gamboge chipping 49
Gardiner, Stephen, appreciation of work of Clive Gardiner 247
Geffroy, Gustave 93, 156
'Ghost' images 234
Glass, as support 21
Glazes, use of 88, 90, 92, 99, 148–9, 151, 184
Glazing 91, 94, 104, 137, 149, 153: excessive dilution to be avoided when g. 135; procedure 133; technique 133–6, 153
Glue size 20, 33: bone 34; casein glue 34; Cologne 33, 34; making 34; parchment 33; rabbit skin 34, 122.
Golden section 191–4
Gooding, Mel, assessment of technique of Ceri Richards 273–5
Green, Peter 201
Green pigments 55
Greys, importance of 74–5, 77
Grounds 33–7: acrylic 33, 36; chalk 34, 35, 37; gesso 34, 36, 37; half-chalk 34; half oil 34, 35 constituents of 37; oil 34, 35–6 constituents of 35, 37; to make 35–6

Hals, Franz 64
Hardboard, as support 17
Hard Edge painters 231
Hayes, Colin 78; works, *The Technique of Oil Painting* 78q

Hiler, Hilaire 25, 78; works, *Notes on the Technique of Painting* 25q, 78q
Hog hair brushes 25–7, 29, 107, 130, 133
Hoogstraten 149
Hues 63, 69, 72, 77, 80, 83, 231

Images, destruction of 274–5
Impasto painting 29, 50, 88, 94, 96, 97, 99, 104, 135, 148–9, *150*, 164–7, 275
Impressionist painters 72, 81, *123*, 142, 165: French 92, 94, 153 'plein air' pictures of 153; technique of 153–63

Januszczak, Wlademar 149
John, Augustus 277

Knife, technique of painting with 102–3
Knives: painting 13, *14*; palette, 13, *14*, 34, 82, 103, 129

Lanyon, Peter, feelings and reactions during final state of painting 241
Le Corbusier 193, 194; modular system devised by 193–4
Lessore, Helen 137
Letter and number forms 237
Lhote, Andre 21
Line moves 197–8
Linear perspective: affinities between photographic image and l.p. 220–21; circular forms 222; cones of vision 222, 225; exaggerated perspective 222–3; one point p. 222; three point p. 222; two point p. 222; use of *217*, 220–23, *224*, 225, 245; 'vanishing point' 220–21
Lines and shapes 194–201; 'emotional' qualities of 195
Linoxyn 48
Linseed oil 34, 130, 153: as most successful binding medium 37, 42–3; constituent of most common painting medium 44
Loran, Erle 47; works, *Cézanne's Compositions* 47q

Mahl stick 14
Manfredi, Girolamo di 64
Mannerists, Italian 223
Marbling technique *207*
Marey, Etienne-Jules 120
Marouflage, as support 24–5
Marshall, Ian 112
Mastic 47; double 48
Maupassant, Guy de 156
Medici series of paintings 144
Metals, as supports 21
Monoprinting 126, 129
Morse, Edward 194
Multiple viewpoints 223
Munsel, Albert, his chromatic colour wheel 62–3, *63*
Muybridge, Eadweard 120

Negative spaces 234
Neo-Impressionist painters 70, 169
Nolde, Emil 60
Nylon brushes 26, 130

Oil colours, drying times for 40–42
Oil of spike lavender 44
Oil painting, speculation as to 'inventor' of 140
Oil paints: 'Artists' Quality' 48–9; composition of 37, 38–9; containers 154; drying time of 48; grades of 48–9; limits to adhesive quality of 112; storing 44; 'Students' Quality' 48–9; two main methods of painting with o.p. 87–8
Oil pastel, uses for 56
Oil sketching paper 19
Op Artists 71, 72
Opal medium 46
Opaque paint 136, 142, 144
Overlapping 216: glazes 149; o. planes device 216

Pach, Walter 158; describes conversation with Renoir 158
Paint: additions to 110, 112, 115; applying 'mixed' 112; diluted 88, 133, 230; use of mixtures to emphasise reality of painting 110
Painting: beginning a p. 184; 'fat over lean' 44, 280; numerous possibilities of 211; procedures 173–87; structure of a p. 188, 191; with flat colour 100; with modulated colour 167–9; with optical mixture of colour 169–73
Painting from photographs 118–22; dangers in 118
Painting media 44–7, 56; beeswax 46; beeswax and oil 46; commercial 46; copal varnish and oil 44; damar varnish 46; most common 44; opal 46; stand oil 44; Venice turpentine 45
Palette(s) 9, 11–13: Basic Nine-Colour 78; cleaning 12–13, 15; knife 13, 14, 34, 82, 103, 129; layout of 182–4; 'limited' 77–80; Monet's p. 158; paper 12; Pissarro's p. 158; Renoir's p. 158; studio 9, 11–12; wooden 11
Paper: as support 20–21; rolling 129
Pattern and texture 200–202, 205–7: aspects of 202; related to organisation and structural harmony of painting 206–7; visual p. 202, 205–7
Perspective device 210, 217, 221, 222
Perugino, Pietro 158
Petroleum spirit, use of as dilutant 43, 44
Photography 121, 123–5
Pigments 38–9, 48–58, 60, 81, 95: black 55, 56; blue 53, 55; brown 55; constituents of 48; earth 49–50; oil percentages in 39–40; opaque 135, 151, 160; permanence of 56–7, 60; red 52–3; technique to be applied 137; using additional layers of 136–7; violet 53; yellow 50, 52
Plan and elevation, use of by Cubist painters 225
Plywood, as support 17

Pointillist painters 60, 70–71, 169
Points for consideration when oil painting 280–81
Poppy oil 37, 43, 44, 48
Position on picture plane 213
Post-Impressionist painters 70, 165, 167
Primers, use of 16–17, 19, 20, 33, 34, 35, 37, 122
Projection systems 225–6; isometric 225; oblique 225
Ptolemy 220

Quattrocento oil painting 17

Rags, usefulness of 14
Read, Herbert 83–4
Red pigments 52–3
Renaissance Art 17, 43, 191, 213, 225, 226
Renoir, Jean 156; describes technique of father, Auguste 156
Rewald, John 68, 173
Root, Ogden 60, 154, 169; works, Modern Chromatics 60q
Root 2 rectangle 193
Rouault, Georges 21

Sabartés, Jaime 10, 11
Sable hair brushes 26, 26, 27, 28, 29, 82, 107
Safflower oil 43, 48
Scale 214: inversions of 214; size of as indication of space and distance 214
Scraping 129, 130, 274
Scumble(ing) 81, 92, 95, 98, 99, 115, 130, 137, 144, 226
Serigraphy 116
Sgraffito 275
Shades 63
Shapes 201: negative 201, 234; positive 201
Siccatif de Courtrai 47
Siccatif de Harlem 47
Silkscreen printing, see serigraphy
Sinking 129–30
Size: glue 20, 33; to make 34
Sketching stools and seats 25
Solvents 44: oil of spike lavender 44; petrol 44; turpentine 44; white spirit 44
Southall, Anne 210
Space and the third dimension 210–11: achieving indication of space 213; negative spaces 234; special relationship indicated by overlapping 216, 218
Spatula 13, 14, 34, 35, 129
Spraying 104; use of spray gun for 104
Squaring-up 174, 176, 229–30; procedure for 229–30
Staining 103–4
Stand oil medium 44
Stencilling 104, 107; brushes for 107
Stretchers 17, 19
Stretching canvas 23–4
Studio equipment, suggested list of items 16
Studio table 8

Subjects for painting, exploration of environment and determining 230–79
Supports 16–24: canvas 17–19; cardboard 20; chipboard 17; Essex board 20; glass 21; harboard 17; metals 21; paper 20; plywood 17; wood 16 disadvantages of as s. 16
Surrealism(ts) 273, 275
Synthetism(ts) 160, 165

Techniques 87–281: of Rembrandt 148–51; of Rubens 144–8; of Titian 142–4; three basic t. 133, 135–7
Tempera painting 17, 34, 35, 55, 140, *141*, 142, 144, *211*: egg 34, *133*, 140; method of production 140
Thompson, D'Arcy 192; works, *Growth and Form* 192q
Tints 63
Titanium 25: use of in making oil grounds 35; white 50
'Tonal' painting 78, 79
Tone(s): selecting of 64, 67–8; value 64
Tonking 14, 125–7, 130, *180*; method of 125–6
Tonks, Henry 125
Turpentine 153: distilled as constituent of common painting medium 44; use of as dilutent 43; use of as solvent 44; Venice 44, 45, 46, 144, 149

Undercoat, decorators, as alternative to making oil grounds 35
Underpainting 34, 82, 88, 90–91, 92, *92*, 94, 107, 133, 137, 140, 148, 153: impasto *151*; monochrome 82, 142, 148–9, *150*

Van den Bergh 21
Varnish media, recipe for 46
Varnishes and varnishing 47–8, *199*: copal or mastic 47, 48; dammar 48; double mastic 481; drying time of 48; mastic 47; matt 47; temporary 47; wax 47; when applied as protective coating 47
Vasari, Giorgio 17, 18, 43, 140–42: attributes 'invention' of oil painting to Jan van Eyck 140; works, *Lives of the Painters, Sculptors and Architects* 140q
Venice turpentine 44, 45, 46, 144, 149
Viewfinder, use of 176, *177*
Violet pigments 53

Walnut oil 37, 43, 45
Wet into wet technique 83, 92, 94, *94*
White lead, use of in making oil grounds 34, 35
'White writing' 237
White spirit 44: use of as cleaning fluid 44
Whiting 34
Wire mesh, use of 104
Wood, as support 16
Wooden panel(s) 16–17, 18, 35: as cheaper substitute for canvas 19
Woodgraining technique *207*
Wurtzbach, Dr van 142: works, *Niederlandisches Kunstler-Lexicon* 142q

Yellow pigments 50, 52

Zinc oxide 25, 50: use of in making oil grounds 35